from
Jade
Terrace
◆
Chinese
Women
Artists
1300
1912

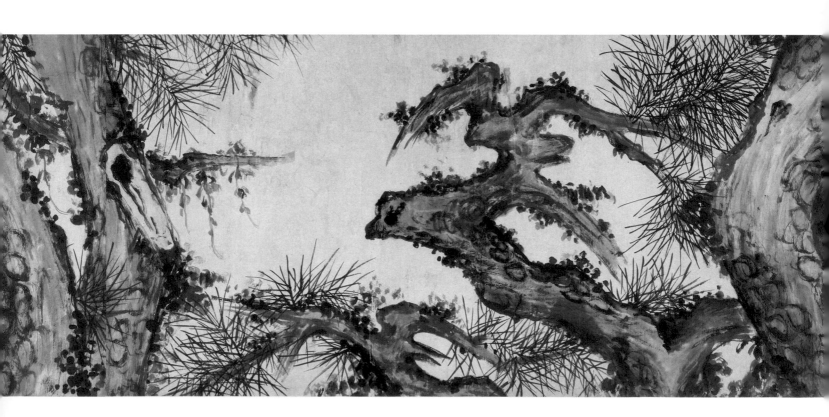

Marsha Weidner

Ellen Johnston Laing

Irving Yucheng Lo

Christina Chu

James Robinson

◆

Indianapolis

Museum of Art

and

Rizzoli, New York

Views from Jade Terrace

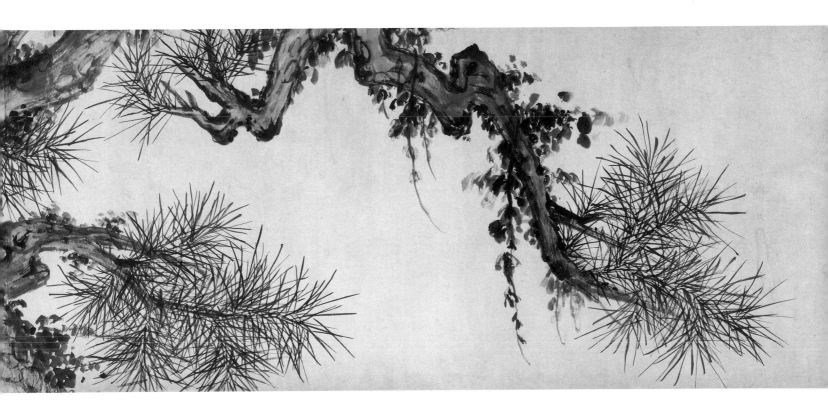

Chinese Women Artists 1300 1912

Exhibition Schedule:
Indianapolis Museum of Art,
 September 3 – November 6, 1988.
Virginia Museum of Fine Arts, Richmond,
 December 6, 1988 – January 15, 1989.
Asian Art Museum of San Francisco,
 February 15, 1989 – April 2, 1989.
National Museum of Women in the Arts,
 Washington, D. C.,
 April 24, 1989 – June 4, 1989.
Hong Kong Museum of Art,
 June 30, 1989 – August 27, 1989.

The exhibition and its catalogue were funded in part by the
Chubb Group of Insurance Companies, the National Endowment
for the Humanities, the National Endowment for the Arts, and
the Indiana Arts Commission.

Published by the Indianapolis Museum of Art,
1200 W. 38th Street, Indianapolis, Indiana 46208 and
Rizzoli International Publications, Inc.,
597 Fifth Avenue, New York, New York 10017

Library of Congress Catalogue Card Number: 88-80498
Hardcover ISBN 0-8478-1003-8
Paper ISBN 0-936260-22-x

Edited by Debra Edelstein.
Designed by Lynn Martin, Chicago.
Typeset by Paul Baker Typography, Inc., Evanston,
and C. A. Design, Hong Kong.
Printed by Hilltop Press, Inc., Indianapolis.

Photography: Kathleen Culbert-Aguilar nos. 3, 4, 8, 9, 13, 16, 18,
19, 22, 23, 25, 26, 28, 29, 32, 33, 37, 38, 42, 49, 50, 52-56, 58, 61-63,
66, 67, 69, 74, 77, 78, and 79; Stephen Kovacik nos. 3, 17, 28, 62;
Shin Hada no. 80; others were supplied by the lenders.

Notes to the catalogue:
 Dimensions for the paintings, exclusive of the mounting, are
recorded in centimeters with height preceding width.
 Characters of the artists' inscriptions, artists' seals, names of
colophon writers (with date of colophon), and collectors' seals can
be found in the *Chinese Catalogue Text*. Other Chinese words
can be found in the index, including the characters for the artists'
zi, a courtesy name for social use, and *hao*, a style name personally
chosen for its meaningful content. The original texts of the
poems translated by Irving Lo follow his essay.
 Figures referenced by letters within the catalogue are located
in the essays or the *Photographic Appendix*. Photographs of the
remaining sections of the catalogue entries follow the figures and
are captioned by their catalogue number.
 Abbreviations for frequently cited sources are given with full
references in the *Select Bibliography*.
 Catalogue entries are followed by the initials of their authors:
CC – Christina Chu; E J L – Ellen Johnston Laing;
J R – James Robinson; MW – Marsha Weidner.

Cover: Mao Yuyuan, *Orchids and Flowers*, 1651 (detail), cat. no. 28.
Frontispiece: Cai Han, *Pine Trees*, 1676 (detail), cat. no. 33.
p. 65: Luo Guifen, *Flowers and Butterflies*, cat. no. 59.
p. 175: Yun Bing, *Orchid and Rock*, cat. no. 42-3.

Contents

Foreword

Views from Jade Terrace: Chinese Women Artists 1300-1912 is the first exhibition ever devoted to the painting of Chinese women artists. In the past two decades the role of women in the arts in general has been extensively, if not yet exhaustively, surveyed in many books and articles and in a number of important exhibitions. *Views from Jade Terrace*, then, can be seen as a continuation of this process and a first attempt to place into proper context the contributions of women to the history of Chinese painting.

The project began in 1983 when Dr. Marsha Weidner, Assistant Professor of Art at the University of Virginia, contacted Dr. James Robinson, the Jane Weldon Myers Curator of Asian Art at the Museum, to discuss the possibility of a show of Chinese women painters, a subject in which she had particular interest and expertise. She did so for two reasons: because she was aware of Dr. Robinson's own interest in the tradition of bird, flower, and insect painting — very often the subject of paintings by Chinese women artists — and because of the scroll by the woman artist Ma Shouzhen, *Colored Fungus, Orchids, Bamboo and Rocks* in the Museum's collection. This painting was acquired for the Museum by Mr. Eli Lilly on the recommendation of Wilbur D. Peat, then Museum director — the team responsible for the extraordinary core of the Museum's extensive holdings in Chinese art.

They decided to pursue the possibility of an exhibition and to contact another scholar who had a long-standing interest in the subject of Chinese women painters, Dr. Ellen Johnston Laing, Kerns Professor of Oriental Art, the University of Oregon. Dr. Laing's response was enthusiastic, and the three scholars met to review Dr. Weidner's proposal and preliminary research and to define exactly what an exhibition of Chinese women painters should be.

The rest, as they say, is history. Once the scope of the exhibition had been determined, two other scholars were asked to join the project. Because Chinese painting has often been treated from a literary point of view, and because poetry is often integrally linked to Chinese paintings, Professor Irving Yucheng Lo of Indiana University, Bloomington, an expert on Chinese literature, generously agreed to examine the relationship of literature and poetry to the art of Chinese women painters and to assist with literary translations. At the same time, Christina Chu, Curator of Chinese Art at the Hong Kong Museum of Art, came on board to help with the catalogue, especially with the works of the later Southern artists of the Canton region, about which she is highly expert.

It is clear that this exhibition and the catalogue that accompanies it were a team effort. On behalf of the Museum, the public, and scholars alike who will see the exhibition in Indianapolis or at its other venues — the Virginia Museum of Fine Arts, Richmond; the Asian Art Museum, San Francisco; the National Museum of Women in the Arts, Washington, D.C.; and the Hong Kong Museum of Art — I wish to extend heartfelt thanks to this remarkable team for organizing both an historically important and beautiful exhibition. Striking out into new research territory can be both enlightening and frightening, but the results, as we can so clearly see, were worth the effort and concern. The Indianapolis Museum of Art is proud to have had the privilege of joining the talents of Professors Weidner, Laing, and Lo and of Christina Chu, to those of its Curator of Asian Art in organizing this milestone exhibition.

Like all exhibitions, this one could not have been realized without the help and support of a much larger group of people both here at the Museum and elsewhere. Space does not permit me to thank all of them by name, but I would like to recognize several individuals and institutions whose contributions were especially important to the success of this exhibition.

First, I wish to extend thanks to the National Endowment for the Humanities for providing a planning grant, which was essential in developing the project, and to both the National Endowment for the Humanities and the National Endowment for the Arts for providing grants to carry the project forward. These grants have made it possible for the exhibition to travel and have enabled us to produce a comprehensive catalogue. For her assistance in securing these grants, I thank Judith McKenzie, Special Assistant to the President and Chief Executive Officer of the Museum.

As national and international sponsor of the exhibition, the Chubb Group of Insurance Companies has provided generous financial support. We are grateful to Mr. Dan Appel, of Gregory and Appel, a corporate member of the Museum, for his aid in obtaining this support, and are extremely grateful to the Chubb Group for making it possible for the exhibition to travel so widely.

To the staff of the Indianapolis Museum of Art, I offer thanks without measure for a job well done. A major exhibition requires the assistance of everyone, and I would especially like to thank Vanessa Wicker-Burkhart and Catharine Ricciardelli Davis of the Registration Department, and particularly Jayne Johnson, Assistant Registrar, who has worked so dili-

gently coordinating loans, seeing to needed photography, and bringing order to the numerous details of shipping, contracts, and the like that are part of any exhibition; Sherman O'Hara, Preparator, and his staff for their excellent installation; Mary Bergerson, Director of Public Relations and Marketing and her staff for their efforts in support of the exhibition; Margot Bradbury, Museum Editor, for her assistance with the catalogue; and to the members of the Education Division who have assisted in the development of or have developed the educational programs offered in conjunction with the exhibition.

I should also like to thank Lynn Martin for the splendid design and production of this catalogue to accompany the exhibition.

I have reserved special thanks for the lenders to the exhibition. Without the willingness of the institutions and individuals (listed elsewhere) to lend their treasures to this exhibition and to allow them to travel for such a long time, there would be no exhibition. Thanks are hardly sufficient to express our deep gratitude.

This exhibition is in keeping with the Museum's tradition of organizing important exhibitions of Asian art, and we hope that it will stimulate the public's interest in the work of women artists, in Chinese painting in general, and in the important genre and tradition of flower-and-bird painting. We also hope that this exhibition will be seen as a pioneering attempt to round out and make more complete our understanding of the long and diverse traditions of painting in China.

Robert A. Yassin
Director and Chief Curator
Indianapolis Museum of Art

Preface and Acknowledgments

Several years ago Marsha Weidner inquired whether there might be interest at the Indianapolis Museum of Art in an exhibition of paintings by Chinese women artists, and my immediate thought was "Why not; there certainly was interest during China's past." From such simple, perhaps innocent beginnings, the questions raised by the topic soon became quite complex. From "ten thousand" miles of travel and hundreds of books, and with the help of generous friends around the world, the exhibition grew through a number of stages and finally reached its present form. Other exhibitions on this subject may follow, and may appear quite different, but this is our hope since there has never before been an exhibition devoted to Chinese women artists active between 1300 and 1912.

Being the first is not in itself a justification, and scholars engaged in women studies may speak more eloquently about the timeliness of the topic, but important for the art historian is the legitimate place of women artists in the history of Chinese art and culture. Traditional Chinese society provided several contexts, or social positions, that encouraged women to discover their artistic abilities, and connoisseurs and collectors acknowledged and recorded women's talents, albeit often in a separated fashion apart from the accomplishments of men. Within the six hundred years covered by this exhibition, many women painted for pleasure and profit. Collectors' catalogues, both imperial and private, and scholarly texts sang their praises, preserving significant commentary about them. It has only been in this century that an unnatural silence has descended on the subject of Chinese women artists. Inevitably, this has hampered a complete understanding of the unique historical traditions of painting in China.

The "Jade Terrace" of our title pays homage to earlier Chinese texts devoted to female artists: *The Jade Terrace History of Calligraphy* and *The Jade Terrace History of Painting*. It is an abstract concept without reference to an actual site. In the literary tradition it was a timeless place where heavenly women congregated. In the sixth century, Xu Ling used the term in a pioneering anthology of love poems, *New Songs from a Jade Terrace*, thereby permanently aligning its association with the women's quarters. In a different way this exhibition is also an anthology, illustrating the role of women in the cultural history of China. We chose to start at 1300 in order to begin with the first woman artist for whom we have both a substantial biography and who is represented by extant paintings. We then went on to select representatives from the wide variety of women artists through six centuries of traditional society, ending with the start of the modern era.

Drawn from collections around the world and including many previously unpublished works, the exhibition offers a rich variety of images that we hope will catch the attention of specialists and nonspecialists alike. In the catalogue, every effort has been made to interpret the paintings and provide information about the social context in which they were made: Who were the artists? How did they live? Why did they paint? What did they paint? How were their works received? Is there a common current in or special character to their art?

Limitations were inevitable. Some were self-imposed, because of the vast scope of the topic and our own resources. In certain cases, fine paintings could not be included because they belong to institutions that, for various reasons, do not participate in loan exhibitions of this type. Many paintings reproduced in old books now appear to be lost, while others, still hidden away, remain to be discovered. A special thanks is due to all the institutions, and particularly to the private collectors, who have willingly loaned their paintings to this exhibition, for they have truly made this enterprise possible.

A great many individuals have supported this project in all its details, providing much needed encouragement and timely spiritual support, sharing expertise and offering advice, and assisting us in a variety of practical ways. Some labored behind the scenes, yet a few must be singled out for special acknowledgement. Since the project began, James Cahill, Howard Rogers, and Arnold Chang have drawn our attention to numerous paintings that we might otherwise have missed. In Japan, Minoru Nishigami of the Kyoto National Museum offered invaluable assistance by facilitating our communication with collectors and institutions. Similarly, the efforts of Harold Wong and Peter Lam made it possible for us to include a significant number of important paintings from Hong Kong collections. Although no works from China are included in the exhibition, a portion of our research for the catalogue was conducted in Beijing, Shanghai, and Taipei, where we were welcomed by Yang Xin and Liu Jiuan of the Palace Museum, Beijing; Chan Guolin, Zhong Yinglan, and Huang Fukang of the Shanghai Museum; and Chiang Chiao-shen, Chang Lin-sheng, and Hu Sai-lan of the National Palace Museum, Taipei. Tseng Yu-ho Ecke kindly shared with us her findings about a number of works from the Mitchell Hutchinson collection.

Many of our labors could not even have begun, and certainly the fruits of our work

would never be known, without the financial support we were fortunate to receive. The National Endowment for the Humanities made this exhibition possible by underwriting both the research necessary for planning and the activities undertaken for implementation. The National Endowment for the Arts and the Indiana Arts Commission have supported crucial phases of this project. Special thanks is due to the Chubb Group of Insurance Companies for their support as corporate sponsor.

We are especially grateful to Julia Cripe, who coordinated and handled myriad aspects of the exhibition and catalogue, and often juggled many hats at once. Hsing-li Tsai, an intern from the University of Michigan, diligently labored through all the textual material and prepared the Chinese text to accompany the catalogue. Elizabeth Brotherton compiled the index, supplied characters, and helped us track down and interpret all sorts of material in Chinese sources. Others who assisted us in locating research, arranging loans, securing reproductions, translating passages, identifying flowers, and so on, are too numerous to mention individually. I have listed these generous people below. My apologies to any I have missed. We are sincerely grateful to you all.

James Robinson
Jane Weldon Myers Curator
of Asian Art
Indianapolis Museum of Art

Martin Amt, Freer Gallery of Art
Daniel Appel, Indianapolis
Terese Tse Bartholomew, Asian Art Museum of San Francisco
Milo C. Beach, Arthur M. Sackler Gallery
Patricia Berger, Asian Art Museum of San Francisco
Libuše Boháčková, Náprstek Museum, Prague
Helmut Brinker, Museum Rietberg, Zurich
Marion Campbell, Honolulu Academy of Arts
C.T. Chiu, Hong Kong
António Conceição Jr, Museu Luis de Camoes, Macau
Jean-Pierre Dubosc, Japan
Joseh M. Dye, Virginia Museum of Fine Arts
George Ellis, Honolulu Academy of Arts
R. H. Ellsworth, New York
Eberhard Fischer, Museum Rietberg, Zurich
Jacques Giès, Musée Guimet, Paris
Peter Ho, Manasquan, New Jersey
Wai-kam Ho, Nelson Gallery-Atkins Museum
Wendy Holden, Asian Art Archives, University of Michigan
Francine Hurwitz, Indianapolis
Mitchell Hutchinson, Honolulu
Jean-François Jarrige, Musée Guimet, Paris
Jane Ju, University of Kansas
Heike Kotzenberg, Museum für Ostasiatische Kunst, Cologne
J. S. Lee, Hong Kong
Chu-tsing Li, University of Kansas
Lin Shuenfu, University of Michigan
Howard Link, Honolulu Academy of Arts
K. S. Lo, Hong Kong
Ma Chengyuan, Shanghai Museum
Gabbi Maes, Indianapolis
Mr. and Mrs. Sandy Mactaggart, Alberta
Nobuyuki Minato, Tokyo National Museum
Yutaka Mino, Art Institute of Chicago
Mr. Christopher Mok, Hong Kong

Paul Moss, London
Matsuo Murayama, Tokyo National Museum
Alfreda Murck, The Metropolitan Museum of Art
Makoto Mutoh, Kurokawa Institute of Ancient Cultures
Makiko Natsumeda, Indianapolis
Mary Gardner Neill, Yale University Art Gallery
Ronald Otsuka, Denver Art Museum
Elinor Pearlstein, Art Institute of Chicago
Mary L. Pei, Toledo
Anne-Imelda Radice, The National Museum of Women in the Arts
Eva Rychterová, Náprstek Museum, Prague
William Schultz, University of Arizona
Clarence Shangraw, Asian Art Museum of San Francisco
Caron Smith, The Metropolitan Museum of Art
J. Součková, Náprstek Museum, Prague
John Stites, Indianapolis
Michael Sullivan, Oxford, England
Laurence Tam, Hong Kong Museum of Art
Ka Bo Tsang, Royal Ontario Museum
Wan Li Mei, Ministry of Culture, Beijing
C. C. Wang, New York
Akiyoshi Watanabe, Agency for Cultural Affairs, Japan
Julia White, Denver Art Museum
David Windsor, Chicago
Eliza Wong, Hong Kong Museum of Art
Marshall Wu, The University of Michigan Museum of Art
Wu Tung, Museum of Fine Arts, Boston
Kozo Yabumoto, Hyogo, Japan
Shogoro Yabumoto, Hyogo, Japan
Nobuyoshi Yamamoto, Agency for Cultural Affairs, Japan
Margaret Yen, Indianapolis
S. Y. Yip, Hong Kong
Louise Yuhas, Occidental College

Lenders to the Exhibition

Art Gallery, The Chinese University of Hong Kong

Art Institute of Chicago

Arthur M. Sackler Gallery, Washington D.C.

Asian Art Museum of San Francisco

Bei Shan Tang Collection

CEMAC Ltd. Collection

Chengxun tang Collection

John M. Crawford, Jr. Collection

Denver Art Museum

Mr. & Mrs. J.P. Dubosc Collection

Robert Hatfield Ellsworth Collection

Museum of Fine Arts, Boston

Musée Guimet, Paris

The Honolulu Academy of Arts

Indianapolis Museum of Art

Kurokawa Institute of Ancient Cultures, Nishinomiya

Leal Senado/Museu Luis de Camoes, Macau

Mr. & Mrs. K.S. Lo Collection

The Metropolitan Museum of Art, New York

The University of Michigan Museum of Art, Ann Arbor

Náprstek Museum of Asian, African and American Cultures, Prague

Occidental College Library, Los Angeles

Museum für Ostasiatische Kunst, Cologne

Private Collection, Honolulu

Private Collections (4)

Museum Rietberg, Zurich

Royal Ontario Museum, Toronto

Tingsong shuwu Collection

Tokyo National Museum

Urban Council, Hong Kong Museum of Art

Wing Yuen Collection

Harold Wong Collection

Yale University Art Gallery, New Haven

Dr. S.Y. Yip Collection

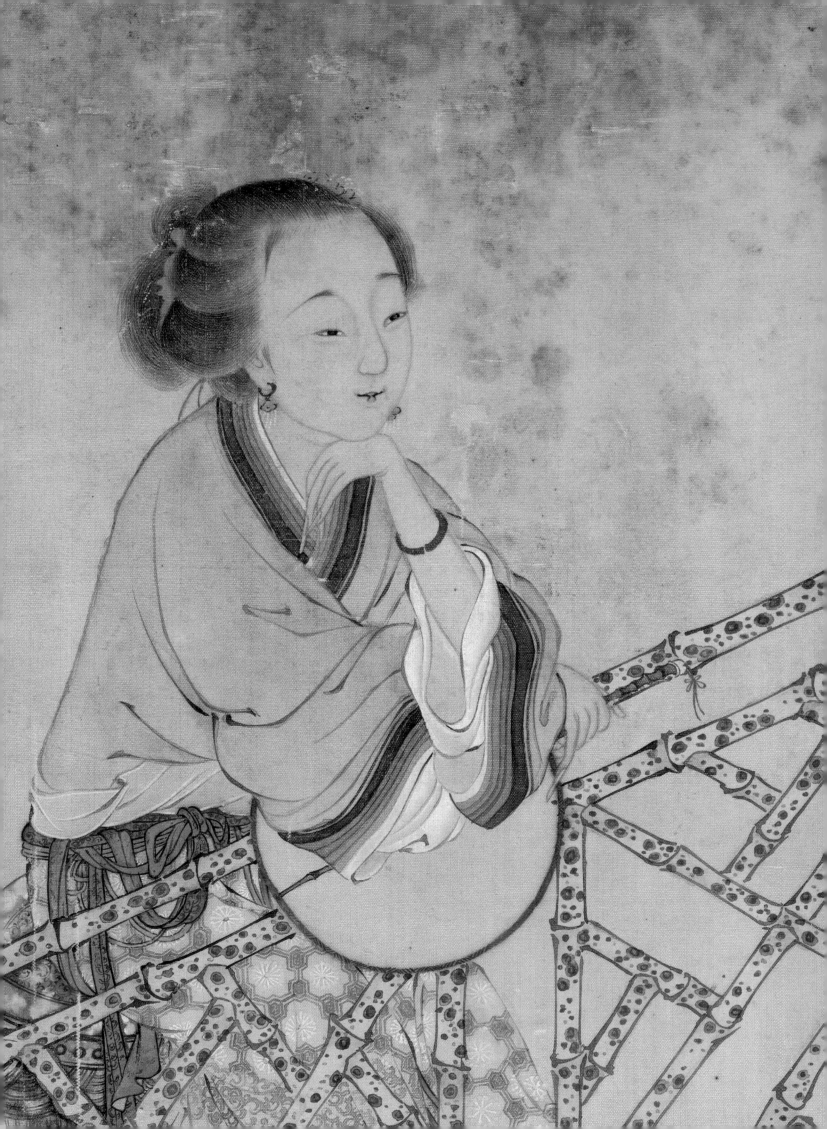

Women in the History of Chinese Painting

Marsha Weidner

Women and the Social History of Chinese Painting

Given the images of Asian women prevalent in Western literature, it may be difficult to visualize a traditional Chinese woman, standing on tiny bound feet, confidently creating a work of art. Yet this was not an uncommon sight in the upper-class households and entertainment districts of late imperial China. During the period covered by this exhibition, 1300-1912, numerous Chinese women were recognized by connoisseurs and collectors for their artistic achievements. Some were wives or daughters of professional painters, but most either belonged to scholar-official families — China's gentry — or were courtesans who served gentlemen of this class. The women of the gentry and courtesans were counterparts to the male scholars whose art theories and practices eventually came to dominate Chinese painting in the Ming (1368-1644) and Qing (1644-1912) dynasties.

These scholars — members of the literary intelligentsia who served in China's government, or at least prepared for official careers — painted as amateurs and regarded their own work as superior to that of professional artists. They maintained that meaningful art was created only by refined, learned individuals who took up the brush for personal reasons or for the pleasure of their friends and that the quality of this art depended upon the character of the artist. In contrast, works produced in imperial and temple workshops or for the general market, although decorative and useful, belonged to the realm of craft, where technical skill mattered more than the personality of the painter. Scholars likened their own painting to calligraphy and poetry and used all three, often in combination, as vehicles for self-expression and instruments of social intercourse. Rather than seeking formal training in painting, they learned brush techniques from the practice of calligraphy, studied antique works and painting manuals, and received instruction from friends and family members. Their success was measured not in sales or commissions, but by the reputations they established among their peers.

If painting had not become an elite pastime, but had instead been left entirely to the professionals, women would seldom have contributed to its history. In traditional China the primary occupations of men and women were quite distinct. Women were generally limited to careers in the home, nunnery, or brothel, and only in the first could they fulfill their primary obligation to Confucian society, the continuance of the family. Since the home was the sole completely sanctioned arena for female activity, gentry women were able to discover their talent for painting only after scholars had made this art a domestic pursuit by practicing it themselves in their private libraries and residential gardens. Once this happened, however, in some respects Chinese women painters faced fewer obstacles than their female contemporaries in the West, who were often denied access to the institutions that provided art training and the means for advancement. Chinese women could become accomplished artists without stepping beyond their front gates. Like their fathers, brothers, and husbands, they gained recognition through familial and social channels. They were further aided by the literati definition of painting as an avocation. Just as Chinese gentlemen did not have to give up their traditional occupations as scholar-bureaucrats to be considered serious artists, ladies did not need to slight their family duties. For both men and women, painting was a lifelong activity, taken up as time permitted, in leisure moments and retirement.

Of course, not all women of the gentry could take advantage of the opportunities offered by the scholar-amateur tradition. A degree of literacy, familiarity with the writing brush, and knowledge of the art of the past were requisites for scholarly painting, and these were beyond the reach of many women. Conservative families protected their daughters from the distractions of literature and taught them little more than filial behavior and needle skills. If these girls were fortunate, they married into families with more liberal attitudes toward female literacy, but this seldom happened. Thus, there are far fewer women than men in the Chinese art-historical record.

It must also be acknowledged that, with perhaps one exception, the renowned bamboo painter Guan Daosheng (cat. nos. 1, 2) of the Yuan dynasty (1279-1368), the names of women do not appear on the rolls of the "great masters." On the whole, Chinese women painters were sustainers rather than innovators. Their inventive potential was limited by conventions designed to support the rigorously patriarchal social system of premodern China. The most infamous of these was the custom of footbinding. However, minds were also bound, not only by the thoroughgoing subordination of women to men within the family and the exclusion of women from public life, but also by definitions of virtue based on self-sacrifice and the equation of fragility with femininity. These and other behavioral constraints on Chinese women are so well known that there is no need to

belabor them here. It is enough to recognize that under these circumstances women were not prepared, intellectually or psychologically, to wrestle with art history, break new ground or assume positions of leadership in the manner of, for example, the late-Ming master Dong Qichang (1555-1636).

Women who became skillful painters usually had the support and assistance of male family members. Dong Qichang went so far as to insist that the women of his household copy pictures, and he scolded any who showed signs of tiring.[1] More typical are accounts of the pleasure that couples took in shared aesthetic interests. References to art as a bond between men and women are common in the literature about female painters, poets, and calligraphers. Often these women were secondary wives, concubines remembered no less for their artistic and literary skills than for their beauty, but intellectual matches also occurred in arranged marriages with primary wives — sometimes by fortunate accident, sometimes by design.

Although the wives and daughters of successful male artists were particularly likely to take an interest in painting, Chinese women painters were not always dependent on fathers or husbands for inspiration and training. Especially during the Ming and Qing periods, artistically inclined young women found female role models in history and literature as well as in their own households. Mothers sometimes taught their daughters to paint and compose poetry, and many families boasted a number of talented women. If a girl expressed an interest in painting and her parents approved, but no one in the immediate family could provide instruction, teachers could be found among more distant relations or family friends. Women could also avail themselves of the scrolls, screens, fans, and "treasures of the scholar's study" — brushes, ink, inkstones, and paper — that were standard equipment in gentry homes.

Amateur painting naturally flourished in the foremost home in the land, the imperial palace, and on occasion gentry women were summoned to Beijing to instruct empresses, princesses, and imperial concubines in this polite art (cat. nos. 74, 75). It also spilled over into China's religious communities. Buddhist and Daoist monks and nuns, taking cues from the secular world of the Confucian literati, produced works that bear little resemblance to the religious images painted by craftsmen on temple walls. In the pleasure districts, especially during the Ming dynasty, elite courtesans such as Ma Shouzhen (cat. nos. 4-9) and Xue Susu (cat. nos. 10-13) added sketching to the repertoire of refined entertainments they offered visiting gentlemen.

The women painters who functioned outside the scholarly tradition were for the most part relatives of professional artists. Just a few can be named, and we know little about them other than that they were proficient in the technically demanding subjects and styles of their fathers. The daughter of the early-Ming master Dai Jin (1388-1462) painted landscapes and figures.[2] The works of Miss Qiu (cat. no. 3) closely resemble those of her father, the Suzhou figure painter Qiu Ying (c. 1494-c. 1552). In the Qing dynasty, Ding Yu of Hangzhou took up her father's practice of using Western techniques in portrait painting.[3] Under normal circumstances, women from "artisan" families lacked the leisure to pursue the arts for their own amusement or as a means of self-expression, so we can assume that these women painted because this was the family livelihood.

The line between professional and scholar-amateur painting, however, like lines between social classes, cannot always be easily drawn. The early-Ming master Sun Long, for instance, was not only skilled at rendering plants and insects, the specialty of the professional painters of his hometown, but also sketched blossoming plums, a theme popular with scholar-artists. The more scholarly side of his art influenced the work of his daughter and her husband Ren Daoxun (1422-1503), both of whom are remembered for their plum-blossom paintings.[4] On the other hand, artists with scholarly backgrounds often deviated from strict amateurism. When family fortunes declined, perhaps as the result of dynastic change, political misadventure, the failure of one or more generations of males to pass the examinations requisite for government office, mismanagement of family properties, or simple extravagance, some well-educated men and women found it necessary to use their literary and artistic skills for material gain. A surprising number of the women represented in this exhibition painted, at least in part, to contribute to the support of their families.

The Lives
of Chinese
Women Painters

A reasonably complete entry for a women painter in a Chinese dictionary of artists' biographies will give her alternate names, native place, the names of important family members and teachers, her favorite painting subjects, preferred painting styles, and other skills, such as poetry and embroidery. Her husband's name will be cited in the same way as official positions are in entries for male artists. For a bit of

spice, there may be an anecdote or perhaps an observation about her fame, beauty, or feminine virtue. The texts from which such entries are excerpted — epitaphs, scholars' collectanea, collectors' catalogues, premodern biographical compilations, and local gazeteers — provide only a little more information. They may tell us about the artist's social connections, particular paintings, or how her works were received. However, these sources often quote one another and rely heavily on stereotypes and clichés. Even the writings of the artist's contemporaries seldom afford more than a glimpse of her real personality and the everyday circumstances of her life.

Records concerning male artists can, of course, be equally formulaic, but the life histories of prominent men are much more extensively documented than those of women. Masculine undertakings, including examinations, official appointments, long journeys, and retirement, resulted in official records and routinely inspired written responses from the scholarly community. Female lives were not punctuated by events of similar consequence. Even those who gained a degree of recognition as mothers of famous men, exemplars of feminine virtue, or women of talent remained footnotes to history.

We are fortunate, then, to have relatively long biographies for a few women painters. Naturally these valuable accounts served as the basis for some of the discussions in this catalogue. They were employed, however, with a degree of polite skepticism because, in keeping with tradition, they too are highly idealized. One of the most famous is Mao Xiang's *Reminiscences of the Convent of Shadowy Plum Blossoms*, the story of his beloved concubine Dong Bai (cat. no. 22).[5] In this novelistic narrative, Mao characterizes Dong as the perfect concubine — beautiful, talented, and thoroughly subservient, his lover and confidante as well as the grateful slave of his mother, sisters, and wife. Dong's strength of character shines through adversity, as she seeks to escape her fate as a courtesan by marrying Mao, endures the chaos following the fall of the Ming dynasty, and then nurses Mao through a succession of illnesses. Although infused with sentiment, Mao Xiang's reminiscences give us the outline of Dong Bai's life and leave little doubt about the hardships faced by women of her social station. At the same time, they reflect the romantic ideals of the seventeenth century and detail the rich aesthetic environments cultivated in gentry homes.

Plays and novels, such as the eighteenth-century classic *The Story of the Stone* by Cao Xueqin (d. 1763), provide comparable perspectives and contextual information that can help us understand the lives of women painters. Cao described in lavish detail the physical features and social conditions of a large and wealthy household, drawing intimate scenes of upper-class life as it was known by some of the women represented in this exhibition. The story is set primarily in the family's Prospect Garden, where young ladies and the young hero dwell in pavilions furnished in accordance with their tastes and intellectual inclinations. One girl's chamber is described as follows:

This room, a three-frame apartment which Tan-chun, who loved spaciousness, had left undivided, had in the midst of it a large rosewood table with a Yunnanese marble top piled high with specimen-books of calligraphy and littered with several dozen miscellaneous ink-stones and a small forest of writing-brushes standing in brush-holders and brush-stands of every conceivable shape and size. On one side of the table was a bucket-sized 'pincushion' flower-vase of Ru ware stuck all over with snow-white pompom chrysanthemums. On the west wall of the room hung a 'Landscape in Mist and Rain' by Mi Fei, flanked by a pair of scrolls bearing a couplet written by the Tang calligrapher Yan Zhen-qing.[6]

Tanchun is not alone in possessing such scholarly quarters. The pavilion of the heroine Daiyu is similarly furnished, as is observed by an old countrywoman, Grannie Liu, who is given a tour of the garden:

Grannie Liu noticed the inkstone and brushes on the table . . . and all the books on the bookshelves and said that she supposed this must be "the young gentleman's study." Grandmother Jia smiled and pointed to Dai-yu.
"It belongs to her — my little grand-daughter." As though incredulous, Grannie Liu studied Dai-yu attentively for some moments in silence.
"It doesn't look at all like a young lady's room," she said finally. "It looks to me like a very high-class young gentleman's study."[7]

In these elegant surroundings Tanchun, Daiyu, and the other female residents of the garden devote hours to literary and aesthetic pursuits, especially poetry. Indeed, the poetry club they form proves so successful that when examples of their work come to the attention of the scholar-associates of the lord of the manor, these gentlemen have the poems published.

The talents of one young woman, Xichun, include painting, and she is instructed by the matriarch to make a picture of the garden to present to the visiting Grannie Liu.[8] This assignment provokes considerable discussion, in the course of which it is clearly stated that Xichun is an amateur, who does "an occasional sketch in the Impressionistic style."[9] Some of the women represented in this exhibition were like Xichun, strictly amateurs who divided their

time among several arts, including poetry, and limited their painting activities to ink and perhaps light color sketches of such standard literati subjects as bamboo, orchids, blossoming plum, and "small scenes."

In creating the world of the Prospect Garden, Cao Xueqin drew upon the experiences of his youth in Nanjing, and his descriptions of the educated, talented young ladies of the novel were undoubtedly based on people he knew. During the late Ming and early Qing periods literacy increased significantly among women in the gentry households concentrated in the eastern Yangzi River region, and poetry reading and writing became very popular among the upper-class women of the area.[10] Qing-dynasty ladies formed poetry societies (cat. no. 30), offered instruction to one another, and collected poems by women.[11] Often they practiced several polite arts, excelling in the "three perfections" — poetry, calligraphy, and painting.

These developments, however, did not meet with universal approval. Men of the most conservative stripe continued to regard ignorance as a virtue in women. A moderate position, taken by scholars such as Lan Dingyuan (1680-1733), allowed that girls should be educated, but primarily to enable them to read edifying texts about women's place in society, familial obligations, and proper conduct.[12] In his own contribution to this genre, the *Nü xue* (Women's Culture), Lan organized literary extracts concerning female exemplars under the headings of virtue, speech, bearing, and duty.[13] By Lan's time handbooks for women already had a long history stretching back to such classics of the Han dynasty as the *Lienü zhuan* (Biographies of Virtuous Women) by Liu Xiang (77-6 BC) and the *Nü jie* (Admonitions for Women) by the woman historian Ban Zhao (c. 45-c. 120).[14] During the Ming and Qing periods such works proliferated. Particularly popular was Lu Kun's illustrated *Gui fan* (Regulations for the Women's Quarters) of 1590 based on the *Lienü zhuan*. Modern scholars have found Lu's work to be of special interest because his model biographies emphasize women's capabilities and reflect some of the more positive views of women current in his day.[15]

In the eighteenth century the debate on women's literacy was stimulated by the participation of the celebrated poet Yuan Mei (1716-98) and his antagonist Zhang Xuecheng (1738-1801).[16] Yuan encouraged women poets, accepted them as students, and published their works (cat. no. 52); Zhang saw poetry as diverting women from the study and pursuit of traditional feminine virtues. This issue is raised in *The Story of the Stone,* which from time to time

slyly introduces criticism applicable to its own characters and literary form. One of the heroines thus piously observes to another, "The little poetry-writing and calligraphy we indulge in is not really our proper business." She elaborates:

As for girls like you and me: spinning and sewing are our proper business. What do we need to be able to read for? But since we can read, let us confine ourselves to good, improving books; let us avoid like the plague those pernicious works of fiction, which so undermine the character that in the end it is past reclaiming.[17]

She speaks, of course, from the depth of just such a work.

While gentlemen were disagreeing about the desirable parameters of female literacy, women were busy reading books that offered them two very different sets of ideals. In novels they found intelligent, talented, and educated beauties paired with noble, sensitive scholars, passing romantic, if eventually tragic lives, filled with love, poetry, and art. The didactic texts, in contrast, gave them "official" characterizations of obedient daughters, submissive wives, self-sacrificing mothers, and chaste widows. Despite the obvious conflicts, all these images contributed to the realities of their daily lives and to the ways in which their lives were recorded.

The two poles are represented by Mao Xiang's account of his relationship with Dong Bai and Qian Chenqun's biography of his mother Chen Shu (cat. nos. 36, 37).[18] The former, as noted, reads like a novel; the latter casts its subject in the role of Confucian heroine. These choices were dictated by the social positions and experiences of the women in question. As a courtesan and concubine who died young, Dong Bai was an inherently romantic figure. Chen Shu, a woman from a good family who became a primary wife, produced three sons, and lived seventy-six years, could be depicted as nothing other than a paragon of virtue, especially by her son. Accordingly, he sets forth her admirable ancestry, fine upbringing, precocious talent, filial behavior, and tireless devotion to her children. Her spinning by lamplight while supervising her son's studies is described at length. The painting talent for which she is remembered today, however, receives slight mention. Fortunately, critics and collectors paid more attention to her work, and many examples were preserved in the imperial collection.

Reconstructing the life of a women painter, then, requires recognition of the stereotypical images in her biography as well as acknowledgment of the roles such images played in shap-

ing her experience. Brief notices can be supplemented and one-sided portrayals balanced with descriptions drawn from contemporary novels and plays. Yet, in the end, more may be learned about the artist's personality from her art.

Women's
Art
History

Chinese women can easily be written into the male history of Chinese painting already familiar to Western audiences: if they were not connected by blood or marriage to famous male artists, at least their painting styles were linked to the schools or traditions of the masters. It should be recognized, however, that the female painters of China did not define their artistic personalities solely in relation to men. In addition to studying with mothers, aunts, and female tutors, they collaborated with sisters and exchanged works with female friends. Moreover, they were well aware of themselves as a distinct group within the larger history of painting. It would have been surprising if they had not been, given the sex-based dichotomies that shaped premodern Chinese life.

The separation of male and female spheres is clearly reflected in the organizational schemes adopted by compilers of artists' biographies. Texts arranged by dynasty typically introduce members of the imperial family first, then the gentlemen of the body politic. Recorded last, and often separately, are individuals outside of the political system: monks, foreigners, and women. If artists are classified by surname or area of specialization, women are usually placed last within each group. Sometimes they are put in a special chapter or an appendix.

Such arrangements, which are also characteristic of other types of histories and literary collections, facilitate the recognition of connections between women painters. Certainly they simplified Tang Souyu's task when she set about compiling her *Yutai huashi* (The Jade Terrace History of Painting), a history of women painters from early times through the beginning of the nineteenth century. Tang Souyu was the wife of Wang Yuansun (1794-1836), a member of a distinguished scholarly family of Hangzhou and heir to a fine library. Wang's great-grandfather had gathered, studied, and collated thousands of volumes, including many rare items. More books were added by his father, and Wang Yuansun himself carried on the family tradition.[19]

With this library at her disposal, Tang was able to draw information from over a hundred sources, ranging from early painting histories to the writings of prominent Ming and Qing figures such as Qian Qianyi (1582-1664), Chen Weisong (1626-82), and Wang Shizhen (1634-1711). She was assisted in this enterprise by her husband, whose observations on paintings or about which he had personal knowledge she occasionally cites. An appendix, which also seems to have been based largely on firsthand information, includes a number of women of Hangzhou. That city had long provided a congenial environment for female scholars, poets, and artists, and perhaps this was one of the factors that prompted Tang to compile her book.

Tang Souyu's specific inspiration, however, was the *Yutai shushi* (The Jade Terrace History of Calligraphy), a survey of female calligraphers compiled by the gentleman Li E (1692-1752), another Hangzhou scholar.[20] Tang slightly modified Li's system of organization based on social status, presenting imperial ladies first, followed by wives and daughters, concubines, and finally courtesans. Since many of the concubines were originally courtesans, there is considerable social overlap in these categories. Within each group the women are organized by dynasty. The largest category is the second, that of wives and daughters, or as Tang and Li designate them, "famous beauties." This was just a polite reference; the women who were really celebrated for their physical charms were the courtesans and concubines.

Starting with ancient times and the attribution of the origin of painting to Lei, the younger sister of the legendary emperor Shun (c. 2200 BC), the *Yutai huashi* introduces a number of women active prior to the Yuan dynasty, the period with which this exhibition opens. The names of a few more early female contributors to the visual arts can be gleaned from other sources. None are represented by extant works, but as forerunners of the artists who are the subject of the exhibition, they deserve brief mention.

For the earliest periods, even written records of women artists are scarce. While some women painters surely went unnoted and accounts of others have been lost, the paucity of information probably reflects historical reality. At least through the Tang dynasty (618-907), painting was primarily the province of professional artists — men — who provided didactic and decorative works for palaces and temples.

Among the few pre-Tang female artists to come to the attention of scholars was Lady Zhao, the wife of Sun Quan (d. 252), ruler of the state of Wu. When her husband expressed a wish for a topographical illustration to be used in planning military strategy, she obliged

by sketching and embroidering mountains, waterways, towns, and troop deployments.[21] Lady Zhao was also skilled in calligraphy, as were other notable women of her time.

Like scholarly gentlemen, women practiced calligraphy as an art long before any appreciable number of them took up painting as a pastime. Two famous examples are Cai Yan (Wenji, 162?-239?) and Wei Shuo (known as Wei Furen, 272-349).[22] The former, who is traditionally regarded as China's first outstanding woman poet, was the daughter of the Han-dynasty scholar Cai Yong (132-192) and was his successor in calligraphy. Wei Shuo is remembered as an early teacher of the great master Wang Xizhi (307-365).

The records concerning Tang-dynasty women are only slightly more informative than those of the preceding periods. Tang Souyu mentions two princesses: one lived humbly and was skilled at embroidery; the other was talented in both music and painting.[23] Among the gentry, a woman of the Zhang family was well versed in poetry and music and clever in painting, and Wang Meiren was known for her depictions of water scenes.[24] From another source we learn of the Buddhist images embroidered by a woman named Yang Lianhua.[25] For this period Tang Souyu also includes two romantic tales about women who painted self-portraits and sent them to absent men.[26]

The most unusual account of a Tang-dynasty woman artist does not concern a painter but rather a wood-carver named Yan. Miss Yan was a Buddhist adherent and the younger sister of a Buddhist monk. When she followed her brother to Hangzhou, she obtained a piece of sandalwood and carved a highly elaborate "Auspicious Lotus Mountain" with five hundred Lohans. This marvelous object was presented to the emperor, winning Miss Yan gold and silk as well as the title "Ingenious Lady."[27]

For the Five Dynasties period of the tenth century Tang Souyu cites five painters. Two lived during the Former Shu (907-925) in Sichuan. Jin Feishan, an empress, is simply said to have been good at painting, while Huang Chonggu is credited with excellence in the "Four Accomplishments": playing the *qin* (zither), *weiqi* (chess), calligraphy, and painting.[28] The Southern Tang (937-975), a period famous for its elegance and cultivation of things aesthetic, was graced by the presence of the remarkable Miss Geng at the palace in Nanjing. Painting, calligraphy, and poetry were among Miss Geng's more mundane pursuits. She was also a Daoist adept, well versed in alchemy and in conjuring ghosts and spirits.[29] A Miss Tong,

part of the same aristocratic Southern Tang world, studied with the court artist Wang Qihan and was especially skilled at painting religious figures. Gentry women, in particular, requested her works. Her picture *Six Recluses* is listed in the *Xuanhe huapu*, the catalogue of the Northern Song (960-1127) imperial collection.[30]

A well-known story from the Five Dynasties period concerns a Miss Li of Sichuan, who was taken by Guo Chongtao (d. 926) when his armies subjugated the area. Guo was a military official of the Later Tang (923-934), a northern dynasty not known for its cultural inclinations. The unhappy Miss Li was sitting alone in a garden pavilion one moonlit night when she noticed the dancing shadows cast by the bamboo and took up her writing brush to trace them on her paper window. This has been called the origin of ink bamboo, one of the most enduring forms of Chinese painting.[31]

Beginning with the Song dynasty (960-1279), the history of Chinese women painters becomes more substantial. Textual references to Song women painters, although less colorful than the accounts of previous periods, reflect the increasing popularity of painting as a refined pastime for the gentry and members of the court. The Northern Song (960-1127) palace collection included pieces by two imperial ladies. Cao Zhongwan, the wife of an imperial family member, was represented by five works: *The Peach Blossom Stream*, *Willow Bank*, *The Smartweed Embankment*, *Geese (Goose?) in the Snow*, and *Herding Sheep*. The critics maintained that she captured the beauty of the rivers and mountains and did not merely paint easy, attractive things to please women and children.[32] Miss Wang, wife of Prince Zhao Jun (late 11th c.), is recorded in the "Ink Bamboo" section of the *Xuanhe huapu*, the imperial painting catalogue. After thoroughly reporting her ideal feminine comportment and the enthusiasm with which she emulated the virtuous women of the past, the catalogue reviews her artistic talents. In calligraphy she practiced the seal and clerical scripts, obtaining the brush methods of the ancients. Her poetry was imbued with "the air of the forests and springs" (*linxia quanjian fengqi*). And she used light ink to sketch bamboo, producing works that looked as if the shadows on the plant had fallen on the silk. Her two works in the imperial collection are described as "sketched from life" (*xie sheng*) ink bamboo.[33]

During the twelfth and thirteenth centuries a number of imperial women established reputations as painters. Miss Zhu, who had the bad

luck to be married to the last Northern Song emperor, Qinzong (r. 1125-27), studied the colored landscapes of Mi Youren (1075-1151) and applied to her paintings a seal reading "Daoist of the Zhu Family."[34] Liu Xi, a concubine of the Southern Song emperor Gaozong (r. 1127-62), was known for her calligraphy, which included writing the imperial signature, and for her figure paintings following the methods of the ancients.[35] Of the artistic ladies of the Song imperial household, the wife of Emperor Ningzong (r. 1194-1224), Yang Meizi, is best known today. She is remembered primarily for her calligraphy, a number of examples of which survive, although later sources maintain that she also painted figures and flowers.[36] At the Jin-dynasty (1115-1234) court in the north, the wife of the art-loving Emperor Zhangzong (r. 1189-1208), a lady of the Li family, sketched plum blossoms.[37]

In the women's quarters of Song-dynasty gentry families, ladies employed the same painting styles and subjects as their male relations. The younger sister of Li Chang (1027-90) made excellent copies of paintings of pines, bamboo, trees, and rocks. Her nephew, the renowned calligrapher Huang Tingjian (1045-1105), wrote poems for her ink-bamboo studies and inscribed her picture *Bamboo, with Small Birds and Cicada*.[38] The third daughter of the master bamboo painter Wen Tong (1018-79) learned her father's methods and transmitted them to her son, Zhang Changsi.[39] And then there was the exemplary Miss Xie, who married into the Tan family. According to Zheng Xia (1041-1119), family affairs were her first concern, and not one escaped her notice. When these were settled, she turned to reading and examining ancient writings. Finally, in whatever time remained, she practiced her calligraphy and produced refined ink paintings.[40]

It is reported that the foremost female poets of the Song, Li Qingzhao (1084-c. 1151) and Zhu Shuzhen (12th c.), upon occasion turned their hands to painting. This is easy to believe of Li Qingzhao, since she is remembered not only for her poetry, but also for her passion for books and ancient works of art. Li is said to have written out and illustrated the Tang-dynasty poet Bai Juyi's "Song of the Lute Player," and Mo Shilong (16th c.) collected what was ostensibly her ink bamboo.[41] During the Southern Song a gentry woman surnamed Hu was compared to Li Qingzhao and praised for her writing, *qin* (zither) playing, skill at *weiqi,* and paintings of bamboo and plum blossoms.[42] Depictions of the same subjects were credited to Zhu Shuzhen by the Ming-dynasty painters Shen Zhou and Du Qiong.[43]

The history of plum-blossom painting also includes a certain Lady Bao, who was apparently a figure of some note. Her talent was recognized by the scholar and master of ink-flower painting Zhao Mengjian (1199-1264). In a poem explaining the important points of ink-plum painting, he wrote:

Monk Ding paints the flowers skillfully but the branches are roughly done, Liu Mengliang has good ideas but his technique is insufficient, yet among women there is Madame Bao, who has been able to preserve her master's method.[44]

Another Southern Song woman whose accomplishments are now known only through poetry was a lady of the Zhu family of Changzhou. Changzhou was the home of a regional school of plant-and-insect painting, often called the Piling School, which in later centuries counted many women in its ranks. Admiration for Miss Zhu's work was expressed in this thirteenth-century poem:

The plants and insects of Changzhou are a marvel,
But the young woman's style does not come from
 a teacher.
She is not like the clever workman transmitting the art
 of Lun Bian;
I suspect that in a former life she was [the master
 painter] Guo Xi.
The vitality of her brush is like that of life,
Adding such details as mosquitos with ceaseless change
 and motion.
Lightly, she applied a delicate yellow to make the
 butterflies;
Heavily, she colored the dragonflies crimson.[45]

A few Song courtesans attracted attention for their painting of literati subjects. Su Cui of Fujian expressed herself through ink sketches of bamboo, plum, and orchids, and an unnamed courtesan of Yanping in Fujian was known for her grass-script calligraphy and ink bamboo. One woman recorded only as the "Bamboo Sketching Courtesan" followed the tradition of Wen Tong.[46] We can assume that painters were also found among women who chose religious vocations. In fact, the well-known handscroll *Wang Zhaojun Leaving China* has long been regarded as the work of a Song-dynasty Daoist nun. However, the artist's inscription admits variant readings, and the date of this scroll has been the subject of considerable scholarly discussion.[47]

Women of the Jin-dynasty gentry joined their fathers and husbands in perpetuating Northern Song taste. Ahuan, the wife of Xie Yixiu, painted landscapes in the tradition of the tenth-century master Li Cheng and studied the bamboo-painting methods of Wang Tingyun of her own period.[48] The landscapes of a lady known simply as Xiu Yinjun (Elegant Retired Scholar) were appreciated by the famous

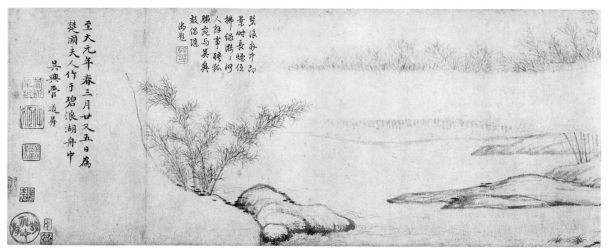

Figure a. Guan Daosheng, 1262-1319, *Bamboo Groves in Mist and Rain,* 1308. Collection of the National Palace Museum, Taiwan, Republic of China. (left section)

scholar Yuan Haowen (1190-1257) and others.[49] A female cousin of Yuan Haowen surnamed Zhang sketched ink bamboo, as did a Miss Jiang of Kaifeng, the widow of a man of the Wanyan clan; apparently both were active just after the fall of the Jin.[50]

Jin-dynasty emphasis on Song-derived landscape styles and ink bamboo set the stage for the major developments in scholar-amateur painting that took place during the Yuan dynasty (1279-1368). This period is represented in the exhibition by works in the tradition of Guan Daosheng (1262-1319; cat. nos. 1, 2), China's most famous woman calligrapher and painter. Guan excelled in all of the standard literati subjects, including figures, landscape, plum blossoms, and orchids, but she has received the most acclaim through the centuries for her studies of bamboo. She is credited with originating a distinctive manner of describing groves of young bamboo after rain (fig. a).

Guan's reputation was greater than has been been suggested by Western art historians, who have discussed her work primarily as a footnote to that of her husband, the celebrated scholar-painter Zhao Mengfu (1254-1322), and treated her as an art-historical anomaly, more remarkable as a woman than an artist. From their writings it might also be concluded that she was the only Yuan-dynasty woman to take up the brush. This was certainly not the case. Other notable women artists of the period include the daughter of the landscape painter Sheng Mou (active c. 1310-60) and Huang Zhigui, a member of a high-ranking official family. Sheng Mou's daughter, whose given name is not recorded, carried on his painting methods. Her artistic habits were described by Huang Yuanzhi: "When resting from needle-work in the daytime quiet of her room, she would return to the window to study and paint the mountains."[51] Huang Zhigui, a painter of

orchids, registered her thoroughly scholarly training and inclinations in an inscription for her now-lost *Nine Fields Picture*:

Mr. Shuangjing of my family compares the orchid to the perfect gentleman. My father, the venerable Dong Ye, is very fond of it. I am fond of it too. Whenever I have had time left over from my needlework I have sketched its likeness, intending only to provide amusement for the women's quarters, not in the hope of becoming famous.[52]

When women of the Ming (1368-1644) and Qing (1644-1912) periods turned to painting, then, they were hardly pioneers. They had for models such exemplary individuals as Wei Shuo and Guan Daosheng. Qing-dynasty women also greatly admired the late-Ming flower painter Wen Shu (1595-1634; cat. nos. 14-16). All three were women of the gentry, and each was connected in some fashion with a literati patriarch: Wei Shuo taught the master calligrapher Wang Xizhi; Guan Daosheng was married to Zhao Mengfu, a founding father of scholar-amateur painting; and Wen Shu was a descendant of Wen Zhengming (1470-1559), one of the most influential scholar-painters of the Ming period. If we add to this line-up the Song-dynasty poet and connoisseur Li Qingzhao, whose father was a friend of the scholar, poet, and painter Su Shi (1037-1101), and take into account the popularity of ink painting among Song ladies, it becomes evident that the history of Chinese women artists closely paralleled the development of the male scholar-amateur tradition as described in Ming- and Qing-dynasty texts and in most modern surveys of Chinese painting. Rooted in the calligraphy of the pre-Tang period, both took shape in the Song, brought forth their greatest exponents in the Yuan, and blossomed vigorously throughout the Ming and Qing dynasties.

Women's traditions were acknowledged in various ways in Ming and Qing writings. The

Figure a. Guan Daosheng, 1262-1319, *Bamboo Groves in Mist and Rain,* 1308. Collection of the National Palace Museum, Taiwan, Republic of China. (right section)

seventeenth-century scholar Xu Qin placed a Ming woman painter in history by citing the works of Li Chang's younger sister, Wen Tong's daughter, and Guan Daosheng as other examples of female excellence in art.[53] Talented women were frequently compared to Wei Shuo, Li Qingzhao, Guan Daosheng, and Wen Shu, and they often referred to these forebears in their inscriptions and seals, just as their fathers and husbands invoked the names of Wang Xizhi, Su Shi, Zhao Mengfu, and Wen Zhengming. Women also collected calligraphy, poetry, and paintings by their female predecessors. The seventeenth-century poet, calligrapher, and painter Xu Fan, for instance, gathered works by eight illustrious individuals including Wei Shuo and Guan Daosheng, in a scroll entitled *Xianggui xiuhan* (Elegant Writings of the Women's Apartments).[54]

Women Painters and the Textile Arts

Chinese painting has always been closely connected to works of art in other media.[55] For textile and ceramic designers, as well as for carvers of wood, bamboo, jade, and ivory, painting provided a rich reservoir of subjects and compositions. Decorative outline-and-color designs, with flowers, birds, figures, and architecture, to cite the most common examples, were easily adapted to embroidery and porcelain surfaces. The literati did not attach the same value to this sort of art as they did to the expressive paintings of the amateur tradition, but they appreciated its beauty and the skill it required. In their homes scrolls of flowers and plants were changed in accordance with the seasons, and symbolic pictures were displayed for annual festivals, birthdays, and other special events. The auspicious motifs employed in these works were then echoed throughout the household on furnishings, ceramics, bedding, and clothing.

Since the home was their world, women were naturally intimately involved with these decorative arts, especially textiles and textile ornamentation. Needlework was the premier feminine art, one measure of a woman's worth. Through embroidery women trained their hands and eyes, became attentive to the smallest details, refined their color sense, and mastered a large repertoire of motifs and compositional formulas. This experience proved useful when they turned to painting, and we no doubt see it reflected in many of the flower-and-bird compositions in the exhibition.

Conversely, the study of paintings contributed to women's development as fabric artists. This is evident, for instance, in the textile designs of Zhu Kerou (Zhu Qiang) of the Song dynasty and Han Ximeng of the Ming, both of whom were also painters. Zhu, who was active in the middle of the twelfth century, became famous for her *kesi* (silk tapestry) depictions of flowers, birds, figures, rocks, and trees.[56] Two fine examples resembling painted album leaves, complete with the artist's seal, are now in the Liaoning Provincial Museum.[57] Both are on blue grounds; one presents a branch of camellia and a butterfly, while the other is devoted to a single peony blossom.

Zhu Kerou's works were treasured in her own time, and later collectors acquired them as they did paintings. The two Liaoning leaves are both recorded, along with anonymous Song *kesi* and embroidered pictures, in the painting section of the catalogue of the distinguished eighteenth-century collector An Qi.[58] The camellia leaf is marked with the seal of the connoisseur Bian Yongyu (1645-1712), and the inscription on the facing leaf, which provides information about Zhu, was written by Wen Congjian (1547-1648), the father of Wen Shu.[59]

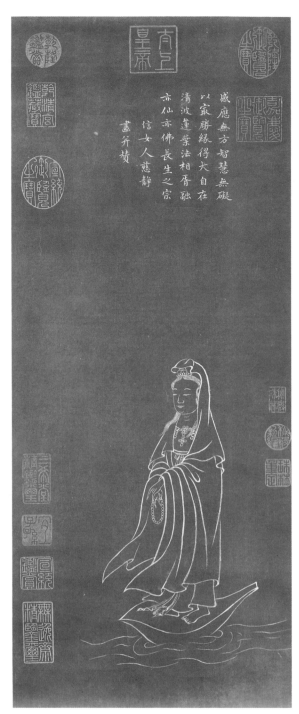

感應無方智慧無礙
以寂勝緣得大自在
清波蓮葉法相胥融
亦仙亦佛長生之宗
信女人慈靜
畫并贊

Figure b. Xing Cijing, 16th-17th century, *Guanyin*. Collection of the National Palace Museum, Taiwan, Republic of China.

The peony leaf became part of the Qing imperial collection and bears four imperial seals.[60]

Embroidered reproductions of paintings were also popular in the Song dynasty. Emperor Huizong (r. 1101-25) set up a special department to produce them in distinct subject categories: landscape, towers and pavilions, figures, and flowers and birds.[61] Dong Qichang, the great Ming-dynasty painter, connoisseur, and champion of the literati painting tradition, enthused over the Song embroideries in his collection:

The needlework of Song embroidery is fine and tight, using only one or two strands of floss and needles as thin as hair. The application of color is exquisite and

delicate, with a brilliance that dazzles the eye. The landscapes distinguish far and near; the towers and pavilions obtain a real existence in space; the human figures all give the feeling of life-like movement seen from afar; and the flowers and birds have an extremely mild, animated [?] air. The best examples are superior to painting.[62]

In Dong Qichang's own period, Han Ximeng, the wife of Dong's student Gu Shouqian, and the women with whom Han lived in the Gu family's famous Dew Fragrance Garden in Shanghai were renowned for their needle skills.[63] They approached embroidery as members of her husband's social circle did painting, by looking to the ancients and copying famous works of the Song and Yuan dynasties. About an exquisite album of flowers, birds, and insects by his wife, Gu Shouqian wrote:

In the spring of *jiaxu* [1634] she investigated famous masterpieces of the Song and Yuan, copying eight examples. One by one the embroideries were completed and collected to make a square album. All who saw it were struck dumb and waved their hands in admiration.... The Chief Minister of the Court of Imperial Sacrifices [Dong Qichang] saw and deeply appreciated it, and asked me how her skill reached this point. I was unable to respond, [but] respectfully replied: "In the sharp cold of winter, steamy heat of summer, windy darkness or rainy gloom, [she] does not dare to undertake it, [but] often when the sky is clear, the sun unclouded, the birds happy and the flowers fragrant, she absorbs the vitality of life before her eyes and stitches [it] into fine silk from Suzhou." The master's wonder increased, [and he] regarded [her work] as beyond human capability.[64]

Many more embroiderers might be cited. The collector Zhu Qiqian recorded approximately one hundred individuals in the embroidery chapter of his *Nügong zhuan zhenglue* (Biographical Sketches of Needleworkers).[65] However, just a few additional examples should suffice to underscore the importance of the connections between this art and the history of women painters.

Xing Cijing, the younger sister of the famous calligrapher Xing Tong (1551-1612), excelled in calligraphy, poetry, and painting as well as embroidery.[66] As a painter she was particularly good at bamboo, rocks, and *baimiao* (fine ink-outline) religious figures in the manner of Guan Daosheng. Her depiction of the (Bodhisattva) *Guanyin* in gold on a dark ground (fig. b) probably resembles the delicately embroidered Buddhist images for which she was well known. The Qing-dynasty poet Yun Zhu (1771-1833), who followed her aunt Yun Bing (cat. nos. 39-44) in painting, was recognized for her stitched versions of such subjects as "The Five Pines" and "The Eastern Garden."[67] Also during the Qing, Zhao Huijun embroidered landscapes and figures that looked

like paintings, and Qian Peiyu, a talented painter, "put forth new ideas" in her needlework images of birds, flowers, and "cut branches"; copied ancient paintings; and embroidered lines of poetry.[68]

For women, then, embroidery was a refined art at home in the company of the "three perfections." The Qing lady Qian Fen of Wujin (Changzhou) once painted a *River Village Picture* based on the scenery of her residence and inscribed a poem on it. She then embroidered it on a piece of silk. The poetry, calligraphy, drawing, and embroidery were apparently all beautiful, and those who saw them praised them as "four perfections."[69]

Subject Matter in
Paintings by Women

As the preceding discussion indicates, all of the standard subject categories of Chinese art—figures, landscapes, architecture, flowers and plants, birds and animals—were accessible to female artists. None of the themes employed by men was thought to be unsuitable or too demanding for women. On the whole, they did not have problems comparable to those confronted by Western women painters, who worked in artistic environments dominated by representations of the human figure while subjected to social restrictions that impeded their acquisition of the training necessary to excel in this challenging subject.

Figure painting had become a secondary genre by the time Chinese women began to paint in appreciable numbers. After the rise of landscape painting during the Song dynasty (960-1279), fine depictions of historical scenes, religious subjects, and beautiful women continued to be produced, but the majority of the leading male artists built their reputations on mountain-and-river views. These scenes included travelers, fishermen, and other stock characters, but often they were sketched in abbreviated, perfunctory ways. Artists were not expected to demonstrate great expertise in figure drawing unless they specialized in it. As far as the connoisseurs were concerned, technically challenging or physically demanding undertakings, such as imperial portraits or temple wall paintings, were the province of professional masters. Women did not invite criticism, then, if they drew figures amateurishly or chose not to draw them at all.

Those who did take up figure painting were fortunate in not having to deal with the nude. Except in erotica, figures in traditional Chinese paintings are invariably clothed and usually heavily draped. Women learned to draw them, as men did, by studying instruction manuals, model books, and old paintings. Many also relied on family traditions. Miss Qiu (cat. no. 3) and Ren Xia (cat. nos. 77-79) learned the techniques of their fathers, and the style of Yu Ling (cat. nos. 64, 65) resembles that of her husband Su Liupeng. Until the early twentieth century, when Chinese artists working in Western modes began to draw from nude models, the question of participation in life-drawing classes simply did not arise.

In figure painting women favored female subjects and religious themes. They were especially drawn to the Bodhisattva Guanyin, a protector of women, and produced images of this Buddhist deity in great quantities, often as acts of devotion. A survey of such works would reveal considerable stylistic and iconographic diversity. It would display, for example, a range of brush styles, from boldly modulated to extremely delicate, as suggested by the contrast between Xu Can's ink rendering of *Guanyin Crossing the Sea* (fig. c — see *Photographic Appendix*) and Miss Qiu's finely drawn representations of the deity in gold (cat. no. 3).

It might be assumed that landscape was for Chinese women what the nude was for women in the West, a subject highly valued yet rendered inaccessible by the rules of society. However, this was only true to a limited extent. Bound feet ruled out mountain climbing, and mansion walls that protected virtue also shut off views of the countryside. Still, many women were quite mobile and well informed about the outside world. Mobility, of course, varied with social status. Courtesans were not as restricted as gentry women and seem to have been able to move around as their financial circumstances permitted. In theory, gentry women had no business beyond the women's quarters, but even here some variation in practice was admitted. Older women, for instance, had more freedom than girls, who were kept out of the sight of men not members of their immediate family. Situations also arose permitting or requiring women, regardless of age, to travel. Journeys were necessitated by changes in family fortunes, perhaps precipitated by social upheavals or the collapse of a dynasty. In times of peace women sometimes accompanied fathers, husbands, and sons to their official posts outside their home districts. From sedan chairs and boats, the same modes of transportation used by traveling gentlemen, they then saw a good deal of China.

Fictional and factual accounts of such travels were set down by Ming and Qing writers. *The Story of the Stone* introduces a female character who had traveled so extensively that she could compose a series of poems about the famous places she had seen. She boasted:

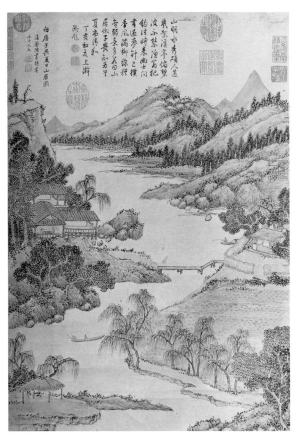

Figure e. Chen Shu, 1660-1736, *Dwelling in the Mountains in Summer, after Tang Yin*, 1734. Collection of the National Palace Museum, Taiwan, Republic of China.

I've been visiting places of historical interest ever since I was little . . . so I really have seen quite a lot. What I've done now is to choose ten of them, mostly associated with some famous person or another, and make up a poem about each one.[70]

According to Mao Xiang and others, Dong Bai (cat. no. 22) enjoyed the scenery of Suzhou, Hangzhou, and other beautiful spots before becoming Mao's concubine. She was later forced to take to the road when the disturbances that accompanied the fall of the Ming temporarily drove Mao and his family out of their native Rugao. The poet-painters Huang Yuanjie, Xiang Pei, and Wu Shan also encountered difficulties at the end of the Ming, and their biographies tell of their moves from place to place in the lower Yangzi region.[71] The early-Qing painter Chen Shu (cat. nos. 36, 37) traveled a fair amount under peaceful conditions, twice leaving her home in Zhejiang to join her son at his post in Beijing. Tang Souyu recorded a painting that Chen did while aboard a boat on Lake Gan in Zhejiang.[72]

Firsthand experiences with nature, however, were not required for landscape painting. Even thoroughly sedentary women could learn to draw streams and mountains the way Ming- and Qing-dynasty men often did, by imitating the methods of "the ancients" transmitted in paintings and illustrated texts such as the *Mus-*

tard Seed Garden Manual of Painting. Freed from representational concerns, they used old compositional formulas and brush methods as vehicles for self-expression. In choosing to describe rocks and trees in particular old "manners," they registered their views on painting history and proclaimed their spiritual affinity with certain of their predecessors and contemporaries. Chen Shu not only sketched the scenic waterways of her native region, but also executed ambitious landscapes in the style of the Yuan master Wang Meng (c. 1308-85), thereby aligning herself with the orthodox artists of her day.

Regrettably, the landscapists, like the figure painters, receive less than their due in this exhibition. The surviving landscape paintings of Huang Yuanjie (fig. d — see *Photographic Appendix*), Jin Yue, and Chen Shu (fig. e) were either unobtainable or could not be located, while the available works by Liu Shi (cat. no. 23), Lin Xue (cat. nos. 18-20), and Zhu Meiyao (cat. no. 66) are small in scale and represent only aspects of their makers' oeuvres. The handsome fans by Lin Xue leave little doubt about her brush mastery and knowledge of old styles, but they do not convey the range of capability indicated by the hanging scrolls that bear her name (fig. f). The contrast between Liu Shi's album leaves (cat. no. 23) and her handscroll of 1643, *Willows on a Moonlit Embankment*, (fig. g — see *Photographic Appendix*) is less dramatic, but the latter must be taken into account in assessing her accomplishments.

Flowers, plants, birds, and insects dominate the exhibition, and in some respects this emphasis is appropriate. Chinese women genuinely loved flowers and apparently accepted the whole package of girl-and-flower associations perpetuated by centuries of poems, stories, and legends, not to mention female names. This conditioning undoubtedly led some women to specialize in flower painting. It will be unfortunate, however, if the disproportionate representation of flower paintings reinforces stereotyped notions about women's "natural" preference for this genre and for the delicate, meticulous painting methods it often entailed.

By and large, Chinese women painted flowers and plants for the same reasons men did, including consumer demand. In many cases they took up this subject matter because it was the specialty of their family or school. For example, Yun Bing (cat. nos. 39-44) and Ma Quan (cat. nos. 45-50), two famous and prolific flower painters of the eighteenth century, were not following feminine inclination but precedents set by male relatives, Yun Shouping

(1633-90) and Ma Yuanyu (1669-1722), respectively.

Although traditionally flower-and-plant painting ranked below landscape in the Chinese hierarchy of genres, it was enormously popular, especially during the Qing dynasty. The old Piling school was revitalized by the brilliance of Yun Shouping. The Yangzhou masters animated plants of all sorts, from ethereal plum blossoms to everyday garden vegetables. Flower specialists were in great demand at the court. Nevertheless, modern scholars, absorbed in the study of landscape painting, have had relatively little time for flowers. Most previous Chinese painting exhibitions have therefore looked very different from this one, so different that it is tempting to identify the contrast as one of masculine versus feminine. But again, appearances are misleading. It would not take much effort to put together a collection of representative works by prominent Ming and Qing male artists—Chen Chun, Lu Zhi, Wang Guxiang, Zhou Zhimian, Xiang Shengmo, Wang Wu, Yun Shouping, Ma Yuanyu, Jiang Tingxi, Zou Yigui, Qian Weicheng—that would bear a striking resemblance to the group of paintings assembled here.

*The Critical
Reception
of Paintings
by Women*

Observing that women painters were mostly hidden and unknown, the Ming scholar Wang Keyu (b. 1587) mentioned two, Bu Yunhui and Jin Shuxiu, who in his view possessed "the air of the forest" (*linxia feng*), meaning an elegant aloofness from the world.[73] This phrase and variations of it were commonly used to praise women. However, as Wang indicated, gentry wives and daughters who adhered strictly to this ideal could not easily make their achievements known. Many, of course, had no wish to do so, preferring to paint only for their own amusement, but those who hoped for a degree of recognition had to rely on female networks and assistance from their male relatives. The role played by the former should not be underestimated. Records of poems, paintings, and visits exchanged by women are abundant, and women often sought works by members of their own sex. It is said, for example, that women of the *San Wu* (three lower-Yangzi areas) "struggled to buy" the Yuan-style landscapes of Jin Shuxiu.[74] Still, it was primarily through the offices of fathers, husbands, and male family friends that gentry women became famous enough to win places in compilations such as the *Yutai huashi*, where,

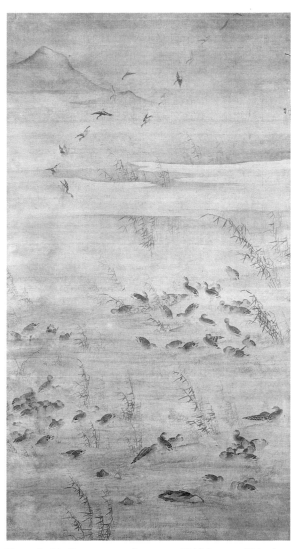

Figure f. Lin Xue, active 17th century, *Wild Geese and Marsh.* Freer Gallery of Art, Smithsonian Institution, Washington D.C.

it should be noted, they far outnumber the courtesan-painters. Their majority was probably even greater than this text suggests. It was easier for the courtesans, at least the most beautiful and talented, to gain recognition because they regularly socialized with literary men, who delighted in extolling their accomplishments.

Whether the painter was a courtesan or a lady, it usually took the intervention of at least one influential man to make her work known beyond her locale and lifetime. This is well illustrated by the case of Chen Shu (cat. nos. 36, 37). While her paintings were much appreciated within her husband's family and immediate social circle, her lasting fame resulted from the efforts of her son Qian Chenqun and her pupil Zhang Geng. The former, an eminent official, repeatedly presented his mother's paintings to the Qianlong emperor. Consequently, Chen Shu's works are more numerous than any other woman's in the Qing court collection preserved in the National Palace Museum. Zhang Geng included Chen's biography in his *Guochao huazheng lu*, a standard source of infor-

mation about early Qing painting. A more modest, and therefore more typical, case is that of the Shandong lady Fan Daokun, whose place in painting history was secured in 1599 when Dong Qichang wrote a note in reponse to one of her albums.[75]

In writing about women painters, critics and historians used some of the same conventions they did when discussing men: they were child prodigies; they excelled at family styles; their works resembled and sometimes surpassed those of great masters; they were reincarnations of a particular old master; their brushwork was strong or forceful; their works were of the "marvelous" or even the "untrammeled" class; and, occasionally, they opened new paths. Women also came in for the same types of criticism applied to men. For instance, Fu Derong's (cat. no. 32) figure paintings were judged skillful, but tainted with a slight professional air.[76]

Mixed with these fairly routine observations are others that are gender specific. Sometimes standard formulas were simply modified. Thus, rather than just comparing Miss Qiu (cat. no. 3) to the Song-dynasty figure painter Li Gonglin, Qian Daxin (1728-1804) called her a "Li Gonglin among women."[77] Most common, however, are the comments that grew out of the literati belief that painters reveal themselves in their art. As a man registers his uprightness and strength of character in his brushwork, so a woman was thought to imbue her painting with feminine purity, refinement, and modesty. The terms "elegant," "refined," "pure," and "chaste" are regularly encountered in descriptions of women's works and styles. From here it was only a short step to the arguable notion that a feminine hand can be recognized as such or, as Wang Wenzhi (1730-1802) put it in describing a work by Wen Shu, "One look and you know it is a woman's brush."[78] Wang meant this as high praise, and went on to assert that the quality of Wen's work is so special that it cannot be duplicated by a man, not even by an old master steeped in the principles of painting. Her artistic descendants could only be women, such as his student Luo Qilan (cat. no. 52) or granddaughter Wang Yuyan (cat. no. 53).[79]

Yet another approach was the qualified or backhanded compliment, such as commending an individual for avoiding the faults "typical of women painters." Qin Zuyong introduced Chen Shu with this note: "Women's use of the brush and ink is either stiff or weak, [but] Nanlou laoren's [Chen Shu] is almost right."[80] A courtesan surnamed Lin received a similar compliment: "[Her] brush strength is not the best, but for a woman it is remarkable."[81]

Statements of this sort, in conjunction with the traditional Chinese practice of presenting women in separate sections or at the ends of biographical compilations, probably encouraged modern Western scholars to slight Chinese women painters. Even though many were routinely recorded by Chinese art historians and sincerely praised by Chinese critics, they have usually been overlooked or discussed in more or less pejorative ways in Chinese painting histories by Western authors. Herbert Giles's *An Introduction to the History of Chinese Pictorial Art* (1905), one of the earliest English-language surveys of Chinese painting, is a noteworthy exception. Tellingly, it was taken very directly from Chinese sources and includes representative citations of women artists through the Ming dynasty.

Osvald Sirén still recognized a few women artists in his *Chinese Painting: Leading Masters and Principles*, published between 1956 and 1958, but his tendency to disparage their accomplishments may well have dissuaded later scholars from taking them seriously. In his chapters on the Ming and Qing dynasties, for instance, he found only the courtesan-painters interesting enough to consider at any length, and marveled that one of them, Xue Susu (cat. nos. 10-13) produced "a masterpiece of a kind that would hardly be expected from a woman painter" (cat. no. 10).[82] Ming and Qing gentry women with equal reputations but more boring biographies were dismissed in a few sentences, if they were mentioned at all. Sirén says of Wen Shu (cat. nos. 14-16): "She painted mainly flowers and insects in a kind of *hsieh-i* [*xieyi*] manner with slight individual expression."[83] At another point he elaborates:

A feminine aspect of this kind of academic flower-painting was continued by Chao Wen-shu [Wen Shu] *tzu* Tuan-jung [Duanrong], the daughter of Wen Tsung-chien [Wen Congjian] (the great-grandson of Wen Cheng-ming [Wen Zhengming]). She possessed excellent technical skill, as may be seen in her small flower paintings in the Ku-kung [Imperial Palace] collection, but would hardly be recorded as a creative artist if it were not that she did her best to carry on a highly venerated family tradition.[84]

Sirén did not reproduce any of Wen Shu's works, although many are equal in quality to the flower paintings by men that he did find worthy of inclusion.

The one "proper" lady Sirén judged worthy of serious consideration was Guan Daosheng (cat. nos. 1, 2) of the Yuan period, but he belittled even her paintings as "minor," "done with love," and possessing "the graceful charm of a woman's brush."[85] It is no wonder that subsequent writers did not find her interesting

enough to mention in their volumes devoted to Yuan-dynasty art.

Only a few scholarly articles concerning Chinese women artists have appeared in English. (See the Select Bibliography.) Most focus on paintings in the collections with which the authors are affiliated, and one also reflects contemporary political efforts in China to give women greater recognition. Presented in diverse publications and at wide intervals, these pieces, though useful, have not compensated for judgements such as Sirén's or for the scarcity of references to women's achievements in surveys and other major studies of Chinese painting.

The reasons for the neglect of Chinese women painters by Western scholars are to be found primarily in Western patterns of scholarship. Western scholars were not accustomed to seeing the women in their own art history, so they did not look for them in China's either. The situation was not helped by the images of oppressed and ignorant Chinese women transmitted to the West by the writings of missionaries, travelers' diaries, and accounts of "things Oriental." Another problem was that many Chinese women painters specialized in flowers, a category of subject matter more esteemed in China than in the West. Finally, most of the known Chinese women painters were active in the late-Ming and Qing dynasties, which Western scholars initially considered artistically stagnant or decadent, hence unworthy of serious consideration. This notion has long since been discredited, but it delayed our studies of the wealth of material handed down from this relatively accessible period. Consequently, the Ming and Qing painters awaiting rediscovery are by no means all women.

Why Investigate
the History of
Chinese Women
Painters?

If women painters were a minority in Chinese art history, and none attained the stature of the "great masters," why should we take issue with the way they have been treated by Western scholars? Why should we include female artists in our considerations of Chinese painting?

We should object to the treatment given Chinese women artists in our texts because, to a considerable extent, it is the product of a value system derived from a narrow view of art history as a succession of "great" moments in certain media and certain genres. The impact of this system on the history of women artists in the West has been the subject of significant scholarly inquiry in recent years. Review of the theoretical and methodological findings of our colleagues engaged in writing the history of Western women artists would take us too far from the subject at hand, but it must be acknowledged that without their work — without the legitimacy and direction they have given to the study of women in the arts — the present exhibition would scarcely have been possible.[86]

The female artists of China, like their counterparts in Europe and America, deserve our attention because they created beautiful objects and were an integral part of their country's art history. Separation of male and female spheres of activity within Chinese society prompted women to recognize artistic lineages of their own, but this did not mean that they were isolated from or ignorant of broader currents. They associated with male artists, scholars, and connoisseurs, participated in major schools and stylistic trends, won the praise of their contemporaries, taught others, and left behind works treasured by later generations. The retrieval of each one brings us closer to a complete picture of painting in premodern China.

Completing this picture in all of its diversity, however, involves more than fitting unfamiliar pieces into a familiar frame. The frame itself has to change to accommodate them. Appreciation of the contributions of women artists requires reassessment of accepted methods and concerns. To date, our approaches to Chinese painting have been based almost exclusively on the roles of men, usually scholars, in the Confucian social order. These men were similarly educated, and, if not personally inclined to travel, had close connections with individuals who traveled extensively. They sat for provincial and imperial examinations and participated in a bureaucratic system that sent them to posts all over the country. These experiences linked them to intellectual networks that operated on a national level, skimming across the top of Chinese society. This is reflected in Chinese painting studies that have adopted a bird's-eye view and followed prominent scholar-painters through a maze of high-level social, political, and artistic connections. The spotlight has been kept on a surprisingly small number of artists identified by the Chinese critics as the elite; often they have been packaged in groups such as the so-called Six Orthodox Masters of the Early Qing and the Eight Eccentric Masters of Yangzhou.

Against this background, women painters can only be seen as tangential. Except for the Empress Dowager Cixi (cat. nos. 70-73) and a few other imperial ladies, women did not function in the national arena. Many were well educated, but they did not prepare for or take the

examinations. Consequently they did not have the personal connections that resulted from these experiences and from holding office. Though they traveled, few were free to roam the countryside or able to make far-flung friends. Most spent their days serving their families at home. It is with the family and the home, then, that the study of women painters must begin. As men have led us through the upper political and intellectual reaches of Confucian society, women can lead us into the heart of its fundamental institutions.

Cross sections of painting history from these two vantage points are quite different. Consider, for example, the cases of Yun Shouping (1633-90) and Yun Bing (cat. nos. 39-44). Studies of Yun Shouping have emphasized the hardships he faced as a Ming loyalist and his unwillingness to compromise his scholarly values although he was forced to paint for a living. They place him among the Six Orthodox Masters of the Early Qing and connect his ideas and practices to those of another of the Six, his close friend Wang Hui (1632-1717). Wang Hui and the other four men included in this group all specialized in landscape painting. Taking this fact and the prestige of the landscape tradition into account, Western scholars have often paid as much attention to Yun Shouping's landscapes as to his flower paintings, even though he displayed his real genius in the latter genre.

Yun Bing was a female descendant of Yun Shouping and followed him in flower painting. Within the existing scheme of Chinese art history, there is really little else to say about her. She and her works appear to be a dead end, until we look beyond landscape lineages and below the upper strata of art-historical connections. Yun Bing was a member of one of China's great painting families, yet we seldom hear

about any of her relatives other than Yun Shouping. The importance of painting as a Yun family enterprise becomes evident when we begin to reconstruct the social environment that permitted Yun Bing to become an artist. More than forty artists surnamed Yun from Wujin (Changzhou) established reputations adequate to secure them places in the written record; twelve were women, and two were Yun Bing's sisters. This flower-painting clan was also closely connected to others. One Yun woman married the famous flower painter Zou Yiqui (1686-1772), and a fascinating web of artistic relationships was woven by the men and women of the Yun, Ma (cat. nos. 45-50) and Jiang (cat. no. 38) families.

More broadly, biographies of women artists provide insights into the circumstances of art production and the use of painting in Chinese gentry society. Reports of women executing scrolls for their husbands' visitors, serving as "substitute brushes" for more famous individuals, and employing "substitute brushes" themselves in order to satisfy large clienteles — examples of which are found in the catalogue entries — indicate, among other things, the extent to which painting served as a form of social currency, a medium of exchange used to secure tangible and intangible rewards in literati circles.

By now the observation that the study of women offers new perspectives on familiar material may be a cliché; nevertheless, it remains true. It is our hope that this exhibition will not only modify existing notions about premodern Chinese women by demonstrating their creative capabilities, but also expand the context within which all Chinese painting is discussed.

1. It was also said that among those who bought Dong's works, many actually obtained pictures painted in the women's apartments. Herbert A. Giles, *An Introduction to the History of Chinese Pictorial Art* (Shanghai: Kelley and Walsh, Ltd., 1905), p. 166.

2. Yu, p. 1448.

3. Ibid., p. 7.

4. Ibid., pp. 679, 185.

5. Mao Xiang, *Yingmei an yiyu*, trans. Pan Tze-yen as *The Reminiscences of Tung Hsiao-wan* (Shanghai: The Commercial Press, Ltd., 1931).

6. Cao Xueqin, *The Story of the Stone*, trans. David Hawkes (Harmondsworth: Penguin Books, 1977), p. 292. The work is also known as *The Dream of the Red Chamber*.

7. Ibid., p. 282.

8. Ibid., p. 280.

9. Ibid., p. 337.

10. Mary Backus Rankin, "The Emergence of Women at the End of the Ch'ing: The Case of Ch'iu Chin," in *Women in Chinese Society*, ed. Margery Wolf and Roxane Witke (Stanford: Stanford University Press, 1975), p. 41; Paul S. Ropp, "The Seeds of Change: Reflections on the Condition of Women in the Early and Mid Ch'ing," *Signs* 2:1 (Autumn 1976):9-11.

11. See also the entry for Zhang Yunzi, Yu, pp. 810-11, for a list of participants in a Suzhou poetry society.

12. *ECCP*, pp. 440-41; Ropp, p. 9.

13. Herbert A. Giles, *A History of Chinese Literature* (New York: D. Appleton and Company, 1929), p. 393-94.

14. For a concise history of women's handbooks, see Tianchi Martin-Liao, "Traditional Handbooks of Women's Education," in *Women and Literature in China*, ed. Anna Gerstlacher, et al. (Bochum, 1985), pp. 165-89.

15. Joanna F. Handlin, "Lü K'un's New Audience: The Influence of Women's Literacy on Sixteenth-Century Thought," in Wolfe and Witke, pp. 13-38.

16. Ibid., p. 38.

17. Cao Xueqin, 2:333, 334.

18. Qian Chenjun, *Xiangshu zhai wenji*, in *Xiangshu zhai quanji* (1885 edition), 26: 6a-22a.

19. *ECCP*, p. 822

20. Li E, *Yutai shushi*, in *Meishu congshu*, 4:3.

21. *YTHS*, 1:1.

22. Li E, pp. 42-47.

23. *YTHS*, 1:2.

24. Ibid., 2:10.

25. Yu, p. 1198.

26. YTHS, 2:9; 5:69.

27. Yu, p. 1516.

28. YTHS, 1:2; 2:12.

29. Ibid., 1:2-3.

30. Ibid., 2:11; *Xuanhe huapu* (Taipei: Commercial Press, 1971), 6:183-84.

31. YTHS, 2:11.

32. Ibid., 1:3-5; *Xuanhe huapu*, 16:457-58.

33. YTHS, 1:3; *Xuanhe huapu*, 20:572-73.

34. YTHS, 1:5.

35. Ibid., 1:5-6.

36. Ibid., 1:6; see also Chiang Chao-shen, "The Identity of Yang Mei-tzu and the Paintings of Ma Yüan," *National Palace Museum Bulletin* II: 2 (May 1967):1-14; 3 (July 1967):9-14.

37. YTHS, 1:7.

38. Ibid., 2:13-14; Yu, p. 350.

39. YTHS, 2:15.

40. Ibid., 2:16.

41. Ibid., 2:16. For background on Li Qingzhao's life and social circumstances, see Chung Ling, "Li Qingzhao: the Moulding of Her Spirit and Personality," in Gerstlacher, pp. 141-64.

42. Zhou Mi (1232-1308), *Qidong yeyu*, cited in YTHS, 2:16-17.

43. YTHS, 2:18.

44. Adapted from Maggie Bickford, et al., *Bones of Jade, Soul of Ice: The Flowering Plum in Chinese Art* (New Haven: Yale University Art Gallery, 1985), p. 254.

45. Jiang Zhongzhen (early 13th c.) cited in YTHS, 2:16. The same (?) poem is credited to Yang Wanli; see Saehyang P. Chung, "An Introduction to the Changzhou School of Painting," I, *Oriental Art*, n.s. 31:2 (Summer 1985):149.

46. YTHS, 5:69-70.

47. Elizabeth Brotherton investigated the problem of the Gong Suran scroll for this catalogue. She reports: "Zhenyang Gong Suran hua," the signature on the Osaka handscroll *Wang Zhaojun Leaving China (Mingji chusai tujuan)*, is our only known premodern reference to the scroll's painter. In its commonly accepted reading, the signature translates "Painted by Gong Suran of Zhenyang." However, identification of Gong Suran as a Daoist nun appears to rest upon a variant reading which joins the character *gong* with the two preceding ones, yielding "Painted by Suran of Zhenyang Temple." The painter and collector Yan Shiqing (1873-1929), who first documented the scroll and sold it in Japan sometime in the 1920s, followed this variant reading to conclude that the painter "Suran" was a woman as well as a member of the Daoist clergy (see Guo Moruo, "Tan Zhang Yu de 'Wenji guiHan tu'," *Wenwu* [1964] 7:5; and Naito Tora, comp., *Soraikan kinsho* [Sumiyoshi, 1930-39] I/1, no. 14). That this identification has never been questioned — on the contrary, it has been repeated in all discussions of the scroll, even though its basis, the signature's variant reading, has been universally rejected — indicates that more basic questions about the painting, most notably its dating, have yet to be resolved. Its present and recent owners have judged it to be a work of the late Northern Song period (960-1127) because it bears a Southern Song (1127-1279) seal. Others, however, date it to the Jin dynasty (1115-1234) or later when they compare it to a handscroll that appears to be its model, Zhang Yu's (fl. early thirteenth century) *Cai Yan Returning to China (Wenji gui Han tujuan)* in the Jilin Provincial Museum. (It is generally agreed that the *pipa*-bearing servant in the Osaka scroll identifies the subject as Wang Zhaojun on her way out of China, rather than Cai Yan returning from her long sojourn with the Huns.) The writers of a 1961 Tokyo National Museum exhibition catalogue *Chugoku sogen bijutsu mokuroku* were probably aware of the Zhang Yu scroll when they listed Gong Suran's painting as a Yuan-dynasty (1260-1368) work; see Luo Tan (Thomas Lawton), "Jiuti xinding," *Gugong jikan* (National Palace Museum Quarterly) 11:1 (Fall 1976):12. More recently, Suzuki Kei (*Chugoku kaigashi*, II:1 [Tokyo: Yoshikawa Kobunkan, 1984], p. 250) has determined that the painting is "Yuan or later," but is unwilling to go as far as Guo Moruo. Guo argues for pushing its date up to the early Qing (1644-1911) and even accuses the

scroll's first known owner, Liang Qingbiao (1620-91) of slyly affixing its Southern Song seal, which is said to be authentic. Chinese writers discussing the scroll subsequent to Guo's article have focused on identifying the authors of the three undated colophons. In the midst of the resulting disagreement and uncertainty, Gong Suran's identity as a Daoist nun seems to have offered a welcome constant, and probably cannot be disproven in any case. It may even have played a role in the continued acceptance of the scroll as an early work, since the artist's low social status might explain its lack of historical documentation.

48. YTHS, 2:19.

49. Ibid., 2:19-20.

50. Ibid., 2:23-24; Yu, p. 814 (Zhang), p. 1358 (Jiang). These women are listed as Yuan in these sources, but they lived in the Jin-Yuan transition period.

51. YTHS, 2:25.

52. Ibid., 2:22 (under Li Furen).

53. MHL, 5:71.

54. Yu Shangling, et al., *Jiaxing fuzhi* (1840), 51:*xia*.

55. For discussions of connections between painting and works in other media, including ceramics and *kesi*, see *Chinese Painting and the Decorative Style*, ed. Margaret Medley, *Colloquies in Art & Archaeology in Asia No. 5* (London: Percival David Foundation of Chinese Art, 1975).

56. Yu, p. 214.

57. *Song Ming Zhixiu* (Beijing: Wenwu chubanshe, 1983), pl. 2.

58. An Qi, *Moyuan huiguan* (1742; reprint Taipei: Commercial Press, 1970), pp. 202-3, 215.

59. Liaoning Provincial Museum, ed., *Ryonei-sho hakubutsukan*, vol. 3, *Chugoku no hakubutsukan* (Tokyo: Kodansha, 1982), p. 224.

60. Ibid.

61. *Guoli gugong bowuyuan kesi, cixiu* (Tapestry and Embroidery in the Collection of the National Palace Museum), (Tokyo: Gakken Company, 1970), *tz'u-hsiu* volume, p. 5.

62. Ibid; also cited in Zhu Qiqi, *sixiu biji, shang*, p. 36b. See also Jean Mailey, *Embroidery of Imperial China* (New York: China Institute in America, 1978), p. 12.

63. Yu, p. 1480.

64. *Guoli gugong bowuyuan kesi, cixiu*, p. 6.

65. Zhu Qiqian, *Nügong quan zhenglue, Meishu congshu*, IV, 5:257-338.

66. Ibid., p. 284; Yu, p. 467.

67. Zhu Qiqian, pp. 305-6; Yu, pp. 1071-72.

68. Zhu Qiqian, pp. 300, 301; Yu, pp. 1295, 1426.

69. Li Baokai, *Piling huazheng lu* (Changzhou wenhua shuju, 1933), *xia*, 23.

70. Cao Xueqin, 2:511.

71. YTHS, 3:47; Yu, pp. 1154, 1122. Tan Cheng-pi, *Zhongguo nüciren gushi* (Taipei, 1981), pp. 68-71, 77-80.

72. YTHS, 3:49-51.

73. Ibid., 3:45.

74. Yu, p. 557.

75. Dong Qichang, *Rongtai ji*, 6:52b-53a; WSSS, 5:84.

76. YTHS, 3:55-56.

77. Ibid., 3:28.

78. Wang Wenzhi, *Kuaiyutang tiba* (n.d.), 7:9.

79. Ibid., 8:14.

80. Qin Zuyong, *Tongyin lunhua fulu* (Guangzhou, 1864), p. 2a.

81. YTHS, 5:70.

82. Osvald Sirén, *Chinese Painting, Leading Masters and Principles* (New York: The Ronald Press Company, 1956-58), 5:72.

83. Ibid., 5:30.

84. Ibid., 5:73-74.

85. Ibid., 4:24.

86. A few recent studies of Western women artists are cited in the the bibliography. See in particular Rozsika Parker and Griselda Pollock, *Old Mistresses: Women, Art and Ideology* (New York: Pantheon Books, 1981).

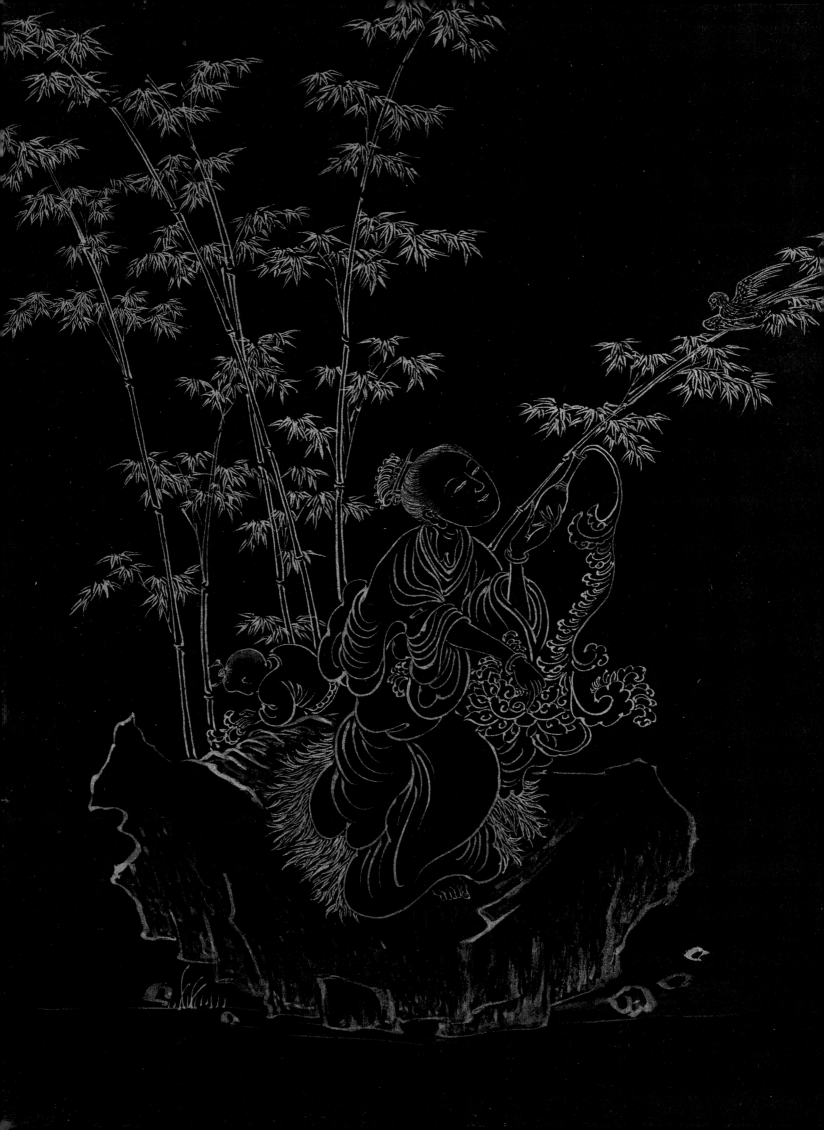

Wives, Daughters, and Lovers: Three Ming Dynasty Women Painters

Ellen Johnston Laing

Wen Shu (cat. nos. 14-16), Miss Qiu (cat. no. 3), and Ma Shou-zhen (cat. nos. 4-9) are among the most significant women painters of the Ming dynasty. The lives of these three individuals shed much light on the circumstances of women painters in the Ming period. Wen Shu (1595-1634) is representative of an old, elite, lettered family. She lived in an inherited ambience of cultured gentry, even though the original splendor of both her natal and marital families evidently was beginning to fade.[1] Nevertheless, she became a model for later generations of women painters. Miss Qiu, active somewhat earlier than Wen Shu, represents the artisan class of painters who from the beginning depended upon their artistic talents for their livelihood. Ma Shouzhen (1548-1604) was a courtesan whose abilities with the brush were appreciated by her clients and others.

Wen Shu was born into a prestigious literatus family of Suzhou. At that time Suzhou, the beautiful southern city located near Lake Tai, was the acknowledged cultural capital of China. Its economy was based on rice and the production and weaving of silk. Its citizens knew wealth, honor, and leisure. The mild climate was conducive to gardens and flowers; the city was laced with canals spanned by arching bridges and punctuated with temples and tall pagodas. More temples, pagodas, and famous places were located in the outlying districts amid attractive natural scenery.

The aura of antiquity and memories of the past were strong in Suzhou. For several generations members of the large Wen family were active there in the arts, in connoisseurship, in poetry and *belle lettres*, as well as in government service. Wen Shu was a descendant of the calligrapher Wen Lin (1445-99). Lin's wife was a painter of bamboo. They were the parents of the most famous artist in Suzhou in the early sixteenth century, Wen Zhengming (1470-1559). Wen Shu's father, Wen Congjian (1574-1648), was a landscapist of middling repute who also has several floral and Buddhist works to his credit.[2] Her brother, Wen Ran (1596-1667), was a calligrapher and a landscape painter.[3] It is not known who Wen Shu's mother was.

In this milieu, Wen Shu received some literary education. How and how much is not revealed in the records, but she was versed in poetry.[4] By her marriage, she added to the already thick web of relationships among the established literati families of Suzhou. She married Zhao Jun, scion of an old Suzhou family, which traced its ancestry back to the imperial family of the Song dynasty and which counted among its sons the famous official and artist Zhao Mengfu (1254-1322). Zhao Jun's father was the recluse-scholar Zhao Yiguang (1559-1625), and his mother was a daughter of Lu Shidao (1511-74), another Suzhou literatus. Zhao Jun studied the classics with Wen Congjian; thus a more permanent liaison between the two families was perhaps inevitable. When Zhao Jun married his teacher's daughter, three illustrious Suzhou families were united.

Zhao Jun was an etymologist and studied Sanskrit with the monk Jianlin (or Beilin). Zhao Jun and Wen Shu lived with the elder Zhao outside the city of Suzhou at Hanshan, an area noted for its natural beauty. Apparently the Zhao family resided in a villa there, for the local gazetteer says they lived a reclusive life at Hanshan and lists the halls and garden spots. In the library known as the Small Pleasure Hall, the Zhaos drank tea and spent time at leisure. Other attractions in the garden were the In a Thousand-foot Snow Cloud Hermitage, the Flipping the Dust Off the Cap House, the Astonishing Rainbow Crossing, the Green Cloud Tower, the Flying Fish Chasm, the Swift Mists Post-station, the Pure Cherishing Hall, and the Clear Bright Tower. Later the residence was converted into a Buddhist monastery, sometimes known as the Baoen Temple.[5] Presumably Zhao Jun and Wen Shu continued to stay there even after Zhao Yiguang's death in 1625, when the family fortunes declined.

There is no doubt that Wen Shu had sterling qualities and that her family was proud of her achievements. She enjoyed a reputation outstanding in a family already full of noteworthy individuals. Evidence of this is found in the major biographical documents for both Zhao Yiguang and Zhao Jun, which always have generous portions devoted to Wen Shu.

Zhao Jun and Wen Shu had one child, a daughter. In the Chinese family system, however, it was essential to have sons to perform the sacrifices to the ancestors and to continue the family line. Consequently, Zhao adopted his nephew Kun.

According to his tomb inscription, Zhao Jun enjoyed watching his wife paint and would sometimes inscribe her works to help "distinguish genuine from false," for her art had become so well known that it was faked. Otherwise he pursued a life of unhurried scholarship: he met with friends, collected examples of epigraphy, discussed the art of seal-cutting, researched rare characters, and perused dictionaries. For years he continued in this fashion, indulging in his own proclivities. He died in 1640.

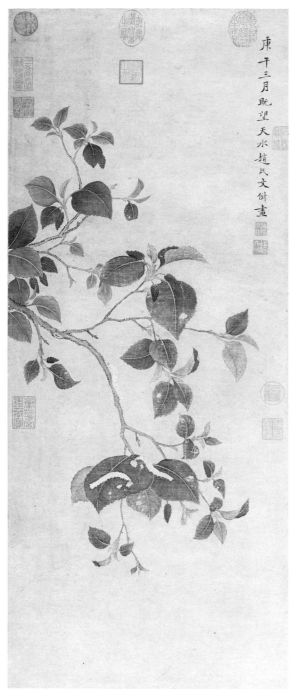

Figure h. Wen Shu, 1595-1634, *Silkworms and Mulberry Branches*, 1630. Collection of the National Palace Museum, Taiwan, Republic of China.

Things were different for Wen Shu. Her dated paintings, as known from both extant examples and through catalogue entries, were mostly done between 1626 and 1633 (the year before her death). This concentration of works between the years of her father-in-law's death and her own suggests that she plunged into painting in order to sell her works to augment the declining family finances. Apparently at this point in her life Wen Shu began to paint seriously, depicting the strange and rare insects and butterflies and flowers of Hanshan; copying the one thousand botanical specimens in the *Ben-cao materia medica*; doing a few figure paintings illustrating poems or poetic themes. Many

of her paintings are not elaborate but present just a few motifs and do not carry dedications or bear lengthy inscriptions, suggesting that they were made for commercial purposes. Further, it is reported that Wen Shu, fearful that others would mar her creations with haphazard writing, painted both sides of her fans.[6] It was not unheard of for upper-class women to sell their art to help support their families or even to support themselves independently of their family.[7]

Much of Wen Shu's art consists of variations on the flower-and-rock theme. She depicted a wide range of plants: roses of all kinds, lotuses, narcissus, orchids, plum blossoms, St.-John's-wort, poppies and opium poppies, asters, begonias, pinks, irises, chrysanthemums. Doubtless her floral subjects had general appeal, but several of her motifs were of interest to women. The begonia, for example, which Wen Shu painted on an unpublished fan now in a private collection, is the feminine flower par excellence because it prefers cool, damp, and shady places and has much forlorn lovelore surrounding it. Sericulture, a primary responsibility of women, is represented by Wen Shu's exquisite scroll of silkworms feeding on mulberry leaves, now in the National Palace Museum in Taipei (fig. h).[8] Even more compelling are those motifs, such as the iris, related to ideas about fertility and bearing sons. For example, an iris broth was used in a ceremonial fructifying bath in some parts of south China, or one could drink wine infused with iris. Irises and artemisia were hung on doors for protection, and irises were believed to prolong life and to promote intelligence.[9] The red pomegranate blossom could ward off evil as well as connote happiness and fertility, and the many seeds in the red fruit symbolize the hopes for numerous male offspring.[10]

The day lily, one of Wen Shu's favorite subjects (see cat. no. 16) was considered the herb of forgetfulness, used especially for the pains of childbirth. In the *Book of Poetry* there is a reference to the day lilies growing in the north courtyard of the house, that is, the women's quarters; thus the plant was associated with motherhood. One name for the day lily is *yinan xuan*, the "must-have-a-son" lily; it was said that if a pregnant woman wore day lilies in her girdle, she would bear a son.[11] Perhaps Wen Shu's use of this motif was related to her own sorrow in not providing the family with a son, or perhaps it was an expression of her own persistent hope for sons. At the same time, paintings with such fertility motifs were undoubtedly attractive on the commercial market. A scroll of Wen Shu's day lilies and rocks,

with their symbolic connotations of auspicious wishes for male children and longevity, respectively, would certainly have been an appropriate gift for a young married woman. Such themes provide gentry women with feminine parallels to subjects usually, but not exclusively, associated with the masculine realm (rocks and bamboo) or the courtesan world (rocks and orchids).

Wen Shu copied the botanical specimens pictured in the *Bencao*. This ancient illustrated pharmacopaeia was revised and amplified in the late sixteenth century by Li Shizhen. His *Bencao gangmu*, published in Nanjing in 1593, was a bestseller, going through at least eight reprintings in the seventeenth century; four of these were issued before Wen Shu's death, one in 1603 in Nanchang, another in 1606 in Huguang, the third around 1620, and the fourth around 1630.[12] Presumably it was this *Bencao* that Wen Shu studied. One may speculate that aside from the very practical reason of familiarizing herself with medicinal herbs, she may have copied the *Bencao* plants to attain greater skill in the rendering of flora (since the Chinese artist did not ordinarily draw from life). As Wen Shu's artistic reputation spread, married ladies and young girls sought her as a painting tutor, and the *Bencao* renditions served as models for her students. Two of her followers, Zhou Xi and her sister Zhou Hu, for example, copied Wen Shu's copies of the *Bencao* pages. This may mean that they studied directly with Wen Shu herself, which would have been possible since Wen Shu and the Zhous did not live far apart.

Aside from being an artistic model, Wen Shu might also have served as a moral model for later women. She had been so well brought up that her mother-in-law, perhaps the single most important person for a daughter-in-law to please in the Chinese family system, had nothing but praise for her; she even told her son, "She is really my good daughter and your devoted wife."[13] As a good daughter-in-law should be, she was committed to the weal of the Zhao family. When they fell on hard times, she used her artistic talents as a resource. Her recognition of their family heritage is implicit in the use of the phrase "Tianshui" in her signatures and seals, referring to a name associated with the Zhao family since the Tang dynasty.

Although Wen Shu had no son, her daughter, Zhao Zhao, understood the proper Confucian role of a son and when necessary took over the duties as well as the prerogatives normally expected of a son. Indeed, it was the daughter who, after the death of Zhao Jun in 1640, returned from her home in Pinghu (where she was married to Ma Ban), collected the biographical data about her parents, and sent the adopted son to request Qian Qianyi to write the tomb inscription. Praising Zhao Zhao, Qian Qianyi commented, "Having a daughter capable of transmitting her father's biography, can it be said he had no son?"[14] Although Zhao Zhao's action was considered atypical and biographical notices of her rarely fail to note this, there was a precedent for accepting such behavior from a woman. In the late twelfth century Yuan Cai compiled his *Rules for Social Life*; this guidebook for the heads of families contains the following passage: "Sometimes people's sons are not capable and they have to depend on their daughter's families for support, even their burials and sacrifices falling to their daughters. So how can people say that having daughters is not comparable to having sons?"[15]

Zhao Zhao, whose *zi* was Cihui, was brought up in the literary and cultural traditions of her grandmother and mother. She did sketches from life (*xiesheng*) as well as orchids and bamboo. She was of a "mist and vapor" disposition, wore a hemp skirt, dressed her hair in a mallet shape, and likened herself to a Daoist. When difficult times broke up the Ma family, she became a Buddhist nun, changed her name to Deyin, and built a retreat on the Lake Tai island of Dongting West Mountain, where she lived for more than twenty years. Her literary works, now lost, were titled *Lüyun ju yigao*.[16]

Wen Shu's art was studied by a host of women through the nineteenth century. In addition to a student of Zhou Xi, a girl by the name of Yao Yi,[17] there were other women from the Suzhou area who took Wen Shu's art as a model: Huang Ro from Taicang, Jiangsu,[18] and, in the late eighteenth and early nineteenth centuries, Luo Qilan, a poetry student of Wang Wenzhi (1730-1802), and his granddaughter Wang Yuyan both worked in the style of Wen Shu.[19] Another granddaughter, Wang Guichan, copied a portrait of Wen Shu holding an orchid, a symbol of a beautiful woman.[20] Wen Qingyu, the second wife of Chen Wenshu (1775-1845), originally had the surname Gao; however, she so admired Wen Shu that she changed her surname to Wen.[21] In 1805 a woman named Wu Sunyun painted a fan of fragrant orchids in the style of Wen Shu.[22] Other women who continued Wen Shu's mode in the Qing period included Li Hui from Jiangxi, who later moved to Guilin; Guo Shu from Suzhou; and Yuan Lan, also from Suzhou.[23] In her art Lu Xichen, a woman from Changshu who died at the age of twenty-two, was said to be a Wen Shu reborn.[24] Thus was the Wen Shu tradition of

flower painting upheld in south-central China.

One Chinese collector claimed that Wen Shu's flowers were the equal of the figures of Miss Qiu (Duling neishi).[25] Little is known of Miss Qiu. She was born into the ranks of those who painted for a livelihood. In general such artists receive but minimal notice in the written records. Her father, Qiu Ying, is a good example. We know nothing of his family background and we do not know his exact birth and death dates. On the basis of present evidence, it is estimated that he was born around 1494 and died around 1552. He lived on the fringes of literati gentry society in Suzhou and its environs and sometimes served as a sort of painter-in-residence. His meager biographical data have been laboriously located in widely scattered sources.[26] But these sources are almost entirely mute about his daughter.

Her birth and death dates cannot be deduced from available information. We are not even certain if she used the personal name Zhu. As late as the mid-nineteenth century, Chen Lang (b. 1822) observed that all the painting books said that Duling neishi was Qiu Ying's daughter but said nothing about her personal name. Chen Lang claimed to have seen a copy of an ink-outline figure scroll of the Song artist Li Gonglin; on it was written "Qiu Zhu copied the second scroll." On the basis of this and the style of the brushwork in the copy, Chen assumed that Zhu was Qiu Ying's daughter's personal name.[27] By modern standards of scholarship, this connection is tenuous at best.

Despite the paucity of material, it is possible to piece together tidbits of information in biographical dictionaries to reconstruct something of Miss Qiu's life. It is evident that her father, Qiu Ying, had at least one son and two daughters, one of whom was called Duling neishi. It is not known whom she married, but wed she did. Marriage, however, did not suit her. She preferred to live alone, "burning incense, playing the qin, cleaning the inkstone, and wielding the brush."[28] Perhaps she appropriated something of the cultural ideals she observed in the life-style of the affluent collectors and patrons she grew up among when her father lived in the homes of his wealthy clients.[29]

The name of Qiu Ying's other daughter is unknown, but she married the local artist Yu Qiu, who must have been a direct pupil of Qiu Ying because he continued Qiu's style.[30] Qiu Ying's son apparently was not a painter. Two members of the next generation, however, were also commercial painters: Qiu Ying's grandson and Yu Qiu's daughter (known only as Miss Yu). The latter worked in the style of her father

and was also a poet. She became the wife of an artist named Zhou Fengyi; they lived off the sale of their works.[31] Taken in the aggregate, this bare recital of the artistic affiliations of Miss Qiu's immediate family demonstrates the direct and continuing involvement of several generations of women in the commercial art world. It also indicates that it was possible for women whose families made no claims to education or scholarship to acquire a modicum of schooling and culture. They were far from illiterate.

As for Miss Qiu's oeuvre, it is, except for one or two flower and landscape paintings, primarily figural, comprised of both secular and religious subjects (fig. i). Strong links were forged between Miss Qiu's art and that of her father. Like Qiu Ying, Miss Qiu was commissioned to do paintings for birthday gifts, and they were both renowned for depictions of ladies. There are a number of pictures from the Ming period depicting court or upper-class ladies engaged in various pastimes on lovely garden terraces. The existence of these scenes, which include some traditionally assigned to Miss Qiu, indicates a continuing interest in such subjects as well as a substantial market for them.[32] Characteristically in these pictures, certain compositional and stylistic elements recall the art of Qiu Ying, specifically his acknowledged ability to copy exactly antique scrolls as well as to "recreate" ancient styles. This was accomplished by using stout or slender figures to allude to the art of the Tang and Song dynasties, respectively. Garden terrace settings were used by Song-dynasty court painters. The tradition of figures on garden terraces was maintained in the painting repertoire after the fall of the Song dynasty and into the early Ming period by artists who lived in the former Song capital in Hangzhou.[33]

Like her father, Miss Qiu was asked to provide pictures to complement calligraphy. Her representation of the Nymph of the Luo River to accompany Wang Chong's (1494-1533) transcription of the narrative poem of the same name underscores the very high esteem in which her art was held, for Wang Chong's calligraphy was widely admired and no one would demean it by coupling it with an inferior illustration.[34] Indeed, Miss Qiu was praised as a "Li Gonglin among women."[35]

Miss Qiu obviously had patrons, although none of these has been clearly identified. Her brother-in-law, Yu Qiu, was well acquainted with the foremost scholar and poet of the region, Wang Shizhen (1526-90).[36] It is conceivable that Wang and his family also patronized Miss Qiu.[37] Perhaps Tu Long (1542-1605), who

inscribed the *Heart Sutra* at the beginning of Miss Qiu's album of Guanyin figures, was introduced to Qiu through the Wangs, since Tu was a close friend of Wang Shizhen. Tu was not only a poet and a dramatist, but also an aficionado of culture who authored treatises on tea, furniture, costume, paper, brushes, inkstones, ink, incense, and art objects.[38]

Aside from the observation that Wen Shu's flowers were the equivalent of Miss Qiu's figures, there is another possible connection between the two women painters. Apparently Wen Shu and Miss Qiu illustrated two different poetic themes using a stock figure of a solitary lady in a peony garden. Wen Shu and Miss Qiu may have seen the same earlier painting or had access to draft copies of it, or to a copy or pattern book. What is important here is the leveling factor: a woman painter from the gentry class and one from the commercial class both use the same image.[39]

Many women in a third segment of Chinese society, that of the courtesan, were also proficient in painting. Courtesans in China specialized in providing upper-class men with cultured entertainment and pleasure. Female singers, entertainers, and courtesans had a long history as a part of Chinese culture,[40] and during the Ming period an increase in general prosperity in China brought an increase in the number of courtesans, especially in affluent South China. The banks of the Qinhuai Canal in Nanjing bustled with courtesan activity. Yangzhou was noted for its entertainment quarter, and Suzhou, Shanghai, Guangzhou, and, in the north, Beijing, were all to develop flourishing courtesan colonies. The rise in the number of courtesans may have forced them to strive for higher levels of artistic accomplishment as competition for clients intensified.

In early centuries, professional entertainers and courtesans were often poets as well, but they were not expected to know how to paint. They might have become involved with painting as models, however. A statement that in the Tang period Han Gan's depictions of Indra, Brahma, and apsaras were "portraits of Lord Ch'i's sing-song girls"[41] raises the intriguing question: did the women sit for the artist (as seems often to have occurred in the West), or did he depict their forms and visages from memory?

It became appropriate for courtesans to engage in painting and calligraphy only when these pursuits were recognized by their gentlemen clients as suitable practices for themselves; they then came to expect such artistic erudition from their party companions as well. By the Song period, as is evident from two short

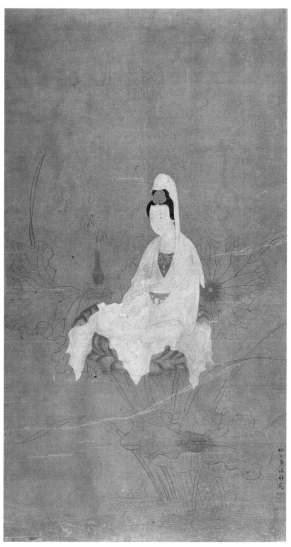

Figure i. Miss Qiu, active mid-late 16th century, *White-robed Guanyin*. Collection of the National Palace Museum, Taiwan, Republic of China.

stories set in that era, courtesans were often hardly more than children, and the most successful of them cultivated various arts. In the twelfth-century story "The Scholar and the Courtesan," we find the following description:

Before she had reached the marriageable age of fifteen she had already become a courtesan of the first order. Her skin shone with remarkable clarity, her body was resplendent in full blossom, her hair shone violet-black, the glittering orbs of her pupils dilated, the bamboo shoots of her hands moved tenderly, seductively bewitching were her charms — in all of these things she was unequaled in her time. The carriages and teams of horses that belonged to her could no longer all be accommodated in the stables, and her houses and hostelries formed virtually a city in themselves. Moreover, she was intelligent and clever by nature, could analyze melodies according to their structure, and was accomplished also in poetry and painting. Young men paid a thousand pieces of gold just for a smile from her, and where her real favors were at stake, their only fear was that they might have to make way for someone else. The whole of the Senior Civil Services crowded to her parties, and she was constantly receiving friends who drove up in horse-drawn carriages.[42]

The short story "The Oil Vendor and the

Courtesan" provides many vivid, and probably typical, details of courtesan life.[43] Set in the early twelfth century, it tells of a well-to-do merchant couple who send their only child, a girl, to village school at age seven. She learns to read and by age ten composes poetry; at age twelve she is an "accomplished lyrist, chess player, calligrapher and painter" and has extraordinary skill at needlework. The family is forced to flee from the invading Jin armies, and the young lady gets separated from her parents. She is "rescued" by the neighborhood "loafer and wastrel," whom she has known since a child and so takes to be a friend. They journey together to Hangzhou, where he sells her to a brothel at West Lake.

In her new home she is "taught music, dancing and singing," at which "she excelled." When it became known "that she was a skilled calligrapher and writer, every day men thronged the door asking for her calligraphy or poems." Her apartment was well furnished. In the middle of her sitting room "hung a painting by a famous artist, while ambergris was burning in an old bronze censer on the table. The writing tables on two sides of the room were laden with curios, and the walls were hung with poems." Her engagement calendar includes "a feast she went to yesterday in Academician Li's house. Today Lord Huang has invited her to go boating. Tomorrow Mr Zhang the poet and some others are asking her to a poetry meeting; and the day after was booked by Minister Han's son some time ago." Later on, "Master Han beg[s] her to go with him to East Village to enjoy the early plum blossoms" and wants "to take her to Ling Yin Monastery tomorrow, too, for a chess tournament."

When the pauper hero of the tale finally arranges a meeting with her, she arrives late from a party and is completely drunk. He stays with her through the night and nurses her through her nausea. He next encounters her when she has been abducted from the brothel by a bully who abuses her and then, after commanding his minion to strip her slippers off her tiny feet, leaves her to "Walk home if you can, you bitch!" The hero saves her and escorts her home, where that evening she "played, sang and danced for him using all her art to please him, until the young man felt he was in paradise and could scarcely contain himself for joy. And as night fell they went arm in arm to her bed-chamber, where Chong's bliss can be imagined." The hero (by this time engaged in a lucrative business venture) and heroine are able to marry after she uses her savings to buy out her contract.

The courtesan was lauded not only for her entertainment value (as seen in a nineteenth-century depiction of a party in progress by the Shanghai artist Wu Jiayou),[44] but also for a host of sometimes precious cultural refinements: playing chess, raising narcissus, witty conversation, appreciation of flowers or incense or gourmet wines or fancy foods. Expertise in such matters might also help secure the release of these women from brothel bondage by attracting a man willing to purchase her contract and take her as a concubine or secondary wife.

This did indeed happen in real life as well as in fiction, since many men formed deep and lasting attachments to their courtesan playmates. The courtesan-painter Liu Shi married the famous scholar Qian Qianyi (see cat. no. 23). Mao Xiang purchased several concubines (all of whom were painters) out of courtesanship. The poet and painter Shen Fu (late eighteenth–early nineteenth century) described the Guangzhou flower-boat district in his memoirs. He became enamored of a pretty youngster from the entertainment quarter, and his wife made arrangements (ultimately futile, as it turned out) for her to join the family.[45] Thus these educated and literate women were sometimes accepted into families, if not granted a branch on the family tree.

Visits to the courtesan quarters were an accepted part of Chinese upper-class life. Men enjoyed writing and reading books about experiences in the courtesan district, which even catalogued the women, complete with comments on their physical attractions, social attributes, hobbies, and cultural talents.[46] In the late Ming, Li Yunxiang compiled *The Hundred Beauties of Nanking*. Patrick Hanan explains the content of this book, published in Suzhou in 1618:

The *Hundred Beauties* consists of prose and verse eulogies (including popular songs) on the one hundred most beautiful singing girls the compiler has met in Nanking. They are ranked like the top hundred candidates in the metropolitan examinations, and each is matched with a particular flower.[47]

The predilection for such parallels is extremely strong in Chinese culture. In the Song dynasty, the organization of palace women (not members of the imperial family, but women responsible for the functioning of the palace) was divided into bureaus comparable to those in the government, where the positions were, of course, occupied by males in the civil service.[48] Li draws the parallel between those men who function somewhat like courtiers in the government and who will rise in office according to their intellectual capacities and the courtesans whose success depends upon beauty, talent, and wit. One wonders if the courtesans devised

similar lists of male patrons that ranked them according to standards set by women.

Aside from the fact that feminine names in China are frequently floral, matching courtesans with flowers was an accepted form of compliment. In a well-known example the Tang poet Li Bai likened the imperial favorite, Yang Guifei, to the peony, the "king" of blossoms. The peony is not only a symbol of feminine beauty, but also a token of love and affection.[49] It seems possible therefore, that some of the handscrolls depicting one hundred flowers are to be understood as references to courtesans.

The courtesan's commitment to the art of painting was apparently somewhat limited. The women may have acquired rudiments of brush painting from their older sisters in the quarters or informally from a client. At least two eighteenth-century Yangzhou courtesans, Yuexiang and Moxiang, took formal lessons in painting from a well-known male artist. However, courtesans, unlike artists outside the entertainment districts, rarely acknowledged either a personal teacher-pupil relationship or an ancient artistic lineage. This suggests that to most courtesans painting was simply another attraction, and a useful one at that, for the courtesan might, through quickly brushing a single picture or writing out a poem on a fan, provide her client with a concrete memento of their encounter. In the late nineteenth century, Gustaf Schlegel, reporting his adventures among the flower-boat girls of Guangzhou, was delighted when one "even favoured me with a fan upon which she had written a few lines of poetry in my praise."[50]

For their paintings, the courtesans of the Ming most often selected the orchid as a subject, perhaps because the forms of its blossoms and leaves lent themselves so readily to representation: they could be quickly executed with the flexible Chinese brush, and a reasonably acceptable image could be drawn after a modest amount of practice. An important reason for depicting the orchid was its symbolism: it was a metaphor for a lovely girl "living in seclusion or in a secret room."[51] Gentlemen described happening upon a lovely enchantress of a courtesan with the distinctly erotic expression of "finding a delicate orchid in a secluded valley." Although some courtesan-painters occasionally expanded into other subjects, such as pines, chrysanthemums, or landscapes, the orchid remained the primary image.

Ma Shouzhen (1548-1604) was one of the Eight Famous Courtesans of the Ming period.[52]

Though physically attractive, she was not a raving beauty and apparently compensated for this with a vivacious personality and a high-spirited life-style possible only in the courtesan context. Her flamboyance was rivaled only by another courtesan-painter, Xue Wu (cat. nos. 10-13), an accomplished equestrian who enjoyed showing off her skill in archery from horseback.[53] Ma Shouzhen was a dramatist (her one play has not survived), a poet, and a calligrapher, as well as a painter. Her success as a courtesan is indicated by her domicile. Situated at a choice location in the courtesan quarter of Nanjing, it had serpentine corridors and numerous rooms and was set in a fine garden with flowers and stones. Her magnanimity was boundless, as she paid for both gifts and feasts. The most famous of the latter was the month-long party with fifteen entertainers held on a two-storied boat in the Willow Catkin Garden, which she sponsored as a birthday celebration for her paramour, Wang Zhideng (1535-1612).

Ma Shouzhen's life-style might have been irregular and dashing, but her brushwork is not. Instead, it is extraordinarily restrained. The exquisite balance and sustained fastidiousness of her delineation of orchids now in the Metropolitan Museum of Art (cat. no. 5) is beyond reproach. The dedications Ma Shouzhen inscribed on her works and the colophons inscribed on them by others give her paintings a distinctly literati flavor. Her work is connected to the literati tradition as well in her landscape of a boat approaching a tree-lined shore (cat. no. 6), which is a free interpretation of a composition similar to one done by Wen Zhengming (1472-1559).[54] In addition, the rock-and-orchid motifs that recur in her scrolls parallel the rock-and-pine or rock-and-bamboo of which literati painters were so fond. And, of course, scholars sometimes also depicted the rock-and-orchid theme.

Whatever their social differences, Wen Shu, Miss Qiu, and Ma Shouzhen were educated and had talents in other artistic fields, such as poetry, music, or calligraphy. All relied upon their painting abilities to augment their income. They therefore tailored their art in both style and subject to meet the expectations of their audience and their patrons. Yet, their paintings are very different, as evidenced by Wen Shu's cool, subtly colored *Lily, Narcissus and Rock* (cat. no. 15), the glittering gold figures and flowers in Miss Qiu's images of *Guanyin* (cat. no. 3), and Ma Shouzhen's monochrome ink *Orchid and Bamboo* (cat. no. 5).

1. Ellen Johnston Laing, "Wen Tien and Chin Chün-ming," *Journal of the Institute of Chinese Studies of the Chinese University of Hong Kong* 8:2 (1976):411-12.

2. For his biography, see Yu, p. 38; representative paintings are listed in Sirén, *CP*, 7:267 and in E. J. Laing, *Chinese Paintings in Chinese Publications 1956-1968: An Annotated Bibliography and an Index to the Paintings*, Michigan Papers in Chinese Studies, 6 (Ann Arbor: The University of Michigan Center for Chinese Studies, 1969), p. 205.

3. For his biography, see Yu, p. 37; for his paintings, see Sirén, *CP*, 7:264.

4. The following biographical information about Wen Shu is taken from Qian Qianyi, "Zhao Lingjun muzhi ming," in *Muzhai chuxue ji, Sibu congkan* ed. (Shanghai: Commercial Press, 1929), 44:17b-21a, and from Zao Yi, "Zhao Yinjun juan," in *Chizhen yecheng* (reprint Taipei: Wenhai, 1968), 14:2a-3b.

5. Wu Xiuzhi, comp., and Cao Yunyuan, ed., *Wuxian zhi* (1933; reprint Taipei: Chengwen, 1970), 37 *xia*, 19a.

6. *WSSS*, 5:85.

7. Ellen Johnston Laing, "Women Painters in Traditional China," in *Women in the History of Chinese and Japanese Painting*, ed. Marsha Weidner (Honolulu: University of Hawaii Press, forthcoming).

8. *Gugong shuhuaji* (Beijing: Palace Museum, 1930-36), vol. 2. In poetry themes of silk-beating and the general production of silk can have sexual connotations; see Birrell, p. 325.

9. An example of an iris painting by Wen Shu is in the Liaoning Provincial Museum; reproduced in *Liaoningsheng bowuguan canghua ji* (Beijing: Wenwu, 1962), 2, pl. 65, and in *Im Schatten hoher Bäume Malerei der Ming-und Qing-Dynastien (1368-1911) aus der Volksrepublik China* (Baden-Baden, 1985), no. 13. For the significance of the iris, see Wolfram Eberhard, *Chinese Festivals* (New York: Henry Schuman, 1952), pp. 82-85, and Wolfram Eberhard, *The Local Cultures of South and East China*, trans. Alide Eberhard (Leiden: E. J. Brill, 1968), p. 157.

10. A fan painting of pomegranate blossoms is reproduced in *Ming Qing shanmianhua xuanji* (Shanghai: Renmin meishu, 1959), pl. 45. For the significance of the pomegranate, see Eberhard, *Local Cultures*, p. 157; Terese Tse Bartholomew, "Botanical Puns in Chinese Art from the Collection of the Asian Art Museum of San Francisco," *Orientations* 16:9 (September 1985):32; C. A. S. Williams, *Outlines of Chinese Symbolism & Art Motives*, 3rd ed. (Shanghai: Kelly and Walsh, 1941; reprint New York: Dover, 1976), p. 333.

11. Nozaki, no. 104.

12. "Li Shih-chen," in L. Carrington Goodrich and Chao-ying Fang, *Dictionary of Ming Biography 1368-1644* (New York: Columbia University Press, 1976), 1:859-65.

13. Qian Qianyi, 44:18ab.

14. Ibid., 44:19b.

15. Patricia Ebrey, "Women in the Kinship System of the Southern Song Upper Class," in *Women in China: Current Directions in Historical Scholarship*, ed. Richard W. Guisso and Stanley Johannesen (Youngstown, NY: Philo Press, 1981), p. 115.

16. Shen Jiyu, *Cuili shixi*, quoted in *YTHS*, 3:52-53; Wu and Cao, *Wuxian zhi* 74 *xia*, 30b.

17. Yu, p. 585.

18. Ibid., p. 1149.

19. Wang Wenzhi, *Kuaiyutang tiba* (Kuangzhi, n. d.), 8:14-15.

20. Reproduced in *Yilin yuekan*, 9:2. Gai Qi's copy of Wen Shu's self-portrait is dated 1819 (reproduced in *Zhongguo minghua*, Shanghai: Yuzheng, 1922-40, vol. 39). Both of these portraits follow an accepted formula: bust-length and three-quarters view.

21. Yu, p. 40.

22. Shao Songnian, *Guyuan cuilu* (Shanghai: Hongwen, 1904), 13:15b.

23. Yu, pp. 402, 958, 762.

24. Ibid., p. 984.

25. Tao Liang, *Hongdoushuguan shuhuaji* (1882), 6:106b.

26. James Cahill, *Parting at the Shore: Chinese Painting of the Early and Middle Ming Dynasty 1368-1580* (New York and Tokyo: Weatherhill, 1978), p. 201; Stephen Little, "The Demon Queller and the Art of Qiu Ying (Ch'iu Ying)," *Artibus Asiae* 56:1/2 (1985):5-80.

27. Chen Lang, *Duhua jilüe* (Shanghai: Commercial Press, 1925), p. 3.

28. Wang Keyu, *Shanhuwang minghua tiba*, in Zhang Junheng, ed., *Shiyuan congshu*, vol. 8, 17:7a.

29. Ellen Johnston Laing, "Ch'iu Ying's Three Patrons," *Ming Studies* 8 (Spring 1979):49-56.

30. Li Mingwan, comp., and Feng Guifen, ed., *Suzhou fuzhi* (1883; reprint Taipei: Chengwen, 1970), 109:18b-19a.

31. Ibid.

32. For example, the picture reproduced in *Tō Sō Gen Min meiga taikan* (Tokyo, 1929), pl. 284.

33. See Ellen Johnston Laing, "Six Late Yüan Dynasty Figure Paintings," *Oriental Art* 20:3 (Autumn 1974): 305-16.

34. Colophon by Qian Daxin recorded in *YTHS*, 3:28.

35. Ibid.

36. A number of notices in Wang's *Yenzhou shanren sibu gao* and *Xugao* reveal that Yu Qiu not only did paintings for Wang Shizhen, but also accompanied him on excursions and similar social occasions.

37. Louise Yuhas discussed Wang Shizhen's activities and his patronage of artists in her "Wang Shih-chen as Patron," paper presented at the ACLS workshop "Artists and Patrons: Some Economic and Social Aspects of Chinese Painting," Kansas City, November 20-24, 1980.

38. See Tu Long's biography in Goodrich and Fong, pp. 1324-27.

39. A hanging scroll given to Wen Shu, now in a private collection in Hong Kong, depicts a solitary woman with arms lowered and hands clasped in front of her facing a tall, flat-faceted garden rock and several lushly blooming peony shrubs. The painting is listed in Suzuki (S 10-007) as *Rising Early in Spring to Lament the Flowers*. Written on the rock is: "Painted by Wen Shu, copying Songxue (Zhao Mengfu), during the Grain Rain [late April-early May], 1631." A seal on the painting identifies it as the one recorded in Ge Jinlang's *Airiyinlou shuhualu* (1881; reprint Taipei: Wenshizhe, 1977, 2:26ab) under the title *Rising Early in Spring to Lament the Flowers*. According to Wang Shizhen, Zhao Mengfu's representation of the subject carried poems by Zhang Yu and Ni Zan, among others. Wang also claims that Zhao's picture was the basis for Wen Shu's version and, in turn, the copy made by her student Zhou Xi (*Xiangzu biji*, 1702; reprint Shanghai: Guji, 1982, pp. 247-48).

The "lamenting the flowers" theme was popularized by the Tang poet Bai Juyi. Two of his verses on the theme are titled *Pitying the Peonies*:

I

Vexed-distressed, the red peonies before the stairs
when night comes have but two branches free.
With tomorrow morning's wind they'll be blown away;
pity the fading red, at night I take a light to see.

II

Forlorn faded red lowered towards the rain,
split open beauties scattered to the wind.
Still vexed-distressed they fall to clear bright earth —
tossed empty into mud, even more bothered my mind.

(Translation by Howard S. Levy, *Translations from Po Chü-i's Collected Works* [New York: Paragon Book Reprint Corp., 1971], 2:26.)

Rising Early in Spring to Lament the Flowers must be the subject of a painting supposedly by Tang Yin (1470-1523). He uses the same stock female figure in a garden of peonies and rock, but she is accompanied by two maidservants who carry a wine jar and a lantern (*Zhongguo minghua*, vol. 30). Two scrolls similar to the one given to Wen Shu in Hong Kong are now in the Freer Gallery of Art, Washington, D. C. Neither is published. One is supposedly signed by Qiu Ying (c. 1494-c. 1552).

The painting attributed to Miss Qiu is a hanging scroll entitled *Illustration to an Idea of a Tang Poet (Tangren shiyi*; reproduced in *Gugong shuhua ji*, vol. 39). It shows a woman standing in a misty peony-and-rock garden. In his notes on paintings in the Imperial Qing collection, Hu Jing identifies the subject as illustrating the three qingping melody lyrics by the Tang poet Li Bai (*Xiqing zhaji* [1816], *Hushi shuhuakao sanzhong* ed., 3:5b). These three lyrics were composed at the command of Emperor Minghuang to honor both his concubine, Yang Guifei, and the splendid blossoming peonies in the Aloe Pavilion garden. The first poem in this set goes:

Clouds call to mind her robes,
the flowers recall her face.
Spring breezes brush the railing,
dew full on the blossoms.
If you don't see her in gods' abode,
on the mountain Hoard of Jade,
You can surely meet her in moonlight,
there on the Terrace of Jasper.

(Translation by Stephen Owen, *The Great Age of Chinese Poetry: The High T'ang* [New Haven: Yale University Press, 1981], p. 116. Translations of the other two poems in this set are in Howard S. Levy, *Harem Favorites of an Illustrious Celestial* [Taizhong: Zhongtai, 1958], p. 154.)

Pictorially, these two themes of lamenting flowers and homage to peonies and Yang Guifei were not kept entirely distinct as the same feminine figure in a garden was used for both. The figure itself became a stock image. In addition to its appearance in the above five paintings, it is also seen in an anonymous Song fan painting of a woman near bamboo entitled *Greensleeves in Winter* (reproduced in He Gongshang, ed., *Lidai meiren huaxuan* [Taipei: Meishu tushu, 1984], pl. 4). It is also highly reminiscent of one of the small figures in the handscroll of palace ladies wearing flowers in their hair attributed to the Tang painter Zhou Fang (frequently reproduced; see ibid., pl. 30). This last association is particularly interesting because Zhou Fang supposedly depicted *A Lady Lamenting Flowers* (Zhang Chou, *Qinghe shuhuafang*, preface dated 1616 [1926 edition], 4.19b).

40. Much valuable information compiled from the histories, from official records, from poetry, and from more casual writings is in Wang Shunü's history of the subject, *Zhongguo changji shi* (Shanghai: Shenghuo, 1935); see also R. H. van Gulik, *Sexual Life in Ancient China* (Leiden: E. J. Brill, 1961).

41. Duan Chengshi, *Sita ji* (reprint Beijing: Renmin meishu, 1964), *shang* 12. Translation from Alexander Soper, "A Vacation Glimpse of the T'ang Temples of Ch'ang-an, The Ssu t'a chi by Tuan Ch'eng-shih," *Artibus Asiae* 23:1 (1960):26.

42. Wolfgang Bauer and Herbert Franke, eds., *The Golden Casket: Chinese Novellas of Two Millennia*, trans. Christopher Levenson (London: George Allen and Unwin, 1964), p. 190.

43. There are, of course, other stories, such as "The Courtesan's Jewel Box," which have courtesan heroines. Excerpts from "The Oil Vendor and the Courtesan" are from *The Courtesan's Jewel Box: Chinese Stories of the Xth-XVIIth Centuries*, trans. Yang Xianyi and Gladys Yang (Beijing: Foreign Languages Press, 1981), pp. 251-98.

44. Reproduced in Yao Hsin-nung, "When Sing-song Girls were Muses," *T'ien Hsia Monthly* 4 (May 1937), opp. p. 475.

45. Shen Fu, *Chapters From a Floating Life: The Autobiography of a Chinese Artist*, trans. Shirley M. Black (London: Oxford University Press, 1960), pp. 52-57. Paul S. Ropp has proposed that Shen Fu's wife may have been bisexual or lesbian and was perhaps herself enamoured of the young girl ("Between Two Worlds: Women in Shen Fu's *Six Chapters of a Floating Life*," in *Woman and Literature in China*, ed. Anna Gerstlacher [Bochum: Studienverlag Brockmeyer, 1985], pp. 114-18).

46. Among the genre of courtesan-quarter reminiscences are Sun Qi, *Beili zhi*, in Robert des Rotours, translator and annotator, *Courtisanes Chinoises à la fin des T'ang entre circa 789 et le 8 janvier 881*, Bibliothèque de l'Institut des Hautes Etudes Chinoises, 22 (Paris: Presses Universitaires de France, 1968); Yu Huai, *Banqiao zaji*, in Levy. Other writings of this genre dealing with the courtesan quarters of Nanjing, Suzhou, Yangzhou, and elsewhere are collected in Zhu Jianmang, comp., *Zhangtai ji sheng ming ju* (Kyoto: Chubun, 1969).

47. Patrick Hanan, *The Chinese Vernacular Story* (Cambridge: Harvard University Press, 1981), p. 89. I am grateful to Tung Yuanfang for bringing this material to my attention.

48. Priscilla Ching Chung, *Palace Women in the Northern Sung 960-1126* (Leiden: E. J. Brill, 1981), p. 11.

49. Williams, p. 321; Birrell, p. 343.

50. G. Schegel, "A Canton Flower-boat," *Internationales Archiv für Ethnographie* 7 (1894):3.

51. Birrell, p. 324.

52. Useful information about Ma is in Eileen Grace Truscott, "Ma Shou-chen: Ming Dynasty Courtesan/Artist," M.A. thesis, The University of British Columbia, 1981.

53. Tseng Yu-Ho, "Hsüeh Wu and her orchids in the collection of the Honolulu Academy of Arts," *Arts Asiatiques* 2:3 (1955):202.

54. Richard Edwards, *The Art of Wen Cheng-ming (1470-1559)* (Ann Arbor: The University of Michigan Museum of Art, 1976), II, F.

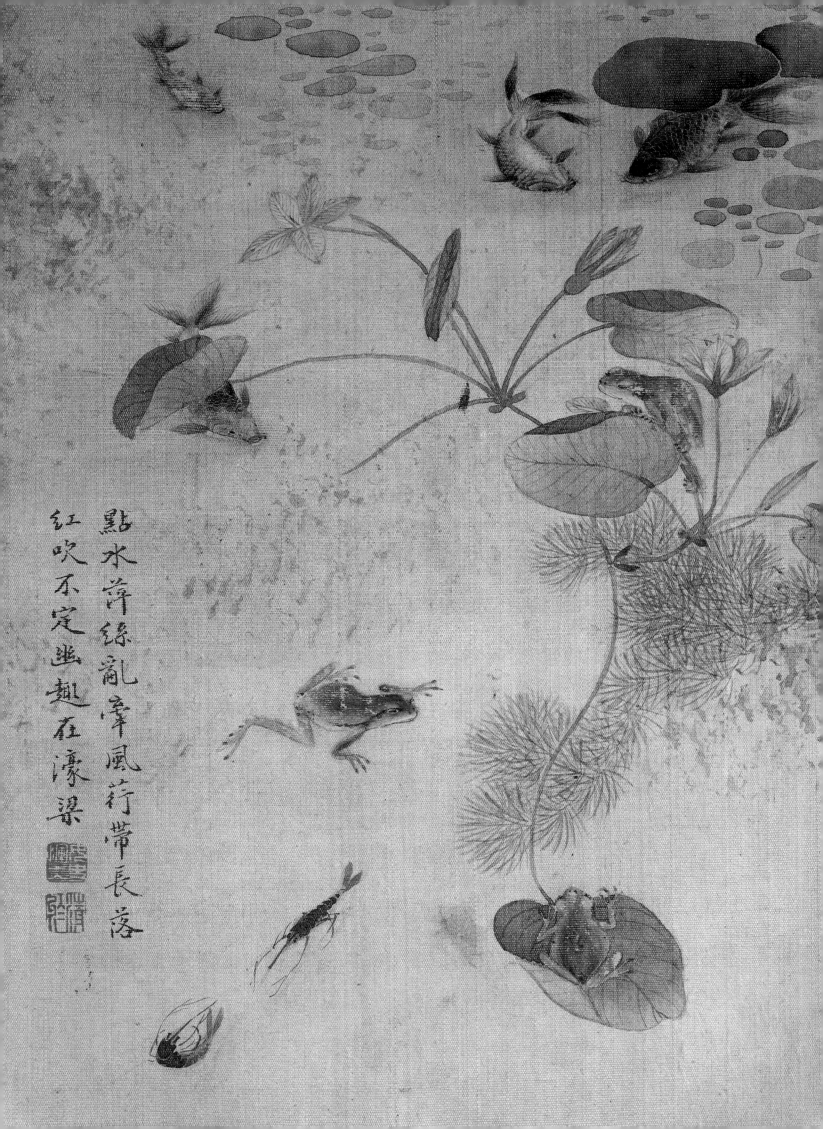

點水萍綠亂牽風行帶長落
紅吹不定幽趣在濠梁

Daughters of the Muses of China

Irving Yucheng Lo

Poetry, painting, and calligraphy are generally considered by the Chinese as the three supreme art forms (*sanjue*), or the "Three Perfections," as Michael Sullivan has called them.[1] Yet in none of the three did the male enjoy a predominance — and this despite the fact that the premodern society of China was in every way dominated by the male sex. What social conditions nurtured and encouraged female accomplishments in poetry? What are the characteristics of their contributions as distinguished from those made by men? In this essay I shall attempt to answer these questions by looking into the subject matter and the imagery of their verses. I will also examine how certain stereotypical ideas about women in the tradition-bound Confucian society of China either inspired or inhibited the development of their genius.

If Confucius were to be called back from the dead to testify before a United States Congressional Committee on the issue of universal feminist rights, what would he say? He would, I am quite sure, try to acquit himself by quoting his now familiar dictum "In education there should be no class distinctions" (*you jiao wu lei*).[2] By extension, he might maintain that there should be no distinction based on sex either — since there can be only two classes of people, the educated and the uneducated. Indeed, access to learning, especially in the polite arts of music, poetry, and painting, has been made available to women since the early days of Confucianism. Among the high achievers in scholarship and literature we can find such excellent examples as the historian Ban Zhao (c. 45-c. 120) of the first century and the lyric poet Li Qingzhao (1084-c. 1151) of the Song dynasty. But the existence of opportunity is one thing and the manner in which it was made accessible is another.

Because of the Confucianists' exaggerated demand for the observance of rituals, or *li*, Chinese women's access to learning was frequently hampered by a strong taboo against the intermingling of sexes in society. From the earliest time come stories about how the Master himself was rebuked by his disciples for paying a visit to a woman of dubious moral principle.[3] This kind of behavioral constraint, coupled with the generally low regard for women in Confucian teaching, is reponsible for such famous legends as the one about the purple silk curtain used by the Han scholar Ma Rong (79-166) to separate himself from female musicians whenever he lectured to his students. In another story, a learned lady of the Jin dynasty (265-419), while in her eighties, delivered lectures to her male pupils from behind a purple gauze curtain. Yet women from good families did receive instruction in their homes, though usually from their parents or kinsmen. And, in later centuries, the taboo was more honored in the breach than in the observance. None other than Mencius himself has remarked that food and sex are both the manifestations of human nature.

In premodern Chinese society, this taboo against the intermingling of the sexes could be overriden in only two ways, neither of which advanced the best interests of the female sex. The first, of course, was marriage or, more precisely, the arranged marriage, which usually occurred at the behest of her parents when a girl was still in her teens. The second course open to a woman for improving her status was the notorious concubinage. The two systems, though working independently and with different rules, existed for the same reason — namely, the economic dependency of a woman upon a man — and served the same purpose — that of giving birth to a male offspring. For the two systems to "mesh," so to speak, the Chinese invented a saying which prescribed that "in taking a woman for wife, it is her virtue that is of primary concern, but in choosing a concubine, it is her beauty that matters most." For two thousand years, by both precept and example, Chinese ethics has therefore held up two ideals: one for marriage and the other for defining an extra dimension of marriage by condoning concubinage. According to the former, a woman's duty in life is to become "a worthy wife and good mother" (*xianqi liangmu*), with all the concomitant moral qualities required to bring that about, such as filiality, obedience, chastity, thrift. A woman's nobility was thus not her own, but was always to be achieved through either her husband or her son. The goal of concubinage was not so much the gratification of the flesh or pleasure or prestige — or all of the above — as the realization of another ideal with heavy literary overtones. I refer here to the celebration of a perfect match between man and woman, in a romance or in real life, known generally under the rubric of *caizi jiaren*, "talented men and beautiful women."[4] Accomplishments made by Chinese women in poetry and the arts were either tolerated or encouraged by the traditional male-dominated society of China precisely because of the existence of these two systems.

Education for women in the homes of the scholar-gentry class increased during the seventeenth century. As Professor William Schultz and I have pointed out in the introduction to

Waiting for Unicorn: Poems and Lyrics of China's Last Dynasty, 1644-1911, what spurred this development was the greater prosperity of the merchant culture, especially in the Jiangnan region; the growth of private academies and of the tutoring profession; and, of course, the increasing spread of printing and the book trade.[5] As a result, the so called "talented gentry women of the boudoir," or *guixiu* — all well educated and accomplished in the arts — were much sought after as wives by young men from families of comparable standing. For example, when Qi Biaojia (1602-45) — authority on Chinese gardens, bibliophile, poet, later martyr of the Ming cause, and one of the five sons of Qi Chenghan (1565-1628) — married Shang Jinglan (1605-76) — one of the three daughters (equally talented) of Shang Zhouzuo, then Minister of Works in Nanjing — their marriage was hailed by the people in their native districts as the union of a "golden lad" with a "jade maiden" (*jingtong yunu*).[6] In other words, it was a match that could have been made only in heaven, something any reader of China's best-known novel *Honglou meng* (*The Story of the Stone*) can understand. In the epithet *jintong yunu* itself, one sees a parallel between marriages of educated women and the concubinage system: the "beautiful lady" of the *caizi jiaren* formula need not always be a courtesan.

Once married, these "talented gentry women" whiled away their time in creative pursuits, such as the writing of poetry on festive occasions, usually in a spirit of friendly competition with other women in the household. Thus, in Ming and Qing society, it was not uncommon in a scholar's family to find a mother-in-law, daughters-in-law, sisters-in-law, aunts and nieces, and concubines banding together to form poetry clubs, through which they demonstrated their talents in verse writing. This was true of the Banana Society, as mentioned in the biographies of the two sisters Chai Zhenyi and Chai Jingyi (see cat. no. 30).

Prominent poets, scholars, and painters, of course, took greater care to educate the women of their household, as in the case of the popular painter-poet Yun Shouping (see the biography of Yun Bing in cat. no. 39), whose numerous progeny carried on the family tradition after his death. There were other "clusters" of great families; for instance, the noted poet and dramatist Jiang Shiquan (1725-85) was tutored by his mother Zhong Lingjia (1706-75), a poet in her own right. Chai Jingyi had a son, Shen Yongji, who was a poet, as well as a daughter-in-law, Zhu Rouze (Daozhu), who was known for both her poetry and her painting.

It was not, however, until late in the eighteenth century that the cause of education for women in China found a redoubtable champion — the unconventional poet and critic Yuan Mei (1716-98). Yuan created his own school for poetry exclusively for young women and even published an anthology of the best poems written by his disciples under the title *Suiyuan nudizi ji* (Poems by the Women Students of the Master of Sui Garden). As a critic, Yuan Mei was used to polemics, especially in his advocacy of *xingling*, "native sensibility,"[7] as the *sine qua non* of poetry and in taking a position against, for example, a more Buddhistic view of poetry as *shenyun*, "spirit and resonance," as championed by the Qing poet Wang Shizhen (1634-1711). He might therefore have had good reason to be proud of his students' works, as we shall see shortly. But rumors concerning Yuan's conduct were rife among his contemporaries. In the fiercest criticism directed against him, which came from the Confucianist scholar Zhang Xuecheng (1738-1801), the specific charge was that Yuan "perpetuated a shameful and ignorant act . . . by seducing women from great families . . . through the cultivation of the image of a 'romantic' (*fengliu*) persona . . . and by fanning what is only a stageworthy ideal, that of *caizi jiaren*."[8]

Although women's education in China was still in its infancy in the late eighteenth century, the tradition of courtesan-poets could be traced to a much earlier period. The Tang capital of Chang'an already had its renowned Northern District (Beili),[9] and the rise of commerce in the Song capital of Bienjing (modern Kaifeng, Henan province) contributed to the enlargement of the entertainment quarters (and also to the development of the art of storytelling and that of lyric or *ci* poetry). But it was not until trade and commerce brought about a more leisurely life among the gentry during the second half of the fifteenth century that there arose centers of luxurious living, such as Yangzhou and Hangzhou, to rival the two capitals. Zhu Yizun (1629-1709), who edited the *Ming shizong* (Comprehensive Anthology of Ming Poetry),[10] explained, in the headnote to the section on courtesan-poets, the dramatic rise in popularity of poetry writing in the entertainment quarters from the mid-fifteenth to the mid-sixteenth century. Characteristically, this section in Zhu's anthology was entitled "*Jiaofang*" — originally a Tang term designating a department of instruction for training singers of the *ci* or lyric poems when this genre of poetry first gained prominence. As used by Zhu, however, *jiaofang* was also a euphemism: it referred to a government office specifically created to oversee the courtesan trade. With

official sanction, we could assume, came greater prestige, which became even higher among those courtesans also skilled in the art of versification. Zhu Yizun's headnote reads:

According to the Ming system of administration, a *Jiaofang* department was established at both the northern and the southern capitals, supervising two wards (eastern and western) in Beijing and a total of fourteen establishments in Nanjing. The business flourished during the years 1567-73, growing from its inception in the reign peiods of Chenghua and Hungzhi (1465-1522).... During the last quarter of the fifteenth century, courtesans with twenty to thirty different surnames organized themselves into a "sisterhood of handkerchiefs" (*jinpa jiemei*), while fourteen of the most illustrious women had their names entered in a mock honor roll as if they were the equals of "Advanced Scholars" (*jinshi*). There was hardly anyone belonging to the Beili district who did not know how to write poetry.[11]

Talented painter-poets of this period who came from the courtesan class are numerous, such as Ma Shouzhen (cat. nos. 4-9), Xue Susu (cat. nos. 10-13), Gu Mei (cat. no. 21), Dong Bai, also known as Dong Xiaowan (cat. no. 22), and Liu Shi (cat. no. 23).

An apparent ethos in the lives of these talented individuals is the attraction of a poet to a woman who is beautiful as well as skilled in embroidery, singing, painting, writing poetry, or entertaining men. Many of these women yearned perhaps for only a chance that some eminent poet would take notice of their poems. A few were thus immortalized without necessarily entangling themselves in a romance with a poet. The courtesan Ji Yinghuai's two or three well-known poems, for instance, would not have been handed down without their having been praised by the Qing poet Wang Shizhen (1634-1711). And it has also been said that Liu Shi had unsuccessfully offered herself first to the poet Chen Zilong (1608-47) before she made a vow that she must marry someone as worthy as Qian Qianyi (1582-1664). The affairs between a famous courtesan and some literary celebrity of those days must have provided gossip material of absorbing interest for the literati. More importantly, however, as a social phenomenon, especially when this kind of romantic attachment led to marriage (through the system of concubinage), such a relationship often worked as an unseen catalyst on a tradition-bound Confucian society, triggering, one might say, some rare declarations of high passion unimaginable between a man and his ("official" or chief) wife.

One could even say that many such unions of a talented man and a beautiful woman have spawned in China a minor literary genre; that is, memoirs of their remembered lives, including their courtship and marriage, their triumphs and tragedies. That the literatus Mao Xiang (1611-93) penned a memoir inspired by his love for his departed concubine Dong Bai is a case in point. *Yingmei an yiyu* (Reminiscences of the Convent of Shadowy Plum Blossoms)[12] places extraordinary emphasis on a woman's loyalty and the loving way in which Dong Bai carried out her many duties, as recalled by her husband in every intimate detail. Thus the memoir by Mao rises above the level of an ordinary elegy; it becomes, in effect, a celebration of conjugal love, an idyll of married bliss — a literary genre which hearkens back at least to Li Qingzhao's loving reminiscences of her husband, written as an afterword to her husband Zhao Mingcheng's (1081-1129) *Collection of Inscriptions on Bronze and Stone*.[13]

Mao's heartrending account of a concubine's life and death soon inspired many worthy imitators. The household of Chen Wenshu (1775-1845), a follower of Yuan Mei in upholding the importance of education for women, consisted of two beautiful and talented concubines and two beautiful and talented daughters, in addition to a son. The son, Chen Peizhi (1794-1826), had the good fortune of marrying a poet-collaborator named Wang Duan (1793-1839), who is known for her poetry as well as for her scholarship in compiling a critical anthology of Ming-dynasty poetry, entitled *Ming sanshijia shixuan* (Thirty Poets of the Ming: An Anthology). Chen Peiji also surrounded himself with beautiful and talented concubines. Upon the death of one of them, Wang Zilan, or Wang Wanjun (1803-24), he, too, left a memoir, entitled *Xiangwan lou yiyu* (Reminiscences of the Xiangwan Pavilion), which is just as warmly written as Mao's account of his love for Dong Bai. The memoir also contains a number of epitaphs written by the various family members, including one by Chen's chief wife, Wang Duan, who expressed her greatest admiration for the concubine's many good qualities. Here, one can clearly see, the two ideals of "the worthy wife and good mother" and "the talented man and the beautiful woman" merge. And this, though difficult for Westerners to appreciate, is the extra dimension of a Chinese marriage, which created both the need and the occasion for expressions of personal emotions of such great intensity.

Before I discuss the poems of a few of the talented women artists, I hope I will be forgiven a slight digression, because I wish to offer one more observation on the subject of these reminiscences. As later Chinese society underwent various kinds of social and economic change, it is to be expected that the profession monopo-

lized by the courtesans would turn somewhat stale through custom, wither, and die out. But the genre of intimate memoirs about wedded lives has never lost its appeal among the Chinese literati. Witness, for instance, the continuing popularity of Shen Fu's (1763-1809) *Fusheng liuji* (Six Records of a Floating Life), written about another famous married couple during the last year of the author's life.[14] The ideal of the *caizi jiaren* has even survived the Communist revolution, in a manner of speaking. Not long after the end of the Cultural Revolution, Yang Jiang (b. 1911), a woman playwright and translator of the Spanish classic *Don Quixote* into Chinese, quietly published her *Ganxiao liuji* (Six Chapters of Life in a Cadre School).[15] Ostensibly written to detail the life of a Chinese intellectual in a thought-reform school during the Cultural Revolution, the book contains numerous intimate observations of nature and society and glimpses into the author's own emotions when separated from her husband and family. (Her husband, Professor Qian Zhongshu [b. 1910], is generally respected as the most erudite of scholars living in China today and its foremost literary critic.).

Read also, for example, Yang Jiang's description of rain in the book: "One of the things I loved about my hometown of Suzhou was the rain. The leaves on the trees in our rear garden turned the color of jade when they were washed clean of their dust."[16] Or the author's account about her many secret trips across the prison compound to visit her husband in his dormitory, and once to celebrate his sixtieth birthday: "Night had fallen by then, and I was concerned that Mo-cun,[17] with his myopia, would find it hard to see where he was going, . . . It was a starless night and the ground was blanketed by snow . . . but there was nothing to be seen in the pervading darkness except the white snow on the ground."[18] Though neither of these passages, strictly speaking, is related directly to the subjects of this essay, I submit that the sensibility that shaped these accounts is worthy of the most prominent artists included in this exhibition. The political landscape of China may have been irreparably altered from the eighteenth and the nineteenth centuries to the present day, but the eternal landscape of China's countryside remains the same. And nature, in whatever way it has been affected by human sufferings and sorrow, still speaks to us through poetry and painting.

Now let us turn to the poems written by courtesan-poets and women from gentry families, including a few whose paintings are featured in this catalogue. Our access to their poetic oeuvres is limited, for while a great number of them published collections of their verse, these were never as widely circulated and preserved as they would have been had they been written by men. Hence, we have to rely mostly on anthologies, which, however well compiled, are but selections and may not include a full range of themes and subjects.[19] Then there is a second difficulty to contend with; namely, the attitude of a male-chauvinistic society reflected in the anthologies. As is also true of all historical and biographical compilations in Chinese, women poets in anthologies are invariably assigned to a section near the end of the volume, only two notches above Buddhist and Daoist priests and nuns and the sinicized foreigners. Poems bemoaning a woman's fate are seldom anthologized, though cries against the male's claim of absolute superiority occasionally break through the silence. In a poem about her trip to Qufu, Shandong province, to visit the Temple of Confucius, Xi Peilan (active 1775), the first and foremost of Yuan Mei's pupils, wrote:

His bejewelled cap is e'en nobler than the Son
 of Heaven's,
In a woman's garb, I'm too lowly to kowtow before
 the uncrowned king.[20]

Here the contrast between her station in life and that of Confucius, the Perfect Sage, whom the Chinese traditionally referred to as "the uncrowned king," is deliberate and heart-rending, tempered only by the irony of the first line, where Confucius is compared to a crowned emperor, or the Son of Heaven.

More typical in anthologies are elegies written on the death of family members, such as a husband, a sister-in-law, or a young child. A lifetime of widowhood is often the subject of a woman's plaintive lament; and the abandoned woman is a theme familiar to readers of Chinese poetry, who have encountered it especially among the "palace-style poems" (*gongti shi*). For more than a millenium, however, this type of poetry remained the exclusive province of male poets who, through the persona of a forsaken and bereaved woman, sang of a woman's tragic predicament. For example, another pupil of Yuan Mei's, Luo Qilan (cat. no. 52), whose poetry will be discussed more fully later, once painted a picture entitled *Tutoring My Daughter in front of an Autumn Lamp*, which won the admiration of many of her friends. Several of them sent her poems about the painting; one, from a family friend, a Mr. Zeng,[21] reads as follows:

A pair of emaciated shadows in front of a single
 lamp—
Autumn's sound outside the window, I can't bear
 listening.
Your fate, my child, is harsher than your loving
 mother's:
Your father while alive had taught you the classics.[22]

The loneliness and the solicitude of a widowed mother in eighteenth-century China are fully orchestrated in this quatrain; it also contains a direct reference to the name of the poet's studio, which Luo Qilan must have chosen for herself. This poem may be considered a successful example of "palace-style poetry" written by a man who adopts the persona of a bereaved woman. The biographical details we know about this poem certainly help it achieve greater poignancy. (Curiously, while Luo's collected works contain several poems on the same subject of "Tutoring My Daughter," none of them has the emotional intensity of Zeng's poem.)

Parting and death are among the most frequent themes in classical Chinese poetry. In the poems of women who have experienced extraordinary losses and tragedy, one may find perhaps an even greater eloquence in their reflections on their helpless situations. I shall illustrate the quality of this type of poetry with one or two works by Xi Peilan, who was considered by Yuan Mei to be the best woman poet of the empire. Xi became the wife of a famous painter-poet, Sun Yuanxiang (1760–1829), known as a prodigy since childhood; he married Xi when he was only sixteen.[23] It was an ideal marriage, to be sure; yet Xi's early wedded life was dogged by tragedies. She lost two sons, aged ten days and six years, on two successive days, and on the third day her own brother died. From an elegy entitled "Song of a Broken Heart" (*Duanchang ci*), too long to be quoted in full here, I translate only a portion, including the opening and closing lines:

On the day you were born, your grandpa received
 an appointment;
On that account he named you "Auspicious Jade
 of Peace."[24]
Today I must write to the land of miasmal fog and
 torrential rain
A few lines for the eyes of a hoary-headed old man.
.
For six years I cherished you like a night-blooming
 cereus;
I smiled when you were happy, and ne'er struck you
 in anger;
So I won from you a special greeting at your bedside:
You called once for your mom and a second time for
 your dad.
.
When the servant lost a silver cup or the maid upset
 a dish,
You amazed your dad by covering up their faults.
.

Your eyes, water-cleaving shears, froze, and then
 grew dark;
Wrapped around your snow-white flesh, the same tiny
 red quilt.
.
With my eyes already like two dried-up wells,
How could I bear the cries of my widowed mother for
 her son?
.
Sadder still that a younger brother died after the elder:
Two rows of a child's tear descended to the Yellow
 Springs.
.
A cup of wine I offer to your spirit tablet,
Mixed with tears of my broken heart, likewise
 intended for you.
Which part is liquid ambrosia and which part my
 tears?
Let my child taste for himself what's bitter and
 what's tart.[25]

Interwoven with memories of ordinary events in a home, such as a letter received or a dish broken—and of a child's earliest altruistic act—one may find in this passage several sharp images all clustered around "tears." Her own eyes are "two dried-up wells," while the eyes of her child while living, she recalls, were once "as bright as the shears that cleave the water"—a conventional metaphor in Chinese poetry for beautiful eyes. Then, in an effective close, the poet refers to her widowed mother's cry of grief at the death of *her* son (Luo's brother) all leading to a mother's final reflection on what life could have offered her dead child.

In a less personal poem, "Upon Hearing the Sounds of Clothes-Pounding Stones,"[26] Xi treats a thoroughly conventional theme—a woman's longing for her absent lover—with consummate artistry:

What night is tonight?
As cold wind scatters the sound of pestle on a stone?
Beaten to pieces: my dream of distant lands;
Pounded to bits: the heart of a traveler far from home.
A hint of autumn's frost in your looks chills;
Your thudding sound quickens the sinking of the
 dawn moon.
Lying securely on my pillow, in my own boudoir,
To myself I still lament the cold quilt, sleeping alone.

This kind of "boudoir poetry" can be found by the hundreds and thousands, written mostly by men, in the Music Bureau (*yuefu*) and the Jade Terrace (*Yutai*) traditions in Chinese literature. Yet, despite the heavy reliance on conventional phraseology here, Xi is able to breathe new life into a much-used theme through her skill with the parallel couplets in the middle section of the poem.

That poems are meant to express grief or grievance, but always with moderation or restraint, is a cardinal tenet of classical Chinese poetry. Reading through the works of our

women poets, one notices immediately the heavy sense of conventionality, in thought or sentiment, that characterizes their poems. Only occasionally does a flash of personal insight break through the conventions, as in this justifiably famous quatrain by Ma Shouzhen (cat. nos. 4-9):

Since you, milord, went away,
No one's there to share with me the jade goblet.
Wine is a thing that kills sorrow,
But how much time can it kill?[27]

Actually, the title of this poem — "Since you, milord, went away" (zi jun zhi chu yi) — comes from the ancient yuefu, tradition[28] much imitated by later poets. All such imitations start off with the same first line, which serves as a formulaic refrain and encourages permutations of the situation in the other three lines. As a common topoi to express a woman's grief at separation, a poet usually refers to either an object of nature, such as the moon or the star, or such ordinary household items in a woman's boudoir as the hairpin or the mirror; in this poem it is the jade goblet. The charm of this quatrain, however, lies not in its conventionality but in the repetition of the word xiao, meaning to dissolve, dispel, or kill off, in lines 3 and 4. The line may also contain a literary allusion: the Tang poet Bo Juyi (772-846) once wrote, "Wine is a drug that kills sorrow (xiaochou yao)/ It works faster than anything else."[29] And the phrase beizhong wu, or "the thing within the cup," is a playful synecdoche for wine found in the works of many early poets, beginning with Tao Qian (365-427) and including Du Fu (712-770). Perhaps the freshness of Ma Shouzhen's line is her ability to forge a new line out of two closely related expressions.

Generally, though, the majority of poems by women are much less heavily laden with allusions than poems written by men. But the yuefu conventions — including the so-called Songs of "Lady Midnight" (ziye) among the more popular Music Bureau titles — do not depend so much on allusions as on the play of language, such as puns. For instance, a poem by another famous concubine, Gu Taiqing (1799-1876?), ostensibly written on the subject of the painting Autumn Lotus by Yun Shouping, is not, thematically, very different from the yuefu poem that tells of the brevity of love and a woman's sad fate. She wrote:

All in disarray the jade canopies: not a single whole leaf;
Bespattered crimson cloaks chill o'er half the pond.
Let autumn wind and rain beat down and disfigure them:
A rueful heart that nurtures the seed, nobody knows.[30]

Here a pun involving the two meanings of zi as "the seed" and "the son" is used to reinforce the intensity of feeling in the phrase "rueful heart" (kuxin, literally "bitter heart").

An equally light touch in the matter of literary borrowings may be observed in a poem by another courtesan, Wang Wei, also known as Wang Xiuwei (17th c.), mentioned by the philosopher-poet Huang Zongxi (1610-95). In his biography of Li Yin (cat. nos. 24-27), Huang grouped her with Li Yin and Liu Shi (cat. no. 23) and called them the "three most celebrated women" of their time. This poem, written on the topic "Thoughts upon Revisiting the Rain-Flower Terrace and Gazing at the Yangze," includes the couplet:

Fallen blossoms by themselves: today like so many yesterdays;
Singing birds transform dusk to dawn.[31]

Through the use of the word bian, meaning to change or alter, with the singing birds in the second line, Wang Xiuwei evokes the celebrated couplet by the Six Dynasties landscape-poet Xie Lingyun (385-433): "Upon the pool, spring grass is growing,/ The garden willows have changed (bian) into singing birds."[32] These two lines are generally admired as the locus classicus of "spontaneity" in classical Chinese verse. (Bian, though a common word, is seldom used in a Chinese poem, as here, to describe nature's suddenly altered appearance and hence its direct participation in the process of change.) The reappearance of this word here demonstrates that what is conventional need not always be inhibitive or detrimental to poetry or painting.

To gauge the range of styles and subjects in the work of a single poet, we now turn from anthologies to the oeuvre of Luo Qilan. Luo was a student of both Yuan Mei and the noted calligrapher-poet Wang Wenzhi (1730-1802),[33] and both her teachers contributed prefaces to her collected works, published in 1795 under the title Tingqiuxuan shiji (Poems from the Listening-to-Autumn Studio).[34] Luo was ranked second only to Xi Peilan by her teacher Yuan among the scores of disciples he published in Poems by the Women Students of the Master of Sui Garden. That two years before her death a collection of her verse was seen through the press by two of the empire's best-known scholars is a mark of esteem accorded her poems by her respected peers. When we examine the subject matter, the collection is just as varied as that of any man — consisting of travels, social occasions, and personal reflections on life and art — though the range of her experience was considerably narrower.

For example, travel for Chinese women was much more circumscribed than for men, although a wife normally accompanied her husband when he moved from one government post to another. Along the way, she could visit places known for either their scenic beauty or historical associations. Like the poet Wang Xiuwei, Luo Qilan visited the famous Rain-Flower Terrace of Nanjing, about which she wrote:

Mountain colors merge with the level grass;
A tall pavilion, entering into one's gaze, disappears.
No monk is here to preach the Buddhist dharma;
I hear only crows crying at night.
Gone are the elegant ladies of past dynasties;
Thickly gather the misty waves in a rear lake.
Fishermen's songs rise somewhere under the
 moonlight,
As a rustic boat darts out from the reeds and rushes.[35]

No one will claim any great originality of thought for this "regulated verse" (*lüshi*) poem, but the intended juxtaposition of courtly sophistication with the freedom and spontaneity found in nature is quite evident in the opening lines. Here again one sees the effective use of literary borrowing. The word *jie*, occurring in the middle of the first line and meaning "to link up, merge, or connect," is taken from a poem by the Tang poet Wang Wei (701-761); it is used here in conjunction with another phrase — *shanse*, literally "mountain colors" — taken from another of his poems.[36]

Let me illustrate Luo Qilan's travel poems with two more examples. The first is entitled "Climbing Mt. Tianping and Lodging at the Middle Convent of White Clouds":

Finding myself in the clouds, I no longer see the cloud;
Climbing up here, I've forgotten the day's about
 to dusk.
Turning my head, I try to make out the road I came;
I hear only the sound of the stream from beyond
 the tree.[37]

In the sparing use of detail and in its quiet, meditative tone, the poem could rival anything written by Tao Qian, Wang Wei, or Su Shi (1036-1101). It employs only the mildest pun with the repetition of the word "cloud" in the opening line and, at the close, a slight hint of synaesthesia. In the rest of the poem, there is nothing else one can comment on: the poem speaks for itself, like a *Chan* ink painting. The other poem is "Facing Snow":

Mounting the tower, facing snow, I'm tired of
 humming verses.
As I lean against the rail, idling, a thought comes
 to me —
Why marvel that people in the world age easily;
E'en Fragrant Mountain[38] versified about his
 white head.

This is the version appearing most often in an-

thologies, but the use of the word *shi* twice as the rhyme word (in lines 1 and 4) is a violation of the prosodic rules of classical poetry. Hence, in Luo's collected works the last line was emended to read: "There are times even the green mountains appear hoary-headed," with the word *xiang* ("fragrant") changed to *qing* ("green") and the rhyme word *shi* (pronounced in the first tone), meaning "poem" or "verse," changed to *shi* (pronounced in the second tone), meaning "time."[39] Such an emendation was clearly intended to make the poem more regular, but the original version (which must have been the more popular of the two among her peers) is the more witty and prankish.

Subject matter in the oeuvre of a woman poet frequently shows a high incidence of poems written for social occasions and festivals or about the seasons, birthdays, and deaths. Inevitably, there will be a few narrative poems on such feminine topics as rearing silkworms and weaving. Luo Qilan, however, has left us a series of eight poems about "strange dreams." In the headnote to these poems, she wrote that such dreams had often afflicted her in childhood, but had later been largely forgotten. So she tried to recall them and, in a manner suggestive of Coleridge's "Kublai Khan," committed them to paper. The topics of these poems include the examination hall, the seashore, a library, and a *Chan* meditation room. Her "Record of A Dream, Number Seven" reads as follows:

In my dream I led a troop of wolfish and tigerish men;
Under the "Rebel" star,[40] I was born to sweep clean all
 the miasma.
My troops rivaled the lightning's swift strikes;
My battle formations: as if planned by magical birds
 and beasts.
At border passes I poured forth brave stratagems;
And sketched my youthful aspirations on high-flying
 clouds.
Suddenly I was awakened by the sounds of a bell;
The same bow-shaped slippers still on my feet.[41]

While the first six lines breathe death and destruction — unlike anything a traditionally bred Chinese woman would normally have written — the pathos of the last line comes as a total surprise and a painful reminder of the legacy of footbinding and sexual bondage.

The feminist side of Luo Qilan's poetry takes other forms as well. According to her headnote, Luo wrote a series of sixteen poems as a playful response to her women companions, who had shown her some samples of "palace-style poetry," or what she called the *xiang lian shi* ("the fragrance and cosmetic-box poems"). The poem "Rouge" in this series belongs to the subgenre of "poems on objects" (*yongwu shi*):

A low chignon combed into shape, and powder evenly
 applied —
One light touch of crimson cherry enhances her
 charms.
Under a bright moon, all songs of Jiangnan have been
 played clear through;
Now I fear a spot of red may have smudged the jade
 pipe.[42]

The "blowing" or "playing" "clear through" (*chuiche*) of a jade pipe is an allusion to a celebrated conversation between a ruler of the Southern Tang kingdom, Li Jing (916-961) and his poet-courtier Feng Yansi (903-960). Both men were skilled practitioners of the new lyric, or *ci* poetry, with Feng (who had also served as the king's prime minister) enjoying perhaps a wider poetic fame. According to the story, recorded in the standard history of Southern Tang, the king confronted his prime minister by asking: "Should a high official have anything to do with a line like 'The wind suddenly rises/ Blows and wrinkles (*chuizhou*) a pond of spring water'?" — a line from a lyric Feng had written (and the king must have admired). Feng was said to have replied: "This line is really much inferior to Your Majesty's 'Through a low tower blows (*chuiche*) the cold sound of jade pipes'."[43] Chinese poetic convention since the publication of the *Yutai xinyong* (New Songs from a Jade Terrace)[44] has encouraged the use of such mildly erotic imagery as the "jade pipe" or "a touch of red" in love poems. And lyric poetry, especially in the early stages of its development, is most prone to adopt this convention. Thus, by hiding behind a literary allusion, Luo has demonstrated how a Chinese woman of the eighteenth century could successfully turn out some erotic verse and encroach on a subgenre heretofore considered the exclusive province of men.

I should like to close this essay with two poems on painting by Luo Qilan. The longer of the two poems, "Inscription for an Ink Bamboo Painting by Madame Guan," is a tribute to Madame Guan Daosheng (cat. nos. 1, 2) of the Yuan dynasty. The poem is rather traditional; nonetheless, it also expresses the private aspirations and fears of a Qing woman artist:

Fame for talent is hard to achieve from a boudoir.
To mix rouge with ink can only serve for self-diversion.
Her romance and poetry illuminate the universe:
Since time began, where's another Madame Guan
 of Wuxing?

What'er she drew miraculously transmits the spirit;
Bamboos in mist or wind, truly beyond compare!
Before the window, she leisurely spread her Goose
 Stream silk;
Shadows of young branches tangled with spring
 sunlight.
Lowering her coiffured head, she took up her mascara
 brush;

Half a day while humming, she strived for perfection.
She mixed the eyeblacks from her cosmetics box with
 fragrances,
And with a sweep of arm, dubbed on myriad branches
 lustrous jade-green strokes.
By accident, she mixed in a bit of rouge from near
 her lips;
Drops of Consort Hsiang's tears were thus stained red.

.

Stars shift their courses, things alter, and time swiftly
 passes on.
But the silk fragment today still emits its rich
 fragrance.
The bamboo shoots of spring can be likened to her
 ten fingers;
Evening hill-peaks resemble her pair of eyebrows
 dyed green.
Such fame enjoyed by the beauty of an age
Needs only the wisdom of a pure soul to round out a
 blissful life.

All talented ones of Jade Terrace excel in literary arts;
But none is your match in married love that lives from
 age to age.
Whither is your beautiful soul returning today?
Transformed into a slip of cloud above the rivers Xiao
 and Xiang.[45]

Here the great Yuan-dynasty painter Guan Daosheng is accorded the highest praise, by means of a conventional compliment, for having "miraculously transmitted the spirit" in her depiction of bamboos in mist or wind. But, behind the eulogy, what appears to preoccupy Luo Qilan's mind as much as Madame Guan's art is the celebrated, happy life she shared with her painter-husband. In Luo's mind, life and art remain irrevocably intermingled — justifying her final evocation of the two ladies of the Xiao and Xiang rivers, the consorts of the legendary Emperor Shun.

The shorter poem belongs to the genre of "poems on paintings" (*tihuashi*). It is about a *Blossoming Apricot and Paired Swallows* painting by the artist Wu Songliang (1766-1834), who is referred to in the title of the poem by his style-name of Lanxue:

Banqueting over, the setting sun slants across the river
 bridge;
One snap of the whip, his horse races to the capital.
His official robe's green is as lush as the grass on royal
 boulevards
Spotted with fresh petals of red, as swallows dislodge
 blossoms from branches.[46]

The poem employs a pun between the two homophonous Chinese words for "swallow" and "banquet," both pronounced *yan*. "Banqueting" leads to thoughts of an official life (cf. *qingpao*, literally "blue gown or robe," and *tianjie*, "street of the capital"), in search of title and honor. And all this is deliberately juxtaposed to an unappreciated scene of nature: the swallows "kicking" petals (*yan cu hua*) to the ground as they hop from one branch to an-

other. The word *zhan* in the last line (translated as "spotted") is powerfully ironic, since the word has two meanings: "to stain" and "to honor." In this "poem on painting," Luo strives to enhance a visual representation with a conceptual richness made possible through allusions, puns, and other literary devices. Again and again, we have seen how the use of a convention can help uncover fresh points of view and lend both spontaneity and power to a depiction of the human condition. Poetry and painting differ only in the media used.

The Muses of Western civilization, the offspring of Zeus and Mnemosyne, may have been nine in number: Clio, Calliope, and all the rest. The Chinese, however, rarely sought inspiration for human activities solely in the divine. Rather, it is often humans — at least some of the worthy ones — who in the dawn of history were elevated to partake of the divine and lend inspiration to poetry and the arts. According to legend, the sage Emperor Yao had two daughters, Ehuang and Nuying, and both became consorts to Emperor Shun, the second of the three sage rulers of antiquity. Upon the death of Emperor Shun, the two consorts (who dwelled on the banks of the Xiao and Xiang rivers) wept their bitter tears before drowning themselves to end their sorrow. It is the lives of these two daughters that were recounted in the first chapter of *Lienu zhuan* (Biographies of Virtuous Women), by Liu Xiang (77-6 BC),[47] the first of a long line of exemplary lives of virtuous women. And Luo Qilan immortalized them as well in her poem "Twin-stem Orchid" (*bingdi lan*) — also a symbol of conjugal happiness: "Who is there to play a song toward the Xiao and Xiang Rivers/ At the time when the two consorts came out to hear them under a bright moon?"[48]

One may wish to take sides with either David Hawkes, the translator of *Honglou meng* (The Story of the Stone), or the late Professor Zachner on whether it should be *homo lacrimans* or *homo ridens* that best describes the hundreds of characters who live in the pages of Cao Xueqin's famous novel.[49] But this can certainly be said: It is the tears of Chinese women shed in their boudoir or under a starless sky that nurtured the "acre upon acres of orchid" (*lanwan*) destined either to waste their sweetness on the night air or to bear fruit in the imperishable arts we admire today.

1. For the translation of *sanjue* as the "Three Perfections, or Three Incomparables," I follow Michael Sullivan. "For over a thousand years," Sullivan writes, "the three arts of painting, poetry and calligraphy have been intimately connected in the minds of cultivated Chinese." See Michael Sullivan, *The Three Perfections: Chinese Painting, Poetry and Calligraphy* (London: Thames and Hudson, 1974), p. 7.

2. *Lunyu* (The Analects), XV:38. Translated by Wing-tsit Chan, in his *A Source Book of Chinese Philosophy* (Princeton: Princeton University Press, 1973), p. 44.

3. Ibid., VI:28.

4. For the influence of this concept on Chinese fiction, see E. Perry Link, Jr., *Mandarin Ducks and Butterflies: Popular Fiction in Early Twentieth Century Chinese Cities* (Berkeley: University of California Press, 1981), especially pp. 64-78.

5. See especially pp. 7-9 of the Introduction to *Waiting for the Unicorn: Poems and Lyrics of China's Last Dynasty, 1644-1911*, ed. Irving Yucheng Lo and William Schultz (Bloomington: Indiana University Press, 1986).

6. See Liang Yi zhen, *Qingdai funu wenxueshi* (Taipei: Zhonghua 1958), p. 1.

7. For the translation of this term, I am indebted to the late Professor James J. Y. Liu. See his *Chinese Theories of Literature* (Chicago: The University of Chicago Press, 1975), p. 86.

8. Zhang Xuecheng, *Bingchen zhaji*, reprinted in *Zhang shizhai zhaji sizhong* (Taipei: Guangwen, 1971), p. 78. Zhang's denunciation of Yuan Mei has been discussed in some detail by David S. Nivison in his monograph *The Life and Thought of Chang Hsueh-ch'eng* (Stanford: Stanford University Press, 1966), pp. 264-65. The controversy between Zhang and Yuan is also referred to in Mary Backhus Rankin's essay "The Emergence of Women at the End of the Ch'ing: The Case of Ch'iu Chin," in *Women in Chinese Society*, ed. Margery Wolf and Roxane Witke (Stanford: Stanford University Press, 1975), p. 42.

9. See Sun Qi (fl. 889), *Beili zhi*, trans. by Robert Des Retours and published under the title *Courtisanes chinois à la fin des T'ang (789-881)* (Paris, 1968).

10. *Juan* 98, for courtesan-poets. There are two *juan* for "talented gentry women," *Juan* 86-87.

11. Zhu Yizun, *Ming shizong*, 1705 edition, 98:1a.

12. See English translation by Pan Tze-yen, published under the title *The Reminiscences of Tung Hsiao-wan* (Shanghai: The Commercial Press, 1931).

13. For a partial translation of this essay, written by Li Qingzhao in 1132, see James J. Y. Liu, *Essentials of Chinese Literary Art* (North Scituate: Duxbury Press, 1979), pp. 36-39. Also see the chapter entitled "The Snares of Memory," by Stephen Owen, in his *Reminiscences: The Experience of the Past in Classical Chinese Literature* (Cambridge: Harvard University Press, 1986) for a translation of the full text.

14. See Paul S. Ropp, "Between Two Worlds: Women in Shen Fu's *Six Chapters of a Floating Life*," in *Women and Literature in China*, ed. Anna Gerslacher, et al. (Bochum, 1985), pp. 98-140. Ropp especially points out: "Qing prosperity continued Ming trends of increasing female literacy and a growing urban entertainment culture.... This combination of prosperity, urban living with greater anonymity, a growing entertainment culture, and increased female literacy helped some couples develop a more egalitarian relationship and lifestyle than had been conceivable in earlier times" (p. 103).

15. The book has been translated by Howard Goldblatt and published under the title *Six Chapters From My Life "Down-under"* (Seattle: University of Washington Press, 1983).

16. Ibid., p. 69.

17. Mo-cun is the courtesy-name of Qian Zhongshu.

18. Goldblatt, p. 77.

19. In addition to *Ming shizong*, edited by Zhu Yizun, there are two larger anthologies of Qing verse, both compiled in the twentieth century. One of *shi*-poetry, compiled under the leadership of Xu Shichang and published in 1919 in Tianjin, is entitled *Wanqing yi Qing Shihui*, and contains ten *juan* (nos. 183-92) devoted to selections by about 450 poets. The other, of lyric or *ci*-poetry, is the *Quan Qing Cichao*, edited by Ye Gongchuo and published in 1975, in which collection selections by 427 women poets are included in *juan* 30-34.

20. "Qufu," *Suiyuan nudizi ji* (Hong Kong: Guangji, n.d.), p. 3.

21. He was known by his courtesy-name of Zeng Bingu.

22. "Tutoring My Daughter in front of an Autumn Lamp." This poem was quoted by Liang, p. 86.

23. Sun Yuanxiang later became known as one of the "Three Princes [of the empire]" along with two other poets:

Shu Wei (1765-1816) and Wang Tan (1760-1817). Xi Peilan's collected works, the *Changzhen ge ji*, were printed in 1829 in the same volume as her husband's, which was published under the title *Tianzhen ge ji*.

24. "Lu-an," with the character *lu* meaning "a precious jade."

25. Liang, pp. 66-68.

26. "Wen Zhen," *Qing shihui*, 186:52b. *Zhen* is a piece of stone, or anvil, upon which clothes are pounded by a mallet as they are washed clean.

27. *Ming shizong*, 98:3b.

28. See *juan* 69 of *Yuefu shiji* by Guo Maoqian.

29. "Quanjiu ji Yuan Jiu," *Xiangshan Changqingji*, 9:4b.

30. Quoted in Shu Zhide, *Zhongguo funu wenxue shihua* (Hong Kong: The Shanghai Book Co., 1963), p. 106.

31. *Ming shizong*, 98:7b.

32. "Up in the Lakeside Tower," trans. J. D. Frodsham in *The Murmuring Stream: The Life and Works of the Chinese Nature Poet Hsieh Ling-yun (385-433), Duke of K'ang Lo* (Kuala Lumpur: University of Malaya Press, 1967), I:121.

33. Wang Wenzhi was also the grandfather of Wang Yuyan (cat. no. 52).

34. Luo Qilan, *Tingqiuxuan shiji* (Jinlin: Gongshi Kanben, 1795). Subsequent references to Luo's poems are made to this edition.

35. "Yuhuatai chun wang," *Tingqiuxuan shiji*, 1:1a.

36. See Poem 78 ("Sailing Down the Han River") and Poem 77 ("Mt. Zhongnan") in Pauline Yu, *The Poetry of Wang Wei* (Bloomington: Indiana University Press, 1980), p. 170. The two lines in question, from Poem 79, read: "White clouds, as I turn and gazed, merge./Azure mists, as I enter and look, disappear."

37. *Tingqiuxuan shiji*, 1:5a.

38. Xiangshan, literally "Fragrant Mountain," is the style-name of the Tang poet Bo Juyi, whose collected works contain several poems written on the subject of white hair. See

Xiangshan Changqingji, 9:2b, 9:6a-6b, 20:6a, and *Xiangshan Changqing houji*, 15:12a.

39. For the alternative version, see *Tingqiuxuan shiji*, 1:4a. The earlier version is given in *Qingdai guixiu shichao*, (Shanghai, 1925), 7:4b. Comparing the two versions, one will note other minor changes: In line 4, the word *ye* is changed to *huan*, both meaning "still" or "even." In line 3, *moguai* ("do not marvel") is changed to *guaidi* ("why marvel"). Also the poem in her collected works is given a fuller title: "Facing Snow at Qian Mountain Tower," probably implying a pun between *qing* ("green") and *qian* ("pretty" and also the name of the mountain). Also quoted in Liang, p. 88.

40. *changqiang*: Chinese name for a comet, used to designate a rebel leader.

41. "Jimeng shi," *Tingqiuxuan shiji* (Jinlin: Gongshi Kanben, 1795), 2:2b.

42. Ibid., 2:9b.

43. See Ma Ling's *Nantang shu* (*Mohai Jinhu* edition in the *Baibu cunshu* series, vol. 42:2), 21:4a. Translation of Li Jing's line is by Daniel Bryant, in *Sunflower Splendor: Three Thousand Years of Chinese Poetry*, ed. Wu-chi Liu and Irving Yucheng Lo (New York: Doubleday Press/Anchor, 1975; 1983), p. 300.

44. See Anne Birrell, trans., *New Songs From A Jade Terrace: An Anthology of Early Chinese Love Poetry* (London: Allen & Unwin, 1982).

45. Luo, 3:9b-10a.

46. Ibid., 3:4a.

47. Liu Xiang, *Lienu zhuan* (Taipei: Zhengzhong reprint), 1:2b-3a.

48. Luo, 2:5b.

49. Cao Xueqin, *The Story of Stone: The Crab Flower Club*, trans. David Hawkes (Bloomington: Indiana University Press, 1979), p. 21. The fourth of this five-volume series, translated by John Minford, published in 1982, carries the subtitle "A Debt of Tears."

哀而不傷：雙蘭窮錦

席佩蘭〈曲阜〉

　　晃旆貴且臨天子，巾幗卑難拜素王

曾賓谷〈秋燈課女圖詩〉

　　一燈雙影瘦伶俜，窗外秋聲不可聽
　　兒命苦於慈母處，當年有父爲傳經

席佩蘭〈斷腸辭〉

　　記兒生日祖遷官，錫汝嘉名曰璐安
　　今日蠻煙瘴雨外，一行書寄白頭看
　　‥‥‥‥‥‥‥
　　六年奉汝似曇花，喜即開顏怒不撾
　　博得床頭臨別喚，一聲娘罷一聲耶
　　‥‥‥‥‥‥‥
　　奴失銀杯婢覆羹，替人擔過受耶驚
　　窮水雙瞳凍欲沈，雪膚還裹小紅衾
　　‥‥‥‥‥‥‥
　　可堪兩眼枯如井，更聽孀親哭子聲
　　弟後兄先更可哀，一雙珠顆落泉臺
　　‥‥‥‥‥‥‥
　　一盃艮醢奠靈床，滴向泉臺哭斷腸
　　誰是酒漿誰是淚，教兒酸苦自家嘗

席佩蘭〈聞砧〉

　　今夕是何夕，涼風動遠砧
　　敲殘天外夢，擣碎客邊心
　　韻雜秋霜冷，聲催曉月沈
　　深閨高臥穩，猶自怨孤衾

馬守眞〈自君之出矣〉

　　自君之出矣，無共擧瓊卮
　　酒是消愁物，能澆幾個時

顧太清〈秋荷題惲南田畫〉

　　批離翠蓋無全葉，零落紅衣冷半池
　　秋雨秋風任憔悴，苦心結子有誰知

王微（王修微）〈登雨花臺望江有感〉

　　落花自古今，啼鳥變昏旦

駱綺蘭〈雨花臺春望〉

　　山色接平蕪，高臺入望無
　　不聞僧說法，唯聽夜啼烏
　　金粉空前代，煙波積後湖
　　月中漁唱起，野艇出菰蒲

駱綺蘭〈登天平山憩中白雲庵〉

　　身在雲中不見雲，登臨忘卻日將曛
　　回頭欲辨來時路，惟有泉聲隔樹聞

駱綺蘭〈倚山樓對雪〉

　　登樓對雪嬾吟詩，閑倚闌干有所思
　　怪底世間人易老，靑山還有白頭時
　　〈對雪〉
　　登樓對雪嬾吟詩，閑倚闌干有所思
　　莫怪世間人易老，香山也有白頭詩

駱綺蘭〈紀夢詩八首之七〉

　　夢領貔貅隊，欃槍掃霧霾
　　師疑霆電下，陣是鳥蛇排
　　關塞抒雄略，雲霄寫壯懷
　　鐘聲忽催覺，依舊著弓鞋

駱綺蘭〈女伴中有以香奩雜詠詩見示者戲
　　　　爲廣之得十六首之六〉〈脂〉

　　倭鬢梳成粉罷調，朱櫻微注更嬌韶
　　月明吹徹江南曲，多恐輕紅染玉簫

馮延巳〈謁金門〉

　　風乍起，吹皺一池春水

李璟〈浣溪沙〉

　　小樓吹徹玉笙寒

駱綺蘭〈題管夫人墨竹〉

　　閨閣才名不易顯，弄墨然脂唯自遣
　　風流詞翰照人寰，古來誰似吳興管
　　夫人繪事善傳神，霧籜風篁尤絕倫
　　當窗閑展鵝溪絹，婀娜柔梢影弄春
　　低鬟輕搦畫眉筆，半日沉吟工取格
　　匀調螺黛半奩香，揮灑琅玕萬枝碧
　　有時誤染口邊脂，幾點湘妃淚痕赤
　　‥‥‥‥‥‥‥
　　星移物換流光速，此日殘縑挹芳馥
　　春筍疑抽十指纖，晚峰似掃雙蛾綠
　　一代紅粧占盛名，憑將淨慧消清福
　　玉臺才子盡能文，佳話千秋卻遜君
　　芳魂此日歸何處，化作瀟湘一片雲

駱綺蘭〈題蘭雪杏花雙燕圖二首之一〉

　　酒罷河橋落日斜，一鞭走馬到京華
　　靑袍綠似天街草，沾得新紅燕蹴花

駱綺蘭〈並蒂蘭二首之一〉

　　誰向瀟湘彈一曲，二妃出聽月明時

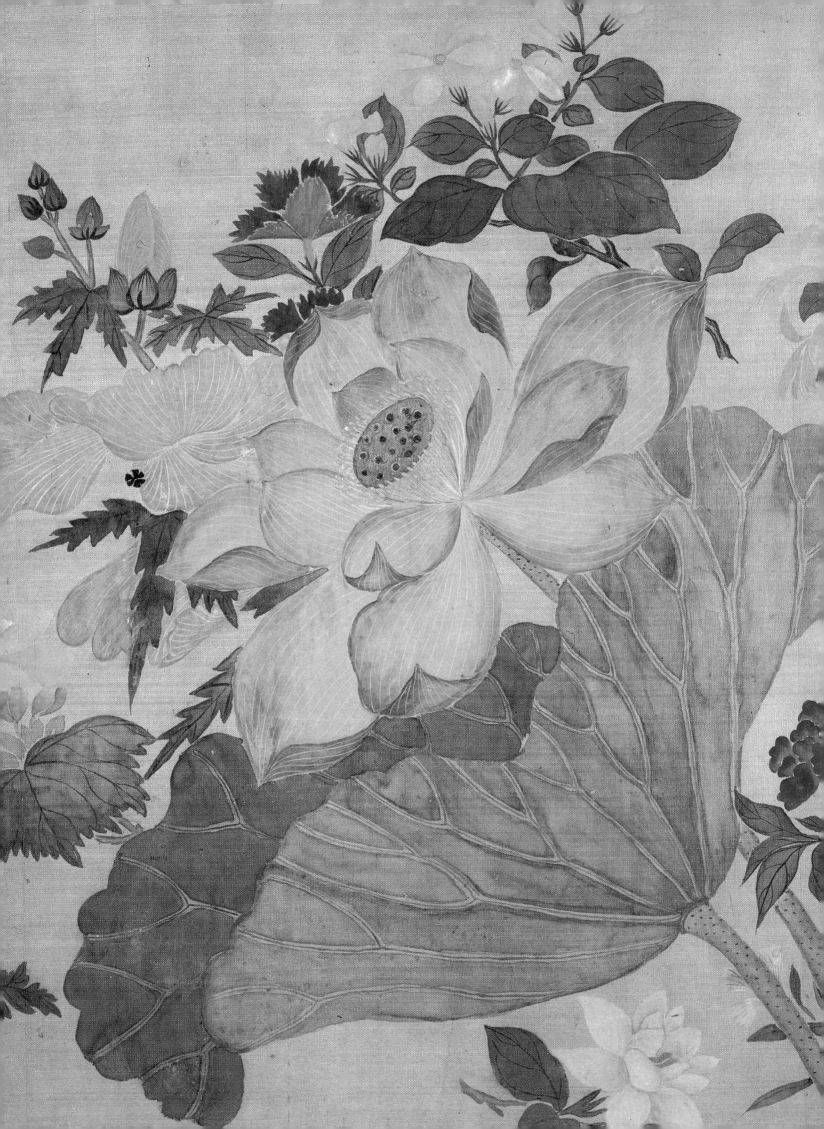

Flowers from the Garden: Paintings in the Exhibition

Marsha Weidner

Literary Moments in the Garden

In the preface to his *Mirror of Flowers* (*Hua jing*), a guide to gardening and "country pursuits," the gentleman gardener Chen Haozi confessed that from his youth he had cared for nothing but books and flowers: "Twenty-eight thousand days have passed over my head, the greater part of which has been spent poring over old records, and the remainder in enjoying myself in my garden among plants and birds.... People laugh at me, and say that I am cracked on flowers and a bibliomaniac; but surely study is the proper occupation of a literary man, and as for gardening, that is simply a rest for my brain and a relaxation in my declining years. What does T'ao Ch'ien say? — 'Riches and rank I do not love, I have no hopes of heaven above.'... Besides, it is only in hours of leisure that I devote myself to the cultivation of flowers."[1] Chen's sentiments exemplify the affection of the Chinese people for all aspects of the garden. Chinese literature is full of treatises on flowers — flowers of particular locales, flower names, flower calendars, and flower arranging — and whole volumes are devoted to single species — the peony, chrysanthemum, orchid, blossoming plum (prunus), lotus, and flowering crab apple.[2] Flowers and flower lore also figure prominently in short stories, novels, and reminiscences. Narratives set in the gardens and courtyards of the gentry portray especially vividly the circumstances that fostered the Chinese art of flower painting.

The writer and painter Shen Fu (b. 1763), a native of the famous garden city of Suzhou, was another man who was, in his own words, "obsessed with a love of flowers."[3] Much of the chapter on "The Pleasures of Leisure" in his famous autobiographical *Six Records of a Floating Life* is devoted to descriptions of the joy he and his beloved wife Yun took in cultivating and arranging various plants. The orchid, he maintained, was his favorite bloom "because of its elegant fragrance and charming appearance." Once he was presented with an especially wonderful pot of orchids resembling lotus blossoms:

The centres were white and broad, and the edges of the petals were straight. They had thin stems, and the petals themselves were quite pale. This was a classic flower, and I treasured mine like a piece of old jade. When I was away from home Yun would water it herself, and its flowers and leaves grew luxuriantly.[4]

Sadly, this treasured plant was deliberately killed by someone to whom Shen had refused a cutting. After the orchid, he favored the azalea:

Although it has no fragrance to speak of, its colours are long-lasting and it is easy to prune. But because Yun loved their branches and leaves, she could not stand to see me prune them too much, so it was difficult to raise them properly. It was the same with all my other plants.[5]

He goes on to discuss the principles of flower arranging, the raising and training of potted trees, garden design, and the creation of small scenes with trees, stones, and flowers. Throughout it is clear that his wife shared his enthusiasm, and he took pride in her ideas:

When living at home I always had a vase of flowers on my desk. Once Yün said to me, "No matter what the weather, you can always manage to put together beautiful flower arrangements. Now in painting there is a school that specializes in insects on grasses. Why don't you try your hand at that?"
"There's no way to control the wandering of insects. How can I study them?" I answered.
"There is a way, but I am afraid it seems almost criminal to me," said Yün.
"Try telling me."
"When an insect dies its colours do not change," Yün said. "You could find an insect like a praying mantis, a cicada or a butterfly, and kill it by sticking it with a pin. Then use a fine wire to tie its neck to a flower or a blade of grass, arranging its feet to grasp the stem or stand on a leaf. It will look just as if it were alive. Wouldn't that work?"
I was delighted and did as she suggested. No one who saw these insects failed to praise them. It is hard to find such clever women these days![6]

The seventeenth-century romantic Mao Xiang devoted a chapter of his reminiscences of his concubine Dong Bai (cat. no. 22) to her keen feeling for flowers. He recalls their strolls among the blossoming-plum trees planted in nearly every available space of his garden and Dong Bai's fondness for plucking budding twigs to arrange in vases. She cultivated bamboo, grass, and flowers that bloomed throughout the year and appreciated especially the "most graceful species"; the "tawdry in colour and taste were... not to her liking." In the autumn she took special pleasure in chrysanthemums. To heighten their enjoyment of an unusually fine specimen, she placed a six-fold screen around it; then in the evening she took a seat in the enclosure next to the plant and placed candles so as to cast graceful shadows of her own figure and the chrysanthemum on the screen. Naturally Mao and Dong also savored the fragrance of the orchid. He wrote:

My concubine once kept nine stalks of the vernal orchid and also some of the Fukien species, so from spring to autumn a most pleasing odour filled her chambers as if one were carried to the orchid-producing centres in Hunan Province.[7]

The role of the garden in gracious living is set forth in great detail in *The Story of the*

Stone, Cao Xueqin's eighteenth-century account of the decline of a wealthy family. As briefly noted in the first essay in this catalogue, Cao's story unfolds in the grand Prospect Garden, where the primary characters reside and pass their days creating elegant diversions inspired by the garden's beauties. One such diversion was the Crab-flower Club, a poetry society. In establishing the club, one of the young ladies issued the following invitation to her brother, another inmate of the garden:

I have been thinking how in the olden days even men whose lives were spent amidst the hurly-burly of public affairs would keep some quiet retreat for themselves with its tiny corner of mountain and trickle of running water; and how they would seek, by whatever arts and blandishments they knew of, to assemble there a little group of kindred spirits to share in their enjoyment of it; and how, on the basis of such leisure-time associations, rhymers' guilds and poetry clubs were then founded, so that the fleeting inspirations of an idle hour might often be perpetuated in imperishable masterpieces of verse.

Now although I am no poet myself, I am privileged to live "midst rocks and streams" and in the company of such gifted practitioners of the poetic art as Xue and Lin; and it seems to me a great pity that the romantic courts and pavilions of our Garden should not echo with the jocund carousal of assembled bards, and its flowering groves and blossoming banksides not become places of wine and song. Why should the founding of poetry clubs be the sole prerogative of the whiskered male, and female versificators allowed a voice in the tunable concert of the muses only when some enlightened patriarch sees fit to invite them?

Will you come, then, and rhyme with us? The pathway to my door is swept to receive you and your arrival is eagerly awaited by,

Your affectionate Sister[8]

Duly formed, the club met to write poems on set themes, the first being the white crab-blossom from which the society took its name. For a later round of composition they chose the chrysanthemum. Although seasonally appropriate, this topic was difficult because so many poems had been written about this flower in the past. After giving the problem some thought, they decided that their efforts might be less hackneyed if they introduced a narrative element "by making up verb-object or concrete-abstract titles" in which "chrysanthemums" would be the concrete noun or object of the verb. Accordingly, they invented a series of poem titles, each describing an action or situation involving the flowers—remembering, seeking, planting, admiring, arranging, celebrating, painting, questioning, and wearing the chrysanthemums, dreaming of the chrysanthemums, the "shadow" of the chrysanthemums, and, finally, the "death" of the chrysanthemums.[9]

In the fictional Prospect Garden, where flower-inspired melancholy reflections on the transience of life were inescapable, the passing of the flowers brought sad little flower burials as well as a colorful send-off for the flower spirits:

Next day was the twenty-sixth of the fourth month, the day on which, this year, the festival of Grain in Ear was due to fall.... It has been the custom from time immemorial to make offerings to the flower fairies on this day. For Grain in Ear marks the beginning of summer; it is about this time that the blossom begins to fall; and tradition has it that the flower-spirits, their work now completed, go away on this day and do not return until the following year. The offerings are therefore thought of as a sort of farewell party for the flowers.

This charming custom of "speeding the fairies" is a special favourite with the fair sex, and in Prospect Garden all the girls were up betimes on this day making little coaches and palanquins out of willow-twigs and flowers and little banners and pennants from scraps of brocade and any other pretty material they could find, which they fastened with threads of coloured silk to the tops of flowering trees and shrubs.[10]

A similar picture, but one based on real events, was drawn by Princess Der Ling in *Two Years in the Forbidden City*, an account of court life under the Empress Dowager Cixi (cat. nos. 70-73). The Empress Dowager greatly loved flowers, and on the twelfth day of the second month of the lunar year she joined her ladies in waiting in celebrating the "birthday of the flowers and trees." After the morning audience, the Empress Dowager led her attendants into the palace grounds, where the eunuchs were waiting with huge rolls of red silk. The ladies cut the silk into narrow strips, then, following the lead of the Empress Dowager, decorated every tree and plant with the ribbons. "This took up nearly the entire morning," Der Ling wrote, "and it made a very pretty picture, with the bright costumes of the Court Ladies, green trees and beautiful flowers." This ceremony was followed by a theatrical performance of the tree and flower fairies celebrating their birthday:

The Chinese believe that all the trees and flowers have their own particular fairies, the tree fairies being men and the flower fairies being women. The costumes were very pretty and were chosen to blend with the green trees and flowers which were on the stage.... The scene was a woodland dell, surrounded with huge rocks perforated with caves, out of which came innumerable small fairies bearing decanters of wine. These small fairies represented the smaller flowers, daisies, pomegranate blossoms, etc.... All the fairies gathered together and drank the wine, after which they commenced to sing, accompanied by stringed instruments, played very softly. The final scene was a very fitting ending to the performance. It represented a small rainbow which gradually descended until it rested on the rocks; then each fairy in turn would sit upon the rainbow which rose again and conveyed them through the clouds to Heaven.[11]

Flowers (cat. no. 11) by the seventeenth-century courtesan Xue Susu, and Wu Shangxi's

Butterflies and Flowers, dated 1854 (cat. no. 61), were both done on the birthday of the flowers. Like the passages quoted above, these paintings and many more in the exhibition testify to the tremendous enthusiasm for floriculture displayed by members of the Ming and Qing gentry.

*Selected Flower
Paintings in
the Exhibition*

The discussion that follows covers a broad range of floral images, encompassing pictures of flowers combined with other plants, fruit, birds, and insects, but it largely excludes "plants and flowers of the mind," the ink studies of bamboo, plum blossoms, and orchids that evoke the scholar's studio more than the garden. Reminiscent of noble figures of the past and laden with literary associations, these subjects affirmed specific scholarly ideals. Brush and ink conventions were developed for their representation; their forms were subjected to varying degrees of abstraction; and, like calligraphy, they became vehicles for scholarly self-expression. Women's contributions to this esteemed form of scholar-painting are represented by a number of fine works in the exhibition, but so much has been written about similar bamboo, orchid, and plum-blossom paintings by men that the notes in the catalogue entries should suffice to place the exhibited pieces in their proper art-historical contexts.

Other plants and flowers also accumulated historical and literary associations, transmitted cultural values, and offered opportunities for original expression, but on the whole they carried less intellectual and art-historical baggage and were subjected to less abstraction than the plum, orchid, and bamboo. Streamside and courtyard blooms were depicted primarily for their seasonal character and sensual beauty. Lovingly detailed descriptions of peonies, peach blossoms, hibiscus, lilies, magnolias, asters, begonias, and camellias, in ink monochrome as well as color, reveal a sensitivity to nature comparable to Shen Fu's feeling for his orchids and to the responses of the young poets of the Prospect Garden to their chrysanthemums. Western audiences, however, have been introduced to comparatively few of the elegant Ming- and Qing-dynasty paintings that correspond to the garden descriptions found in the literature of the period.[12] This essay is therefore devoted to selected examples from the exhibition.

To capture the beauty of wild and garden flowers, Ming and Qing painters relied not only on firsthand observation, but also on a number

of well-established styles and techniques. By the time the Ming dynasty was established in the fourteenth century, flower painting was already a very old genre in China, with a history encompassing regional developments as well as styles created for different social contexts. Scholarly painters were well aware of the methods of their predecessors and used them self-consciously in their own works.

A number of artists represented in the exhibition drew inspiration from traditions created by masters who served the courts of the Five Dynasties (907-960) and Northern Song (960-1127) periods, namely Xu Xi (died before 975), Huang Quan (903-968), and their successors. Xu Xi of Nanjing is said to have preferred subjects drawn from the countryside — waterside blooms, wild bamboo, aquatic fowl, "deep-swimming fish of rivers and lakes," garden vegetables, herbs, and flowering branches — but he found his audience at court. Paintings of "clustered blooms and heaped rocks with herbs sprouting from their sides" and "birds, bees and cicadas" by Xu and his school were presented to the ruler of the Southern Tang dynasty (937-975) for the decoration of his palace.[13]

Huang Quan of Sichuan and his followers were contrasted with Xu, as indicated by the saying "The Huangs were rich and noble; Xu Xi was rustic and free." The Huangs treated such dramatic subjects as falcons, white pheasants, peacocks, and cranes, as well as smaller birds, flowers, and insects, in a detailed, richly colored manner. Huang Quan's son Huang Jucai (933-after 993), for instance, served the Song-dynasty court by painting "the rare fowl, auspicious birds, unusual flowers, and grotesque rocks found in the imperial park."[14] The style of the Huangs was taken up by Xu Xi's grandson Xu Chongsi, an artist often cited as a model by later painters. Xu Chongsi was particularly admired for his "boneless" (*mogu*) method of painting flowers in color without visible ink outlines.[15]

The "realistic" art of the Huangs and their followers set the direction of flower-and-bird painting in the imperial academies of the Song dynasty, the "golden age" of court or "academic" painting. The genre reached unsurpassed heights during the reign of the great artist and patron Emperor Huizong (r. 1101-25). Huizong took a profound interest in his garden, with its marvelous animals, birds, and flowers collected from all over the empire and presented by emissaries from exotic lands. Each newly acquired plant and creature was carefully recorded, and the finest were depicted by the emperor himself and by members of his academy. The twelfth-century

scholar Deng Chun reported:

During the long period of prosperity and peace, many auspicious things which bring good luck came in day after day, and they were all noted down by the recorders. Among the birds and animals there were the red crow, the white magpie, the heavenly deer, and the Java sparrow. They were all kept in the palace garden. Among the trees and plants were many kinds of junipers and purple fungi, peal-lilies and gold-oranges, double bamboo, melon flowers, and Lien-chin trees; they were all extraordinary.... The emperor selected fifteen of the most extraordinary specimens and painted them in colours in an album.... There were furthermore the scented jasmine and the Indian *Sala* flowers, both products of foreign countries. He made inquiries into their place of origin and examined their nature thoroughly. Then he described them in poems and made pictures of them which formed a second album.[16]

The process described in this passage — careful selection, thorough examination, and description in poetry as well as painting — constituted the typical courtly response to the rarities of the imperial garden. The resulting paintings were, for the most part, meticulously colored, highly finished portrayals of exquisite motifs alone or combined in decorative arrangements. They not only paid tribute to the myriad wonders of nature, but also suggested the power of the ruler who could command such wonders for his own pleasure and, too, the good fortune of all who had the privilege of being ruled by such an individual.

The flower-painting methods of the Song court academies naturally became the basis for palace and professional styles of later periods, but they were also taken up by semi-professional and amateur painters. In the present exhibition the floral glories of the palace are most vividly evoked by the handscroll of *The Hundred Flowers* (cat. no. 34), which bears the signature of the late-seventeenth-century painter Jin Yue, a concubine in the household of the literatus Mao Xiang of Rugao, Jiangsu province. Jin is regarded as an amateur, even though she painted at Mao's command and was apparently as capable as a professional in handling different subjects and styles. The conservative character of her colorful scroll is explained in part by Mao Xiang's colophon, in which he stated that he ordered his concubine to "imitate the ancients." To underscore his antiquarian concerns, he also wrote out a poem on flowers by the eminent Song-dynasty scholar Ouyang Xiu (1007-72). Jin Yue's composition, with its alternation of red and white flowers and seasonal progression, could almost have been dictated by the first two lines of the poem:

The light and the deep, the red and the white, should
 be spaced apart;
The early and the late should likewise be planted in
 due order.[17]

In a broader art-historical context, Jin's *Hundred Flowers* scroll can be compared with such Qing-dynasty works as the *One Hundred Flowers* by Zou Yigui (1686-1772) and Qian Weicheng's (1720-72) *All Flowers Bloom at Once in the Spring*.[18] It shares with these paintings the technical excellence, opulent color, and decorative impact characteristic of the academic tradition. All three handscrolls are precisely drawn, without a hint of spontaneity or individual idiosyncracy. Within this general framework, however, they have different personalities. The scrolls by Zou Yigui and Qian Weicheng display a stiffness and compositional rigidity characteristic of much Qing-court flower painting. Individual branches and clusters of blossoms in Zou Yigui's *One Hundred Flowers*, for example, are widely spaced, with a good deal of empty silk left around each, and they cling to the upper and lower edges of the scroll. Although Jin Yue's *Hundred Flowers* has a comparable formality, with each element carefully placed in relation to the next, it retains a degree of naturalness. The blossoms are spread boldly across the middle of the picture space, without contrived reference to the edges, giving the pleasing impression that they just tumbled onto the silk.

Of course, Jin's composition, perhaps taken from an old model, is not without its own contrivances. It opens and closes with small clusters set slightly apart to function as brackets for the lush fullness of the center. After beginning with delicate plum blossoms and narcissus, spring hints of the glories of the season to come, it swells to a lavish summer display that culminates with an opulent pink lotus, then concludes with branches of camellia and wax plum, the relatively modest plants of winter. Combinations of various species provide an array of engaging contrasts. Consider the almost whimsical juxtaposition of the exuberant, sensuous pink lotus and the fragile pink begonia: the similarity in their colors underscores the differences in their floral characters. Each of Jin's flowers, like those by the Song court masters, invites close examination. We appreciate the delicately drawn veins, the nuances of shading, and the smoothness of her boneless applications of color.

The fan painting of a preening bird on a branch of blossoming plum by Jin Yue's contemporary Zhou Xi (cat. no. 31) similarly depends on academic precedents, recalling the Southern Song fan paintings that present one or two flowering branches artfully arranged on an abstract ground and birds in all sorts of positions. Chen Weisong, a seventeenth-century scholar and friend of Jin Yue's husband Mao

Xiang, associated Zhou Xi with early court traditions when he wrote that her painting methods were between those of the tenth-century masters Xu Xi and Huang Quan.[19] Zhou's extant works include a hanging scroll of birds, camellias, and plum blossoms, probably from a set of the four seasons, in the Nanjing Museum (unpublished?).[20] This academic composition on silk may well resemble the eight flower-and-bird paintings by Zhou Xi and her sister Zhou Hu obtained by the sons of the scholar Jiang Shaoshu in 1651. The conservative outline-and-color technique matches Jiang's description of the fresh, elegant colors and the brushwork "like the silk of the spring silkworm" with which the Zhou sisters captured the spirit and vitality of their subjects.[21]

Zhou Xi was the daughter of a gentry family, but from the acclaim she received and the character of her paintings it is evident she was not truly an amateur artist. She portrayed Buddhist figures and horses as well as birds and flowers, and it was said that connoisseurs struggled to obtain her works.[22] As painters, Zhou Xi and Zhou Hu had much in common with Mao Xiang's concubines, Jin Yue and Cai Han (cat. nos. 34, 33), who also did ambitious, sometimes decorative paintings. Their audiences too were similar, with literati admirers including the poets Wang Shizhen (1634-1711) and Zhu Yizun (1629-1709).[23]

More references to the art of the distant past are found in the paintings of the Chai sisters (mid-17th c.) of Hangzhou and Chen Shu (1660-1736) of Xiushui (Jiaxing). On their handscroll *Flowers and Insects* (cat. no. 30) the seventeenth-century poet-painters Chai Zhenyi and Chai Jingyi wrote that they had "copied," but did not specify their model. Perhaps it was a work in the tradition of Xu Xi or the Song-dynasty master Zhao Chang (c. 960-after 1016), both of whom are credited with paintings of such subjects, or it may just have been an anonymous Song-style academy painting. Their *Flowers and Insects* might be compared, for instance, to the Palace Museum's lovely handscroll of butterflies, grasshoppers, and water plants attributed to Zhao Chang, or to the handscroll of flowers, plants, grasses, and butterflies signed "Xu Xi," a work in the collection of the the National Palace Museum.[24] The Chai sisters' intimate view of nature displays not only the historicism of the seventeenth-century literati, but also a taste for quiet, low-keyed beauty. The colors are gentle, softened by the paper to which they are applied. A pale green wash on the ground plane unifies the composition, and the bright or dark colors are confined to small elements — butterflies, bees, a spider, a cicada,

a few berries, and flowers.

While the Chai sisters' scroll takes us into the countryside, Chen Shu's *White Cockatoo* (cat. no. 36) returns us to the confined world of the palace. Chained to a bronze perch in a peach-blossom scented courtyard is an exotic white bird like those sometimes encountered in stories of beautiful palace ladies. Originally, this particular cockatoo was the subject of a Song-dynasty court painting. A Ming-dynasty version of the same composition on silk, now in the collection of the Seattle Art Museum, is inscribed as "after the Xuanhe (Song Emperor Huizong) brush." The close-up view, elimination of all save the most significant motifs, eloquent use of empty space, and diagonal arrangement of the primary motifs are typical features of Song-dynasty flower-and-bird paintings. Chen Shu made only a few changes that suggest the scholarly preferences of her own period: she pruned the lush blossoms and recreated the composition on paper, bringing out the cool elegance inherent in the pink, green, and white color scheme. The same sensibility is evident in her *Autumn Wildlife* (fig. j). Inscribed "copying the ancients," this is another precisely executed, delicately colored reworking of an old academy composition. Quail in autumn landscape settings were painted time and again by court artists, but this scroll also brings to mind the work of the Yuan-dynasty scholar Wang Yuan (14th c.), who himself imitated old masters, especially the tenth-century master Huang Quan.

Apparently Chen Shu also produced strongly colored, overtly decorative paintings in an academic vein. Her name is attached, for instance, to a twelve-leaf album of seasonal flowers, done in heavy colors on silk, and to two New Year's hanging scrolls of auspicious arrangements of flowers and fruit.[25] At the same time, she worked on the opposite end of the stylistic spectrum in the manner of the Ming-dynasty literati flower painter Chen Chun (1483-1544).

In turning to the artistic legacy of Chen Chun we leave behind Song-derived academic traditions and move completely into the realm of scholar-amateur painting. Like Shen Zhou and other scholarly painters active in the garden city of Suzhou in the middle and late Ming, Chen Chun sketched flowers and plants in a fluid, *xie yi* (to write out ideas and feelings) manner. With dynamic, modulated strokes and boneless applications of color or subtly graded washes of ink, he turned natural images into personal statements. A degree of abstraction was inherent in this calligraphy-based approach, but abstraction and individual

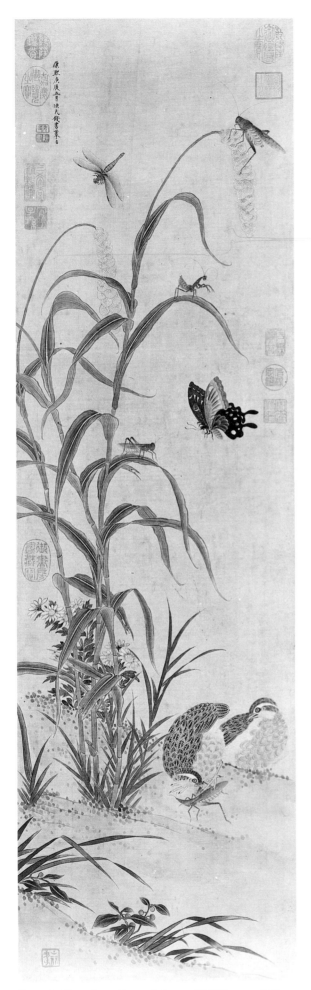

Figure j. Chen Shu, 1660-1736, *Autumn Wildlife*, 1700. Collection of the National Palace Museum, Taiwan, Republic of China.

response were only aspects of Chen's art; they never overwhelmed his subject matter. Chen Chun always brought his flowers to life by capturing the essential nature of each plant.

In her seventy-fifth year Chen Shu created a lively ink handscroll of narcissus based on a work by Chen Chun; this painting is now in the collection of the Tokyo National Museum. Among the other extant works after the master are two in the National Palace Museum: a hanging scroll of lotus flowers and an album of flowers, plants, birds, and insects in light colors on paper, dated 1713 (fig. k — see *Photographic Appendix*). The album leaves display the same deft, sure touch evident in her fan painting in the exhibition (cat. no. 37).[26]

Chen Shu was but one of many painters who worked in the tradition of Chen Chun. About a century earlier, ink methods very similar to his had been adopted by the Nanjing courtesan Xue Susu. Xue's *Flowers* dated 1615 (cat. no. 11) recalls, for instance, his scroll flowers of 1537, now in the Palace Museum.[27] Both present a parade of different blooms, each characterized in ink alone through the subtle manipulation of calligraphic line and wash, varied ink tones, and textures. Xue Susu's plants, like Chen Chun's, grow vigorously from the lower edge of the paper, each fully realized and self-contained. Her blossoming plum and ·chrysanthemum, two of the so-called Four Gentlemen (bamboo, plum blossoms, orchid, and chrysanthemum), are confident, conventional exercises, but her descriptive capabilities are more readily seen in the other flowers, such as the gorgeous tree peony. Dark, wet leaves created with a heavily loaded brush provide a foil for lacy petals rendered in light, dry ink. Graded washes suggest the light catching the leaves at different angles. The gracefully tapering, calligraphic strokes of the stems smoothly convey the strength of the plant at the peak of its season. While making each flower sketch a satisfying study in itself, Xue never lost sight of the scroll as a whole. Throughout she provided pleasing contrasts in form, line, ink tonality, and texture. The single, robust peony blossom is followed by a graceful fan of magnolia, its flowers and buds rendered in a striking combination of outline and graded-wash strokes. This, in turn, gives way to a leggy yellow hibiscus with spider-like leaves.

Li Yin (1616-85; cat. nos. 24-27), a native of Hangzhou who became the concubine of a scholar named Ge Zhengqi from Haining, was yet another who was indebted to the master Chen Chun. Her works, however, especially those executed on slick satin grounds, have a brashness that can be attributed to the speed

with which they were executed, probably in response to commercial demand. In her hanging scrolls she swiftly spread a few symbolic birds and plants over the satin in fairly dark ink; the tree or flower branches usually sweep in from one edge of the composition to fan out across the picture space. The appeal of these paintings lies in their dramatic designs and strong dark-light contrasts, rather than in subtle textural variations or fine details. The same is true of both her handscroll of *Flowers of the Four Seasons* on satin dated 1649 (cat. no. 24) and her *Yellow Hibiscus* fan (cat. no. 25).

In the seventeenth century, between the decorative conventions of academic flower painting on the one extreme and the expressive scholar-amateur applications of ink and color on the other, was another literati mode of flower-and-plant painting, which is represented in this exhibition by the works of Wen Shu (1595-1634). This mode, which was also employed by such male artists as Xiang Shengmo (1597-1658), retained the academic love of detailed description based on careful observation but departed from court traditions by avoiding obvious appeals to the senses through rich colors and dramatic compositions. The ostentatious beauty of the imperial parks was rejected in favor of the quiet refinement of the scholar's retreat, exemplified by the gardens of the Jiangnan, the lower Yangzi region. These were, of course, the gardens that inspired scholars such as Mao Xiang, Shen Fu, and Cao Xueqin to write so lovingly about life amid the plants and flowers.

The affluent Ming and Qing families of the southeast created whole worlds within the walls of their large residential compounds — islands of tranquility, complete with mountain, lake, and river views. A celebrated example was Yuan Mei's Sui Yuan in Nanjing, which the eighteenth-century poet came to believe was really the Prospect Garden described in *The Story of the Stone*. In Arthur Waley's words:

The Sui Yuan, Yuan Mei's residence, when finished consisted of twenty-four pavilions standing separately in the grounds, or built around small courtyards. Behind the pavilions was a piece of artificial water, divided into two parts by a meandering causeway, with little humped bridges that enabled a boat to pass from one part of the lake to the other. It was a miniature imitation of the causeways over the Western Lake at Hangchow. At the western end of the artificial water was another miniature imitation — that of the Ch'i-hsia Monastery at Nanking.[28]

Even private gardens as marvelous as Yuan Mei's, however, were masterpieces of understatement in comparison to the grand imperial parks of Beijing, with their acres of pavilions, lakes, lotus pools, pleasure boats, exotic architecture, gorgeous birds, rare plants, and profusion of blooms. The famous gardens of Suzhou, such as the Garden of the Master of the Fishing Nets, the Garden in which to Linger, and the Humble Administrator's Garden, all have an air of quiet dignity and scholarly modesty. Designed to facilitate the literati lifestyle and intensify scholarly pleasures, they were places for convivial gatherings, conversation, tea tasting, literary composition, painting, strolling, or contemplating the wonders of nature. Although composed of just a few basic elements — rocks, water, plants, and pavilions — a well-designed garden provides unlimited potential for discovery — new views to be encountered in every season, around every corner, at the end of the zigzag path, beyond the moon door and lattice window, even through the holes in the eroded rocks.

Much of this is conveyed by the flower paintings of Wen Shu (1595-1634), a descendant of the great Suzhou literati master Wen Zhengming. Familiar rather than exotic, intimate rather than showy, her flower studies have the freshness of scenes discovered in the course of a morning walk in a residential garden. Like the artfully arranged gardens themselves, however, this impression was carefully orchestrated. For her *Lily, Narcissus, and Garden Rock*, dated 1627 (cat. no. 15), Wen Shu adapted a compositional formula long used in paintings of bamboo and orchids and often encountered in gardens of Suzhou, where plants and oddly-shaped rocks pose before white garden walls. The stone is the dominant element; we are invited to look around and through it to the demure flowers beyond. This trick, the framing of small views, offering glimpses of beauty just out of reach, is also borrowed from garden design. Our interest is further held by striking contrasts: dark, rough ancient stone and jagged thorns versus delicate flowers and fragile butterflies. The red-orange lilies that demand our attention almost seem too strong for the pale blue-green leaves and white flowers below.

Wen Shu did many variations on this rock-and-flower theme, pairing bold brushwork with fine line and setting rich ink tones against soft or bright colors. A scaled-down version is found in the fan of *Carnations and Garden Rock* (cat. no. 14). Another handsome example, a hanging scroll dated 1630, belongs to the Freer Gallery of Art (fig. l). Here too a perforated garden rock is arranged with two types of flowers, large and small, and a coolness is imparted to the whole scene by the light colors of the blue-green stalks and leaves.

Cultivated in the rarified atmosphere of the scholar's garden, Ming-dynasty "Suzhou

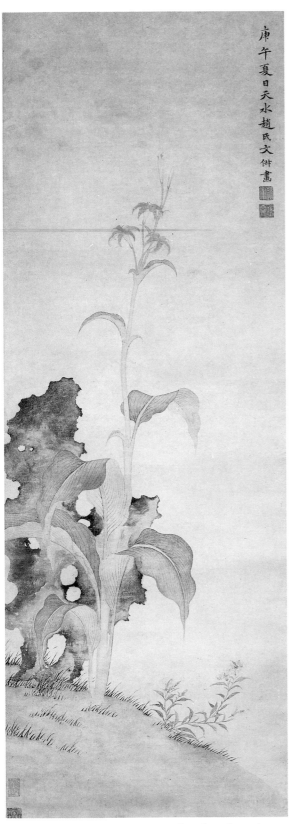

庚午夏日天水趙民文倣畫

Figure 1. Wen Shu, 1595-1634, *Tiger Lily and Garden Rock.*
Freer Gallery of Art, Smithsonian Institution, Washington D.C.

taste" pervaded the Jiangnan in the sixteenth and seventeenth centuries. Consequently, connections can be observed between the paintings of women of varied social backgrounds and from different locales. The outline-and-color orchids by the courtesan Ma Shouzhen (1548-1604; cat. nos. 7-9), like Wen Shu's flowers, combine delicate outlines and cool colors, and Wen would surely have approved of the Chai

sisters' scroll, in which strong colors are limited to a few flowers and insects. Similarly, the style of the master Chen Chun, also a product of the Suzhou gardens, was taken up by a Nanjing courtesan (Xue Susu), a Hangzhou concubine (Li Yin), and a gentry lady from Jiaxing (Chen Shu).

These styles and the academic traditions discussed earlier represent the conservative side of the flower painting of the late Ming and early Qing dynasties. In fact, the seventeenth-century works in this exhibition give little indication that a "revolution" in plant-and-flower painting took place in this period. This revolution was led by the master Yun Shouping (1633-90), the most celebrated and influential flower painter of the Qing dynasty.

Yun Shouping was born into an impoverished gentry family of Wujin (Changzhou), the home of a conservative school of "realistic" plant, flower, and insect painting with a history stretching back to the Song dynasty. Finding it necessary to earn his living as a painter, Yun took up the subjects and Song-derived descriptive methods of this school and recast them along scholarly lines to create a new and enormously popular form of decorative naturalism. We can generalize about Yun Shouping's flower-painting style by referring to such basic characteristics as his liquid applications of ink and translucent colors without outlines in the boneless manner, but his paintings display considerable variation. Some are abbreviated sketches that recall the work of Chen Chun; others are highly finished pieces with the air of a palace garden. Much of this diversity resulted from his art-historical concerns. Like the "orthodox" landscape painters with whom he associated, Yun frequently invoked the authority of the past. His ideas about the history of flower-and-bird painting can be compared to the views of the late-Ming connoisseur Dong Qichang on the development of landscape traditions. Yun's chosen models extended from the old masters Xu Xi and Xu Chongsi to the relatively recent Wu School artists of Suzhou. To all of this Yun added yet another significant element: the careful study of living plants. Yun's achievement, then, was a synthesis of academic traditions, scholar-amateur ideals, and lessons learned directly from nature.[29]

Among his descendants, Yun Shouping's most illustrious follower was Yun Bing, who was active through the first half of the eighteenth century. Yun Bing's name appears on some large hanging scrolls of peonies and rocks that are virtually indistinguishable from many paintings of the same subject attributed to Yun Shouping, and also on lush handscrolls

filled with blossoms. More appealing, however, are her small-scale pieces, such as the album leaves (cat. nos. 39-41) and fans (cat. nos. 42-44) in the exhibition.

Yun Bing acknowledged the Wu School in one of her album leaves on paper now in the collection of the Royal Ontario Museum. The leaf of pea vines and a grasshopper (cat. no. 41), done in thinly applied, muted colors, is inscribed as after the Suzhou painter Lu Zhi (1496-1576). The air of literati restraint perceptible here also permeates Yun's orchid fans (cat. no. 42). In two of the fans shy green orchids are described in a fine outline-and-color technique; in the other two, ink-painting methods are used to apply color, and the long, graceful orchid leaves are drawn in unoutlined strokes of green. The latter method was picked up by Luo Qilan (cat. no. 52), one of Yun Shouping's late-eighteenth-century followers, and by Luo's contemporary Wang Yuyan (cat. no. 53).

Yun Bing is best known for her gorgeous nature studies, represented in the exhibition by two albums (cat. nos. 39, 40). Like the album leaves of the Southern Song academy masters, they offer close-up views, seductive colors, and exquisite details that invite and repay close scrutiny. The beauties thus discovered, however, often seem more fragile and fugitive than those fixed on silk by the Song masters. This impression is created, especially in the Musée Guimet album, by the shimmering, translucent, soft-edged color washes that capture so effectively the look of nature in the warm, moist atmosphere of the Jiangnan.

It is instructive to compare these album leaves to the paintings of the late-Ming lady Wen Shu. Basically, Yun Bing and Wen Shu set themselves the same task: the accurate, tasteful recording of the particulars and the ambience of their gardens. Both accomplished it through painstaking observation, refined brush techniques, and delicate applications of color. Yet the results are quite different. Compared to the studied informality of the second leaf of the Musée Guimet album by Yun Bing, a composition of roses, campanula, rock, and beetle, Wen Shu's *Pinks and Rock* has the arranged feel of a still life. Beside Yun Bing's exuberant depiction of pink-shaded white hydrangeas entwined with yellow squash flowers, Wen Shu's lilies and narcissus appear remote, self-consciously chaste. Sensual responses to the floral glories of the garden were not unknown in the Ming-dynasty Suzhou tradition and are to be found, for instance, in some of the bright, freely brushed flowers of Chen Chun, but the Changzhou School of Yun Shouping took positive delight in the vibrant colors and subtle textures of the flowers and plants that thrive in the lush lower Yangzi River region.

Scholars liked to pair Yun Bing with Ma Quan (cat. nos. 45-50), another famous woman artist active in the first half of the eighteenth century and also a member of a distinguished family of painters. Ma's father Ma Yuanyu (1669-1722) studied "sketching from life" with Yun Shouping, and many connections are to be observed between the flower paintings of the Ma and Yun families. They treated similar subjects, displayed a comparable concern with verisimilitude, and looked back to the same ancient masters, notably Xu Chongsi. While Ma Quan and Yun Bing had much in common — perhaps because they did — scholars distinguished them by maintaining that Yun was famous for her boneless method and Ma for her outline-and-color technique. In fact, neither artist used one method to the exclusion of the other, but there is no doubt that they deserved their respective reputations for the skill with which they handled these techniques. Ma Quan described the begonias in her fan of flowers and butterflies (cat. no. 48) with light color and very delicate lines. Like the outlines in many of Ma's paintings, these are fine but firm, unassertive yet effective elements of design.

The Ma family was also connected with another major flower-painting family, that of the court master Jiang Tingxi (1669-1732). Both were from Changshu, Jiangsu. Ma Yuanyu is said to have "discussed the Six Laws of painting" with Jiang Tingxi; Ma Quan's brother Ma Yi also studied with Jiang Tingxi; and both father and son stood in for Jiang as "substitute brushes." The eighteenth-century art historian Zhang Geng describes Jiang as a master of many techniques, and Jiang is said to have established a "school" of his own, but fundamentally he was indebted to Yun Shouping for his flower-painting style. The decorative naturalism of the Yun style is likewise the basis for the peony fan (cat. no. 38) by Jiang Tingxi's younger sister Jiang Jixi. Looking at Jixi's painting of lush flowers in full bloom, their lacy petals spread, is like viewing a small part of a summer garden through a fan-shaped window.

Yun Bing, Ma Quan, and Jiang Jixi represent three of the most important flower-painting families of the Qing period, and their works, together with those of Luo Qilan, exemplify facets of the Yun Shouping tradition as it was transmitted in the century following his death. Yun Shouping's followers were legion, however, and his style remained influential into the modern period. Introduced to the painting academy by Jiang Tingxi and sustained by artists such as Zou Yigui, Yun's boneless

method became the foundation for the dominant mode of Qing academic flower painting.[30] One of the last artists to serve the court, the Empress Dowager's teacher and "substitute brush" Miao Jiahui (cat. nos. 74, 75), used this method extensively in her flower paintings. It can be seen both in works she signed and in many of those to which Cixi affixed her seal.

The long reach of the Yun style, and its role as a unifying factor in the late history of Chinese flower painting, can be illustrated with one last work, a fan of a peony and peach blossoms (cat. no. 63) by the nineteenth-century lady Wu Shangxi of Guangdong, in the far south. Wu Shangxi wrote on this fan: "Emulating the color application of Ouxiangguan [Yun Shouping]." Light, shaded washes of color shape the peony leaves and thin lines of the same green reinforce the edges of the single white flower. The branch of small pink blossoms reaching out across the fan offsets both the coolness and heaviness of this bloom. The composition was thoroughly calculated, but the easy relationships between the carefully observed flowers makes it seem as if they were just picked and casually arranged, one over the other, on the gold flecked paper.

The reader familiar with the general history of late-Ming- and Qing-dynasty painting will have noticed that certain terms, such as "individualistic" and "eccentric," are missing from the preceding survey. This was not an oversight. In general, these adjectives can be applied only to paintings by the men with whom some women artists associated; they are almost never appropriate for works by the women themselves. For social and cultural reasons, as suggested in my introductory essay, women were not prepared to break with conventions or to take positions at the forefront of methodological controversies, such as those involving questions of orthodoxy and individualism in the seventeenth century. Although certainly aware of the issues, they seem to have been largely sympathetic to conservative points of view. This is particularly evident in landscape painting, the genre upon which literati-painting theories focused—Lin Xue (cat. nos. 18-20), Huang Yuanjie (fig. d—see *Photographic Appendix*), and Chen Shu (fig. e) made determinedly "orthodox" decisions in choosing their models

and brush techniques—but it is also true of flower painting. We have yet to discover a woman who might be regarded as a "free spirit," a female counterpart to the early-Qing individualist Shitao, and if any woman created images comparable to the disquieting birds, fish, and flowers of the seventeenth-century master Zhu Da, she too remains to be identified.

In eighteenth-century Yangzhou, Fang Wanyi (cat. no. 51), Yuexiang (cat. no. 54), and other women did paint in styles related to those of some of the so-called Eight Eccentrics, but as far as is currently known their own art was not in any respect "eccentric" or "strange." At issue here, of course, is not just female conservatism, but also the appropriateness of using the term "eccentric" or any similar adjective to categorize the heterogeneous work of the male scholar-painters active in Yangzhou in the middle of the Qing dynasty. Along with the truly odd images and idiosyncratic recastings of conventional forms, these men produced appealing *xieyi* sketches of plants, flowers, fruit, and vegetables, and handsome ink reinterpretations of classic themes: bamboo, orchids, and plum blossoms. The female painters of Yangzhou simply seem to have avoided the unconventional, preferring the more traditional subjects and milder modes of expression. For example, although Fang Wanyi's paintings of plum blossoms, bamboo, and a single potted azalea can easily be compared with certain works by her husband Luo Ping, she does not seem to have shared any of his stranger visions. But then, not many men shared them either.

Previous exhibitions of Ming- and Qing-dynasty painting have given us "restless landscapes" and "fantastics and eccentrics"—to borrow descriptive terms coined in the titles of two such shows. The present exhibition offers another perspective on the art of the same period and often the same social groups. It has dramatic moments in, for example, the figure paintings of the nineteenth century, but the tranquility of the garden prevails. Undisturbed by brooding mountains or ghostly apparitions like those that have haunted other Ming and Qing exhibitions, we can emulate the scholar-gardener Chen Haozi and concentrate on the small wonders of nature—a wandering squash blossom, a branch of lichee, a spider in its web.

1. Chen Haozi, *Huajing* (1688; reprint Beijing: Nongye chuban she, 1962), p. 1. Translation from Herbert A. Giles, *A History of Chinese Literature* (New York: D. Appleton and Company, 1929), pp. 413-14.

2. For a survey of Chinese horticultural literature and a bibliography of Chinese studies of plants and flowers written before 1850, see H. L. Li, *The Garden Flowers of China* (New York: The Ronald Press Company, 1955), pp. 12-21, 216-27.

3. Shen Fu, *Six Records of a Floating Life*, trans. Leonard Pratt and Chiang Su-hui (Harmondsworth: Penguin Books, 1983), p. 56.

4. Ibid.

5. Ibid.

6. Ibid., pp. 62-63.

7. Mao Xiang, *Yingmei an yiyu*, trans. Pan Tze-yen as *The Reminiscences of Tung Hsiao-wan* (Shanghai: The Commercial

Press, Ltd., 1931), pp. 55-57.

8. Cao Xueqin, *The Story of the Stone*, trans. David Hawkes (Harmondsworth: Penguin Books, 1977), 2:214.

9. Ibid., pp. 250-53.

10. Ibid., p. 24.

11. Princess Der Ling, *Two Years in the Forbidden City* (New York: Moffat, Yard and Company, 1911), pp. 348-50.

12. Beyond brief sections in the standard surveys of Chinese painting, such as Osvald Sirén's *Chinese Painting: Leading Masters and Principles* (New York: The Ronald Press Company, 1956-58), and entries in catalogues of exhibitions of various genres, comparatively little has been written on garden flowers in later Chinese painting. Noteworthy exceptions include James Robinson, "The Vitality of Style: Aspects of Flower and Bird Painting During the Yüan (1279-1368)," Ph.D. dissertation, University of Michigan, 1984; Richard Barnhart, *Peach Blossom Spring: Gardens and Flowers in Chinese Painting* (New York: The Metropolitan Museum of Art, 1983); Chang Lin-sheng, "*Qingchu huajia* Yun Shouping" (The Early Qing Painter Yun Shou-p'ing), *Gugong jikan* (National Palace Museum Quarterly), 10:2 (Winter 1975):45-80 (English summary pp. 27-31); Saehyang P. Chung, "An Introduction to the Changzhou School of Painting — 2," *Oriental Art*, n.s. 31:3 (Autumn 1985):293-308.

13. Guo Ruoxu (c. 1080), *Tuhua jianwen zhi*; cited from *Early Chinese Texts on Painting*, ed. Susan Bush and Hsio-yen Shih (Cambridge: Harvard University Press, 1985), p. 126.

14. Ibid., p. 125.

15. Shen Gua (1031-95), *Mengqi bitan*; cited from Bush and Shih, p. 127.

16. Deng Chun, *Huaji*; cited from Sirén, 2:79.

17. A. R. Davis, *The Penguin Book of Chinese Verse* (Harmondsworth: Penguin Books, 1968), p. 37.

18. Zou Yigui's work is reproduced in Edmund Capon and Mae Anna Pang, *Chinese Painting of the Ming and Qing Dynasties* (International Cultural Corporation of Australia Limited, 1981), cat. no. 65; Qian Weicheng in Kojiro Tomita and Hsien-chi Tseng, *Portfolio of Chinese Paintings in the Museum (Yüan to Ch'ing Periods)* (Boston: Museum of Fine Arts, 1961), nos. 165, 166.

19. Chen Weisong, *Furen ji* (Shanghai: Zhongyang shudian, 1935), p. 48.

20. Ann Arbor Photographic Distribution slide no. 7672.

21. *WSSS*, 5:85-86.

22. Chen Weisong, p. 48.

23. *YTHS*, 3:31, 4:66-67.

24. The painting attributed to Zhao Chang is reproduced in *Yiyuan duoying* (1979), no. 1; Xu Xi in *Caozhong hua tezhan tulu* (Illustrated Catalogue of a Special Exhibition of Grass-and-Insect Painting) (Taipei: National Palace Museum, 1986), pp. 28-29.

25. The album is in the Tokyo National Museum; see Suzuki, JM1-134. Both of the New Year's pictures belong to the National Palace Museum; see Daphne L. Rosenzweig, "Official Signatures on Qing Court Paintings," *Oriental Art*, n.s. 27:2 (Summer 1981), fig. 4, and *Descriptive and Illustrated Catalogue of Paintings in the National Palace Museum* (Taipei: National Palace Museum, 1967), no. 301.

26. For the handscroll in the Tokyo National Museum see Suzuki, JM1-311.

27. Capon and Pang, cat. no. 19.

28. Arthur Waley, *Yuan Mei, Eighteenth Century Chinese Poet* (London: George Allen and Unwin Ltd., 1956), p. 48.

29. For Yun Shouping's biography, see *ECCP*, pp. 960-61. See also the studies of Yun Shouping cited in note 12, especially Saehyang P. Chung, pp. 298-99.

30. She Ch'eng, "The Painting Academy of the Qianlong Period: A Study in Relation to the Taipei National Palace Museum Collection," in Ju-hsi Chou and Claudia Brown, *The Elegant Brush, Chinese Painting Under the Qianlong Emperor 1735-1795* (Phoenix: Phoenix Art Museum, 1985), p. 340.

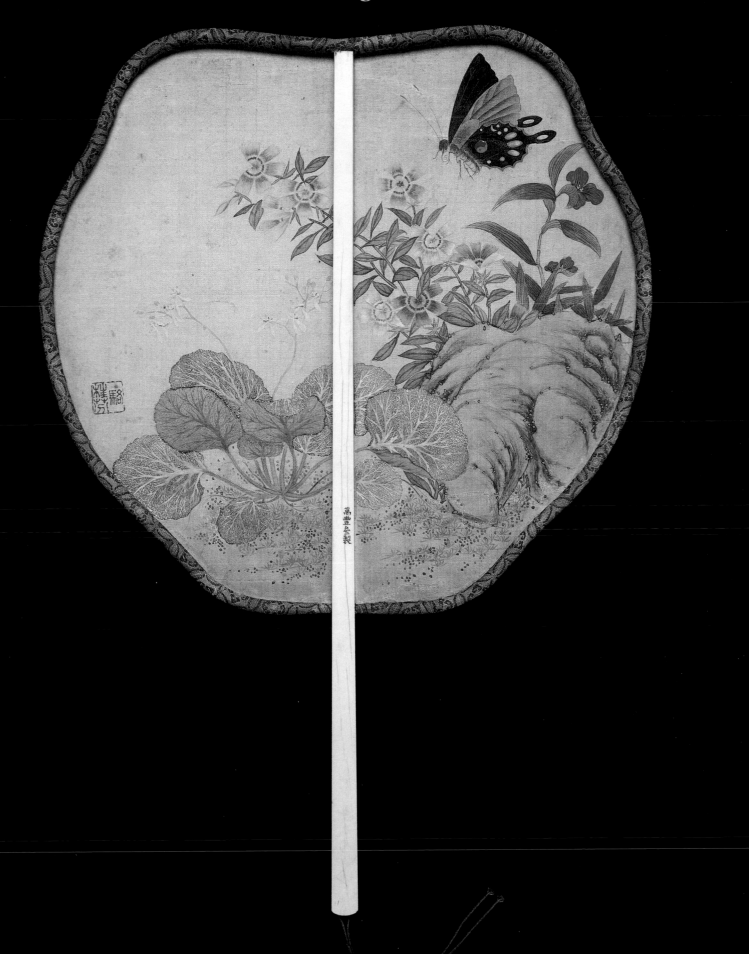

1

Attributed to Guan Daosheng

1262-1319
Bamboo, 1309
Ink on silk
Handscroll, 27.9 x 135 cm.
Museum of Fine Arts, Boston,
James Fund (08.133)

Colophon by Guan Daosheng's sister,
Dao Gao, concludes:
*On the second day of the fourth month in
the second year of the Zhida reign [1309],
my younger sister, the Madam of Wei
Kingdom,[1] Second Sister, visited here at
Nanxun.[2] While peacefully sitting in the
Gentleman's Studio, Madam said, "Since
'Gentleman' is the name of the studio, why
is there no bamboo?" Thereupon, an at-
tendant was asked to grind ink, and she
sketched this branch in the middle of the
studio.... On another day, when my
brother-in-law Songxue [Zhao Mengfu]
will come to look [at this painting],
I will ask him to write his inscription.
Yao Guan Daogao.[3]*

By almost any measure, Guan Daosheng
(*zi* Zhongji) can be considered the first
lady of painting in the long history of
that art in China. She influenced many
later artists and remains the first female
artist survived by enough paintings to
permit us to understand a sense of per-
sonal style.

Guan Daosheng was born in 1262,
during the Southern Song dynasty, and
her epitaph, written by her husband, the
well-known artist Zhao Mengfu (1254-
1322), records that she was a descendant
of Guan Zhong (Yiwu, d. 645 BC), who
fled the disorders in Qi (a state in Shan-
dong) to Wuxing, Zhejiang. People so
esteemed the family that their land was
called "Roost of the Esteemed." Accord-
ing to her epitaph:

> Her father was Guan Shen, whose style
> name was Zhifu and whose wife was from
> the Zhou clan. Mr. Guan was known for
> his exceptional talent and unconventional-
> ity, and his chivalrous conduct was the talk
> of the neighborhood. My wife since birth
> had intelligence that surpassed others. Her
> father cherished her, definitely wanting to
> get a fine son-in-law. Her father and I were
> from the same district, and because he also
> had a high regard for me, I knew someday
> that she would become my wife.[4]

Guan and Zhao were married ten years
into the Yuan dynasty. This was rather
late in their lives by Chinese fashion, as
she was twenty-seven and he thirty-five.

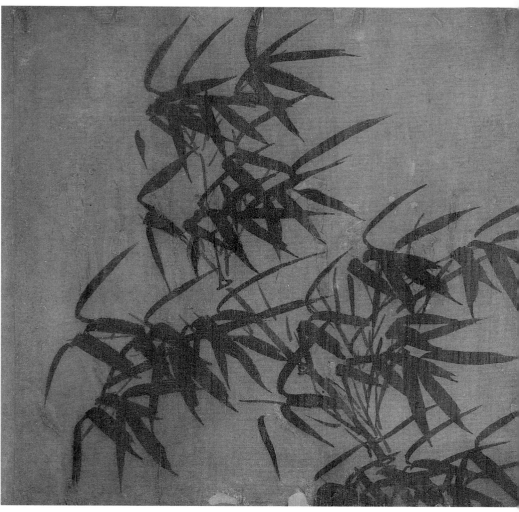

1 Attributed to Guan Daosheng, *Bamboo*, 1309

By all appearances they had a wonderful
marriage together, full of children and
companionship. With his first wife, who
probably died before his marriage to
Guan, Zhao had one son and four daugh-
ters, and Guan was to have two more of
each.[5] In the year of their marriage,
1289, Guan Daosheng accompanied her
husband to the capital, Dadu (Beijing),
where they stayed until their return to
Wuxing in 1292.

By about 1296 Guan Daosheng ap-
pears active as an artist, and in 1299 she
supposedly wrote a rhyme-prose on the
cultivation of bamboo and sketched an
ink bamboo for Madam Yao (see note
13). Over the next twenty years she
raised a family that included one son,
Yong, who became a famous painter;
produced paintings and letters docu-
menting her activity as an artist; and
lived a pious Buddhist life that included
monks and nuns among the family
friends, among whom was the famous
Chan monk Zhongfeng Mingben (1263-
1323), for whom she and her husband
completed paintings.

Her husband's career required them
to travel throughout the cultural cor-
ridor between Hangzhou in the south
and Dadu in the north. In the capital in
1317 she received the honorary title

"Madam of Wei Kingdom," and during
the winter of the following year she be-
came sick and asked permission to re-
turn home from the north. She left for
the south on the twenty-fifth day of the
fourth lunar month (May 15, 1319), and
almost a month later on the tenth day
of the fifth month, (May 29, 1319), she
passed from this world aboard her boat
near Linqing, Shandong, at the age of
fifty-seven. Her husband was so dis-
traught that he had to rely on their son
Yong to arrange funeral matters. Zhao
noted that all their relatives paid re-
spects, and none did not cry, a fact that
enables one to understand his wife's vir-
tue. He remained in the south, where he
died at the age of sixty-eight in the sixth
lunar month of 1322.

Guan Daosheng was honored during
her own lifetime by the highest levels of
society as a truly talented artist. She was
recognized as multitalented and was
known for her accomplishments in
poetry, calligraphy, and paintings of ink
bamboo, orchid, plum, landscapes, and
Buddhist figures. The most famous inci-
dent to illustrate her achievement was
included by her husband in her epitaph.

poet Su Shi (1037-1101) about his friend Wen Tong (1019-79):

> When Wen Tong painted bamboo,
> He saw bamboo and not himself.
> Not simply unconscious of himself,
> Trance-like, he left his body behind.
> His body was transferred into bamboo,
> Creating inexhaustible freshness.
> Zhuangzi is no longer in this world,
> So who can understand such
> concentration.[7]

Like the Daoist philosopher Zhuangzi, who did not know whether he was a man dreaming he was a butterfly or a butterfly dreaming he was a man, the expressed ideal of the artist was to become so involved with the subject that distinctions of separate existence would disappear.

Bamboo was the first plant to become the subject of a major genre of painting, and it was the first to be depicted in a monochrome, black ink fashion. The origin of noncolored bamboo painting has been attributed to a Lady Li of the Five Dynasties (907-60), who traced moonlit shadows of bamboo leaves on her window.[8] The use of black ink plus the simple leaf structure and the random leaf patterns encouraged bamboo representations to be critically evaluated in terms similar to calligraphy, the premier art of personal expression through brush movements. Thus, as in the art of beautiful writing, the nature and character of artists were considered to be revealed in their art through brushstrokes that flowed from the heart.

Bamboo, with its long associations with gentlemen, had rather masculine connotations. Guan Daosheng seemed aware of the male domain into which her artistic interest took her. In an inscription on a bamboo handscroll supposedly done in 1310 while in her husband's studio, Guan wrote: "To play with brush and ink is a masculine sort of thing to do, yet I made this painting. Wouldn't someone say that I have transgressed [propriety]? How despicable; how despicable."[9]

Guan Daosheng's pictorial achievements were recognized by all who followed her. The great theoretician Dong Qichang (1555-1636) wrote a colophon in praise of her bamboo painting:

> In this handscroll of bamboo branches, the free, sweeping ink is marvelous, as if scattered by wind and rain. [The rhythm of the composition of the branches] is similar to the great Lady Gongsun's sword dance, and not the caliber of the basic character of the women's quarters. Extraordinary; extraordinary.[10]

Wu Qizhen echoed these sentiments in a discussion of a joint painting by Guan and her husband:

> Zhao added a clump of orchids to Guan's stalk of bamboo, and each artist has an inscription. Looking at her use of brush,

Emperor Renzong (r. 1312-21) ordered Daosheng to write the *Thousand Character Classic* and also ordered calligraphies from her husband and son. The emperor is said to have remarked, "Later generations can know that my reign not only had an expert female calligrapher, but a whole family capable in calligraphy, which is an extraordinary circumstance." Over the following years, Guan presented a couple of paintings to the throne and enjoyed the beneficence of two imperial reigns. She and Zhao Mengfu were two great artists who typified the flourishing of the age.

It was through Buddhism that Guan Daosheng was to achieve some measure of public fame in later years. Guan, like her husband, painted murals for local Buddhist temples, a circumstance that allowed free, public access to her art. A report by Wu Qizhen, recording his being caught in a downpour in 1672, describes a mural of bamboo and rock "on the east wall of the Revered Buddha Temple hall of Huzhou":

> It was over ten feet tall and fifteen or sixteen feet wide and depicted one big rock on an embankment using the "flying white" [split brushstroke] texture method. With only several brushstrokes, she painted a rock and before, behind, to the left and right, several stalks of tall bamboo three or four feet in height. These were bamboo seen as the rains cleared, standing as erect as life. Looking at it, one could almost feel a gentle breeze slowly coming up and sending a chill through one's bones. The brushwork was ever so facile, free, and vigorous. The painting had not the slightest appearance of having been done by a woman. Very powerful. An extraordinary painting of all time, and of the spiritual class.[6]

Praise such as this established her achievements in the important genre of bamboo painting as the core of her fame.

Bamboo, perhaps the literati subject par excellence, was frequently used by poets and philosophers as a symbol or portrait of the perfect gentleman. Many virtuous qualities were compared to qualities of the plant, such as its strength, which lay in its flexibility — being able to bend without breaking. That it remained green through the winter gave bamboo the connotation of nonfading companionship. Bamboo quickly accrued many evocative associations, and it came to be a form of self-portraiture. One of the finest statements about the relationship of artist to bamboo was penned by the Song-dynasty

the stalk is hoary and vigorous, without the slightest similarity to traditional female (styles of painting). The brushwork used in the orchid flowers was supple and pliant, without the slightest of masculine airs.[11]

The astute collector and connoisseur An Qi (c. 1683-after 1764) recorded in his catalogue an ink-bamboo painting by her and noted, "dense leaves and strong sinews not like the frail delicate brushwork of the gentlewomen." An Qi also remarked that after observing the painting, he realized the origin of the bamboo-painting style of the popular Ming-dynasty artist Tang Yin (1470-1523).[12]

Though there is only one extant painting by Guan Daosheng that is generally considered genuine (see cat. no. 2), the Boston painting represents an important aspect of her style.[13] It shows the influence of Zhao Mengfu, and having lived with a master such as Zhao for twenty years, Guan Daosheng undoubtedly learned many of her painting skills from him. She may have had something to teach her husband, as well, for Sun Chengze (1592-1676), in his record of paintings seen during retirement in the summer of 1660, considered Madam Guan's style of painting bamboo superior to her husband's.[14]

As short as the Boston handscroll is, there is clear similarity to bamboo by Zhao Mengfu. The leaves are depicted in a dense fashion, and, as with Zhao's style, the density is not uniform but uneven because of the coupled clusters of leaves.[15] The forcefully depicted leaves are similarly quite long and generally taper in a smooth, even fashion. The segments of the stem barely swell toward the joints, which are rather plain except for a firm, bold stroke that vigorously emphasizes the lower end of each upper segment, and joins to the sides. The patterns created by the leaves also reflect the preeminent traditions of her husband or her contemporary, the bamboo specialist Li Kan (1245-1320). The parallelism and echoes of forms, particularly in the peripheral leaves of the painting, are quite accomplished. The leaves are boldly presented, yet, as in the best of bamboo painting, the patterns avoid being repetitious. The poem accompanying this painting speaks to the very qualities for which Guan Daosheng was famed as a painter of bamboo.

> Outside my window everywhere
> Myriad poles of slender bamboo grow.
> Meshed dense leaves lay down shadows;
> Strong sinews withstand the cold of the
> year.[16]

1. According to the epitaph by her husband, she was given the honorary title "Madam of Wei Kingdom" (Weiguo furen) in 1317. Reference to Daosheng with this title on a painting she supposedly did in 1309 may be explained only if the colophon were written after 1317. The literary tone of the colophon does not suggest that Guan Daosheng had already died. Thus it could only have been written between 1317 and 1319 to record an earlier event. Not only does the date present a problem, but the text varies slightly from, and is not as clear in a couple of phrases as, an almost identical colophon recorded to have been seen by Qian Yong in 1794. In the printed record of what is presumably this painting, or another version, Qian remarked:

> The ink bamboo paintings that are attributed to Guan Zhongji [Daosheng] are very numerous, but the authentic ones are extremely rare.... In a lodge at West Lake I saw a handscroll that was certainly the best work of the lady's life. (Lüyuan conghua [preface of 1825; 1870 edition], 10:23a-24a, 23b.)

It is impossible to say for sure whether or not the colophon recorded by Qian is the one on this particular painting, the source for this one, or one on another painting still unknown.

The other records about the writer of this colophon, Guan Daogao, date from the same time as Qian's record and present a third factor that could be the source or result of the Boston colophon or Qian's document (see note 3 below). Since Qian's record is more complete in its phrasing, his must be considered more accurate. Both colophons present the same historical problem by referring to Guan Daosheng's title when describing events in her life before the title was actually bestowed upon her. I am indebted to Irving Lo for suggestions to this and all my translations.

2. Nanxun is between Wuxing, Zhejiang and Wuxian, Jiangsu.

3. This colophon bears the signature of Guan Daogao, supposedly Daosheng's sister, but there has been some question as to whether Guan Daosheng had a sister because there is no contemporary reference to her sister in any of the writings about her or her family. Yet Daosheng's style name (zi), Zhongji ("Second girl") and her husband's reference to her as "Second Sister" suggest she was second in her family. We know she had no brother, but it is not until 1881 that her sister is first mentioned (in a local gazeteer). There she is named Daogao, recorded as having married into the Yao family of Nanxun at a young age, and noted by Zhao Mengfu as being a calligraphist of some renown. If Daogao did leave home when young, her father's intense affection for her sister, Daosheng, could help explain why he waited so long to find a worthy husband for his only remaining daughter. The inscription on the present handscroll may support the possibility of Daosheng's having had an elder sister, or it may even be the source for that information (see note 1 above). The seal following the Guan Daogao signature on the Boston scroll reads "Wei Kingdom family descendant" (Weiguo shijia). Two convenient sources for biographical information about Guan Daosheng, upon which this account is based, were written by Ch'en Pao-chen, "Guan Daosheng he tade Zhushi tu," Gugong jikan (The National Palace Museum Quarterly) 11:4 (Taipei, 1967): 51-84 (English summary, pp. 39-49; chronology, pp. 7-84) and Chen Gaohua, ed., Yuandai huajia shiliao (Shanghai: Shanghai Renmin meishu chubanshe, 1980), pp. 43-45. See also YTHS, pp. 20-21, and Yu, p. 1260.

4. Chen Gaohua, p. 43. There are other opinions regarding her birthplace, but her epitaph and the dedicatory inscription for her family shrine, which were both written by her husband, should be considered definitive sources.

5. Weng Tongwen, "Wang Meng wei Zhao Mengfu waisun kao," Dalu zazhi 26:1 (Taipei,

1963), pp. 30-32, from Ch'en Pao-chen above.

6. Wu Qizhen, Shuhua ji (Shanghai: Shanghai renmin meishu chubanshe, 1963), pp. 626-27, translated following suggestions of Irving Lo. Wu continued, "The four corners of the wall were deteriorating, and the powdered colors are slightly darkened."

7. Susan Bush and Hsio-yen Shih, Early Chinese Texts on Painting (Cambridge: Harvard University Press, 1985), p. 212; and Susan Bush, The Chinese Literati on Painting: Su Shih (1037-1101) to Tung Ch'i-ch'ang (1555-1636) (Cambridge: Harvard-Yenching Institute Studies 27, 1971), p. 41.

8. Li Kan, Zhu pu [c. 1312], Yishu congbian ed. (Taipei: Shijie shuju, 1967), p. 245; or Wang Yuanqi, et al., Peiwenzhai shuhuapu (1708), 49:3a.

9. Hu Jing, et al., Shiqu baoji sanbian (1816; reprint Taipei: Guoli gugong bowuyuan, 1970), 7:3084.

10. Bian Yongyu, Shigu tang shuhua huikao (1682; reprint Taipei: Zhengzhong shuju, 1958), 4:147.

11. Wu Qizhen, Shuhua ji, p. 179.

12. An Qi, Moyuan huiguan (1742), Yishu congbian ed. (Taipei: Shijie shuju, 1977), p. 234. Xiangfan copied a painting by Guan titled as An Qi described (see cat. no. 58).

13. Another example of this type is a handscroll dated 1313 in the Tokyo National Museum. Interestingly, the Tokyo handscroll is inscribed by Guan Daosheng as having been done at the request of the wife of Censor Yao, presumably her sister. It also has the anachronism of Guan using her 1317 title (see note 1 above). See Ch'en Pao-chen, pl. 11, and Nanhua dacheng (Taipei: Yiyuan wenwu kaifa yuxiangongsi, 1978), 1:5. Another handscroll with a bamboo fu-verse and sketch is recorded to have been made in 1299 and also presented to Madam Yao (Hu Jing, et al., Shiqu baoji sanbian [1816; reprint Taipei: National Palace Museum, 1969], p. 3084).

14. Sun Chengze, Gengzi xiaoxia ji (1660) as recorded in YTHS, p. 21.

15. Compare, for example, the handscroll Bamboo, Rocks, and Lonely Orchids (78.66) in the Cleveland Museum of Art, reproduced in Eight Dynasties of Chinese Painting: The Collections of the Nelson Gallery - Atkins Museum, Kansas City, and The Cleveland Museum of Art (Cleveland: The Cleveland Museum of Art, 1980), no. 81.

16. "Lay down shadows" in Qian, see note 1 above; "summer shadows" on scroll.

One colophon and one seal.

Bibliography: Osvald Sirén, Chinese Paintings in American Collections (Paris: Musée Guimet, 1927-28), p. 125; James Cahill, An Index of Early Painters and Paintings: T'ang, Sung, and Yüan (Berkeley: University of California Press, 1980), p. 294; Sirén, CP, 7:119.

JR

2 Attributed to Guan Daosheng, *A Bamboo Grove in Mist*, section

2

Attributed to Guan Daosheng

A Bamboo Grove in Mist
Ink on paper
Handscroll, 15 x 112.4 cm.
Yale University Art Gallery, Gift of
Mrs. William H. Moore for the Hobart
and Edward Small Moore Memorial
Collection (1953.27.17)

Artist's signature:
Miss Guan Daosheng

Artist's seal:
Zhongji

One of Guan Daosheng's great achievements was the reintegration of bamboo into a landscape setting, and an acknowledged innovation of hers was the depiction of bamboo clumps, particularly a grove of bamboo in mist after fresh rain.[1] Several similar examples are recorded and some exist in the hanging scroll format.[2] Though they sometimes include a multiroom dwelling, the paintings' common feature is a bamboo grove highlighted against the mist at the base of a series of staggered mountains. The bamboo is cut by narrow bands of mist and the leaves are small and dense, extending over the top half of the stalks. The gently sloped mountains are reminiscent of the moist, soft styles of Gao Kegong (1248-1310) and of her husband, Zhao Mengfu.[3]

Guan Daosheng's finest extant painting, and the one that has received the most support for its authenticity, is a short handscroll of this subject dated to the spring of 1308 and titled *Ten Thousand Bamboo Poles in Cloudy Mist* (figure a).[4] The scene unfolds from a distant view, presents the dominant bamboo grove foreground, then recedes along a waterway, and concludes with a small clump of bamboo on the right side of a slope that fades off the end. Like the Boston handscroll (cat. no. 1), the bamboo segments are basically of even width and are highlighted at the bottom and the joints by a single line. In the center tall bamboo stalks grow in clumps that fan out toward the top. The tight textures of subtly varied ink tones within the dense leaves handsomely contrast with the flat horizontal band of cloudy mist that separates the foreground from the distance. The exquisite ink textures through the small leaves and thin stalks create a feathery quality, which was a main part of the attraction of this tradition for later artists. The composition of the Yale painting is essentially the same, but compared to the 1308 scroll, the brushwork and ink tones are harder and stiffer. These differences, as well as the repetitive elements and shapes, indicate that it is a later painting (note the small, waterside grass and the left side of the foreground boulder). Though possibly quite faithful in overall composition to an original, it nevertheless departs from Guan Daosheng's style in much the same way that performances of the same music may vary.

Many artists adopted Guan Daosheng's novel depiction of a bamboo panorama, and frequently their debt to her was overtly acknowledged in their inscriptions. Artists of the next generation, such as Guo Bi (1280-1335), and of later dynasties, such as Song Ke (1327-87) or Xia Chang (1388-1470) of the

Ming dynasty or Wang Hui (1632-1717) of the Qing dynasty, painted images based on her format of low-level views of groves of tall bamboo with short, sharp leaves densely arranged over the top half of the stalks. Of considerable interest is an undated landscape album by Luo Pin (1733-99) containing a leaf after the Song-dynasty artist Judge Xue's *Autumn Stream and Misty Bamboo* that is clearly within the Guan Daosheng tradition. In fact, the facing page has a colophon by Fan Zengxiang (1845-1931) that boldly states: "Should he [the artist, Luo Ping] have been born five hundred years earlier, Huzhou's Guan Daosheng is none other than he."[5]

Guan Daosheng may have chosen bamboo along waterways to bring feminine associations to the image of bamboo. One such association is alluded to in one of the poems after the Yale painting. Tan Zekai wrote:

Once a thousand jade-green bamboos lined
the stream;
Circling clouds were reflected in the
waters of the Xiao and the Xiang.
The tears of the two ladies, now forgotten,
are shadows;
Their orchid rooms, no more than cold
dreams.[6]

The "two ladies" were daughters of the legendary Emperor Yao and wives of his successor, Emperor Shun. The tears they shed over the death of Shun supposedly caused the speckled markings on the bamboo that grew on the banks of the river in which they took their lives. Thus, the theme of bamboo on a riverbank might be interpreted as a feminine correlative to the unaccompanied bamboo branch or bamboo with single rock.

Some also credit Guan Daosheng with the innovation of red-bamboo painting, while others trace it back to Su Shi and even to the Han dynasty.[7] That she began using red ink to paint bamboo could have resulted from a desire to create a more feminine representation of bamboo. Zheng Yuanyou (1292-1364) supports this possibility, for he described her red-bamboo painting with the appropriately feminine images of "the vermilion phoenix," "the red dragon," and the "exhausted tears of blood from the Xiang wives" of Emperor Shun.[8]

1. Yu, p. 1260; Zhu Qiqian, *Nügong zhuanzhenglüe*, Meishu congshu ed., p. 13b; and see cat. no. 1, note 5.

2. See Bian Yongyu, *Shigutang shuhua huigao* (1682; reprint Taipei: Zhengzhong shuju, 1956), 4:150, and Ch'en Pao-chen, "Guan Daosheng he tade Zhushi tu," *Gugong jikan (The National Palace Museum Quarterly)* 11:4 (Taipei, 1967), pls. 8, 9.

3. Bian Yongyu, 4:150. A beautiful and sensitive handscroll by the Southern Song dynasty artist Zhao Kui, *After a Poem by Du Fu*, could be considered a predecessor of this type of low-vantage-point, close-up view of nature. However, the focus of Zhao's earlier painting is the poet and his experience, not the bamboo. Thus the image contains more reminders of humanity, as well as fewer bands of mist. It is quite possible that Guan Daosheng may have seen the painting, which is by a relative of her husband, because the colophons were written by people in the circle in which she and her husband traveled. See *Yiyuan duoying* (Shanghai, 1978), 2:3-8.

4. This suitable title was given by the extraordinary connoisseur An Qi when he recorded it in his catalogue, *Moyuan huiguan* [1742], *Yishu congbian* ed. (Taipei: Shijie shuju, 1977), p. 235. Now part of a handscroll with paintings by other Yuan masters, it is presently in the National Palace Museum, Taipei, and titled *Bamboo Groves in Mist and Rain*. See Ch'en Pao-chen, pl. 7.

5. Ju-hsi Chou and Claudia Brown, *The Elegant Brush: Chinese Painting Under the Qianlong Emperor, 1735-1795* (Phoenix Art Museum, 1985), p. 207, no. 66D.

6. Louise Hackney and C. F. Yau, *A Study of Chinese Paintings in the Collection of Ada Small Moore* (London and New York: Oxford University Press, 1940), no. 27, p. 116.

7. YTHS, p. 21; Yu Jianhua, *Zhongguo hualun leibian* (Hong Kong: Zhonghua shuju, 1973), p. 1189; Wang Yuanqi, et al., *Peiwenzhai shuhuapu* (1708; reprint n.p., n.d.), 12:4a; and Jao Tsung-i, "Mozhu keshi Jianlun mozhu yuanliu," *Gugong jikan (The National Palace Museum Quarterly)* 8:1 (Taipei, 1974) 54.

8. Yu Fengqing, *Yushi shuhua tiba ji*, as quoted in YTHS, p. 21.

Nine colophons and seven collector's seals.

Bibliography: Louise Hackney and C. F. Yau, *A Study of Chinese Paintings in the Collection of Ada Small Moore* (London and New York: Oxford University Press, 1940), no. 27, p. 116; Sirén, CP, 7:119; Karen Petersen and J. J. Wilson, *Women Artists: Recognition and Reappraisal from the Early Middle Ages to the Twentieth Century* (New York: Harper & Row, 1976), p. 153; James Cahill, *An Index of Early Painters and Paintings: T'ang, Sung, and Yüan* (Berkeley: University of California Press, 1980), p. 295.

JR

3

Miss Qiu

Active mid-late 16th century
Portraits of Guanyin
Gold on black paper
Album, twenty-six leaves, 29.9 x 22 cm.
Mr. and Mrs J. P. Dubosc Collection

Artist's inscription (on last leaf):
Drawn by Miss Qiu of Wumen.

Miss Qiu is usually recorded in the literature on painting as Qiu Shi or under her *hao*, Duling neishi. Her birth and death dates are unknown; one painting, no longer extant, is recorded as being dated 1576.[1] The daughter of the Suzhou painter Qiu Ying (c. 1494-c. 1552), she followed his style in landscapes and figures. One report assures us that, although her father did pornographic pictures, she spent her days in solitude — burning incense, playing the *qin*, cleaning the inkstone, and using the brush — and did not sleep with her husband.[2] She was especially noted for her pictures of the Bodhisattva of Mercy, Guanyin. These were presented with "compassionate countenances and a grave demeanor as well as with a beauty and elegance rendering them mysteriously transcendent; one look and you knew they were from the brush of a woman."[3]

3-26 Miss Qiu, *Portraits of Guanyin*, facing page

There is no doubt that Buddhist icons were in great demand in traditional China and that many, perhaps most, Ming and Qing artists did Buddhist pictures. The most popular image was that of Guanyin, because of the flourishing cult associated with that deity. By the medieval period the once neuter Bodhisattva had been transformed into a woman.[4] This feminine aspect of Guanyin was furthered by the legend of Miaoshan, a young woman who forsook marriage for religion and who saved her father from certain death by giving him her eyes and arms. She became a transformation of Guanyin. Knowledge of this legend was widespread and was vividly modified by storytellers, playwrights, and others.[5] In addition, as a compassionate deity, Guanyin was credited with many capacities, not the least of which was bestowal of children. The exceedingly strong feminine caste of Guanyin would explain her appeal to women: for those who were married, she could be asked for the all-important sons; for those who preferred religion, Buddhism promised salvation. It would be a mistake, however, to assume that Buddhism and Guanyin were addressed only by women. A man, Tu Long (1542-1605), wrote out the *Heart Sutra*, in which Guanyin is a major personage, as a foreword for Miss Qiu's album of Guanyin figures; and many well-known men artists were famous for their representations of Buddhist subjects.

Miss Qiu's father did a number of pictures of Guanyin, but most of these have disappeared. One published painting attributed to Qiu Ying, and seemingly of some quality, depicts *Guanyin on a Carp*.[6] A work given to Miss Qiu, *A White-robed Guanyin*, now in the National Palace Museum, Taipei (fig. i),[7] compares quite favorably with Qiu Ying's presentation in the physical proportions of the figure, the facial conformation, and the general brushwork. There is no evidence, however, that Qiu Ying produced a set of images such as seen in Miss Qiu's album.

On the other hand, Miss Qiu's album, which consists of alternating images and short text passages, is, in both iconography and style, close to twenty-eight images of Guanyin accompanied by text, also done as an album in gold on dark paper, by Du Jin (now in the Tokyo National Museum).[8] Du Jin, a failed scholar who took up painting for a living in Nanjing in the mid-fifteenth century, had considerable impact in Suzhou. It is possible that his album or something like it served as a model for Miss Qiu's set. Both sets open with the *Heart Sutra*, one of the most widely known scriptures in the large corpus of *Prajñāpāramitā* literature, which defines the essence of

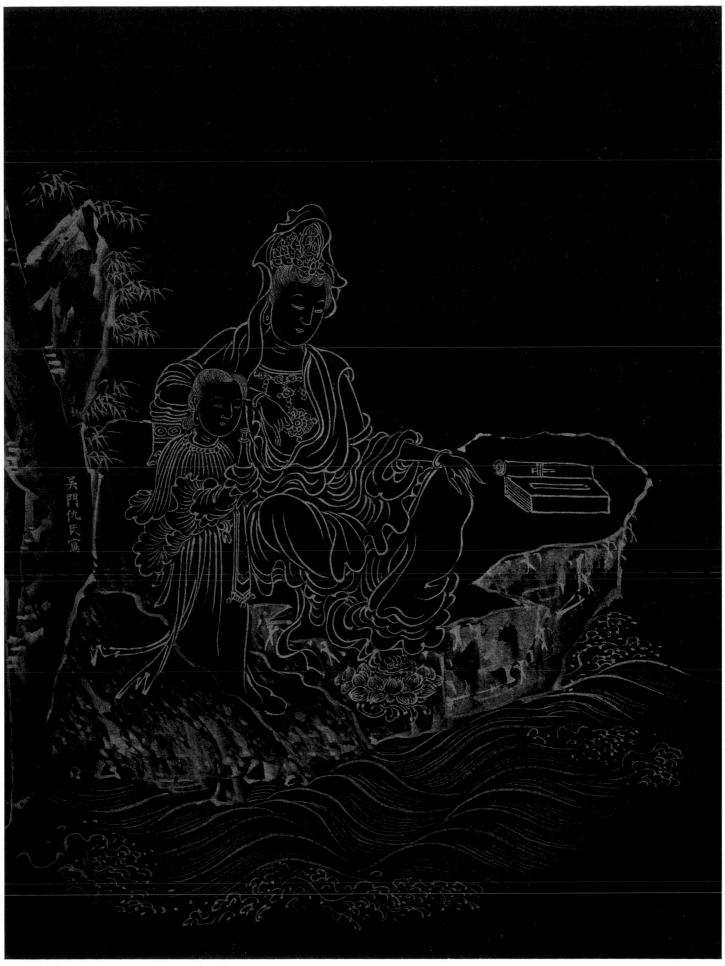

3-26
Miss Qiu
*Portraits of
Guanyin*

Bodhisattvahood. In turn, the brief *Heart Sutra* literally embodies the "heart" of Buddhist insight and "transcendent wisdom" (*prajñāpāramitā*). It was translated from Sanskrit into Chinese in 649 by Xuanzang. The scripture was highly influential in the esoteric sects of Buddhism as well as in Chan Buddhism.[9]

The theme of the Guanyin images in the works by Du Jin and Miss Qiu may be that of a spiritual pilgrimage, as the presence of the child, identified as the pilgrim Sudhana in the accompanying text, indicates. Determining the exact nature of this journey requires explicating the text written next to each picture; but this text is noncanonical and must be further analyzed to ascertain its origin and proper interpretation.

1. Zhang Dayong, *Ziyiyuezhai shuhualu* (1832), 3:16.

2. Wang Keyu, *Shanhuwang minghua tiba*, in Zhang Junheng, ed., *Shiyuan congshu* (1913-17), 17:7a.

3. *WSSS*, 5:81; Wang Zhideng, *Danqing zhi, Huashi congshu* ed., p. 7; Zhu Mouyin, *Huashi huiyao, Sibu congkan* ed. (Taipei: Commercial Press, 1971), 4:88b.

4. Diana Y. Paul, *Women in Buddhism: Images of the Feminine in Mahayana Tradition*, 2nd ed. (Berkeley and Los Angeles: University of California Press, 1985).

5. See Glen Dudbridge, *The Legend of Miaoshan* (London: Ithaca Press, 1978).

6. Qiu Ying's picture is reproduced in Fei Fanjiu, *Lichao minghua Guanyin baoxiang* (Shanghai: Jingyuanshe, 1939).

7. Reproduced in *Gugong canghua jingxuan* (Hong Kong: Reader's Digest Association Far East, 1981), p. 217.

8. Reproduced in Suzuki, JM 1-110; another series by Chen Xian (act. 1635-75), now in Manpukuji Temple near Kyoto, is reproduced in Suzuki, JT 178-009.

9. Douglas A. Fox, *The Heart of Buddhist Wisdom: A Translation of the Heart Sutra with Historical Introduction and Commentary*. Studies in Asian Thought and Religion, 3 (Lewiston/Queenston: The Edwin Mellen Press, 1985), pp. 74, 139.

Three collector's seals.

EJL

4
Ma Shouzhen
1548-1604
Orchid, Bamboo, and Rock, 1563
Ink on paper
Hanging scroll, 102.23 x 31.12 cm.
Private Collection

Artist's inscription:
Though companion to small grass,
Furtive orchid fragrance emanates from
* the valley;*
Its true heart is entrusted to a gentlemen,
To be brushed by a clear breeze from time
* to time.*
Guihai [1563] during the "Grain Rains"
season [fourth-fifth lunar month],
sketched in a kiosk by the Qinhuai waters.
Xuanxuanzi, Xianglan, Ma Shouzhen.

Artist's seal:
Ma Xianglan yin

As is the case with most courtesans, there is very little substantial information about the life of Ma Shouzhen (*zi* Xuaner, Xuanjue; *hao* Yuejiao), also known as Ma Xianglan. She is remembered by only a few stories about events that have entered the realm of local folklore. Nevertheless, during her lifetime she achieved considerable, even international, renown, for "her paintings were not only treasured by the elegant dandies, but her name was heard beyond the seas, and envoys from Siam also knew to buy her painted fans and collect them."[1] In his lively account of the brothel district of Nanjing, *Banjiao zaji*, Yu Huai (1616-96) lamented, at the beginning of his section on "Beauties," that he became employed in Nanjing after 1640 and thus was unable to see three specific women, one of whom was Ma Shouzhen.[2]

A standard introduction of Ma was written by a contemporary, Zhou Tianqiu (1514-95), as an explanatory colophon on an eight-leaf orchid album by her:

> Xianglan [Ma Shouzhen] is the only person after Wenji[3] and Madame Guan [Daosheng]. She resides in Jinling [present day Nanjing] and is well enough refined in the "female arts" to be head of the "gay quarters." In sketching orchids and bamboo she is without equal. Now, this album of paintings was done for Peng Kongjia, who treasures it like a precious jade disc and asked me to add an inscription.[4]

Zhou Tianqiu was, in his day, a famous and accomplished artist who specialized in orchid painting; and he possibly instructed Ma. Peng Nian (1505-66), the man for whom the album was painted, was a prominent member of Suzhou literati society. He was evidently proud enough of the painting to seek an inscription from Zhou. Peng died in 1566, so the album must have been painted before the end of Ma Shouzhen's eighteenth year. Clearly, at a young age she had achieved considerable success, and her work was appreciated by some of the luminaries of the day.

A long handscroll, painted in 1580, also links Ma Shouzhen to Zhou Tianqiu, as well as to about eighty other admirers of orchids. In that painting Zhou depicted several images of the plant without a ground plane, relying, he said, on the marvelous writers to fill up the blank spaces, which they did admirably. Among the contributors to this joint work, which reads like a "who's who" of the age, is Ma Shouzhen.[5]

Ma Shouzhen's connections with respected literati were made possible by her professional career. As an entertainer and celebrity with widely admired talents, doors to every type of social event were opened to her, and she certainly enjoyed the company of a variety of aspiring and established talents. One story from her life can illustrate both her quick wit and how a courtesan's life intersected various strata of society:

> There once was a man, attending the official exam for the second degree, who asked for an introduction. She refused him. Later, he obtained a first-place honor on the exams and was given the post of Secretary in the Ministry of Rites in the capital. It just happened that someone had brought litigation against Ma Xianglan. The official ordered her arrest, but the crowds acted as mediator. The magistrate would not listen to them, but since he came to interview her, he angrily said, "People say Ma Xianglan merely enjoys a hollow reputation!" Xianglan replied, "Only because in earlier days I enjoyed a hollow reputation have I today encountered this real misfortune." The magistrate laughed and released her.[6]

Her most famous relationship was her lifelong affair with a good friend and rival of Zhou Tianqiu, Wang Zhideng (1535-1612), the popular poet and calligrapher, who led the literati after Wen Zhengming (1470-1559).[7] Certainly the height of this relationship, which included an expressed desire on her part for marriage, occurred on Wang's sixty-ninth birthday.

> In honor of Wang's birthday, she arranged a big celebration in Feixu yuan (Garden of [Floating] Willow Catkins), where drinking, writing, and revelry lasted almost a whole month. The story came to be described in an opera.... In the same year [1604] Ma Xianglan breathed her last

quietly and serenely after a long prayer. She was a devout Buddhist . . . [and Wang Zhideng] also wrote 12 stanzas as an elegy.[8]

Ma Shouzhen's "spirits were cavalier, while her beauty and accomplishments were the fascination of her day."[9] She was noted for her fair complexion, and her "ability to entertain and charm people is mentioned as long lasting, at least into her fifties."[10] She was a playwright, musician, and able poet, remembered for having written, "Wine is a thing that kills sorrow, but how much of time can it kill?"[11]

It is for her orchid painting, particularly the portrayals in an outline technique, that Ma Shouzhen is lauded today. She is known to have painted other plants, such as bamboo, narcissus, and plum blossoms, but it is the orchid for which she had the greatest affinity. Her love for the orchid (*lan, cymbidium*) is frequently noted as the reason she took the name Xianglan (literally, Xiang River Orchid). Inscriptions in an album of orchids that was in the imperial collection of Qianlong (r. 1736-95) list some of the artists Ma Shouzhen studied and copied. She named Wen Tong (1018-79), Guan Daosheng (see cat. no. 1), and "my relative Ma Wan" (c. 1350).[12]

The hanging scroll of *Orchid, Bamboo, and Rock* is generally dated 1563, when Ma Shouzhen was only fifteen years old.[13] The painting is certainly not beyond the means of a talented teenager, and the album done for Peng Nian verifies that just a few years later her work was recognized by senior literati of her day. Ellen Johnston Laing points out in her essay that girls trained as courtesans were very well established and active by their middle teens.

The image in this hanging scroll is simple and direct: a prominent and central orchid, accompanied by bamboo and backed by rock, is set against a blank background. The orchids are rendered in the "double-outline" (*shuanggou*) technique, in which elements are delineated by a thin boundary line. This is the method most frequently associated with Ma Shouzhen, and it characterizes the work of Zhao Mengjian (1199-c. 1267), whose style is generally mentioned as an influence on her art. The brushwork in the bamboo leaves is not very strong, and there are excessive tonal variations of ink and some unsuccessfully shaped leaves. The dense clump of

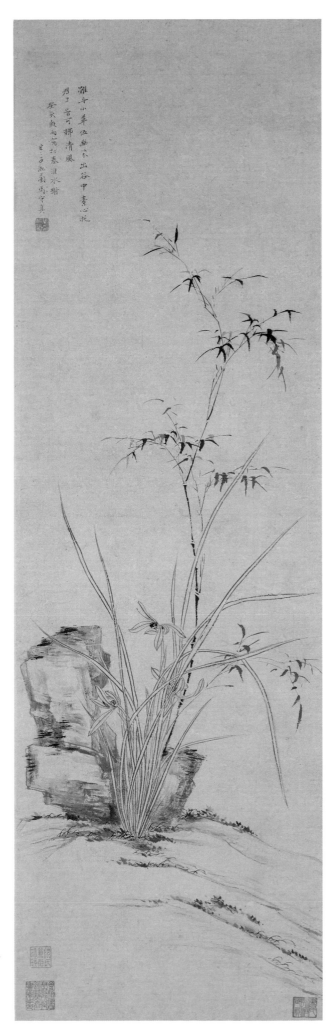

4
Ma Shouzhen
Orchid, Bamboo, and Rock
1563

orchid with elongated parts is, on the whole, handsomely painted, but several of the longer leaves are somewhat exaggerated, as if the artist was overly enthusiastic, and are not of the same high quality as the rest of the plant or rock. Yet these are the shortcomings and excesses of a young artist and will disappear in later works. The stocky, quick bamboo leaves and the simply depicted orchid petals, which have a plump appearance and lilting, turned tips, were to become a hallmark of her style.

Ma Shouzhen learned to paint at a time when the subject of orchids was well established in the arts. A colophon on the handscroll by Zhou Tianqiu mentioned above speaks enthusiastically, yet accurately, about some of the traditions surrounding the orchid:

> In "Discourses on Painting" landscape is considered superior, and orchid and bamboo follow it. I say this is not so. In landscape painting the use of the brush is casual, so if one is not contentedly satisfied, one still can adjust and embellish. For orchid and bamboo, as soon as the brush hits the paper it is impossible to make alterations. Furthermore, orchids are more difficult than bamboo. The reason is that bamboo leaves are concealed and dense while orchid leaves are desolate and revealingly sparse. It has been said that sketching orchids is similar to calligraphy in ancient Seal or Clerical script, and need not be displayed in all painting collections. Those who know, [know] the propriety of this. As for singing about the orchid, this is even more difficult! The character of the orchid is lofty. In terms of human traits [that is to say, compared to a person], it can only be Xuanfu [Confucius] and Lingjun [Qu Yuan]; as ci-type poetry, it can only be Lisao or the ancient mournful music of the lute. In terms of terrain [where orchids grow], it can only be the dark valleys of the rivers Xiao and Xiang. In terms of allusion, it is always — following the category [of a thesaurus] — "twining my girdle of orchids," as like as one grain to another, produced ad nauseum. Hardly there is a new tune.... Therefore, in my anthology of "Poems on Objects)," I deliberately omitted a section on orchids.[14]

Not surprisingly, Ma Shouzhen's poetic inscription presents some of these standard allusions to the orchid. She speaks of companionship, a secluded valley, an unadorned or true heart, a gentleman, and the awaiting of recognition. The Confucian classic of divination, the Yijing, compared the serenity of being in like-minded spiritual and emotional rapport with someone to the orchid, which resulted in phrases such as "orchid relations" and "orchid friends."[15] This classical allusion supported the appropriateness of depicting this plant for a friend. The themes of Ma's inscription are reflected as well in a story in the Qincao. When Confucius was unemployed for lack of a king to recognize his talents, he went for a stroll in a secluded valley and saw that only the fragrant orchid flourished. Thinking of his own situation, he lamented that although the fragrant orchid grew together with various grasses, it still does not fail to be the "fragrance of kings."[16]

The most famous thematic connections occur in the poetry associated with Qu Yuan, and the state of Chu, in which good and evil are personified in plants.[17] Here the orchid was the nation's fragrance, people wore it, and the unrecognized statesman of pure virtue, Qu Yuan himself, was identified with the plant. Thus Wang Yun (1227-1304) could praise an orchid painting by Madame Li by saying, "When you view the profundity of this flower, it is as if she sketched Lingjun's [Qu Yuan] furtive mournfulness."[18] In an inscription on one of his paintings, Zhao Mengfu wrote about the orchid:

> A hundred plants, a thousand flowers, fresh day and night;
> This gentleman, "beneath the forest" [in retirement] is the first to know spring.
> Though without pretentions, like a beautiful woman,
> It's naturally endowed with a furtive fragrance, like a man of virtue.[19]

The coupling of "orchid" and "rock" became the embodiment of the "fragrant" and "strong," symbolic representations of excellent moral values.

Anything people appreciated could be compared to a fragrance. The revered poet Su Shi perhaps said it most simply: "Spring orchids are like beautiful women."[20] The phrase dainü, which we might literally render as "waiting for a woman," is actually a cognomen for "orchid flower." It is also used in opposition to the lily, which was symbolic of the birth of sons.[21] The rarified literati world promoted aesthetic values such as spontaneity and unassuming naturalness, and the taste proved constant, whether for qualities in paintings, people, or plants.

1. WSSS, 5:83 and YTHS, p. 73.

2. Yu Huai, "Diverse Records of Wooden Bridge," trans. in Levy, pp. 48-49.

3. Cai Yan (?162-239?), a poet and calligrapher of the Eastern Han dynasty.

4. Hu Jing, et al., Shiqu baoji sanbian (1816; reprint Taipei: National Palace Museum, 1970), p. 2120. The album also has a title by Zhou Tianqiu dated to 1580, which suggests that someone who owned the album after Peng asked Zhou to add the title.

5. The handscroll is now in the National Palace Museum, Taipei, and is recorded in Gugong shuhua lu (Taipei: National Palace Museum, 1965), 4:220-27.

6. Chu Jiaxuan, Jianhu sanji, 4:11a.

7. Wang wrote a small book, Wujun danqing zhi (1563), about artists of the Suzhou area, which included Miss Qiu (see cat. no. 3).

8. Liu Lin-sheng, "Wang Chih-teng," Dictionary of Ming Biography, 1368-1644 (London: Cambridge University Press, 1976), pp. 1361-63. The nineteenth-century scholar Kong Guangtao recorded that Wang once abandoned Ma in hardship, but he does not explain the circumstances. He does, however, describe the party and notes that Ma "purchased a multi-storied boat loaded with several dozen attractive beauties.... [Ma's] features and complexion were as her youth. Wang playfully said to her, 'Darling, the wrinkled chicken-skin of old age [on you] has thrice returned young. Pity, I am not able to do as did the wizard Shengong [become young and elope]!'" (Yuexue lou shuhua lu [1861], 5:17b.)

9. Ibid.

10. Eileen Grace Truscott, "Ma Shou-chen: Ming Dynasty Courtesan/Painter," M.A. thesis, The University of British Columbia, 1981, p. 11.

11. Chu Jiaxuan, p. 11a. Neither Ma's collection of poems, for which Wang Zhideng wrote a preface, nor an opera she wrote are extant (Liu Lin-sheng, p. 1362). See also the essay by Irving Lo.

12. Hu Jing, p. 2119.

13. Given the cyclical system of dating, an alternate reading of the date might be 1623, nineteen years after the date of her death as given by Wang Zhideng. The characters written for the date repeat every sixty years, and without the presence of a fixed date, such as a reign designation or a person's age, any feasible sixty-year multiple is possible. Both Osvald Sirén and, more recently, Paul Moss have suggested that Ma lived beyond 1604. See Paul Moss, Emperor Scholar Artisan Monk: The Creative Personality in Chinese Works of Art (London: Sydney L. Moss, Ltd., 1984), pp. 24-26. Sirén, CP, 7:218-19. Their argument appears based on the desire not to reject the good paintings — some they date to 1627 — that are "dated" beyond her death, and even beyond Wang's death date of 1612. In the cyclical system 1627 could also be 1567, five years after the painting under consideration. The paintings dated between 1605 and 1613 would obviously yield implausible dates if adjusted between 1545 and 1553, but since they do not appear to be Ming-dynasty paintings, they can be dismissed from consideration. There is no need for conflicting views if the eulogy written by Wang Zhideng is accepted as accurate. Since her death was soon after the famous party she gave for him, it should be reliable.

14. Yu Ling's colophon as recorded in Gugong shuhua lu, 2:226. Translated with suggestions by Irving Lo.

15. Nozaki, p. 557: "If two people speak with one mind, their words will have the fragrance of the orchid." See also R. H. Van Gulik, Sexual Life in Ancient China (Leiden: E. J. Brill, 1961), pp. 92 and 102.

16. Nozaki, p. 555, from "Kongzi jiayu."

17. Wu Renjie, Lisao caomu shu, Zhibuzuzhai congshu ed., vol. 54, 1:11a.

18. Wang Yun, Qiujian xiansheng daquan wenji, Sibu congkan ed., 11:4a-b.

19. Zhao Mengfu, "Inscription on Own Plum, Bamboo, Secluded Orchid and Narcissus Presented to Haogao," Songxue zhai, p. 219.

20. Su Shi, Su Dongpo quanji (Beijing: Zhongguo shudian, 1986), 1:252.

21. See Ellen Johnston Laing's essay.

Three collector's seals.

Bibliography: Cincinnati Collects Oriental Art (Cincinnati Art Museum, 1985), no. 71; Oriental Art 31:2 (summer 1985): 203.

JR

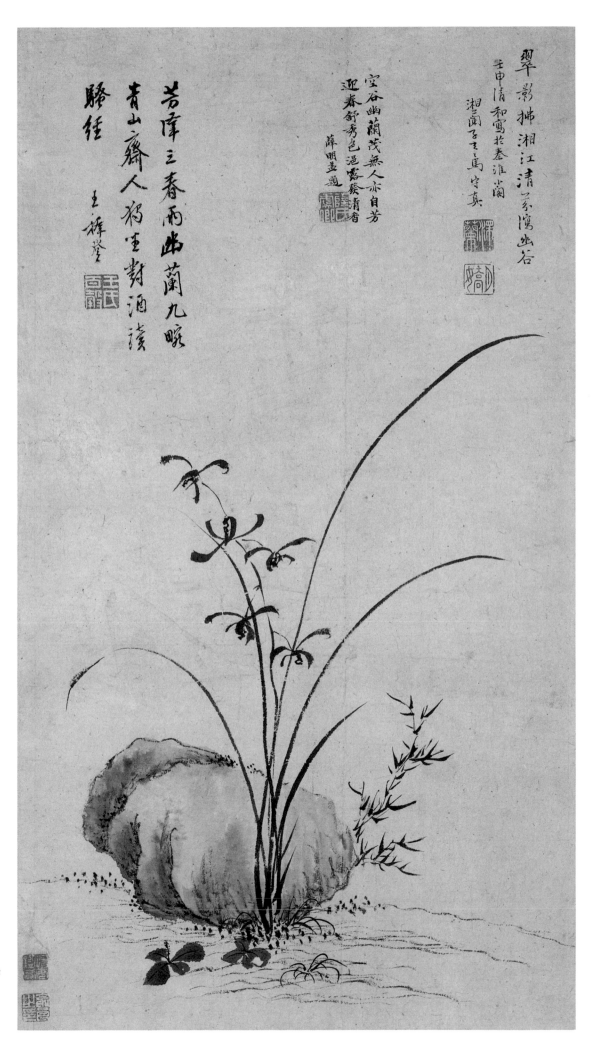

5
Ma Shouzhen
Orchid and Rock
1572

7

Ma Shouzhen

Colored Orchids, 1592
Ink and color on paper
Hanging scroll, 111.4 x 29.8 cm.
Kurokawa Institute of Ancient Cultures

Artist's inscription:
During the Wanli reign in the renchen year [1592] on a long summer's eve sitting in the Qinhuai water pavilion, I painted this to present to my social brother Baigu [Wang Zhideng] for correction. Xianglan, younger sister, Ma Shouzhen.

Artist's seals:
Ma; Yuejiao; Shouzhen

The artist Zheng Sixiao (1241-1318) once remarked that there was no ground depicted around his orchids because the Mongols had stolen the land.[1] The style and composition of Zheng's portrayals of "the nation's fragrance" (see cat. no. 4) were legendary and were often repeated in horizontal formats, either handscrolls or album leaves, by artists well known to Ma, such as Zhou Tianqiu (see cat. no. 4) and Chen Yuansu (c. 1620-50). Vertical formats, however, wherein not a hint of a ground plane or cliff is shown to give the plants a foundation or a compositional anchor, are extremely rare before the seventeenth century.

Not only is there a difference in format in this scroll, but there are changes in almost every other aspect as well. Ma's orchids are not shown in a simple, balanced composition. The leaves, with complex curves, are outlined by thin lines of numerous modulations and were not created by a single stroke with one simple fluctuation of the brush at the center of the arc. In this aspect she is similar to her contemporary Xue Susu (cat. no. 10). Ma's orchid leaves cross the center of the plant, which is not nearly as symmetrical about a center axis as Zheng's orchid. The graceful parallel curves of the leaves in the upper plant and the even, reverse symmetry of the leaves in the lower plant reveal the interest of Ming artists in complex, interrelated forms.

In depicting the *hui* orchids in this elegant hanging scroll, Ma Shouzhen has used an outline method for which she is best remembered, and she has applied the faintest of coloring. The coloring is essentially two tones of green: a faint, bluish green for the leaves and a slightly more olive green for the stalk and flowers. A blush of light rose color highlights the stamens of the typical, languid, opened-petal flower. The fragile, delicate style aptly suggests the nature of the plant itself and creates a poetic feeling for the soft, floating fragrance of the orchid.

1. James Cahill, *Hills Beyond a River: Chinese Painting of the Yuan Dynasty, 1279-1368* (New York: Weatherhill, 1976), pp. 16-17. Ma Shouzhen's elder contemporary Zhou Tianqiu wrote that he omitted the ground plane so that writers could fill the spaces and thus the calligraphy would accompany the orchid like a rock (see cat. no. 4).

Two collector's seals.

Bibliography: Suzuki, JM 19-015.

JR

8

Ma Shouzhen

Colored Fungus, Orchids, Bamboo, and Rocks, 1566
Ink and color on paper
Handscroll, 27.54 x 200.6 cm.
CEMAC Ltd. Collection

Artist's inscription:
Bingyin *[1566] summer day for Mingyang, elder brother. Xianglan, Ma Shouzhen.*

Artist's seals:
Xianglan; Shouzhen Xuanxuanzi; Xianglan nüshi; Jiuwan zhong ren[1]

9

Ma Shouzhen

Colored Fungus, Orchids, Bamboo, and Rocks, 1604
Ink and color on gold flecked paper
Handscroll, 26.5 x 229.5 cm.
Indianapolis Museum of Art, Gift of Mr. and Mrs. Eli Lilly (60.25)

Artist's inscription:
During the Wanli reign in the jiachen year [1604] during an autumn month, while sitting in Qinhuai water kiosk. The lady Xianglan, Ma Shouzhen.

Artist's seals:
Ma Xianglan yin; Shouzhen; Xianglan nüshi; Jiuwan zhong ren[2]

The handscrolls dated 1566 and 1604 (cat. nos. 8, 9), which are identically composed, raise questions of authenticity common in the study of Chinese painting: is one, both, or neither an authentic work by the artist in question? As with other known examples of virtually identical images, the painting must have been of considerable importance to be so closely duplicated, for in China as in the West, imitation is a high form of flattery. The craze for paintings by Ma Shouzhen was well established during her lifetime, and the composition represented by these paintings is one of the finest and most appealing of all those associated with her name.

The image of orchids in the painting is a visual anthology of the poetic symbolism of the plant. On the right, the Indianapolis scroll begins with a seal that reads *Jiuwan zhong ren*, or "the person in nine acres of orchids" (an allusion to Qu Yuan), which clearly portends an excursion through orchids.[3] What follows are depictions of nine groups of orchids that evoke a host of associations.

9
Ma Shouzhen
Colored Fungus, Orchids, Bamboo, and Rocks
1604 (detail)

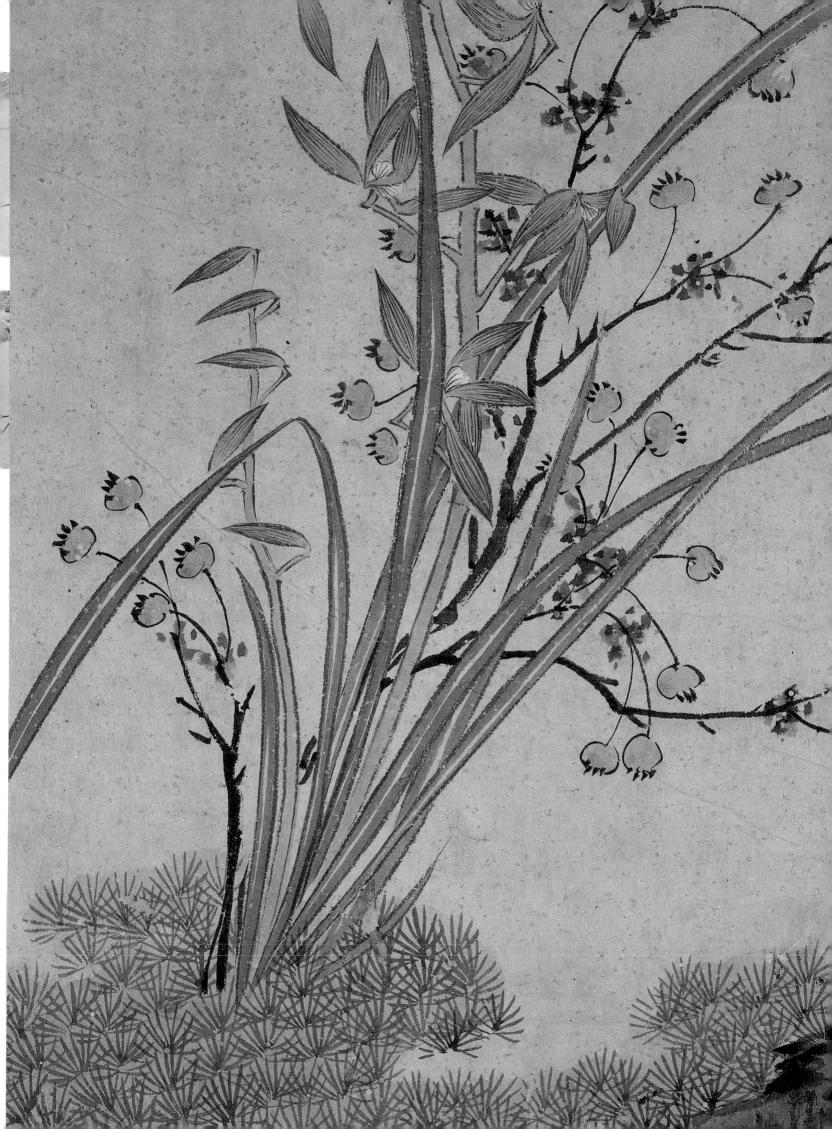

10 Xue Susu, *Outlined Ink (Wild) Orchids*, 1601, section

10

Xue Susu (Wu)

Late 16th to mid-17th century
Outlined Ink (Wild) Orchids, 1601
Ink on paper
Handscroll, 31.8 x 598.17 cm.
The Honolulu Academy of Arts (1667.1)

Artist's inscription:
Xinchou *[1601], during the first [lunar]
month in spring, sketched by Xue Susu.*[1]

Artist's seal:
Xue [X?]

By almost any measure, Xue Wu (*zi*
Suqing, Runqing, Susu, Sujun; *xiao zi*
Runniang) must be considered an ex-
traordinarily talented woman. Like her
contemporary Ma Shouzhen, she was a
courtesan and flower of her age. A popu-
lar literatus wrote about Xue when she
was a teenager:

Xue Wu looks amiable and graceful. Her
conversation is refined and her manner of
moving lovely. Her calligraphy in the regu-
lar style is excellent, her painting of bam-
boo and orchids even better. Her brush
dashes rapidly; all her paintings are full of
spirit. They are superior to those of most

professional painters in town. She is also a
superb archer. While galloping on horse-
back she shoots two balls from her cross-
bow, managing to make the second ball hit
the first one in the air. Or she puts one of
two balls on the head of her maid, and the
second ball strikes away the one from the
maid's head without scratching her. Or she
puts a ball on the ground at a distance, and
while her body is turned and her arms are
crossed backwards, she hits the one on the
ground with another ball. She never misses
a single of such shots in a hundred.

She values herself highly, does not re-
ceive common people, but only learned
and intelligent men. Her spirit is heroic
and she loves originality. . . .

Susu was interested in Buddhism,
which she studied with Yu Xianzhang. She
was fond of poetry, which she learned from
Wang Xingfu. People used to call her
"*jiaoshu*" (book-reviser).[2] Her poetry, al-
though lacking in freedom, shows a talent
rare among women.[3]

Xue was clearly a desired and talented
beauty, and was even praised through
poetry for her entertainment of guests.[4]
She evidently could afford to choose her
own companions, for a certain Peng
Xuanwei of Xiyang deeply admired her
portrait and expended gold beyond
measure to get it, but was unsuccessful.[5]
Her attentions to others made men jeal-
ous; and her relations with men appear
slightly more transient than those of the
other courtesan-painters represented in
the exhibition, who all found one man
on whom to focus their attentions.

[Xue Susu] was taken as wife by Mr. Li,
"the subduer of the [Southern] Man re-
gion." Her portrait circulated in the un-
civilized Man tribe where it fascinated the
Man barbarians. In middle age she fasted
long and embroidered Buddha images,
and married several times — all without
success. Late [in life] she returned to a
wealthy family master in Wu [Suzhou re-
gion], as a household concubine, and died
in old age.[6]

Li Rihua (1565-1635) spoke of Xue
Susu's rather sad or unfulfilled life:

However, a flower after many springs is
old, man's sentiments cannot avoid having
thoughts of the green shade of youth. A
charming girl is unable to apply force [to
change] the situation. Today, again she
uses the method of painting to refinely
sketch a Bodhisattva to pray for all loving
couples under heaven to have descendants.
This to her credit fills a big deficiency.
Thus I happily praise her, saying:
Clever girl with cultured hand nurtured
by spring breezes,
A hundred flowers from your fingers
blossom forth.
A Bodhisattva appears within a flower;
Natural result of true, real fruit [of
their just desserts].[7]

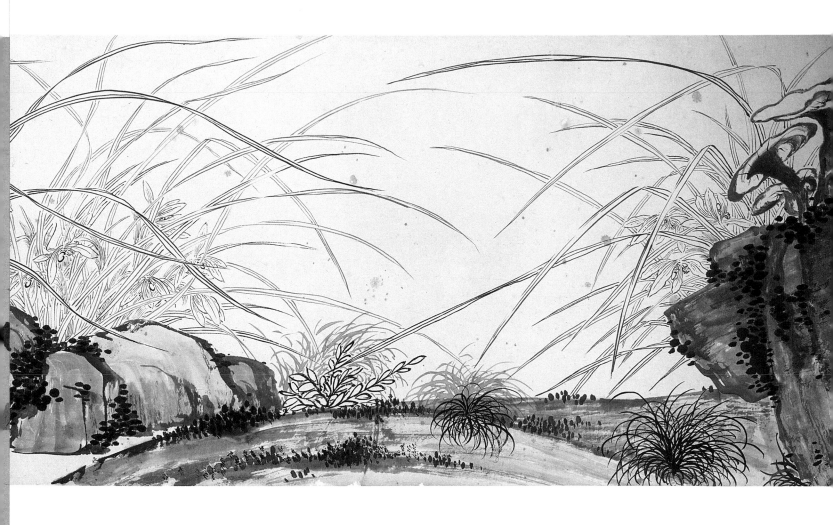

Finally, Xu Jing explained her lingering fame:

> In spite of her long life, ingenuous-minded Xue retained her glamorous reputation. After she had passed away, fiction grew around her, saying that she had possessed witchcraft by means of which she attached younger men to her. But this is a legend only. Studying her portrait, one sees a fastidious woman, but without pretentions. It is more likely that, as Daoist tradition has it, her high spiritual power had preserved her charm. Why should it not have been with her as with Xia Ji, whose beauty enchanted admirers without decline?[8]

Her paintings were praised by the connoisseurs of her day. Dong Qichang (1555-1636) so "loved at first sight" her ink painting of the Buddhist figure Guanyin that he inscribed the *Heart Sutra* (see cat. no. 3) and a colophon:

> As for landscapes, orchids, and bamboo, she puts the brush to paper quickly and sweepingly. None lack the bearing that enters the divine . . . skilled at orchids and bamboo. . . . Even a skilled artist with good hands is not able to surpass her.[9]

The Honolulu scroll opens with a waving cluster of blossoming orchid plants, which is immediately followed by another tangle of flowers and leaves. Ultimately some eight groupings or clumps of orchids are presented in this *tour de force*. Inviting, open, airy, and with outline at the start, by the end everything is reversed, having become cold, closed, and snow-covered with free wash to depict objects in reserve.

The orchids are strongly depicted with a pronounced sense of naturalism. This naturalism results in part from the attention to detail and in part from the absence of artifice like that found in the numerous and repetitious double-curved leaves so popular in the Wen Zhengming (1470-1559) tradition of unoutlined or single-stroke leaves.[10]

The earliest record of Xue in the painting literature records that "for the subject of ink bamboo she was extremely skillfull, as she was also with orchid and rocks."[11] Indeed, it is only in the tradition of bamboo painting that one can find precedence for this dramatic composition. In the outline technique of flower studies, as opposed to bamboo, Zhao Mengjian's (1199-c.1267) handscrolls of narcissus must be considered as a possible influence. Though his vision of narcissus presents the complexities of intertwined leaves, the surface of the ground level remains parallel and near the bottom edge of the handscroll.[12] In the tradition of ink-orchid painting, which, according to records, has its roots in the Northern Song dynasty and the art of Mi Fu (1052-1107), there appears to be no prototype for what Xue Susu has done in this painting.[13] Artists such as Zhang Sun (act. 1349) in the outline tradition and Wang Fu (1362-1416) and Xia Chang (1388-1470) in the ink-bamboo tradition are possible precedents. Their bamboo handscrolls often begin with a section of land as level horizon and then, after the scene crosses a waterway, all sky and horizon are lost as the view becomes a close-up vision of the ground. A handscroll dated 1464 with a Xia Chang signature in the Freer Gallery of Art (52.27), is remarkably similar in rhythm, motifs, and even size to Xue Susu's scroll.

Thus, she apparently borrowed a compositional layout from the bamboo-painting tradition and adapted it to her subject. This innovative translation from bamboo painting to orchid painting shows her artistic insight and her ability to create a bold vision of a time-honored subject. The sheer exuberance of line and rhythm manifested in this scroll surely reflects her robust personality, and make this handscroll one of the finest to have come through the ages.

You ask of me "How can this be so?"
"When the heart is far, the place of itself
 is distant."
I pluck chrysanthemums under the eastern
 hedge,
And gaze afar towards the southern
 mountains.
The mountain air is fine at evening of
 the day
And flying birds return together
 homewards.
Within these things there is a hint
 of Truth,
But when I start to tell it, I cannot find
 the words.[2]

Harrie Vanderstappen has published the following concise analysis of the relationship between Tao Qian's poem and Xue Susu's work:

> It is hard to realize the implications of the meanings which have become attached to chrysanthemums in connection with the "eastern fence." For instance, the eighth-century poet Ts'en Shen [Cen Shen] in the far regions of northwest China combines the chrysanthemum with drinking and listening to the music of string and flute at the eastern fence, and the combination would only make sense in reference to T'ao

Yüan-ming's [Tao Qian] poem. The same is true of Hsüeh Wu's [Xue Susu] poem on this fan in which she joins the accumulated nostalgia that ages of readers have felt at the words which express the sudden fullness of joy in the simple, almost accidental gesture of the eye, looking up from a simple task to encompass unexpectedly the beauty of the world in the Southern Mountains. The knowledge of the poem and its historical overtones link one's learning and emotional, intellectual experiences to the painting.[3]

The chrysanthemum, symbol of the ninth month, was one of the so-called Four Gentlemen, along with bamboo, blossoming plum, and orchid, all of which were associated with scholarly ideals.

One of the seals Xue Susu affixed to this fan reads "*Nü jiaoshu*," meaning "female reviser of books." *Jiaoshu* was an ancient, semi-honorific designation for a high-class courtesan with exceptional literary ability. It was first given to the Tang-dynasty courtesan Xue Tao (768-831) in recognition of her poetic achievements. Since Xue Susu had the same surname, her use of this seal was doubly appropriate.

 1. Translated by Irving Lo.
 2. Cyril Birch, ed., *Anthology of Chinese Literature: From Early Times to the Fourteenth Century* (New York: Grove Press, 1967), p. 184.
 3. Harrie A. Vanderstappen, "Late Ming Fans," *Honolulu Academy of Arts Journal: A Selection of Chinese Art in the Collection* (1977), 2:50.

Bibliography: Harrie A. Vanderstappen, "Late Ming Fans," *Honolulu Academy of Arts Journal: A Selection of Chinese Art in the Collection* (1977), 2:50; Tseng Yu-ho Ecke, *Poetry On the Wind: The Art of Chinese Folding Fans from the Ming and Ch'ing Dynasties* (Honolulu: Honolulu Academy of Arts, 1981), no. 35, pl. 71; Suzuki, A 38-054.

 JR

13

Xue Susu

Cicada on Leaf
Ink and color on gold paper
Fan, 17 x 47 cm.
Chengxun tang Collection

Artist's inscription:
Susu sketched.

Artist seal:
Suqing huayin

Like her 1633 fan painting of chrysanthemums (cat. no. 12), this painting reveals Xue Susu's confidence with the use of both wash and line for depicting solid, structurally clear forms. Different here is her use of color, which may have had some relationship to her recorded expertise in embroidery.[1] The brilliant turquoise against the soft, graded yellow of the leaf and the fine-line leaf veins suggest the influence of that art.

Every bit as evocative as orchids or chrysanthemum, the cicada is an hon-

12
Xue Susu
*Chrysanthemums
and Bamboo*
1633

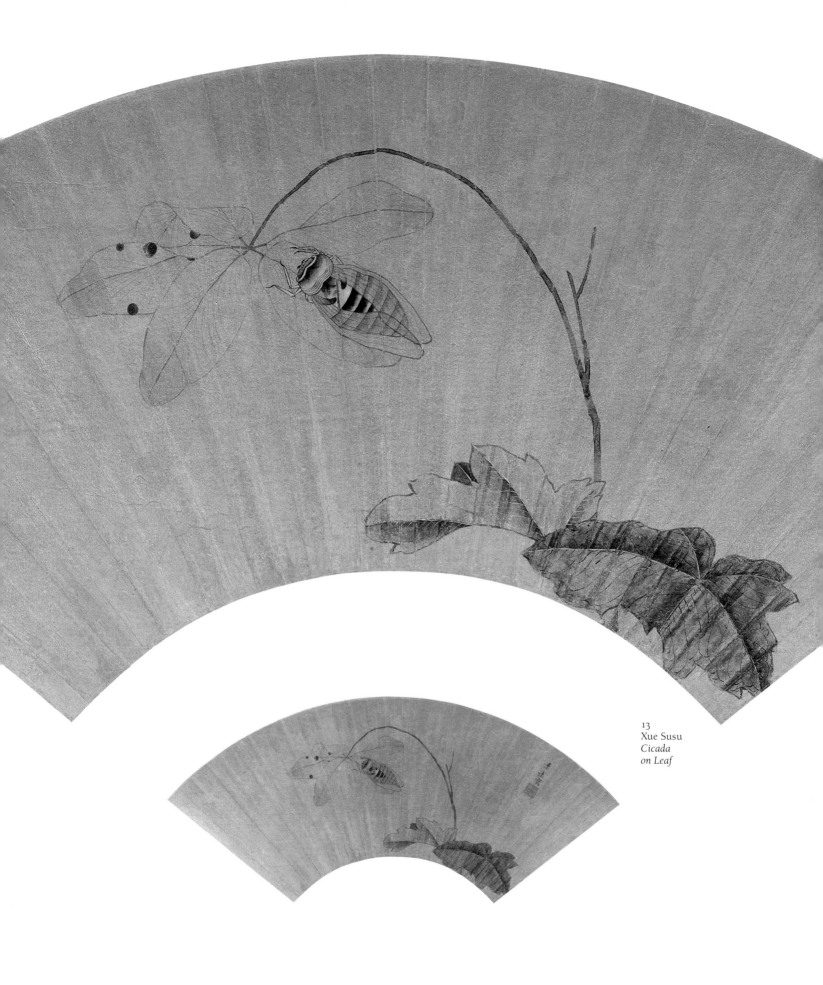

13
Xue Susu
*Cicada
on Leaf*

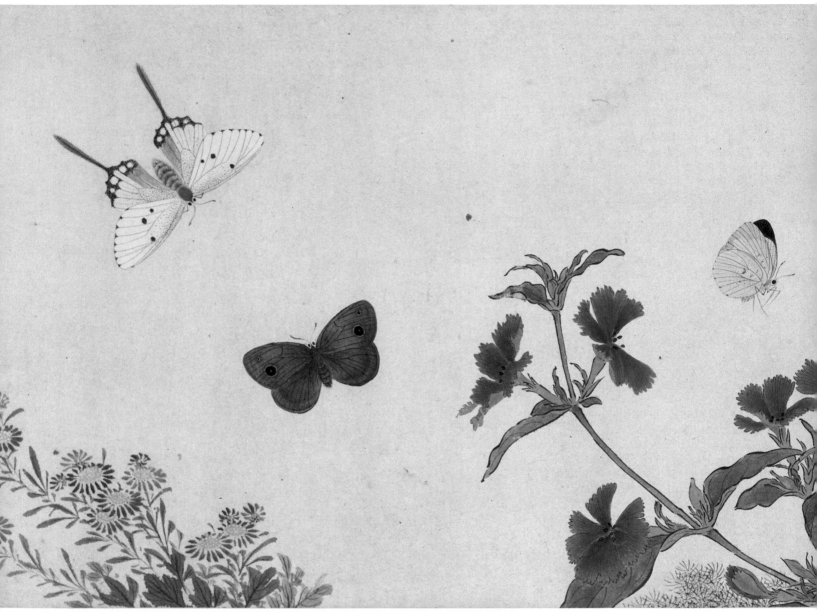

16 Wen Shu, *Playing Butterflies*, 1630, section

preciation, combined with a polished elegance of description may hark back to Wen Zhengming. The actual painting techniques, however, seem to reflect more closely the art of the great Suzhou flower painter Chen Chun (Daofu, 1483-1544).

1. Qian Qianyi, "Zhao Lingjun muzhi ming," in his *Muzhai chuxue ji*, preface dated 1643, *Sibu congkan* ed. (Shanghai: Commercial Press, 1929), 44:17b-21a; Zhang Geng, *Guochao huazheng xulu*, *Huashi congshu* ed. (Shanghai: Renmin meishu, 1963), *xia*, 114.

Bibliography: Harrie A. Vanderstappen, "Late Ming Fans," *Honolulu Academy of Arts Journal* 2 (1977): 3; Tseng Yu-ho Ecke, *Poetry on the Wind: The Art of Chinese Folding Fans from the Ming and Ch'ing Dynasties* (Honolulu: Honolulu Academy of Arts, 1981), no. 44; Suzuki, A 38-053.

EJL

15

Wen Shu

Lily, Narcissus, and Garden Rock, 1627
Ink and color on paper
Hanging scroll, 127 x 51.4 cm.
Lent by John M. Crawford, Jr.

Artist's inscription:
Brushed by Wen Shu, of the Tianshui Zhao family, on a summer day, tingmao [*1627*].

Artist's seals:
Zhao Wen Shu yin; Duanrong; Wen Shu zhi yin; Wen Duanrong shi; Langui

The scalloped contours of the rock forms and the spreading of the stalks, leaves, and blossoms into a triangular composition in this hanging scroll are similar to what is seen in the carnations and garden rock fan of 1627 (cat. no. 14). Here, however, there is a greater emphasis on curves, with the arching rocks repeated in the curved petals of

the lilies and in the two cabbage butterflies. The Metropolitan scroll might be compared to a hanging scroll by Wen Shu dated 1630, now in the Freer Gallery of Art, Washington, D. C. (fig. l).

The particular combination of motifs — rocks, flowers, and two butterflies — is very ancient in origin. It evolved out of Tang-dynasty flower, insect, and bird compositions largely preserved today only in Tang decorative arts.

Butterflies and rocks both have symbolic values. Rocks stand for longevity. The butterflies also mean long life because their name in Chinese, *die*, has the same sound as the word for septuagenarian. The lily pictured here is a *Lilium concolor*, and the small white flower at the base of the rock is in all likelihood *Tupila edulis*, a common plant native to China.[1]

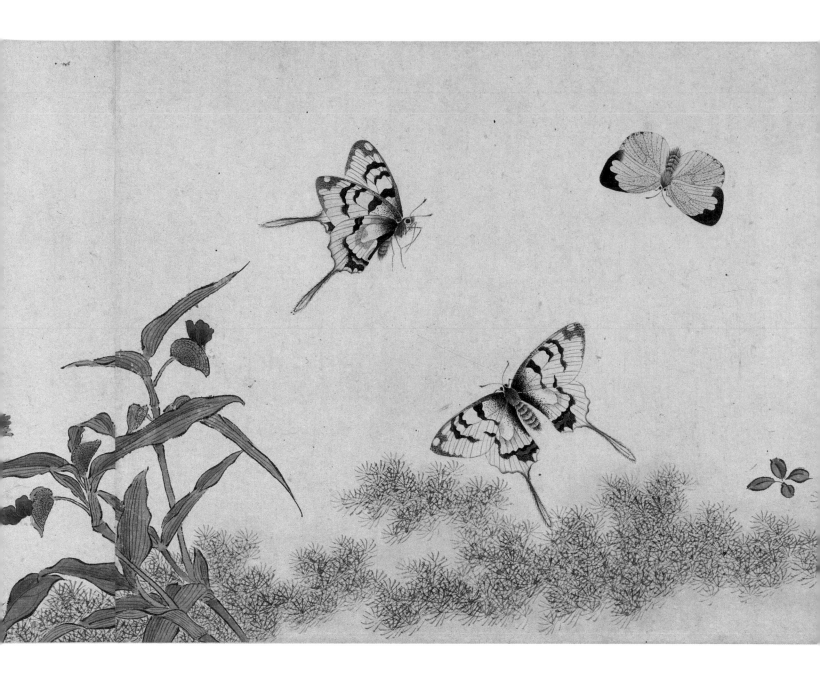

1. I am indebted to Dr. Warren H. Wagner, Jr. and to Dr. Anton Reznicek, both at the University of Michigan, for identification of some of the plants and butterflies seen in Wen Shu's paintings.

Four collector's seals.

Bibliography: Tseng Hsien-ch'i, *Loan Exhibition of Chinese Paintings* (Toronto: The Royal Ontario Museum of Archaeology, 1956), no. 36; Sirén, *CP*, 7:267; Suzuki, A 15-007; *The John M. Crawford, Jr. Collection of Chinese Calligraphy and Painting in the Metropolitan Museum of Art Checklist* (New York: Metropolitan Museum of Art, 1984), p. 40.

EJL

16

Wen Shu

Playing Butterflies, 1630
Ink and color on paper
Handscroll, 20.5 x 272 cm.
Bei Shan Tang Collection

Artist's inscription:
Painted by Wen Shu of the Tianshui Zhao family late in the third month of gengwu [1630].

Artist's seals:
Wen Duanrong; Zhao Wen Shu yin; Duanrong

In this scroll the artist combined an exacting outline-and-color technique and a *mogu* (boneless) application of color. Regardless of which method is employed, the plants are described with a high degree of accuracy both in terms of shape and color; modulated hues further contribute to a realistic effect.

Above the bamboo, asters (?), day lily, and other plants, a variety of butterflies — sulphurs, cabbage butterflies, swallowtails, fritillary, and wood nymphs — flit, hesitate, and hover, almost posing, in an exquisite display of subdued colors and delicate patterns. The symbolic message of the day lily, the wearing of which was believed to ensure the birth of a son, is reinforced by the mating cabbage butterflies. According to tradition, this type of flower-and-insect composition, including undulating landforms, goes back to the tenth century and the work of Xu Xi.[1]

1. Such a scroll, attributed to Xu Xi, is now in the National Palace Museum in Taipei. See *Caochonghua tezhan tulu* (Taipei: National Palace Museum, 1986), no. 22.

One colophon and nine collector's seals.

EJL

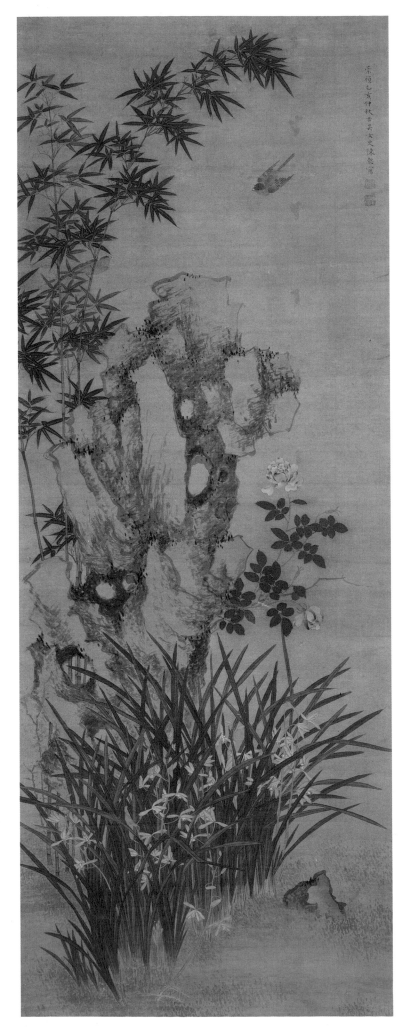

17
Chen Yi
*Orchids, Bamboo,
and Roses by
Garden Rock*
1635
(detail at right)

17

Chen Yi
17th century
*Orchids, Bamboo, and Roses by Garden
Rock*, 1635
Ink and color on silk
Hanging scroll, 160.8 x 59.8 cm.
Indianapolis Museum of Art, Given by
Mrs. Erwin C. Stout in memory of
Wilbur D. Peat, Director of the
Indianapolis Museum of Art and Curator
of Oriental Art, 1929-1965 (1988.1)

Artist's inscription:
*During the Chongzhen reign in the yihai
year [1635] at mid-autumn, sketched by
the lady of ancient Wu, Chen Yi.*

Artist's seals:
Guwu nüshi; Chen Yiyuan shi

According to her signature, Chen Yi was
from an ancient artistic region around
Suzhou, Jiangsu, that boasted a high
concentration of active women artists
during the middle and second half of the
seventeenth century. Judging by this
painting, Chen was an established artist
during the first half of the seventeenth
century. From a fan in the imperial col-
lection of Qianlong, we know her style
name (*zi*) was Demei.[1] Her biography
does not appear to have been recorded,
and fan paintings by her that are known
today, which depict flowers and butter-
flies, add no other information.

 This painting has been in Japan for
well over a century. Japanese records
state that it was "displayed in 1852 at the
major Kyoto exhibition of Chinese paint-
ing held in honor of the 70th birthday
of Yamamoto Baiitsu."[2] Baiitsu (1783-
1856) was a Japanese artist famous for
his flower and bird paintings in the
Chinese manner, and this painting by
Chen, with elements of rich color jux-
taposed with plain ink motifs, is quite
similar to the style he favored.

 1. Wang Jie, et al., *Shiqu baoji xubian* (1793;
reprint Taipei: National Palace Museum, 1971),
2:537. Though the seals are different, she is con-
sistent in the phrasing of her signature.
 2. Howard Rogers thoughtfully passed on this
information.

Bibliography: Suzuki, JP 14-041.

JR

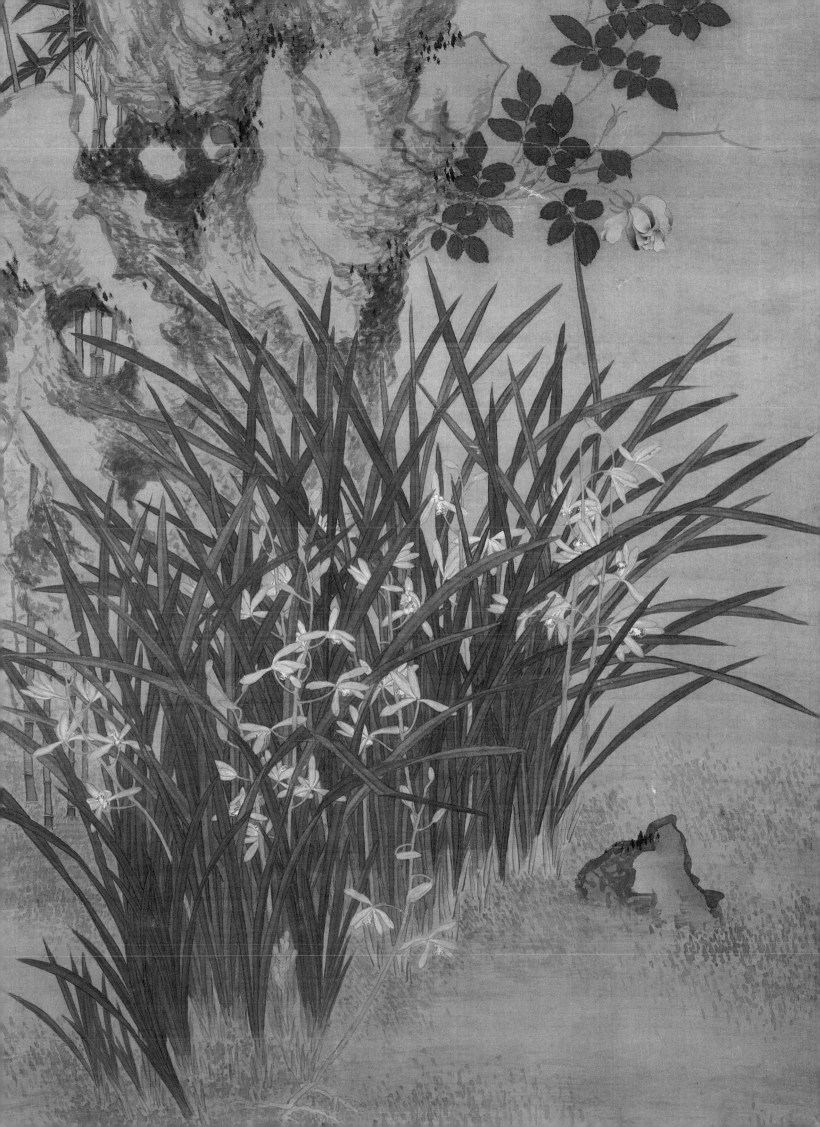

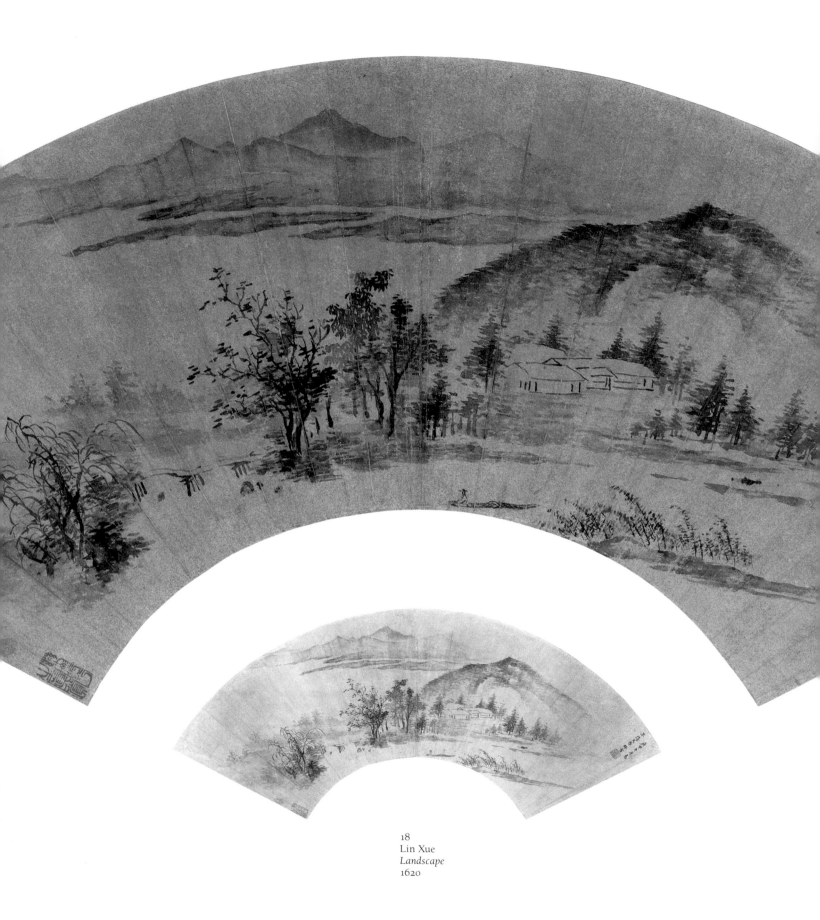

18
Lin Xue
Landscape
1620

18

Lin Xue
First half of 17th century
Landscape, 1620
Ink on gold paper
Fan, 17.3 x 54.5 cm.
Mr. and Mrs. J. P. Dubosc Collection

Artist's inscription:
Gengshen [1620], winter month [eleventh month], done for elder brother Pingqian,[1] *Lin Xue.*

Artist's seal:
Lin Xue

Lin Xue, also known as Lin Tiansu, was a courtesan from Fujian province who took up residence by the West Lake in Hangzhou. Her calligraphy and painting came to the attention of some of the leading figures of the day. She received poems, for instance, from the painter Li Liufang (1575-1629), who loved to visit the West Lake, as well as from Dong Qichang (1555-1636).[2] Dong also mentioned Lin in a record concerning the work of another woman artist, Fan Daokun of the Li family of Shandong.[3]

Lin Xue was primarily a landscape painter and is said to have copied antique paintings with considerable success.[4] Although no specific model is cited in the inscription on this fan, the low rolling hills textured with soft dots and the tranquil mood of this southern river view recall the works of Song-dynasty master Mi Fu (1052-1107) and his son Mi Youren (1075-1151) as well as those of their Yuan-dynasty follower Gao Kegong (1248-1310). This is the earliest of Lin Xue's extant dated works.

1. Probably the Hanlin official Huang Hui (*jinshi* 1589). Yu, p. 1163.
2. Li Liufang, *Tanyuan ji* (1689 edition), 1:22a-b; 6:10; Dong Qichang, *Rongtai shiji* in *Rongtai ji* (Taipei: National Central Library, 1968), 2:32b (p. 1464), 4:40b (p. 1642).
3. Dong Qichang, *Rongtai bieji*, 6:52b-53b (pp. 2192-94). In this record Dong also mentions a woman painter of Hangzhou named Wang Youyun. The identification of Wang remains a puzzle. At one point the text calls her Youyun and at another Yunyou. Other sources speak of a woman of Hangzhou named Yang Huilin, *hao* Yunyou, who was Lin's friend and equally famous. Yu Jianhua lists them separately (pp. 62, 1198) without comment, but in *Zhongguo huajia renming da cidian* (pp. 39, 585) it is suggested that Wang is a corrupt reading of Yang, and these references were, in fact, to a single person. This and the problems posed by different versions of the passage from the *Rongtai shiji* await further study.
4. Li Guangyang, *Xihu yishi*, cited in YTHS, 5:78.

One collector's seal.

MW

19

Lin Xue
Landscape, 1642
Ink on gold paper
Fan, 16.3 x 50.4 cm.
Chengxun tang Collection

Artist's inscription:
Sketched in renwu [1642], the first month of spring, Lin Xue.

Artist's seals:
Lin Xue; Tiansu

Colophon:
The southern breezes softly blowing come early to the painted pavilion;
From afar I recall the grand courtesan Lin.
Beiyuan's [Dong Yuan] refined style is just like yesterday;
How many times have I let my eyes roam as alone I paced to and fro?

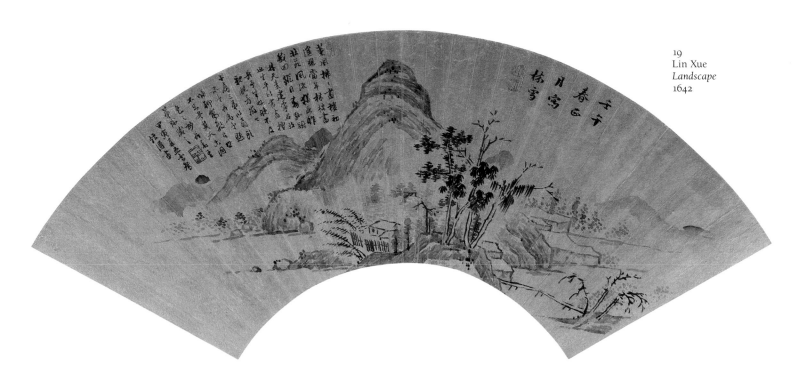

19
Lin Xue
Landscape
1642

Lin Tiansu was a famous courtesan of Qianning [Fujian]. Throughout her life she excelled in painting and calligraphy. I was born too late to know firsthand her beauty and accomplishments.

My third brother Zifang showed me this fan and asked me to write something on it. I have written just a few lines, but am afraid they are inadequate to express completely the wonder of her beauty [literally: heavenly fragrance and national beauty]. I hope my younger brother will treasure it. Jiayin [year], summer, first month, casually written by Xuelu guan.[1]

The colophon writer was reminded of the style of the tenth-century landscape master Dong Yuan, but Lin's source of inspiration could equally well have been the paintings of Dong's later interpreter Huang Gongwang (1269-1354).

1. The writer's seal reads Jin Lang; he has not been identified. I wish to thank Irving Lo and Hsing-li Tsai for their assistance with this translation.

MW

20

Lin Xue
Landscape after Huang Gongwang
Ink on gold paper
Fan, 19 x 56 cm.
Museum für Ostasiatische Kunst, Cologne (A55.7)

Artist's inscription:
Lin Xue imitated the brush method of Zijiu [Huang Gongwang].

Artist's seal:
Tiansu

The fans in the exhibition support the claim that Lin Xue was given to copying ancient masterworks and indicate that she was well versed in the styles of the "orthodox" lineage of Dong Qichang's Southern School. It is therefore not surprising that Dong appreciated her work. The impression of her art given by these fans is generally sustained by two landscape hanging scrolls with her signature, dated 1621, in the Shanghai Museum; however, both of those are bolder works on satin, and in one case the agitated brushwork is at variance with the restraint evident in her small scenes. Lin Xue's name is also attached to a large scroll of a very different sort in the collection of the Freer Gallery of Art (fig. f). This atmospheric view of geese on a marsh is indebted to Zhe School precedents. If all these paintings came from her brush, she was quite a versatile painter, capable of moving easily from large-scale decorative works to intimate studies done with a delicate touch. The fans, however, may be her most satsifying works — each a small, spacious world unto itself.

Bibliography: Suzuki, E 17-071.

MW

21

Gu (Xu) Mei
1619-64
Orchids and Rocks, 1644
Ink on satin
Handscroll, 27 x 170.8 cm.
Arthur M. Sackler Gallery, Smithsonian Institution, Washington, D. C. (S87.0269)

Artist's inscription:
Winter solstice, Mei painted at the Mo Chou Dwelling.[1]

Artist's seal:
Baimen Meizi

Colophon by Gong Dingzi:
After the snow, I embraced the bronze hand warmer. It was bitterly cold, but I had no money for wine. My classmate Junwan presented me with a bottle of famous wine in exchange for an orchid painting by my wife. I was delighted by his proposition and hurried my wife to paint this. In ancient time, Zizhan painted the old tree and then sent it to Mr. Jian and said: "If there is an enthusiast at Wuxiu who would present you with one hundred kilos of rice and three jugs of wine every month for the rest of your life, then you can give my painting to him." If that were true, then Mr. Junwan should owe me more wine! In the mid winter of 1644, [I] playfully wrote.[2]

20
Lin Xue
Landscape after Huang Gongwang

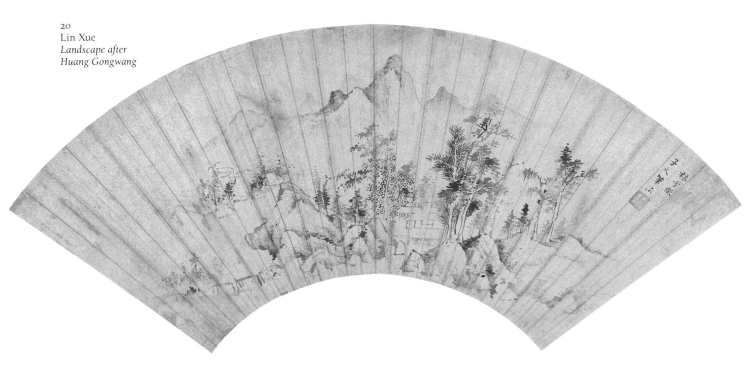

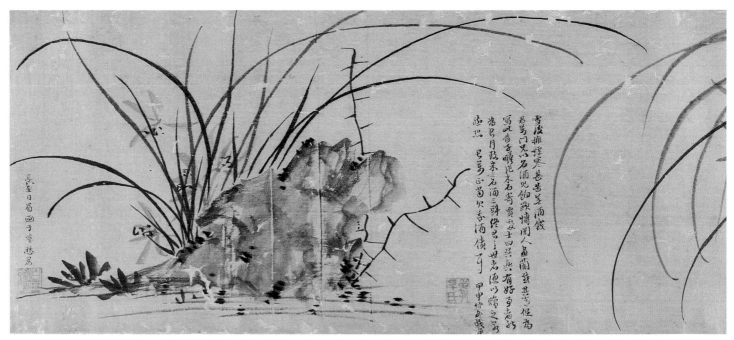

21 Gu Mei, *Orchids and Rocks*, 1644, section

In the Qinhuai district of Nanjing, Gu Mei (*zi* Meisheng, Meizhuang; *hao* Hengbo, Zhizhu, Meisheng) was one of the most sought-after courtesans of her day. The poet Yu Huai (1616-96), in his reminiscences of late-Ming Nanjing, maintained that literary drinking parties were joyless without her presence. He enumerated her physical charms, employing all the conventional terms of praise: her hair was like clouds, her face like peach blossoms, her little feet elegant, and her tiny waist soft and fragile.[3] Her name, Mei, in one form means "fascinating" and in another "eyebrows"; her pen name Hengbo refers to the "sidelong glances" cast by seductive beauties. If this were not enough, Gu was also intelligent, conversant with literature and history, and a talented painter. Her pavilion, called Mei or Eyebrow's Tower, was filled with scrolls, musical instruments, the scent of fine incense, and the delicate sounds of wind chimes.[4]

Gu's self-cultivation was rewarded; she won the affections of Gong Dingzi (1616-73), a poet, painter, and official who served both the Ming and Qing dynasties. He was one of the so-called Three Masters (poets) of the Eastern Yangzi River Region, along with Qian Qianyi (see cat. no. 23) and Wu Weiye (1609-72).[5] As a painter he tried his hand at landscape.[6] Gong took Gu as his second wife, and if Yu Huai is to be believed, they were ideally suited. Gong enjoyed guests and willingly complied with their requests for his poems, while Gu similarly responded to their petitions for her orchid paintings. Gong's colophon for the Sackler painting provides

a glimpse of their social life and the role Gu's painting played in it. However, the austerity of this occasion, which took place in the winter of the year the Ming dynasty collapsed, contrasts with the lavishness of others, such as the party Gong threw in Nanjing in 1657 for Gu's birthday. This time several hundred guests feasted beneath lanterns and watched the play *The Queen Mother Banquets at the Fairyland Pool*. Meanwhile, Gu invited some of her old friends from the pleasure quarters of the city to share a banquet.[7]

According to Yu Huai, in 1664, when Gu was in Beijing with Gong, she fell ill and died. Her surname was then changed to Xu, and she was posthumously called Lady Xu. Other accounts state that this was her original family name. It has also been suggested that she changed her name to Xu when she married Gong. Late Ming and Qing writers usually referred to her as Gu Mei, but in Yu Jianhua's recent dictionary of Chinese artists her biography appears under the name Xu.[8]

Like most courtesan painters, Gu Mei specialized in orchids. Her skill in this genre was noted by Yu Huai, who also observed that she followed in the footsteps of the orchid painter Ma Shouzhen (cat. nos. 4-9) while surpassing her in physical charm. Yu connected the two women in only a vague way, as talented beauties of Nanjing, but Gu is appropri-

ately regarded as an artistic successor to Ma Shouzhen. Gu's work is generally similar to several of the ink-monochrome orchid paintings that today bear Ma's name, including the hanging scroll in the Metropolitan Museum of Art (cat. no. 5) and *Orchid, Bamboo, and Rock* in the collection of the Art Museum, Princeton University.[9] At the same time it reveals a distinct artistic personality. Gu's brushwork is looser, bolder, and more animated. The scroll in the exhibition has little of the coolness and restraint that mark Ma Shouzhen's works, but it matches Chen Weisong's description of Gu Mei's orchid-painting style as free and uninhibited.[10] It also supports Zhang Geng's assertion that Gu put forth her own ideas, rather than appropriating those of her predecessors.[11] This is not to say, however, that she was unaware of the history of her chosen genre. On a handscroll of orchids and rocks now known only through an old reproduction, she wrote, "On an autumn day in 1648 [I] copied the brush idea of Zhao Songxue [Mengfu]."[12] Although it is not so inscribed, the scroll in the Sackler collection also recalls the orchid-and-rock compositions of this Yuan-dynasty master.

The extent of Gu Mei's fame is indicated by the names of some of the individuals who took note of her and her works. In addition to those mentioned above, the poets Zhu Yizun (1629-1709), Peng Sunyu (1631-1700), and Li E (1692-1752) wrote in appreciation of her paintings.[13] The Sackler painting is followed by fifteen colophons. The writers include Huang Yi (1744-1802), Weng Fanggang (1733-1818), Wu Xiqi (1746-1818), and Yu Ji (1738-1823). Also

4.
From an empty kiosk I listen to a rushing
torrent after rain,
And with no one around but a fisherman,
the autumn lake is a mirror.
Evening breeze and dusk's glow—a scene
of purest leisure,
While the moonlight slowly climbs up my
white head.[9]

5.
Coolness spread from the shade of the
green wutong *[tree];*
Each evening at dusk I strum my lute
lying aslant.
A calm envelopes a thousand mountain
streams;[10]
Seated, I bid farewell to clouds from
across the brook.
Immortal music dreams of a paradisiacal
Golden Age;
Sounds of autumn fall among the flocks
of wild geese.
The breeze by the window is ever so
gentle and fine,
While fragrance seeps into my lotus-
patterned skirt.

6.
A flowing date-tree curtain hangs low in
the evening dusk;
By the carved window I chance upon a
fine old inscription.
Over the mossy pathway human tracks
are few;
Immortal cranes fly past the westernmost
bamboo branches.

7.
Leaf after leaf of deep sorrow, inch after
inch of shade;
Under a sky of dark clouds, longing for
someone faraway,
I've turned less and less to poetry.
I recall the time listening to the sound of
rain echoed from the mountain peaks:
I was just another plantain tree, my heart
just as full.

[I] imitated the Song masters' methods of
applying color and inscribed [this].

8.
One layer of azure void, one layer of
mist—
A three-storied tower and pavilion: a bit
of heaven.
Most suitable for a man of talent is a
beautiful woman;
An immortal's fated partner must be the
Goddess of the Moon.
How could I fail with brave words to
compliment spring's radiance?
Hearing a discourse on origin[11] *leads*
easily to awakening.
One's karma must be cultivated, and
fragrance transplanted;
The east wind still must issue from
beneath the swing.[12]
[The remaining lines are badly damaged.]

Artist's seal:
Liu Yin shuhua

Liu Shi was originally called Yang Ai (or Aier; *hao* Yinglian). She began as a courtesan in a brothel in Shengze (Wujiang) where she was a student of a famous entertainer named Xu Fo, who played the *qin* and painted orchids.[13] Liu established a reputation as a poet, painter, and calligrapher and set her sights on marrying a gentleman. In 1640, dressed as a scholar, she called upon the celebrated poet and official Qian Qianyi (1582-1664) of Changshu, Jiangsu, and asked to study with him. The following year she became his concubine and was subsequently known as Hedong *jun*, or Madame Hedong.[14]

Qian is said to have given her the name (*zi*) Rushi and called her residence the Wowen Chamber, borrowing from the conventional opening phrase in Buddhist sutras: *Rushi wowen*, meaning "I heard it said." Both of these names are used in the signature on this album, "Wowen jushi Liu Rushi." Below the signature is the artist's seal, which reads "Liu Yin *shuhua*." This combination of appelations has raised questions because Liu Yin, meaning "Willow Recluse," can be interpreted as "recluse of the willow (brothel) district," and presumably she would not have called herself this after she entered Qian's household. This point has been made by Chen Yinke, the author of a three-volume biography of Liu Shi. Rather than casting doubt upon the authenticity of the painting, however, he suggests that Liu was already called Wowen jushi and Rushi before she met Qian and that the album was done prior to this event.[15] If this is the case, then the line concerning a "man of talent" and "a beautiful woman" in the last poem must either be regarded as prophetic of Liu's relationship with Qian Qianyi or as a reference to another alliance.

Regardless of its specific date of execution, this album of paintings and poems reflects the scholarly side of Liu's personality and is in keeping with the life she eventually enjoyed with Qian. In 1643 Qian built a library, the Jiangyun lou, at the foot of the Yu mountains in

Changshu, and there the couple wrote poetry and compiled books for a number of years. Liu helped Qian edit the section on women poets in his anthology of Ming poets, the *Liechao shiji*, printed in 1649. (This was one of the sources upon which Tang Souyu drew heavily in compiling the *Yutai huashi*). After the library burned in 1650, Liu and Qian turned to Buddhism, and in 1663 she tonsured her hair in the fashion of a Buddhist nun. Qian died the next year, and his enemies forced Liu and Qian's son to give up the family property. In the face of pressure from these individuals and in an effort to save her daughter and stepson from more trouble, she committed suicide.

Liu expressed herself primarily through poetry, but she was also known for her painting. Before she took the name Liu and became Qian's concubine, her work came to the attention of the collector and connoisseur Wang Keyu (1587-1645), who wrote:

> There is a Yang Yinglian of Songling, Shengze who is able to write poetry and is good at painting. I have seen her painting of narcissus, bamboo, and rock. The light ink is imbued with vitality and strength. It is not inferior [to the work of] . . . Zigu [Zhao Mengjian]. Her calligraphy is also beautiful.[16]

Unfortunately, this record cannot be connected in any way with the extant paintings that bear Liu Shi's name: a decorative depiction of a bird on a blossoming branch, a *baimiao* (ink outline) drawing of ladies on a terrace and in the upper story of a pavilion, a handscroll, *Willows on a Moonlit Embankment,* dated 1643 (fig. g), and the album in the exhibition. In a recent study James Cahill found the attributions of the first two "unsafe" and focused his discussion on the last two as "more reliable works."[17]

Willows on a Moonlit Embankment, formerly in the Tianjin City Museum and now in the Palace Museum, is mounted with a landscape by another well-known woman artist, Liu's good friend Huang Yuanjie.[18] (Huang's work was painted for Liu in 1651; fig. d.) Liu's landscape is a mild view of a pavilion amid gently blowing willows on a riverbank in the moonlight; a rustic bridge leads to the distant embankment, and a simply sketched boat is moored at the shore. Relying on reproductions, it is difficult to compare this handscroll to the album in the exhibition. The most that can be said is that they are similarly unassertive, deliberately amateurish views of the Jiangnan.

Although the album is inscribed as after the "ancients" and Song-dynasty models are cited along with the Wen family, it is a straightforward exercise in the Wu School manner of Wen Zheng-

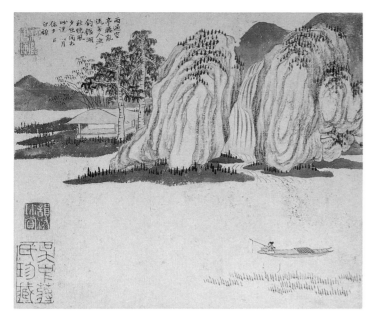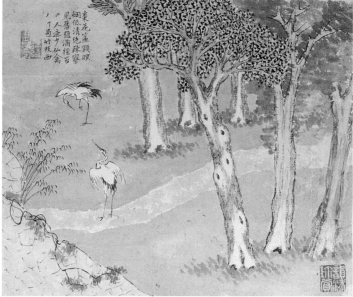
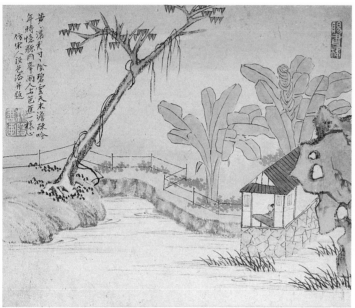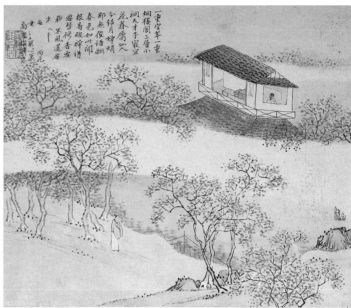

23-4, 6, 7, and 8 Liu Shi, *Landscapes with Figures*

ming and his followers. In every respect, from the soft, warm orange-brown/cool blue-green color scheme to the subject matter — gardens and river views — these paintings perpetuate the scholarly taste and life-style of Ming-dynasty Suzhou. A scholar washes an inkstone in a convenient stream; a lady plays the zither accompanied by a gentle breeze. Fishermen ply the rivers and cranes dance among the trees.

1. The poems were translated by Irving Lo, who also provided notes 2-12.

2. *Feng* and *Sao* refer, respectively, to the "airs of the states," or *guofeng*, section of the *Book of Odes* (*Shijing*) and to the *Li Sao* poem by the ancient Chinese poet Qu Yuan, translated by David Hawkes as *Ch'u Tz'u: The Songs of the South*.

3. The first two words of this line, *xiaoxi*, are borrowed from the first chapter of the *Zhuangzi*, where the text reads, "living things blowing each other about" [translation by Burton Watson, "Free and Easy Wandering," *The Complete Works of Chuang Tzu* (New York: Columbia University Press, 1968), p. 29].

4. The phrase *tuiqiao* alludes to a story about the poet Jia Dao, who asked the older poet Han Yu (768-824) if "to push" (*tui*) or "to knock" (*qiao*) would be more poetic in a line of his which reads, "A monk is pushing (or knocking) at the gate beneath the moon."

5. Two unusual words in the opening line, *qianyun*, allude to a poem by the Song poet Su Shi, who left in the preface of the poem the following account: "One day when I returned from the city, the clouds were so dense that they rushed toward me like thundering horses. . . . I pulled apart the clouds with my bare hands, had them stored in a cage, and opened the cage to let the clouds out when I got home."

6. The "tile" in the third line probably refers back to the inkstone. "Angry frogs" alludes to a story in the writing of the ancient Chinese legalist philosopher Han Fei Zi about how he once stood up in his chariot to salute angrily staring frogs in order to teach his disciples the important lesson of bravery. Because of Liu Shi's

active involvement in opposing the Qing government at one time, the "public scandals" in the last line may refer to some secrets that had to be concealed from the court.

7. "Misted over" or *yun* (literally "halo" or "vapor") probably refers to the ink-wash method in Chinese painting; specifically, to dilute ink with water to produce a blurred impression.

8. While the third word, *yu*, is supplied by conjecture, the "Seven Guests" is probably an allusion to the Seven Sages of the Bamboo Grove. Still the overall meaning of the poem is unclear because the allusion to the Seven Guests cannot be identified.

9. The third line of this poem contains an extra character that appears to have been "inked out" (indicated by a dot — usually three dots — to the right of the character) by the writer. And the fourth line contains at least two and possibly three characters that are not legible.

10. This alludes to the story of Zhong Ziqi, whose zither playing is appreciated only by his best friend Boya, who allegedly always knew beforehand whether the music had as its theme the high mountain or the flowing water.

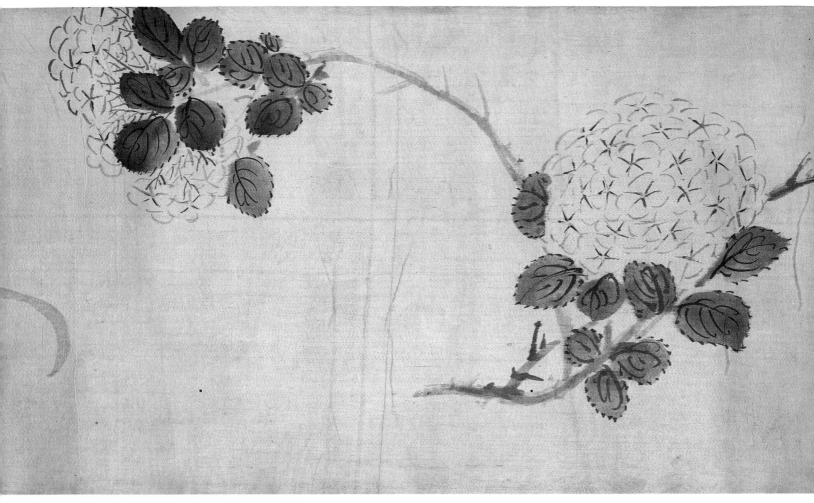

24 Li Yin, *Flowers of the Four Seasons*, 1649, section

11. *Wengen* in the text is a Buddhistic phrase, meaning literally "hearing about the root."

12. The last two words of the line, not entirely legible, appear to be *qiuqian* (that is, the swing in the garden): *qian* is the correct rhymeword for this poem.

13. Yu, pp. 607, 704; *YTHS*, 4:65 (under the name Yang Yinglian).

14. The information presented here was drawn largely from the biographies of Liu Shi and Qian Qianyi in *ECCP*, pp. 529-30, 148-50.

15. Chen Yinke, *Liu Rushi biezhuan* (Shanghai: Guji chubanshe, 1980), p. 36.

16. Wang Keyu, *Shanhuwang hua lu*, cited in *YTHS*, 4:65.

17. James Cahill, "The Painting of Liu Yin," in *Women in the History of Chinese and Japanese Painting*, ed. Marsha Weidner, forthcoming.

18. James Cahill compares these paintings in his study of Liu Shi cited in the previous note.

Four colophons and seven collector's seals.

Bibliography: Chen Yinke, *Liu Rushi biezhuan* (Shanghai: Guji chubanshe, 1980), pls. 2-4; *Liu Rushi shanshui ce* (Shenzhou guoguang she).

 M W

24

Li Yin

1616-85
Flowers of the Four Seasons, 1649
Ink on satin
Handscroll, 25.2 x 581 cm.
Private Collection, Honolulu

Artist's inscription:
Jichou [1649], first month of autumn, sketched at the Liuyan tang. Li Yin of Qiantang.

Artist's seals:
Li Yin zhi yin; Jinshi sheng

The ancestry of Li Yin (*zi* Jinshi, Jinsheng; *hao* Shian, Kanshan yishi, Haichang nüshi) of Hangzhou is not recorded, but we know from a biographical sketch prepared by the eminent scholar Huang Zongxi (1610-95) that her parents made her study poetry and painting when she was very young.[1] She established a considerable reputation for her talent by the time she was fifteen years old. According to Huang, her line of poetry on plum blossoms — "One branch, I wish, could delay its opening till late in spring"[2] — so captivated the scholar and painter Ge Zhengqi (d. 1645) that he took her as a concubine.

Ge Zhengqi, a man of Haichang (Haining), Zhejiang, took his *jinshi* degree in 1628 and rose to the position of Vice Minister of the Court of Imperial Entertainments in Beijing.[3] Li Yin went to the capital with her husband, where, surrounded by rare works of art and antiques, they painted and practiced calligraphy in their leisure time. Li is said to have imagined that in a former life she was the Song lady poet Li Qingzhao, who similarly joined her husband in collecting and studying ancient works of art.[4]

In 1643 Ge and Li left the capital to "travel among the rivers and lakes," returning to the south to retire to a beautiful villa. His property included a garden that passed into the hands of the Attendant Censor Gu Baowen (*jinshi* 1655).

About it Gu's contemporary Mao Zhike (1633-1708) wrote:

> The Yuanpu [garden] of the Attendant Censor Gu Qiean [Baowen] was formerly the Ge garden. It is said to have been the boating place of the Vice Minister Ge and his concubine. The Vice Minister became famous for his poetry and Madame Shian [Li Yin] painted, reaching the "untrammeled class." The refined elegance of the literary affairs of that time can still be imagined.[5]

Li Yin and Ge Zhengqi clearly enjoyed a close relationship. In private they did paintings to amuse one another.[6] Ge added inscriptions to his concubine's works and especially admired her flower paintings. He wrote that in this genre he was not her equal, although her landscapes did not measure up to his own.[7] His pride in Li Yin's accomplishments led him to present her painting of a cut branch of peonies to the painter and art critic Li Rihua (1565-1635), who responded with a poem.[8]

After Ge's death Li Yin lived alone at the Laughing Bamboo Studio, and in her loneliness she turned to Buddhism.[9] Finding herself in straitened circumstances, she supported herself with her art.[10] Her reputation as an artist grew to the point that her paintings came to be considered essential gifts or souvenirs from Haichang, and locally more than forty individuals were turning out works under her name.[11] In the nineteenth century Qin Zuyong warned collectors that the popularity of Li Yin's work had resulted in many fakes.[12] Indeed, we can be certain that among the numerous extant paintings that bear Li Yin's name are imitations by lesser artists produced in response to the demand created by her fame.

Li Yin studied painting with a Hangzhou painter named Ye Danian.[13] Ye's works are not known today, but he is reported to have painted landscapes in the tradition of Gao Kegong (1248-1310), been good at ink bamboo, and sketched flowers and birds in an inventive manner. Like many artists of her period, Li Yin also followed the sixteenth-century Suzhou flower painter Chen Chun (1483-1544). She is, in fact, said to have honored him with an image carved in aloes wood.[14] In the flower sketches of the handscroll in the exhibition, she paid her respects to the master through straightforward imitation of his flowing ink style. A collector added a prefatory inscription reading "In the Spirit of Baiyang [Chen Chun]."[15]

Over the centuries Li Yin received continuing critical acclaim. The scholar and poet Zhu Yizun (1629-1709) praised the "life movement" in her flowers and birds,[16] as did the seventeenth-century scholar Xu Qin. Xu also saw a "scholarly spirit" in her works and found her large pieces particularly fine.[17] Tao Yuanzao of the eighteenth century described her paintings as without the "air of the women's quarters."[18] Qin Zuyong not only appreciated the hoary, modest, yet free quality of Li's ink-monochrome flowers and her grasp of the traditions of the Ming masters Xu Wei (1521-93) and Chen Chun, but went so far as to proclaim her the best female painter, "truly preeminent in the women's quarters." In one of his pithy margin notes, he observed: "Among women, [in regard to] brush strength, Jinsheng [Li Yin] must be regarded as 'number one.'"[19]

1. Huang Zongxi, *Huang Lizhou wenji* (Beijing, 1959), pp. 88-89. This biography is transcribed in a twentieth-century colophon to the *Flowers of the Four Seasons*. For a translation see

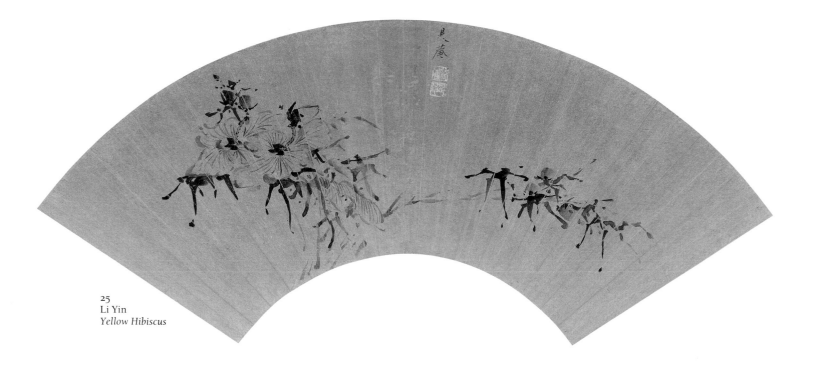

25
Li Yin
Yellow Hibiscus

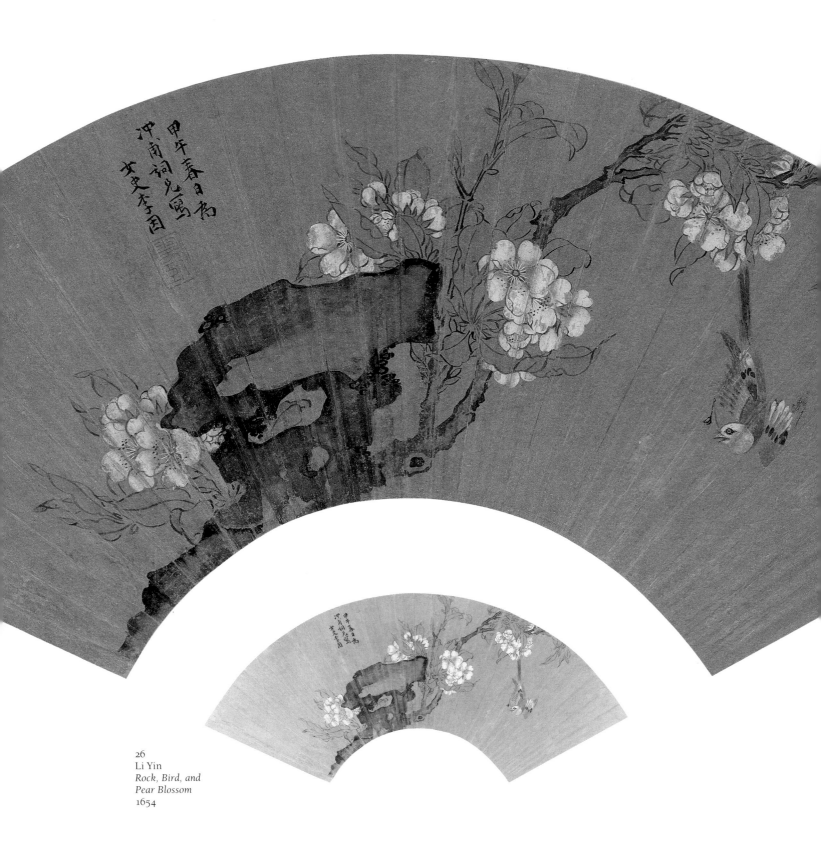

26
Li Yin
*Rock, Bird, and
Pear Blossom*
1654

Tseng Yu-ho Ecke, *Wen-jen Hua: Chinese Literati Painting from the Collection of Mr. and Mrs. Mitchell Hutchinson* (Honolulu: Honolulu Academy of Arts, 1988), p. 34.

2. Translation by Irving Lo.
3. *WSSS*, 7:131.
4. Huang Zongxi, p. 88.
5. Mao Jike, *Anxu tang wenchao*, cited in *YTHS*, 4:63.
6. *WSSS*, 5:86.
7. Ibid.
8. Li Rihua, *Liuyan zhai sanbi*, cited in *YTHS*, 4:63.
9. *Qing huajia shishi*, Li Junzhi ed. and comp. (1930), *gui, shang*: 3a-b; Huang Zongxi, p. 88.
10. Huang Zongxi, p. 88.
11. Ibid.
12. Qin Zuyong, *Tongyin lunhua fulu* (Guangzhou, 1864), p. 1b.
13. *MHL*, 6: 89; Yu, p. 1214.
14. Zhu Yizun, *Jingzhiju shihua*, cited in *YTHS*, 4:62.
15. With the seal of Huang Junshi.
16. Zhu Yizun, cited in *YTHS*, 4:62.
17. *MHL*, 6:90.
18. Tao Yuanzao, *Yuehua jianwen* in *Huashi congshu* (Shanghai, 1963), *xia*: 63.
19. Qin Zuyong, p. 1b.

Two colophons and collector's seals.

Bibliography: Tseng Yu-ho Ecke, *Wen-jen Hua: Chinese Literati Painting from the Collection of Mr. and Mrs. Mitchell Hutchinson* (Honolulu: Honolulu Academy of Arts, 1988).

MW

25
Li Yin

Yellow Hibiscus
Ink on gold
Fan, 16.7 x 49.6 cm.
Chengxun tang Collection

Artist's signature:
Shian

Artist's seals:
Li Yin; Shian

With quick, quirky brushstrokes Li Yin animated this simple spray of autumn flowers. This type of hibiscus, characterized by striking digitate leaves, was a popular painting subject.

MW

26
Li Yin

Rock, Bird, and Pear Blossoms, 1654
Ink and color on gold paper
Fan, 17 x 52 cm.
Mr. and Mrs. J. P. Dubosc Collection

Artist's inscription:
Jiawu [1654], spring day, sketched for my literary elder brother Chongfu, the lady Li Yin.

Artist's seal:
Yunwo

Typically Li Yin worked in ink monochrome, conveying impressions of plants and birds with fluid, swiftly applied strokes. However, as a professional artist she must have had a range of painting techniques at her command, so it is not surprising to find her name on this more tightly executed ink-and-color fan.

MW

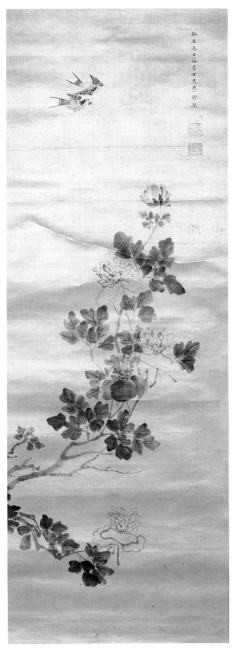

27
Li Yin
Swallows and Peonies
1673

27
Li Yin

Swallows and Peonies, 1673
Ink on satin
Hanging scroll, 144.2 x 50.2 cm.
Private Collection, Japan

Artist's inscription:
Guichou [1673], winter day, painted by the lady of Haichang Li Yin.

Artist's seals:
Li Yin zhi yin; Jinshi sheng

This ink-monochrome painting, with a few symbolic motifs spread gracefully and dramatically across a satin ground, is representative of Li Yin's best-known work. It is a relatively late example, and long practice is evident in the assurance of the composition, the smooth brushwork, and the descriptively varied ink tones. It is a "functional" piece expressing wishes for the owner's good fortune. Swallows, birds of good omen and symbols of marital happiness,[1] fly above a lush branch of a tree peony, *mudan*, the flower of riches and honor. Peonies were also symbols of love and affection, feminine beauty, and springtime. Over the centuries these showy flowers continually captured Chinese imaginations. As H. L. Li noted:

> Peonies, the most aristocratic and gorgeous of all flowers . . . won a place of great esteem as the "King of Flowers" and have been favored by emperors and empresses, praised by lords and ladies, lauded by poets, extolled by scholars, and appreciated as well by the poor and humble.[2]

1. Swallows symbolize marital happiness in China because they often fly in pairs. Also, the Chinese words for "swallow" and "wild goose" are homophones (*yan*), although they are written differently, and the wild goose is a well-known symbol of marital fidelity because it takes only one mate. Noted by Robert Mowry in *The Chinese Scholar's Studio, Artistic Life in the Late Ming Period*, ed. Chu-tsing Li and James Watt (New York: The Asia Society Galleries, 1987), p. 162.
2. H. L. Li, *The Garden Flowers of China* (New York: The Ronald Press Company, 1959), p. 22.

MW

28

Mao Yuyuan
Active mid-17th century
Orchids and Flowers, 1651
Ink and color on gold paper
Fan, 16.8 x 51 cm.
Chengxun tang Collection

Artist's inscription:
Sketched on an Autumn day in xinmao
[1651]. Miss Xiaosu.

Artist's seals:
Yuyuan; Xiaosu

Mao Yuyuan (*zi* Xiaosu) was from Hangzhou. She was the daughter of Mao Jiureng and married Xu Shiyi.[1] Her mother, Liang Mengzhao, was well known for her literary ability and highly praised as a painter of landscapes, flowers, and birds.[2] As a child Mao studied with her mother and soon became similarly accomplished in the arts.[3]

In this painting firm lines bound and detail the light ochre, red-veined orchids, pale pink and white begonias, and snow-white gardenias with jade-green leaves. The subtle tints and shades of the orchids quietly harmonize with the gold ground. The plants are rendered in such an easy, natural manner that it is not immediately apparent that the image is like a bouquet. This exquisitely refined color scheme complements the powerful composition, which is dominated by the orchid leaves that dynamically fan out across the arched format.

1. Yu, p. 636. Yu Jianhua quotes from *Tuhui baojian xuzuan*, but misprints her father's name as Jiucheng. See *Tuhui baojian xuzuan*, *Huashi congshu*, ed., p. 66.
2. No paintings by Liang Mengzhao have ever been published or are known to exist, but the *Minghua lu* relates: "She was skilled in literature, and elegantly good at painting landscapes which were deep and distant, refined and untrammeled. Her style was not that of the crowd" (*MHL*, p. 71). Furthermore, Chen Jiru (1558-1639), one of the arbiters of literati taste during the late Ming dynasty, praised her as a rarity among people (*WSSS*, 7:133).
3. No specific dates have yet been found in Mao Yuyuan's life to permit the cyclical date on this fan to be firmly fixed as 1651. From known dates of her great-grandfather, Mao Zan (*jinshi* in 1538 at age 39 *sui*), and those surrounding her mother, a mid-16th-century date is more plausible than the other possibilities of 1591 or 1711.

Two collector's seals.

JR

29

Su Chenjie
Late 16th or mid-17th century
Begonia and Swallowtail Butterfly, 1591
or 1651
Ink and color on paper
Fan, 16.8 x 48 cm.
Chengxun tang Collection

Artist's inscription:
A sheet of green clouds strung with light
 red,
Coquettishly contending in beauty in the
 eighth month.
I suspect Ahuan's slightly inebriated tears
Soak into the fragrance at the kiosk edge,
 drowsing in the autumn wind.
Drawn and written in early summer xin
mao [1591 or 1651] by Su Chenjie.

Artist's seals:
Daya; Su Chenjie yin; Taisu

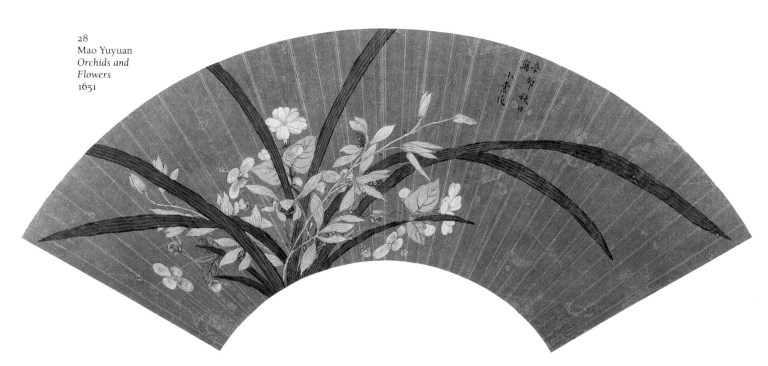

28
Mao Yuyuan
*Orchids and
Flowers*
1651

Su Chenjie (*zi* Taisu) was married to a government scholar from Changshu, in Jiangsu province, named Lu Yuzai (unidentified). She excelled in flower and bird painting and was noted for her poetry.[1]

No other paintings by Su are known to be extant, but the overall fastidiousness seen in the two images of floral spray and hovering butterfly, their restrained spacing and arrangement in a composition of elegant arches and echoing curves, and the delicate colors all suggest that Su was working in a mode associated with an artist like Wen Shu.

Su's poetic sensibilities are well demonstrated in the combination of visual and poetic imagery. The hardy begonia plant flowers in autumn. One of its names in Chinese is "the eighth-month flower." It has been paired with the springtime favorite, the crab apple (*haitang*) and so is sometimes called the

autumn crab apple (*qiu haitang*). The reddish-green leaves of the begonia subtly foil its light pink blooms. Because it prefers shady, damp places, the begonia is a perfect *yin* or feminine plant; and in China it has romantic connotations. According to legend, a lady deserted by her lover lamented his absence and longed for his return. "At last, at the very spot where she used to stand under the northern window in her yard, a beautiful flower grew up which was kept wet every day with her unceasing flow of tears." The begonia "came to console the lady in her sorrow."[2]

Allusions to the physical appearance of the plant and to its lore inform the poem written by Su on her painting. The first line can describe equally well the begonia plant and a beautiful woman. "Green clouds" can refer to the begonia leaves, which are tinted with red; "green clouds" is also a conventional term for lustrous, black tresses, here highlighted with light red ornaments. The begonia and the woman compete in beauty. In the third line, Ahuan is another name for the famous Tang-dynasty imperial concubine Yang Guifei. Slightly tipsy, she weeps like the lady of yore by a pavilion. The wind is autumnal, the season of the begonia and the time of melancholy parting and separation.

The authors of the four other poems on the painting remain unidentified. Three of these poets are unrecorded, and the fourth, Wen Ying, poses a problem, for there may be two people named Wen Ying, both women. The first, listed under the Ming dynasty, was a niece of Wen Boren (1502-75); the Wen family registry was in Changzhou (Suzhou).

Her exact dates are unknown, but she must have lived during the late sixteenth century. The second Wen Ying is listed as a Qing-dynasty woman, who, like Su Chenjie after her marriage, resided in Changshu. Both Wen Yings were good at landscape painting and poetry.[3] Since the second Wen Ying was from the same region as Su Chenjie, it is more likely that she inscribed the poem on this fan painting. It is possible, however, that the record refers to the same person.

1. Yu, p. 1526.
2. Chen Haozi, *Hua jing* (17th c.; 1962 reprint annotated by Yi Qinheng; reprint Beijing: Nongye chubanshe, 1979), pp. 364-65; H. L. Li, *The Garden Flowers of China* (New York: The Ronald Press, 1959), pp. 173-74.
3. Yu, p. 37.

Four colophons and three collector's seals.

EJL

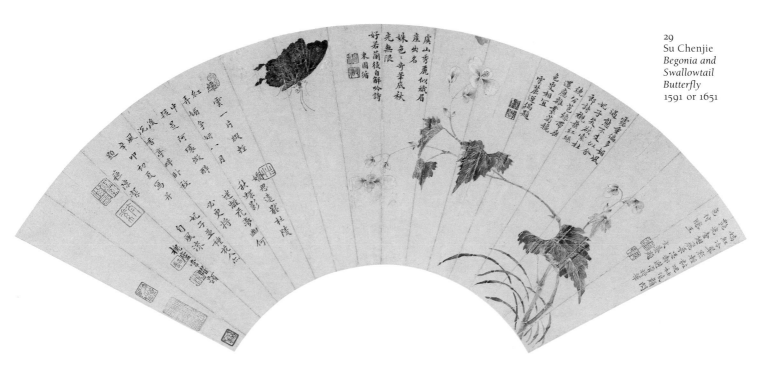

29
Su Chenjie
Begonia and Swallowtail Butterfly
1591 or 1651

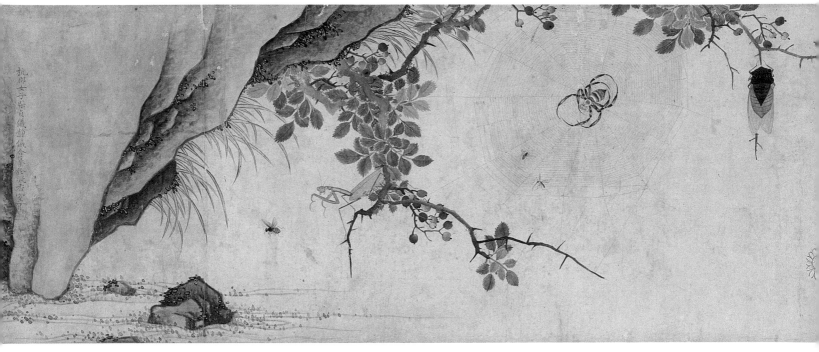

30 Chai Zhenyi and Chai Jingyi, *Flowers and Insects*, section

30

Chai Zhenyi and Chai Jingyi

17th century
Flowers and Insects
Ink and color on paper
Handscroll, 27.9 x 330.6 cm.
The Art Institute of Chicago,
S. M. Nickerson Fund (1954.104)

Artists' inscription:
*The ladies of Hangjun [Hangzhou] Chai
Zhenyi [and Chai] Jingyi copied this to-
gether in the Frozen Fragrance Chamber.*

Artists' seal:
Zhen Jing hetong

Chai Zhenyi and her younger sister Chai
Jingyi were natives of Hangzhou and the
daughters of Chai Shiyao. Zhenyi mar-
ried a man named Huang Jiemei, and
Jingyi married Shen Liu (Hanjia) of
Hangzhou. Although their father and
husbands do not appear to have been
known as artists or poets, the sisters es-
tablished reputations as both. Jingyi left
a collection of writings entitled *Poetic
Transcriptions of the Frozen Fragrance
Chamber (Ningxiang shi shichao)*[1] and
was a member of the Banana Garden
Poetry Society, formed in the early Qing
by another Hangzhou lady, Gu Yurui.
Jingyi was one of the so-called Banana
Garden Five; the other four were Zhu
Rouze, Qian Fenglun, Lin Yining, and
Xu Can. Later Jingyi, Qian, and Lin were
counted among the Banana Garden
Seven.[2] Like the Chai sisters, a number
of these women were painters as well as
poets. Lin Yining (1655-?) was good at
calligraphy and painting, excelling in
ink bamboo.[3] Xu Can painted female fig-
ures, images of Guanyin, flowers, and
plants.[4] Her painting of *Guanyin Cross-
ing the Sea* may still be extant (fig. c).[5]

Zhu Rouze, also a painter, was the
wife of Chai Jingyi's son Shen Yongji,
who was active in the early Kangxi
period (1662-1722). Shen studied with
his mother when he was young, traveled
widely, and earned a reputation for his
poetry. His associates included two of
the so-called Three Great Masters of
Lingnan, the Guangdong poets Liang
Peilan (1632-1708) and Qu Dajun (1630-
96), and he was one of the literary men
patronized by the Manchu poet Yunduan
(or Yueduan, 1671-1704). According to a
story popular at the time, when he was
in the capital with Yunduan, his wife
painted a scroll with the landscape of
their native region, inscribed it with a
poem, and sent it to him. Her wandering
husband then returned home.[6]

Chai Jingyi was known for her
sketches of plum blossoms and bamboo.
Chai Zhenyi is said to have excelled at
painting subjects of the type found in
this handscroll—flowers, grasses, and
insects.[7]

Insects may seem a trivial subject, but
they had a long history in Chinese art
and literature, reaching back to the *Book
of Songs*. One of the agricultural songs,
for instance, includes insects in its de-
scription of the seasonal progress of
daily life:

> In the fifth month the locust moves its
> legs,
> In the sixth, the grasshopper shakes its
> wings.
> In the seventh, the cricket is in the fields,
> In the eighth, it moves under the eaves,
> In the ninth, to the door,
> And in the tenth under the bed.[8]

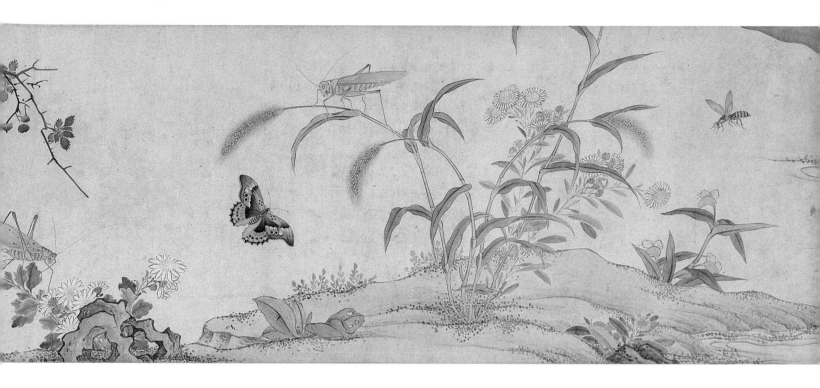

Later writers devoted entire poems to crickets, bees, cicadas, and other insects.

From poetry insects found their way into painting. In fact, the compilers of the early twelfth-century imperial painting catalogue, the *Xuanhe huapu*, justify the inclusion of paintings of grasses and insects by pointing out that these subjects are often encountered in the metaphors and allusions of the poets.[9] A century later a familiar lesson in painting was taught through the example of insect painting:

Tseng Yün-ch'ao [Zeng Yunchao], Wu-i [unidentified] is good at painting insects and, as the years pass, he becomes increasingly skillful. I once asked him from whom he had learned. Wu-i laughed and said: "How is there any method that could be transmitted in this? When I was young I caught insects, kept them in a cage, and observed them for whole days and nights without tiring. Then, fearing that their spirit was not complete, I went to look at them in a grassy spot and from this first grasped their nature (*t'ien*). When I start to paint, I don't know whether I am an insect, or whether the insect is me. This is probably not any different from the workings of Creation as it produces things. How could there be a transmittable method?"[10]

The Chai sisters' "copy" belongs to the tradition associated with Xu Xi (10th c.), Zhao Chang (c. 960-after 1016), and other early masters of insect painting. It might be compared, for example, to the finely detailed handscroll *Flowers and Insects* signed "Xu Xi" in the collection of the National Palace Museum.[11] The Chai sisters reinforced the scholarly character of their academic exercise with restrained brushwork and a quiet color scheme. Light green washes impart an air of coolness to this intimate view of nature, softening the visual impact of the bright butterflies and flowers. In sum, this is a thoroughly refined painting appropriate for ladies of the Chai sisters' social class and intellectual inclinations.

The artists' seal following the signature line can be translated "Zhen and Jing together." That the sisters went to the trouble to have such a seal made suggests that they collaborated fairly often. The painting has been trimmed on either end, with portions of the collectors' seals lost, but this neither affects the composition nor casts doubt on the signature.

1. Feng Jinbo, *Guochao huashi* (1797; 1831 edition), 16:18b; Wu Dexuan (1767-1840), *Chuyue lou xuwenjian lu*, 4:5a-b.

2. *Zhongwen dacidian* (Taipei, 1976), 8:109.

3. Yu, p. 524.

4. Yu, p. 720.

5. *Zhongguo minghua* (1920-23), 15:3.

6. Feng Jinbo, 17: 2b; Wu Dexuan, 4:5a-b.

7. Both artists were represented in the collection of Tang Souyu, the author of the *The Jade Terrace History of Painting*, also a native of Hangzhou (*YTHS, bielu*, p. 3). Tang treasured Zhenyi's painting *Apricot Flowers and Spring Swallows* and Jingyi's *Sweet Osmanthus and Hibiscus*. These were thoroughly traditional auspicious themes.

Apricot flowers — known as the "successful candidate flowers" because they bloom in the second month, the time of the imperial examinations — and swallows — a word pronounced in the same way as one meaning "banquet" — together comprise a rebus wishing a man success in the imperial examinations and the consequent honor of being invited to a banquet by the emperor. The osmanthus and hibiscus combine to symbolize the ideal marriage: "a husband honored at court, and a wife esteemed at home."

8. *Selections from the "Book of Songs,"* trans. Yang Xianyi, Gladys Yang, and Hu Shiguang (Beijing: Panda Books, 1983), p. 71.

9. Susan Bush and Hsio-yen Shih, *Early Chinese Texts on Painting* (Cambridge: Harvard University Press, 1985), p. 129.

10. Ibid., pp. 219-20.

11. *Caochonghua tezhan tulu* (Taipei: National Palace Museum, 1986), pp. 28-29.

Eleven collector's seals.

M W

31

Zhou Xi (Zhou Shuxi)

Late 17th century
White Bird on Plum, 1663
Ink and color on gold paper
Fan, 15.2 x 44 cm.
Museum of Fine Arts, Boston, Marshall
H. Gould Fund (1977.751L)

Artist's inscription:
Done by Zhou Xi, Jiangshang nüzi, in late autumn, guimao [1663].

Artist's seal:
Shuxi zhi yin

Zhou Xi (*zi* Jiangshan nüshi or Jiangshan nüzi) was from Jiangyin, Jiangsu province. Sometimes known as Zhou Shuxi, she was a daughter of Zhou Rongqi (1600-86), himself a poet and a painter of Mi-style landscapes. Zhou Xi excelled in depicting images of the Bodhisattva Guanyin, other Buddhist subjects, and horses. She and her sister Hu (or Shuhu) were particularly noted for painting flowers, insects, and birds using fine, delicate lines and beautiful colors. Both were Wen Shu's students and copied her illustrations to the *materia medica Bencao*; Zhou Xi also did figures as illustra-

tions to the *Nine Songs*. Zhou Xi married into the Huang family of Jiangyin; Hu's husband was Pan Shengrui (unidentified) of Jinsha.[1] Zhou Xi had at least one pupil in painting, a woman by the name of Yao Yi, also from Jiangyin.[2]

The Zhou sisters were active in the mid-seventeenth century, and must have been child prodigies. The aesthete Chen Jiru (1558-1639) claimed that Xi's sixteen pictures of Guanyin surpassed the brush of the legendary Tang Buddhist painters Lu Lengjia and Wu Daozi.[3] If Chen's comment was in regard to one of Zhou's earliest efforts, and if she was twenty years old when Chen died in 1639, she would have been born approximately in 1619. Her father would have been a youthful nineteen-year-old.

The Zhou sisters sometimes collaborated in their artistic efforts, and their art was widely admired. Their talent was recognized by Jiang Shaoshu, the compiler of one of the best collections of biographies of Ming-dynasty artists. When Jiang Shaoshu's two sons were on their way to take the civil service examinations in 1651, they stayed with the Zhou family and acquired a set of eight flower-and-bird paintings (perhaps an album) by the two women; the paintings were treasured by Jiang.[4] Literary luminaries such as Wang Shizhen (1634-1711) also owned their works.[5] A set of ten *luohan* was commissioned by a Hangzhou man in 1670. This set, along with a hanging scroll of a bird on a pomegranate branch, attributed to Zhou Xi, are in the former Qing imperial collection.[6]

Zhou Xi was capable of composing large-scale works such as the impressive hanging scroll now in Nanjing depicting

a thicket of flowering trees and a multitude of birds with heavy, rich coloring. Other works by Zhou suggest something closer to the rock, flower, and butterfly themes for which Wen Shu is known (see cat. nos. 15, 16). As exemplified in this fan painting of a bird on a plum branch and in a hanging scroll depiction of a bird on a camellia branch dated 1639 or 1699, now in Nanjing,[7] the few motifs are carefully arranged. A single, but active, bird perched on an arching branch is placed near the center of the composition; on either side is a discreetly placed floral cluster, and the exquisiteness of the full blossoms is set off by a backing of leaves or buds.

1. *MHL*, 1:5; *WSSS*, 5:85-86; *YTHS*, 3:31.
2. Wang Shizhen, *Chibei outan* (1691; reprint Shanghai: Commercial Press, n. d.), 15:167.
3. Zhu Yizun, quoted in *YTHS*, 3:31.
4. *WSSS*, 5:86.
5. Wang Shizhen, quoted in *YTHS*, 3:31.
6. The set of ten *lohan* is recorded in Wang Jie, et al., *Bidian zhulin xubian* (1793; reprint Taipei: National Palace Museum, 1971), p. 320, and reproduced in *Gugong zhoukan* (Beijing: Palace Museum, 1930-36), 486-90. The painting of a bird on a pomegranate branch is recorded in Zhang Zhao, et al., *Shiqu baoji* (1745; reprint Taipei: National Palace Museum, 1971), p. 1165.
7. Reproduced in *Nanjing bowuguan canghuaji* (Beijing: Wenwu, 1966), 1:132.

EJL

31
Zhou Xi
*White Bird
on Plum*
1663

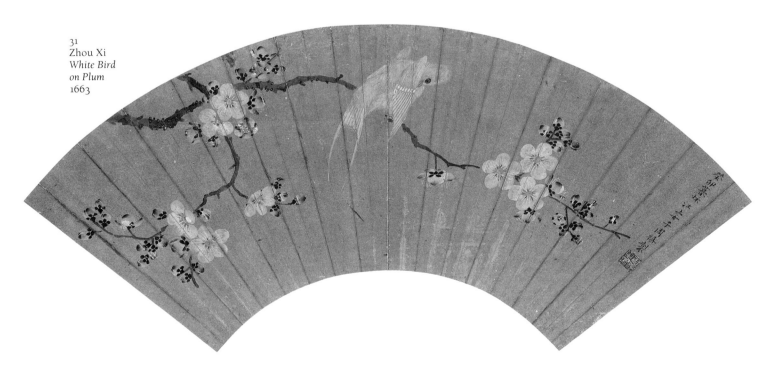

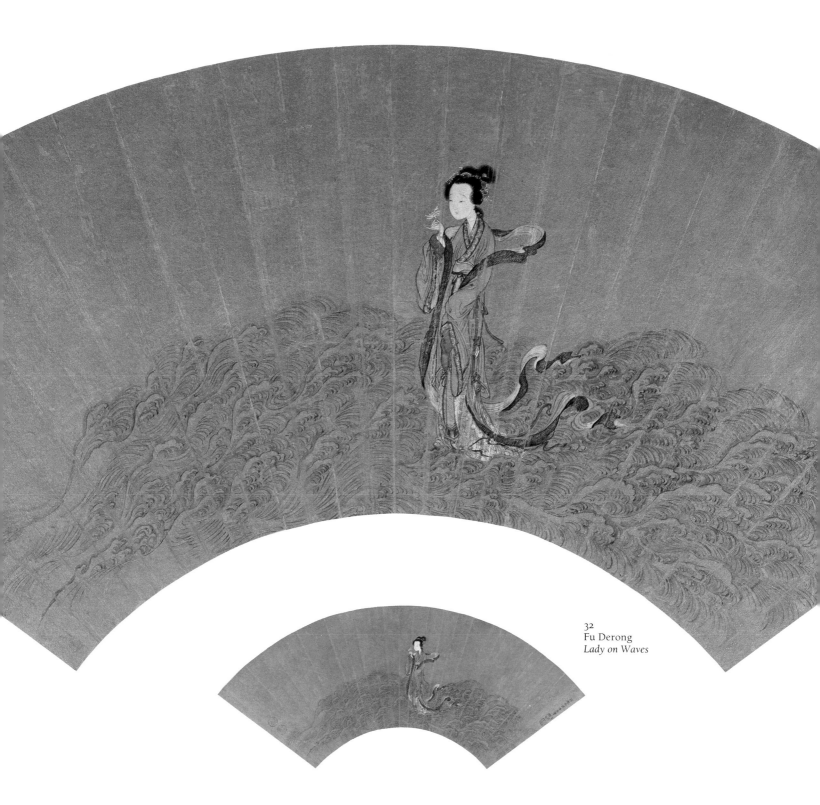

32
Fu Derong
Lady on Waves

32
Fu Derong
Late 17th century
Lady on Waves
Ink and color on gold paper
Fan, 16.9 x 49.8 cm.
Chengxun tang Collection

Artist's inscription:
Return to Longxi, Fu Derong brushed.

Artist's seals:
Derong; illegible

Fu Derong lived during the Kangxi period (1662-1722) in the city of Suzhou, where she and Fan Xueyi were the leading women painters. Both excelled at figure painting, but Fu's style was said to be more meticulous and craftsmanlike than Fan's.[1]

By the time Fu Derong was active in Suzhou, that city was no longer the artistic center of China. Her art is nevertheless grounded in the descriptive Suzhou figural style, but the thin neck and sharply sloping shoulders of the figure betray the later stages of the tradition. A hint of consternation in the woman's countenance suggests an inner distress,

which the stormy, surging waves seem to reflect. In poetry, to heighten the poignancy of separation, absent lovers were conventionally said to be in remote places to the north, the south, the east, and the west.

Longxi, which means West of the Long Range, a ridge between the provinces of Shaanxi and Gansu in the western reaches of China which was protected by Chinese border patrols, was a stock term for the far west. It ap-

111

33 Cai Han, *Pine Trees, after Xia Chang*, section

pears, for example, in the verse from *Four Sorrows, Four Poems* by Zhang Heng (78-139):

> The one I love lives at Hanyang.
> I long to go after him, but Lung range is too long.
> Leaning forward I look west, tears soak my coat.
> My handsome one gave me a sable wrap.
> How shall I requite him? With bright moon pearls.
> The road is far, they won't arrive. I give in to anxiety.
> How anxious I am, my heart so disturbed.[2]

A type of ballad known as *Longxi xing* dwells upon women grieving for their husbands off at war. The woman in the painting holds an orchid, which is perhaps a clue to her identity; but the actual subject of the painting remains to be determined.

1. Zhu Xiangxian, *Wenjian oulu*, in Zhang Chao, *Zhaodai congshu*, collection *geng* (1833), 23:42b. Four of Fan's figure paintings are reproduced in *Zhongguo minghua ji* (Shanghai: Yuzheng, 1934), 1:61-64.

2. Birrell, p. 235.

Two collector's seals.

EJL

33
Cai Han
1647-86
Pine Trees, after Xia Chang
Ink on paper
Handscroll, 48.5 x 441 cm.
Bei Shan Tang Collection

Artist's (?) seals:
Shu zhong you nü hua zhong you shi;
Rugao Mao shi Shuihuian langui shuang huashi.

Colophon by Mao Xiang:[1]
Shaoling [Du Fu] once said: "How many people in the world are painting ancient pine trees?"[2] This [subject] is definitely not one that can be painted with ease by [someone with] a feeble wrist. In my concubines' quarters there are those who can release the brush to make a straight trunk. Early in the summer of 1676 elder brother [i.e. my dear friend] Fang Shaocun [Fang Hengxian][3] of Longmian [Mountain] paid me a visit, and together we looked at many paintings and calligraphic works. He admired most the "horizontal pines like dragons" by Xia Taixue [Xia Chang, 1388-1470].[4] I spoke of this when I returned to my quarters, and again there were those who could copy them. [The pines look] so lofty and precipitous, coiling as if roiled, eccentric and fantastical as [character illegible] Ren, and again undulating and sinuous as [in a painting by] Ma Yuan. Before entering Tiantai Mountain, how can one behold the scenery south of the stone bridge?[5] It's like coming to a monastery and suddenly being able to sweep away one thousand years, ten thousand years [long-accumulated misconceptions.] This does not come from knowledge or learning, or from the filtering down of some minor skill. One look at an ancient work, and one can im-

mediately pour out one's energy, coping with every kind of situation, and rival [it]. Isn't it as the Master of the Stone Drum Cave said: "Forget brush and ink, and then the true scenery emerges."[6] I inscribe this for Shaocun's keeping and his amusement. Younger brother Chaomin Mao Xiang of Rugao, at the age of sixty-six [sui].

Two colophons by Cai Jintai, one before and one after the painting:
This is from the brush of Cai Nüluo, the concubine of Mr. Mao of Rugao, a man of the late Ming dynasty. According to the record in Zhang Geng's Huazheng lu, her name was Han. [She was the daughter of] Cai Mengzhao of Wu county [Suzhou].[7] She was good at landscape and figure painting, and her paintings of pines were especially skillful. [The phrase] "Langui shuang huashi" [the pair of painters of the women's quarters, or pair of lady painters], devised by Mao, refers to Cai Han and Jin Yue. Cai was especially able to throw off the manners and habits typical of female artists. This scroll is based on the work of Xia Zhongzhao [Xia Chang]. The strength of her brushwork is excellent; this may be her best work. According to Mao's colophon, it was done for the Censor Fang Shaocun. Fang was a leading calligrapher and painter. It is fitting that a "good horse met with an expert connoisseur."

112

This was done by my ancestor Cai Han, known as the Lady Nüluo. Her husband Mao Chaomin inscribed it to thank the Censor Fang Shaocun. Shaocun was a leading calligrapher and painter, but a delicate young woman openly displayed her skill before him. She was not lacking in courage — truly not lacking in courage! I have seen the Seven Junipers *handscroll by old Shitian [Shen Zhou; 1427-1509], and its style, in fact, does not surpass this, but I don't really know how this might compare with Wei Yan's work. As to the work of Xia Taichang, even without waiting to see the original, I can say that this is in no way inferior. I have thought [about this painting], and, looking at it carefully for ten days, after having it mounted, I am genuinely impressed by her talent. I inscribe this to attach my name to a truly immortal work of art. Xuantong [reign period], gengxu [1910], mid-spring, written by Cai Jintai of Jiangzhou.[8]*

Beyond the information reviewed by Cai Jintai, little is known of the life of Cai Han (*zi* Nüluo). She became Mao Xiang's concubine in 1665, but he left no account of their relationship like the moving one he wrote about the great love of his early years, Dong Bai (cat. no. 22). The unreliable *Tuhui baojian xuzuan* reports that Cai Han practiced dietary abstinence, embroidered Buddhist images, and was familiar with classical allusions,[9] but most writers have stressed her painting. She treated many subjects — landscapes, flowers and birds, fish and figures — and was skilled at copying. According to the *Guochao Huazheng xulu*, she once painted pines on a large screen. Mao inscribed a long poem on it, and famous men of the time

composed poems in response. Numerous individuals also wrote poems for her ink painting of a phoenix.[10]

Cai Han is usually mentioned with another of Mao's concubines, Jin Yue (cat. no. 34). People of the time spoke of them as the "Two Painters of the Mao Family."[11] One of the seals affixed to this scroll can be translated "The pair of lady painters of the Water-painting Hermitage of the Mao family of Rugao" (*Rugao Mao shi Shuihuian langui shuang huashi*). Above it is one that reads, "Among the books there are women, among the paintings there are poems" (*Shu zhong you nü hua zhong you shi*). Similar seals are found on other unsigned paintings that have been attributed to both women.[12] It should be noted that Mao does not identify the painter of this scroll. The identification was made by the later colophon writer. However, from the *Guochao Huazheng xulu* we know that this was a subject Cai Han painted.

Mao Xiang inscribed a number of the known paintings by Cai Han and Jin Yue, usually writing something relevant to the subject and naming the intended recipient. Typically these works were done for presentation to his friends, and some of his colophons clearly state that he "ordered" his concubines to do them. From this we can surmise that these women were kept not only as concubines, but also as artists. Perhaps their function in Mao's household was, in part, similar to that of the actors of his private theater troupe. Whatever the

case, their talent was recognized by leading scholars and poets of the period, such as Wang Shizhen and Zhu Yizun.

The subject of this scroll, as Mao Xiang and Cai Jintai both indicate, was used and reused by some of China's greatest writers and painters. Mao recalls the poem written by Du Fu for Wei Yan's picture *Pair of Pines* and, quoting the Master of the Stone Drum Cave, invokes the famous tenth-century landscape painter Jing Hao, author of *A Note on the Art of the Brush* (*Bifa ji*). In Jing Hao's text the Master instructs the young man in the art of painting, and the young man responds with a poem, "Eulogy to an Old Pine Tree," which includes these lines:

> What the ancient poems praised in him
> [the pine]
> Was his noble air of the superior man.[13]

Old pines — upright, strong, and ever green — symbolized the ideal character of the Confucian gentleman. Han Zhuo (active c. 1095-1125) wrote:

> Pine trees are like noblemen; they are elders among trees. Erect in bearing, tall and superior, aloft they coil upward into the sky and their force extends to the Milky Way. Their branches spread out and hang downward, and below they welcome the common trees.[14]

The painting of pines by Xia Chang (1388-1470) that Cai used as her model is no longer known, but Ming handscroll treatments of old trees are well represented by Shen Zhou's *Three Juniper Trees*, dated 1484, and two scrolls by Wen Zhengming, the *Seven Junipers* of 1532 and the undated *Old Pine Tree*.[15] Following this tradition, Cai Han adapted her vertical subject to a narrow, horizontal format by presenting a cross section of twisting pine branches that

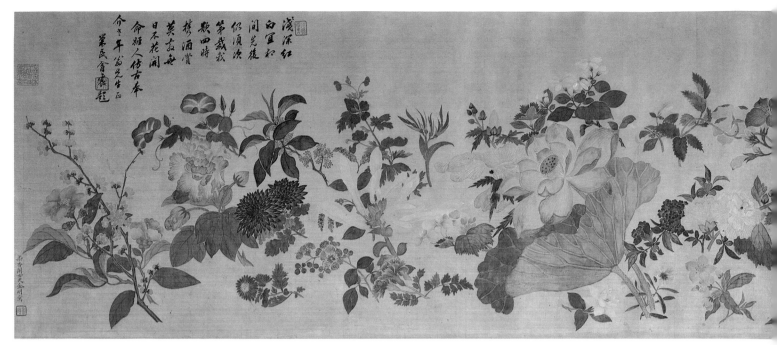

34 Jin Yue, *The Hundred Flowers*

writhe like dragons as they take control of the long picture space. The strength of the trunks below and the reach of the branches above are easily imagined. There is nothing reticent or delicate about her composition or brushwork. The vigorous dry strokes and strong tonal contrasts capture perfectly the rugged character of the old boughs. In spirit this painting is closer to the work of Shen Zhou than to the comparatively fussy, finely textured scrolls of Wen Zhengming.

1. Based on a translation by Irving Lo, who also provided notes 2-5.

2. Mao quoted from memory the first line of a poem by Du Fu (substituting the word *he* for *ji*) entitled "A Song Written in Jest for the 'Pair of Pines Picture' [by Wei Yan]." The T'ang-dynasty master Wei Yan, who was known for his paintings of horses, pines, and rocks, was a good friend of Du Fu while he was living in Chengdu in the years just before 761, and Du Fu addressed several poems to him. The last line of the poem for Wei Yan's pines reads, "I ask you to release your brush to paint [for me] a straight trunk"; this line is also paraphrased by Mao Xiang in this colophon.

3. Fang Hengxian was a scholar-official from Tongcheng, Anhui province. He took his *jinshi* degree in 1647. He was also known as a painter of landscapes after Huang Gongwang, flowers, and birds.

4. Xia Chang, from Kunshan, Jiangsu, was known as a calligrapher and specialized in bamboo painting.

5. This alludes to the story of two youths of the Han dynasty, Liu Chen and Juan Zhao, who on a herb-gathering expedition entered the fairyland of Tiantai Mountain, where they met two beautiful maidens. Only after they came out of the mountain and could not find their way back again did they realize that seven generations had elapsed in the human world.

6. The Master of the Stone Drum Cave is the wise old man of the *Bifa ji* by Jing Hao (c. 870-930).

7. The name Cai Mengzhao does not appear in Zhang Geng's text, but Cai Han is said to have been this person's daughter (Feng Xianshi, *Tuhui baojian xuzuan* in *Huashi congshu* [Shanghai, 1963], 3:76). The colophon, however, omits the character for daughter.

8. I wish to thank Irving Lo and Hsing-li Ts'ai for their assistance with the translation of these colophons.

9. Feng Xianshi, 3:76.

10. Zhang Geng, *Guochao huazheng xulu* (Nagoya book shop edition), *xia*, 15a-b.

11. Ibid.

12. *Autumn Flowers and Butterflies*, hanging scroll, *Huayuan duoying* (Gems of Chinese Painting) (Shanghai, 1955), 1:55; *Cat Watching a Butterfly*, hanging scroll, British Museum. Although they bear the same legends, the seals on these works are not identical to those on the *Pine Trees* handscroll.

13. Jing Hao, *Bifa ji*; cited from Susan Bush and Hsio-yen Shih, *Early Chinese Texts on Painting* (Cambridge: Harvard University Press, 1985), p. 148.

14. Han Zhuo, *Shanshui Chunquanji*; cited from Bush and Shih, p. 149.

15. The *Three Juniper Trees* by Shen Zhou is reproduced in James Cahill, *Parting at the Shore: Chinese Painting of the Early and Middle Ming Dynasty, 1368-1580* (New York and Tokyo: Weatherhill, 1978), pls. 42, 43. For Wen Zhengming's *Seven Junipers*, see Richard Edwards, et al., *The Art of Wen Cheng-ming (1470-1559)* (Ann Arbor: The University of Michigan, 1976), no. 30; the *Old Pine Tree* is in *Eight Dynasties of Chinese Painting* (Cleveland: The Cleveland Museum of Art, 1980), no. 172.

Seals of Mao Xiang and Cai Jintai.

Bibliography: Suzuki, S 7-029.

MW

34
Jin Yue
17th century
The Hundred Flowers
Ink and color on silk
Handscroll, 41.5 x 197.5 cm.
Occidental College Library, Special
Collections Department

Artist's inscription:
Sketched by the lady of the Fragrance Diffusing Pavilion, Jin Yue.

Artist's seal:
Jin Yue

Colophon by Mao Xiang:
*The light and the deep, the red and the
 white, should be spaced apart;
The early and the late should likewise be
 planted in due order.
My desire is, throughout the four seasons,
 to bring wine along and enjoy [them],
And to let not a day pass without some
 flower opening.*[1]
[I] instructed my concubine to copy the
ancients for presentation to the venerable
Mr. Weng for correction. Inscribed by
Chaomin Mao Xiang.

The biography of Jin Yue (*zi* Xiaozhu; *hao* Yuanyu) is as sketchy as that of Cai Han (cat. no. 33), with whom she lived and worked in the home of Mao Xiang. Jin was a native of Kunshan, Jiangsu. She entered Mao's household in 1667 and lived in his Fragrance Diffusing Pavilion.[2] Mao called upon her, as he did Cai Han, to paint for special occasions and to produce works for presentation to his friends.

The Hundred Flowers can be related in a general way to other decorative paintings of similar subjects attributed

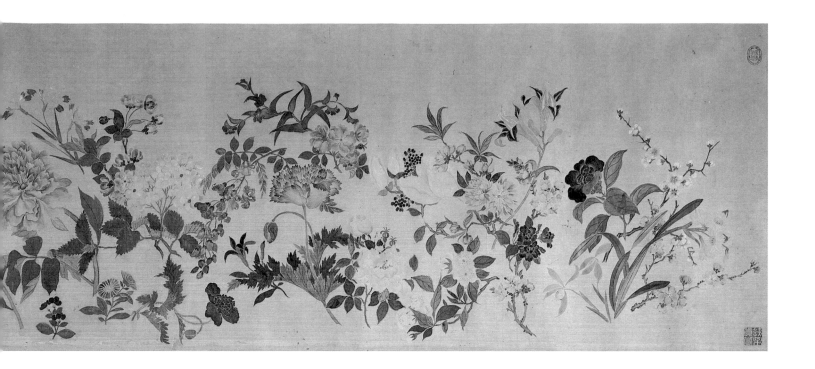

to Jin Yue, including a precisely executed hanging scroll of birds, flowers, and a fruit tree dated 1662 and signed "The Studying-Painting Lady of the Water-painting Hermitage (*Shuihui an*) Women's Quarters."[3] Jin is also said to have copied and captured the spirit of a painting of a very different type, a landscape by the Yuan master Gao Kegong (1248-1310).[4] An example of her work in this manner was included in an exhibition of Ming and Qing paintings held in 1949.[5] Apparently both Jin Yue and Cai Han often worked from old models, and this may explain why their known paintings do not form a cohesive group, either in terms of subject matter or style. In other words, their impressive versatility probably stemmed in large part from the diversity of the "masterpieces" they were asked to copy.

The term "hundred flowers" (*baihua*) now used as the title for this scroll, simply means all sorts of flowers, or various flowers. References to the "hundred flowers" appear in poems of the Six Dynasties and Tang periods, and the tradition of combining many different blooms in a single painting also has a long history. A fine early example is the anonymous late Southern Song or early Yuan ink-monochrome handscroll in the Palace Museum.[6] In the Ming dynasty, scholar-painters such as Chen Chun

(1483-1544) brought assorted flowers together in handscrolls executed in light colors or ink monochrome. This tradition is represented in the exhibition by Xue Wu's painting done on "the birthday of the flowers" in 1615 (cat. no. 11), and by Li Yin's *Flowers of the Four Seasons* (cat. no. 24). While thematically related to these works, Jin Yue's gorgeous floral display reflects the taste of the palace rather than that of the scholar's studio. It belongs to the same tradition as such Qing-dynasty paintings as the *Ten Fragrances* and *One Hundred Flowers* by Zou Yigui (1686-1772) and Qian Weicheng's (1720-72) *All Flourishes at Once in Spring*.[7] With their rich colors and precise details, such designs also lent themselves readily to other media, especially to silk embroidery and porcelain decoration.[8]

Opening with glimpses of spring — fruit-tree blossoms, narcissus, and magnolia — Jin Yue's scroll proceeds through flowers of summer and autumn to conclude with the wax plum of winter, but the seasonal progression is subtle. The cut branches look as if they were just casually dropped on the silk. Their profusion suggests abundance, an auspicious message typical of decorative compositions of the "hundred" type, another well-known example being the "one hundred children."

1. In quoting the poem "Assistant Xie Planting Flowers at the Secluded Valley" by the Song-dynasty scholar Ouyang Xiu (1007-72), Mao changed two characters. The translation by A. R. Davis has been modified accordingly. See Ouyang Xiu, *Ouyang wenzhong gong ji* (Shanghai: Commercial Press, 1929), 1:8b; A. R. Davis, *The Penguin Book of Chinese Verse* (Harmondsworth: Penguin, 1968), p. 37.

2. Zhang Geng, *Guochao huazheng xulu* (Nagoya book shop edition), *xia*, 15b.

3. Fang Junyi, *Mengyuan shuhua lu* (1875), 16: 34; reproduced in *Zhongguo minghua* (1920-23), 15:4.

4. Zhang Geng.

5. "Landscape after Mi Fei," in Jean-Pierre Dubosc, *Great Chinese Painters of the Ming and Ch'ing Dynasties* (New York: Wildenstein and Company, Inc., 1949), no. 75, p. 69.

6. *Wenwu*, no. 2 (1959), inside back cover.

7. *Descriptive and Illustrated Catalogue of the Paintings in the National Palace Museum* (Taipei: National Palace Museum, 1968), no. 305; Edmund Capon and Mae Anna Pang, *Chinese Paintings of the Ming and Qing Dynasties, XIV-XXth Centuries* (Clayton: International Cultural Corporation of Australia, Ltd., 1981), cat. no. 65, p. 141; *Boston Museum of Fine Arts, Portfolio of Chinese Paintings in the Museum*, vol. II (Yüan to Ch'ing Periods), ed. Kojiro Tomita and Hsien-chi Tseng (Boston: 1961), pls. 165-167.

8. For examples of the "hundred flowers" motif on porcelain, see Terese Tse Bartholomew, *The Hundred Flowers: Botanical Motifs in Chinese Art* (San Francisco: Asian Art Museum, 1985), nos. 54, 55.

One colophon and five collector's seals (in addition to the colophon and two seals of Mao Xiang).

Bibliography: Mary Fong, "Notes on Four Chinese Paintings in a Private Collection," *Oriental Art* 28: 2 (Summer 1982): 177-78.

MW

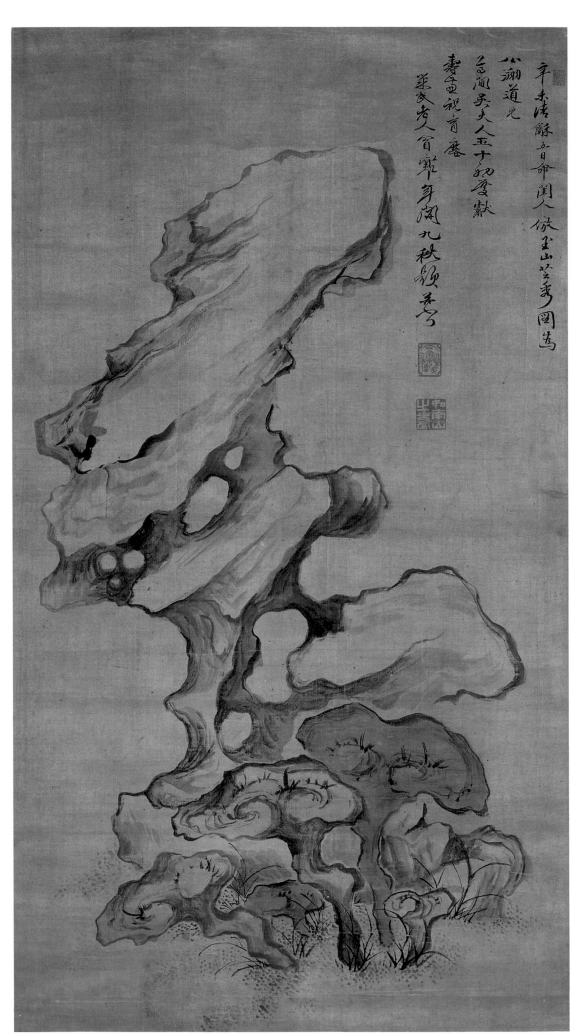

辛未清穌五日命閨人傚王山笑画圖為

山翁道光

名聞吳夫人五十初度歟

壽畫視前塵

棻友老人貪寐身開九秩頫笑寺

35
Mao Xiang's
Concubine
Rock and Fungi
1691

35
Mao Xiang's Concubine (Jin Yue?)

Rock and Fungi, 1691
Ink and color on satin
Hanging scroll, 101.5 x 56.3 cm.
Private Collection

Colophon by Mao Xiang:
*Xinwei [1691], fourth month, fifth day
[I] ordered my concubine to make a copy
of the "Jade Mountain Fungus Picture"
to be offered as a longevity painting to
brother Gongxiang's wife Lady Wu on the
occasion of her fiftieth birthday to wish
her the long life of the female unicorn.
Composed and inscribed by Chaomin
laoren Mao Xiang at the beginning of his
ninth decade.*

This birthday painting combines two
common symbols for long life: an eroded
"old age rock" and the *lingzhi* (*Polyporus
lucidus*), the "plant of immortality." The
lingzhi is a brownish fungus that grows
at the roots of trees and is believed to
possess supernatural properties, espe-
cially the power to ensure longevity. Ac-
cording to legend, it is found on the Isles
of the Immortals and gives eternal life
to all who eat it.[1]

The artist was probably Jin Yue, since
Mao's other famous painting concubines
were no longer alive by 1691. The ink
modeling and fluctuating brushstrokes
used to shape the rock and fungi con-
trast with the meticulous outline-and-
color techniques found in Jin Yue's
Hundred Flowers handscroll, but they
are employed with similar authority.
This again suggests the near-professional
versatility of the women painters of
Mao's household.

1. C. A. S. Williams, *Outlines of Chinese Sym-
bolism & Art Motives* (New York: Dover Publica-
tions, Inc., 1976; reprint of 1941 edition pub-
lished by Kelly and Walsh, Limited, Shanghai),
p. 328.

M W

36
Chen Shu

1660-1736
White Cockatoo, 1721
Ink and color on paper
Hanging scroll, 94 x 43.7 cm.
The Metropolitan Museum of Art, John
Stewart Kennedy Fund, 1913 (13.220.31)

Artist's inscription:
*Xinchou [1721] second month of winter,
the Old Person of the Southern Pavilion,
Chen Shu.*

Artist's seals:
Nüshi; Chen Shu

Chen Shu (*hao* Shangyuan dizi, Nanlou
laoren) was born into a once-distin-
guished family of Xiushui county, Jia-
xing prefecture, Zhejiang province.[1]
Over the centuries the Chens produced
their share of notable scholars and offi-
cials, but her father, Yaoxun, an educated
and charitable man, was not among
them. If he was a painter, his works
failed to attract attention. In fact, Chen
Shu's immediate family seems to have
been without significant artists. How-
ever, she was undoubtedly aware of the
rich cultural history of Xiushui, which
had long been a major center for the pro-
duction, study, and collection of paint-
ing. She also must have been encouraged
by the fact that Xiushui and the Jiaxing
area in general were very receptive to
women artists, many of whom were rec-
ognized by leading local scholars.

As set forth by her son Qian Chenqun
(1686-1774), the story of Chen Shu's
life includes elements common in biog-
raphies of eminent individuals: super-
natural portents and evidence of pre-
cocity.[2] As a child she learned to read by
asking the boys of her clan to pass along
what they learned in school. Her strict
mother initially frowned on such un-
feminine conduct and forbade her to
take time away from her needlework to
practice with the brush. Undeterred,
Chen Shu one day made a copy of a
famous painting hanging on the wall
of her father's study. For this she was
beaten, but a god intervened by appear-
ing to her mother in a dream and saying:
"I have given your daughter a brush.
Some day she will be famous. How can
you forbid it?" This tale served to under-
score the idea that Chen Shu was des-
tined for great achievement and perhaps
was used to explain her devotion to pur-
suits regarded by some as unnecessary,
even undesirable, for women.

Chen Shu married into the Qian fam-
ily of nearby Haiyan, becoming the sec-
ond wife of Qian Lunguang (1655-1718).
Qian did not distinguish himself as an
official, but he did earn a modest reputa-
tion as a calligrapher and poet. Shared

artistic interests were a part of the
couple's relationship, and Qian occasion-
ally added poetic inscriptions to Chen's
paintings.[3] Her more illustrious father-
in-law, Qian Ruizheng (1620-1702), a
noted calligrapher and a painter of pines
and rocks, also appreciated her paintings
and maintained that her use of the brush
not only resembled that of the Ming
master Chen Chun (1483-1544), but sur-
passed it in force and originality.[4]

The Qian family associated with some
of the leading scholars of the area and
took pleasure in entertaining guests, evi-
dently in a manner beyond the family's
means. To defray the costs of these
gatherings, Chen Shu pawned her cloth-
ing and sold her jewelry and paintings.
We can assume that she was also familiar
with, and to some degree influenced by,
the painting methods of family friends.
Among them was Yu Zhaosheng (*jinshi*
1706), whose ink studies of flowers and
plants were said to combine the best
qualities of the styles of the Ming mas-
ters Chen Chun and Xiang Shengmo
(1597-1658), the latter a native of Chen
Shu's home, Xiushui.[5] Chen Shu also
admired the paintings of her husband's
relation Qian An (*jinshi* 1655), who was
known for his landscapes in the manner
of Yuan-dynasty master Huang Gong-
wang as well as for his splashed-ink
techniques.[6]

The shape of Chen Shu's artistic
career was determined by her primary
roles as wife and mother. From the
1680s through the first decade of the
seventeenth century, much of her time
was devoted to caring for her four chil-
dren (three sons and one daughter),
parents-in-law, and mother. She also
looked after the education of Zhang
Geng (1685-1760), whose later career
included writing the *Guochao huazheng
lu*, a standard history of early-Qing
painters. Chen Shu undoubtedly contin-
ued to paint during these busy years, but
her last three decades seem to have been
her most productive; her surviving dated
paintings were executed between 1700
and 1735.

In 1721 Qian Chenqun, her eldest
son, became a Metropolitan Graduate
(*jinshi*) and received an appointment
to the Hanlin Academy. Since Chen Shu
had been widowed three years earlier,
he showed proper filial concern and
brought her to the capital. This trip may
have contributed to her development as
a painter by broadening her knowledge
of the artistic currents of the day, espe-

cially the conservative practices in vogue among the artists associated with the court. After three years in Beijing, Chen Shu returned home, where she remained for ten years. When her son asked the court's permission to visit her in 1735, she nobly insisted that he stay at his post and again set out to join him in the capital so that he could care for her in her old age without neglecting his official duties. She was then seventy-five years old, and the long trip took a serious toll on her health. Late in the spring of the following year she died in Beijing. Qian Chenqun then composed her biography, characterizing her as the embodiment of Confucian womanhood, the quintessential meritorious mother.

In the course of his successful career under the Qianlong emperor (r. 1735-95), Qian Chenqun frequently presented paintings by his mother to the throne. The emperor received Chen Shu's works with pleasure and wrote on many of them with his characteristic lack of restraint. As a consequence of Qian Chenqun's generosity, Chen Shu is better represented in the former Qing imperial collection than any other woman painter. Twenty-three of her works are recorded in the *Shiqu baoji* catalogues of the palace collection compiled in the eighteenth and early nineteenth centuries. A number of these paintings are now in the collection of the National Palace Museum in Taipei. Chen Shu's paintings were also in important private collections, including that of Wang Yuansun (1794-1836), the husband of the author of *Yutai huashi*.[7]

Chen Shu's poems were collected in a volume entitled *Fuan shigao*, which apparently was not published. The *Qing huajia shishi* (History of Poetry of Qing-dynasty Painters) includes her poem composed for a painting of hibiscus flowers, which she did for Madame Zou, the mother of the flower painter Zou Yigui (1686-1772).[8]

A number of young artists were directly influenced by Chen Shu, including her own children. Qian Chenqun, who received his early education from his mother, was recognized more for his calligraphy, but he did paint. His younger brother Qian Jie studied their mother's *xiesheng* (sketches from life) and became known for his ink studies of plum blossoms and narcissus.[9] (Chen Shu's third son died young, and information about her daughter has yet to be found.) Zhang Geng also took up some of the styles and subjects Chen Shu preferred. He sketched flowers in the manner of Chen Chun and his *Landscape after Wang Meng*, dated 1732, in the National Palace Museum, is very like her landscapes in old manners done around the same time.[10] Chen Shu's great-grand-nephew Qian Zai (1708-93), whom she also looked after when he was a child, began by following her in "drawing from life," but later studied the painting methods of the Jiang family (see cat. no. 38) in the capital.[11]

Other recipients of Chen Shu's instruction included her brother's son, Chen Yuan; Qian Weicheng (1720-72), a member of her husband's family of the same generation as her grandsons; and a young woman named Yu Guanghui (d. 1750). Nothing is known of Chen Yuan's achievements,[12] but Qian Weicheng became a celebrated artist and official, rising to the position of Vice Minister of the Ministry of Justice. Qian began his career as a painter by studying the free sketching (*xieyi*) of flowering branches with Chen Shu; we may see her influence in works such as his hanging scroll of chrysanthemums in the National Palace Museum.[13] Yu Guanghui was the granddaughter of Yu Zhaosheng, who took part in the scholarly gatherings hosted by the Qian family. The Qian and Yu families were also connected by marriage; one of Yu Zhaosheng's nieces was married to Chen Shu's eldest son. Yu Guanghui was by nature fond of painting, and one day, when she was seven years old, she sketched a branch of flowers on the wall. When her grandfather saw it, he was so impressed that he arranged for her to study with Chen Shu.[14]

Through her paintings Chen Shu reached later generations, especially, but not exclusively, her female descendants, including her great-granddaughter Qian Yuling (1763-1827); Qian Juying, a daughter of Qian Zai's grandson Qian Changling (1771-1827); and Qian Yunsu, her great-great-granddaughter.[15] Her influence also extended beyond the family. For instance, the lady-painter Cheng Jingfeng, concubine of Peng Yuncan (1780-1840), is said to have been very fond of her work.[16] And since many of Chen Shu's paintings became part of the Qing imperial collection, it is not surprising to find that the court master Jin Tingbiao (active during the reign of Qianlong) executed an album in her manner.[17]

Chen Shu was an ambitious artist; she tackled the full range of traditional subjects—didactic and religious figures, landscapes, birds, flowers, and plants.

Most of her surviving works are landscapes or studies of birds and flowers. In landscape painting she relied on the methods of the Ming-dynasty painters of Suzhou and revived the styles of certain earlier masters in accordance with the dictates of the Qing orthodox school. Among her least interesting works are her "orthodox" landscapes in the manner of Wang Meng, such as *The Mountains are Quiet and the Days Grow Long* in the National Palace Museum.[18] The specific composition upon which this painting was based was well known and can be found in the late-Ming album of reduced-size copies entitled *Xiaozhong xianda* (The Great Revealed in the Small).[19] While faithful, Chen Shu's version is mechanical. Like many works in antique manners by Qing artists, it suffers from over-reliance on the model and a monotonous application of texture strokes. More appealing is her *Imitation of Tang Yin's [1470-1523] Dwelling in the Mountains in Summer* (fig. e), in which she filtered aspects of the style of Wang Meng through the gentle, lyrical mode of the Wu School.

It was in painting birds and flowers, however, that Chen Shu was particularly successful and influential, even though here too she either copied old masterworks or drew inspiration from the Wu School, specifically from the manner of Chen Chun. Both approaches are represented by paintings in the exhibition.

White Cockatoo is not inscribed as after an ancient model, but the scroll was clearly based on a decorative Song academy painting. The same composition can be found in a painting inscribed "Fifteenth day of the fifth month of the second year of Xuande [1427], copying the Xuanhe brush [Emperor Huizong] for presentation to Yang Shiqi of the Grand Secretariat," in the collection of the Seattle Art Museum. Chen Shu's seals on the *White Cockatoo* match those on another work based on an old model, the hanging scroll *Autumn Wildlife*, dated 1700 (fig. j). This delicately colored autumnal view of quail beneath stalks of grain is inscribed "copying the ancients" and recalls paintings by the fourteenth-century master Wang Yuan.

The subject of the Metropolitan scroll, an exotic bird, is also a courtly one. Edward Schafer tells of a cockatoo presented at the Tang court and the emperor's comparison of the bird to another tribute gift, a pair of lovely girls:

> Silla, the rising state on the peninsula, and the good friend of T'ang [Tang], sent a pair of desirable girls, distinguished as much for their beautiful hair as for their musical talent, to T'ai Tsung [Taizong] in 631. The monarch uttered some sententious remarks . . . and went on to tell the patient ambassadors how he had sent back to

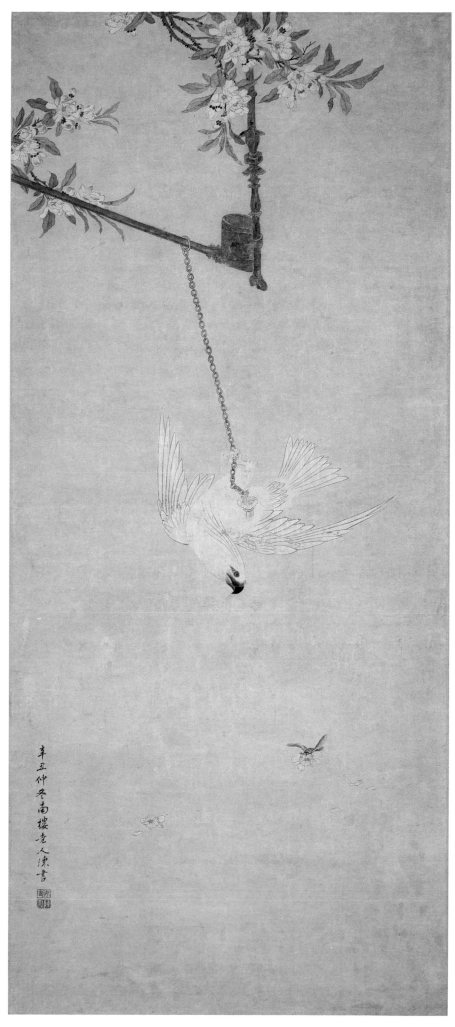

36
Chen Shu
White
Cockatoo
1721

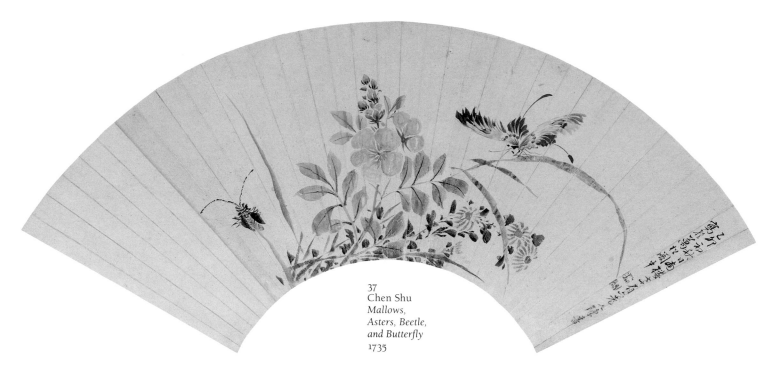

37
Chen Shu
*Mallows,
Asters, Beetle,
and Butterfly*
1735

Champa the royal gift of a white Moluccan cockatoo, and concluded his speech by declaring that these lovely maidens were more to be pitied than an exotic parrot, and so back they must go to Silla.[20]

More specifically, the white cockatoo recalls Snow-Garbed Maiden, the pet of China's most famous *femme fatale*, Xuanzong's concubine Yang Guifei. It is said that when the emperor was losing at a game of "double-six," Yang would fly the bird at the game board to disrupt play and allow the emperor to save face. This scene was depicted by the Tang-court painter Zhou Fang.[21]

The Yuan-dynasty scholar Yu Ji (1272-1348) also associated a white bird with a beautiful woman in his poem "The Girl of Wu Paints Flowers and Birds":

The girl of Wu has a lovely countenance,
Washing her face, she looks at the flowers, and the flowers seem filled with sorrow.
She mixes vermillion into a powder, not to apply to herself,
But to sketch the snow-garbed bird [white parrot] among the blossoms.
Deep within the women's quarters the spring day arrives late;
The affairs of the heart of half a lifetime are known to the flowers and birds.
Flowers wither and birds fly away, but the man does not return;
In the drizzling rain the plums sour, and sadly she paints her own eyebrows.[22]

1. *ECCP*, p. 99. For a more complete study of Chen Shu's life and extant works, see *Women in the History of Chinese and Japanese Painting*, ed. Marsha Weidner, forthcoming.

2. Qian Chenqun, *Xiangshu zhai wenji*, in *Xiangshu zhai quanji* (1885 edition), 26:6a-22a.

3. At least three albums of Chen Shu's paintings with Qian Lunguang's inscriptions are known: two in the National Palace Museum, one with six leaves and another with ten leaves (*Gugong shuhua lu*, 6:156-58), and one, with six leaves, reproduced by the Yuzheng Book Company of Shanghai.

4. Zhang Geng, *Guochao huazheng lu* (preface 1735; Nagoya book shop edition), *xia*, 22a. Chen Shu used a seal reading "Baiyang *jia xue*" — "In the tradition of Baiyang [Chen Chun]."

5. Yu, p. 571.

6. Ibid., p. 1438.

7. *YTHS*, 3:50.

8. *Qing huajia shishi*, ed. and comp. Li Junzhi (1930) *gui, shang*, 20a.

9. Yu, p. 1429.

10. *Descriptive and Illustrated Catalogue of the Paintings in the National Palace Museum* (Taipei: National Palace Museum, 1968), no. 302.

11. Yu, p. 1434.

12. Ibid., pp. 991, 1013.

13. Ibid., p. 1434; *ECCP*, p. 158; *Descriptive and Illustrated Catalogue . . .* , no. 308.

14. Zhang Geng, *Guochao huazheng xulu, xia*, 16a.

15. Yu, pp. 1435, 1438.

16. Ibid., p. 1099.

17. *Gugong shuhua lu* (Taipei, 1965), 8:155.

18. Ibid., 5:557-58.

19. Ibid., 6:71-75. This leaf is reproduced in *Shina Nanga Taisei* (Tokyo, 1935-37), 14:74.

20. Edward Schafer, *The Golden Peaches of Samarkand* (Berkeley, 1962), pp. 56-57.

21. Ibid., p. 101.

22. Yu Ji, *Daoyuan yigao*, cited in *YTHS*, 2:25.

Bibliography: John C. Ferguson, *Special Exhibition of Chinese Paintings from the Collection of the Museum* (New York: The Metropolitan Museum of Art, 1914), no. 62; Karen Petersen and J. J. Wilson, *Women Artists: Recognition and Reappraisal from the Early Middle Ages to the Twentieth Century* (New York: Harper & Row, 1976), p. 160.

M W

37
Chen Shu

Mallows, Asters, Beetle, and Butterfly, 1735
Ink and colors on paper
Fan, 16.3 x 48.8 cm.
Chengxun tang Collection

Artist's inscription:
Yimao [1735] early autumn, the Old Person of the Southern Pavilion at seventy-six years of age, Chen Shu, sketched in the Myriad Pines Pavilion.

Artist's seals:
Chen; Shu

In contrast to the *White Cockatoo*, this fan painting suggests the inspiration of the moment. Lightly sketched in a fluid, boneless manner that recalls the methods of Chen Chun, these autumn flowers and insects are very close to her *Sketches from Life*, dated 1713 (fig. k). Chen Shu's popular reputation, as distinct from the acclaim Qian Chenqun won for her at court, must have been based to a considerable extent on the easy grace of paintings such as these. This was one of the last works Chen Shu painted in the south, before she left to join her son in Beijing, where she died the next spring.

M W

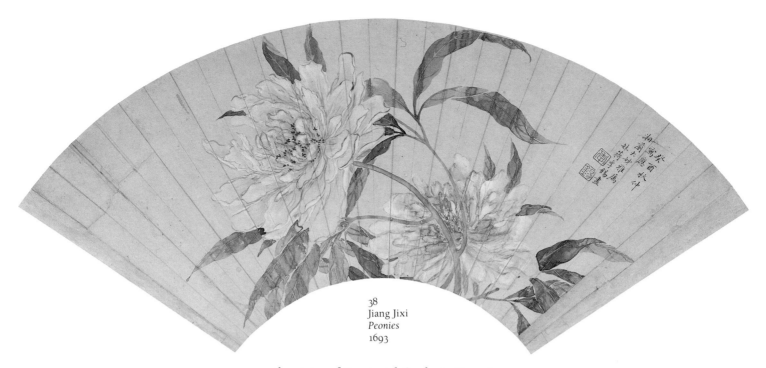

38
Jiang Jixi
Peonies
1693

38

Jiang Jixi

Late 17th-early 18th century
Peonies, 1693
Ink and color on paper
Fan, 19.7 x 53.1 cm.
Chengxun tang Collection

Artist's inscription:
Sketched in the second month of autumn of guiyou [1693] in response to the request of elder sister Xianglan. Painted by younger sister Jiang Jixi.

Artist's seals:
Ji; Xi

Jiang Jixi (*zi* Pingnan) came from a prominent family of Changshu, Jiangsu, and married into the equally distinguished Wang family of Huating. Her husband, Wang Tuwei, was the son of the scholar-official and calligrapher Wang Hongxu (1645-1723). Her grandfather held various official posts in the late Ming period, and her father, Jiang Yi (1631-87), became famous when he served as censor in Guangxi and submitted memorials to the throne accompanied by his own paintings depicting the sufferings of the people. One of her elder brothers, Jiang Chenxi (1653-1721), obtained the position of governor-general of Yunnan and Guizhou. Another, Jiang Tingxi (1669-1732), achieved

the status of Provincial Graduate (*juren*) in 1699, then served with distinction as a painter at the imperial court. As a Metropolitan Graduate (*jinshi*) of 1703, he became a member of the Hanlin Academy and eventually rose to the position of sub-chancellor of the Grand Secretariat.[1]

Jiang Tingxi succeeded Yun Shouping (1633-90) in flower-and-bird painting, becoming the leader in this genre in the Kangxi (1662-1722) and Yongzheng (1723-35) periods. He is said to have taken up and developed the methods of Yun Shouping, while establishing a school of his own. One of Jiang Tingxi's good friends and artistic companions was his fellow townsman Ma Yuanyu (1669-1722), the father of Ma Quan (cat. nos. 45-50). According to some accounts, Jiang Jixi "obtained Ma Quan's methods."[2] However, because she belonged to the same generation as Ma Quan's father, it does not seem appropriate to cast her in the role of Ma Quan's follower. Connections between the works of Jiang Jixi and Ma Quan are probably best explained by the close association of their families. Similarly, because the painters of both families were indebted to Yun Shouping, Jiang Jixi's painting style is related to that of Yun Shouping's famous female descendant Yun Bing (cat. nos. 39-44).

Jiang Jixi outlined the gauzy petals of her *Peonies* with gently modulated strokes to suggest the fragility of the blossoms, and she painted the stems and leaves in soft, fluid color. The languid grace of the brushwork and the naturalistic description of the flowers confirm her debt to the Yun Shouping tradition.

The Jiang family, like the Yun family, boasted a number of accomplished female painters. Jiang Shu, Jiang Tingxi's

daughter, followed her father in painting plants and flowers and, like Jixi, married into the Wang family of Huating.[3] The sisters Jiang Yue'e and Jiang Xing'e were both good at depicting flowers in color.[4] Jiang Zhuyin was able to paint flowers and compose poetry.[5]

The late-Qing collector Shao Songnian owned and recorded a twelve-leaf album of fine-line and color paintings of flowers and fruit by Jiang Jixi, which she inscribed as based on her brother's "brush idea."[6] She did not date the work, but in referring to her brother she used the honorific name bestowed on him after his death in 1732. If authentic, this inscription indicates that she was active well into the second quarter of the eighteenth century.

Jiang Jixi is also remembered as a calligrapher and poet. She left a volume of writings, *Qingfen ge ji* (The Pure Fragrance Pavilion Collection).

1. *ECCP*, pp. 142-43.
2. Yu, p. 1360; Wen Zhaotong, *Jiang Tingxi* (Shanghai: Shanghai renmin meishu chuban she, 1985), p. 15. Feng Jinbo (*Guochao huashi* [1797], 7:4a) says she obtained the Ma family methods and followed Yun Shouping.
3. Wen Zhaotong, p. 16; Yu, p. 1362.
4. Wen Zhaotong, p. 16; Yu, pp. 1358, 1361.
5. Wen Zhaotong, p. 16; Yu, p. 1359.
6. Shao Songnian, *Guyuan cuilu* (1903), 11:23b-24a. An album of flowers and fruit in the Zongguo Wenwu Shangdian may be the one Shao recorded; *Zhongguo gudai shuhua mulu* (Beijing: Wenwu chuban she, 1983), p. 38 (9-134).

M W

39
Yun Bing
18th century
Flowers of the Twelve Months
Ink and color on silk
Album of twelve leaves, each 40.9 x
33 cm.
Asian Art Museum of San Francisco,
The Avery Brundage Collection (65D49)

Artist's inscription:
*Respectfully painted by Nanlan nüshi,
Yun Bing.*

Artist's seals:
Yun Bing; Qingyu

Yun Bing (*zi* Qingyu) of Wujin (Chang-zhou), Jiangsu, was related to the illustrious painter Yun Shouping (1633-90), one of the Six Orthodox Masters of the Early Qing.[1] Among the many painters in the Yun family, she was the master's most successful follower. Their specific familial relationship, however, has at times been erroneously reported.

Particularly problematic is Yun Bing's biography in the *Guochao huazheng xulu*, the continuation of Zhang Geng's (1685-1760) history of early-Qing painters:

> Yun Bing, *zi* Qingyu, was Nantian's [Yun Shouping] daughter. She was good at [painting] flowers and plants using the methods of her family and became famous in the Wu [Suzhou] area. She married an unidentified man from her home town. [Her] four sons all transmitted her [painting] practices.[2]

This account was corrected by the poet and painter Yun Zhu (1771-1833),[3] a female relative, who was much better informed:

> Yun Bing, *zi* Qingyu, from Yanghu [Changzhou prefecture], Jiangsu, was the second daughter of [Yun] Zhonglong and the wife of Mao Hongdiao. She was my paternal aunt. [Yun Zhu's father was born in 1732.] At the age of thirteen [*sui*] she could already paint, and with her elder sister thoroughly studied the Six Laws [of painting]. She was especially skilled at [depicting] flowers and plants, birds and animals. With her application of color and brushwork she transmitted the methods of Nantian [Yun Shouping]. Upon completing a work, she would quickly add a brief poem.

Her style was one of antique elegance. Early in the Qianlong period [1736-95] the gentleman Yinjishan [1696-1771], posthumously named Wenduan, presented a painting by my aunt to the Empress Dowager Xiaosheng. [Emperor] Gaozong appreciated it and inscribed a poem in praise of it. [Her] fame then greatly increased. She did not have time to respond to all of those who called at her gate seeking paintings. Her sons Fengchao, Fengwu, and Fengyi were all painters, and her granddaughter Zhou, *zi* Liucun, was able to obtain her ideas. She became very famous in the capital. The *Huazheng lu* by the Recruit for Office Zhang Guatian [Geng] mistook my aunt for Nantian's daughter, and was also in error in saying that she had four sons. I am correcting this.[4]

Another clansman, the famous scholar-official Yun Jing (1757-1817), maintained that Yun Bing was three generations removed from Yun Shouping,[5] and the scholar Wu Dexuan (1767-1840) concurred.[6] Wu Dexuan also described Yun Bing as a contemporary of Ma Quan (cat. nos. 45-50), who was active in the first half of the eighteenth century. He observed: "At that time Yun Bing of Wujin painted and was famous for her boneless method. Jiangxiang [Ma Quan] was known for her outline technique. People of the Jiangnan called them a 'pair of perfections.'"[7] It is clear, then, that Yun Bing was not Yun Shouping's daughter, but was rather a somewhat distant descendant active in the mid-eighteenth century. No doubt this is why she was included in the continuation of Zhang Geng's text rather than in the main volume, which has a preface dated 1735.

Yun Jing's note on Yun Bing also provides a more intimate glimpse of her life. From it we learn that her husband, Mao Hongdiao, did not become a candidate for office, but built a small pavilion, where the couple lived "chanting poems and painting until they grew old."[8] Undoubtedly much of their livelihood came from the sale of Yun's paintings.

The Yun family boasted many talented women in addition to Yun Bing, including her granddaughter Zhou and Yun Zhu; and several Yun women also married artists. Yun Lanxi, for instance, became the wife of Zou Yigui (1686-1772), a celebrated court painter who specialized in flowers. Sometimes the couple worked together, and they are reported to have spent a whole night crawling along the floor executing a long scroll of some three hundred peaches of immortality.[9] Yun Xiang's husband He Lin can probably be identified as the artist of this name known for his landscapes and sketches of flowers, plants, birds, and animals.[10] Cao Heng, the husband of Yun Huai'e, learned the tradition of Yun

Shouping from his father-in-law Yun Yuanjun.[11]

Like Yun Shouping and Yun Bing, a number of Yun ladies used their painting skills as a means of support. This was the case with Yun Bing's younger sister Yun Yu.[12] Yun Huaiying's husband died while serving in the capital, leaving her in poverty and forcing her to use her brush to provide for the family.[13] Yun Heng (1776-1809) not only sold her paintings to support her family, but also served as a ghost painter for her maternal uncle Zhuang Cun, and no one was the wiser.[14] This was, of course, not an unusual practice. It was common for lesser-known artists to handle the overflow of commissions given to family members or friends or to add more famous names to their own works. Given the number of painters in the Yun family and the fact that most followed the same traditions, we can be certain that some of the paintings that today pass under the names of both Yun Shouping and Yun Bing were in fact the work of less-celebrated relatives.

Yun Bing seems to have devoted much of her energy to refining the descriptive and decorative side of Yun Shouping's art. A delicate mode that required an exhaustive, firsthand knowledge of flowers and plants and absolute control of the color medium, it was particularly well suited to small-scale formats such as fans and albums. The leaves of this album invite us to linger over the elegant shapes and jewel-like colors of the plants so artfully arranged on the silk.

The theme of this album, the flowers of the twelve months, was very popular during the Ming and Qing dynasties in both painting and porcelain. The Asian Art Museum of San Francisco, for instance, has a set of Kangxi-period (1662-1722) cups decorated with the twelve flowers of the year, and similar sets can be found in other collections.[15] The practice of associating specific flowers with the months is a very old one. Early precedent is a calendar in the *Book of Rites* in which a flower or plant is mentioned along with other natural phenomena for each month. Chinese garden books also include floral calendars (*hua li*), and

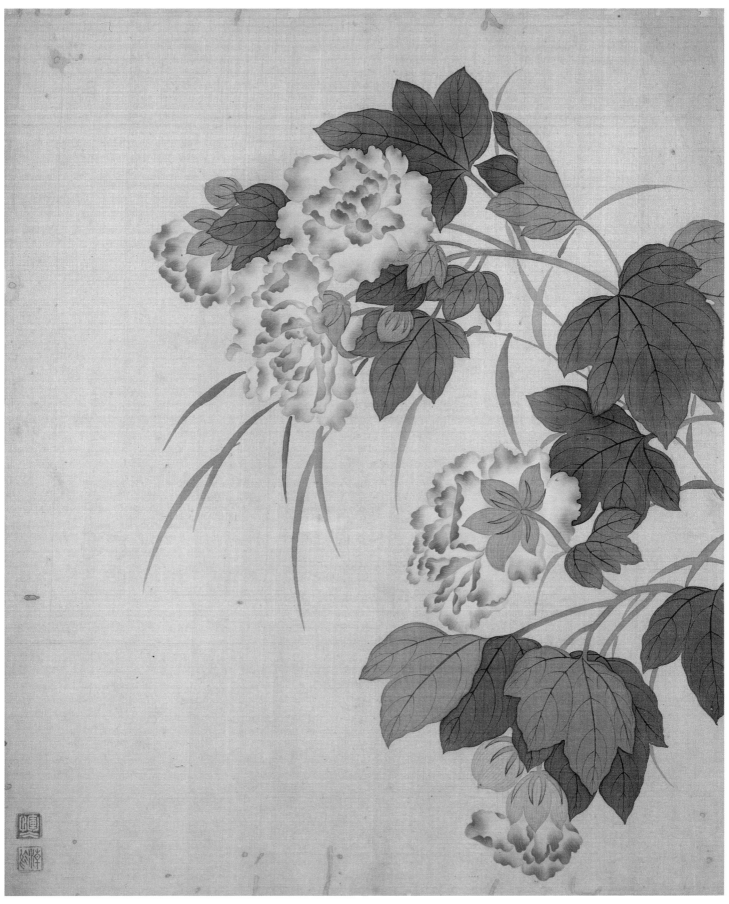

39-10
Yun Bing
*Flowers of
the Twelve
Months*

floral calendars are mentioned in folk songs.[16] In the early seventeenth century Tu Benjun set down a table of vase flowers for the twelve months (*Pingshi yuebiao*), with three ranks of flowers for each month. By month, those of the first rank are

(1) prunus (blossoming plum), double-flowered camellia;

(2) crab apple, Yulan magnolia, peach blossoms;

(3) tree peony, Yunnan camellia, spring cymbidium;

(4) herbaceous peony, champac michelia, silk tree;

(5) pomegranate, day lily, oleander;

(6) lotus, plantain lily, Arabian jasmine;

(7) crape myrtle, summer cymbidium;

(8) red osmanthus, osmanthus, cotton rose;

(9) chrysanthemum, litsea;

(10) white double-flowered camellia, sasanqua camellia;

(11) red-flowered blossoming plum;

(12) wintersweet, single-flowered cymbidium.[17]

Although certain flowers, such as the blossoming plum, orchid, lotus, and chrysanthemum, were singled out for exceptional esteem and weighted with literary and artistic tradition, the selection of flowers used to represent the seasons or months was by no means set or routine. There were, for instance, regional variations. According to H. L. Li, in the lower Yangtze River region the flowers typically associated with the months of the lunar calendar were

(1) prunus (plum blossoms);

(2) spring cymbidium;

(3) peach blossoms;

(4) apricot blossoms;

(5) tree peony;

(6) lotus;

(7) gardenia;

(8) osmanthus;

(9) chrysanthemum;

(10) cotton rose;

(11) sasanqua camellia;

(12) wintersweet.[18]

Painters also varied their combinations and depicted a rich array of species. The leaves of this album are composed of prunus and bamboo; peach blossoms; quince and magnolia; herbaceous peony (*shaoyao*); lily and pinks; lotus; canna and smartweed; yellow hibiscus and asters; chrysanthemum; rose mallow; poppies; wintersweet, nandina, and podocarpus. The last three plants are alternately known as wax plum, heavenly bamboo, and Luohan pine, and the composition is a play on the famous theme "Three Friends of Winter": prunus, bamboo, and pine.[19]

1. *ECCP*, pp. 960-61.

2. Zhang Geng, *Guochao huazheng xulu* (Nagoya book shop edition), *xia*, 16a. A recorded painting with a Yun Bing signature dated Kangxi *bingyin* (1686) seems to confirm that she was either Yun Shouping's daughter or of his children's generation (Ge Sitong, *Airiyin lou shuhua xulu* [1913], 5:4b). However, given the other evidence concerning her period of activity, it must be concluded that this work was spurious. The early date may well have been based on the *Guochao huazheng xulu* biography.

3. *ECCP*, p. 507.

4. Yun Zhu, *Guochao guixiu zhengshi xuji* (1831-36), 1:2a.

5. Yun Jing, *Dayun shanfang wengao* (1811-1815; 1884 edition; Commercial Press reprint, 1929), 3:52a.

6. Wu Dexuan, *Chuyue lou xu wenjian lu*, 1:1a.

7. Ibid.

8. Yun Jing, 3:52a-b.

9. Yu, p. 1073.

10. Ibid., pp. 1072, 251.

11. Ibid., pp. 896, 1073.

12. Ibid., p. 1070.

13. Ibid., p. 1073.

14. Ibid., p. 1071.

15. H. L. Li, *The Garden Flowers of China* (New York: The Ronald Press, 1959), pp. 121-22.

16. H. L. Li, *Chinese Flower Arrangement* (Philadelphia: Hedera House, 1956), pp. 37-38

17. Ibid., pp. 38-39.

18. Ibid., p. 38.

19. Terese Tse Bartholomew, "Examples of Botanical Motifs in Chinese Art," *Apollo* (July 1980):53.

Bibliography: R. L. Wing, *The I Ching Workbook* (Garden City: Doubleday & Co., Inc., 1979), p. 27; Terese Tse Bartholomew, "Examples of Botanical Motifs in Chinese Art," *Apollo* (July 1980): 48-54; Rita Aero, *Things Chinese* (New York: Doubleday, 1980), pp. 110, 156, 190; Terese Tse Bartholomew, "Botanical Puns in Chinese Art from the Collection of the Asian Art Museum of San Francisco," *Orientations* (September 1985): 18-34; Terese Tse Bartholomew, *The Hundred Flowers, Botanical Motifs in Chinese Art* (San Francisco: Asian Art Museum of San Francisco, 1985).

M W

40

Yun Bing

Flower and Insect Paintings
Ink and color on silk
Album of ten leaves, each 34.5 x 23 cm.
Musée Guimet, Paris (MA2536)

Artist's inscriptions:[1]

1. [Grasshopper, rose mallow, and lilies]
As frost chills the northern desert, ducks return south;
A few water lilies, opening wide, rest on the water.
Just a scene of mountain village when autumn's half gone:
Which painter has ever seen a picture like this?

2. [Beetle, roses, and campanula]
Month after month, blown by the wind, but never exhausted —
These exquisite flowers are for painters' eyes alone.

3. [Katydid and chrysanthemums]
Luxuriantly dangle priceless clusters;
Zigzag hang discs of purplish jade.
Ornaments on the neck of some tribal women —
Fit offerings before a goddess cast in gold.

4. [Grasshopper and lilies]
To those who believe in appearance as augeries of ill-fate,[2] I say
The Coupled-in-Joy[3] flowers are always full of feeling when they smile.

5. [Butterflies and roses]
Butterflies sporting in the gentle breeze come to the edge of the grass;
For months on end, they send forth the message for all flowers to open.

6. [Frogs, fish, and water plants]
Dotting the water, entangled threads of duckweed;
Snarled in the wind, long ribbons of waterplant;
Fallen red petals, blown about, unsettled —
Such dark mystery ne'er exists since the Hao River bridge.[4]

7. [Crab apple]
A goddess fit as a companion for the Prince of Western Mansion,[5]
Clad in beauty but with no trace of scent — in deep, deep slumber.

8. [Gardenias and azaleas]
For miles around the fragrance o'erfills the valley;
The Snow of July[6] is sealed in every branch.
Blown this side and that of the jade railing —
No immortal's visage can be fairer, I guess.

9. [Hydrangea and squash]
Putting down my needles and thread, and in a languid mood,
How I'd love in my autumn boudoir to indulge in kicking Embroidered Snowballs![7]

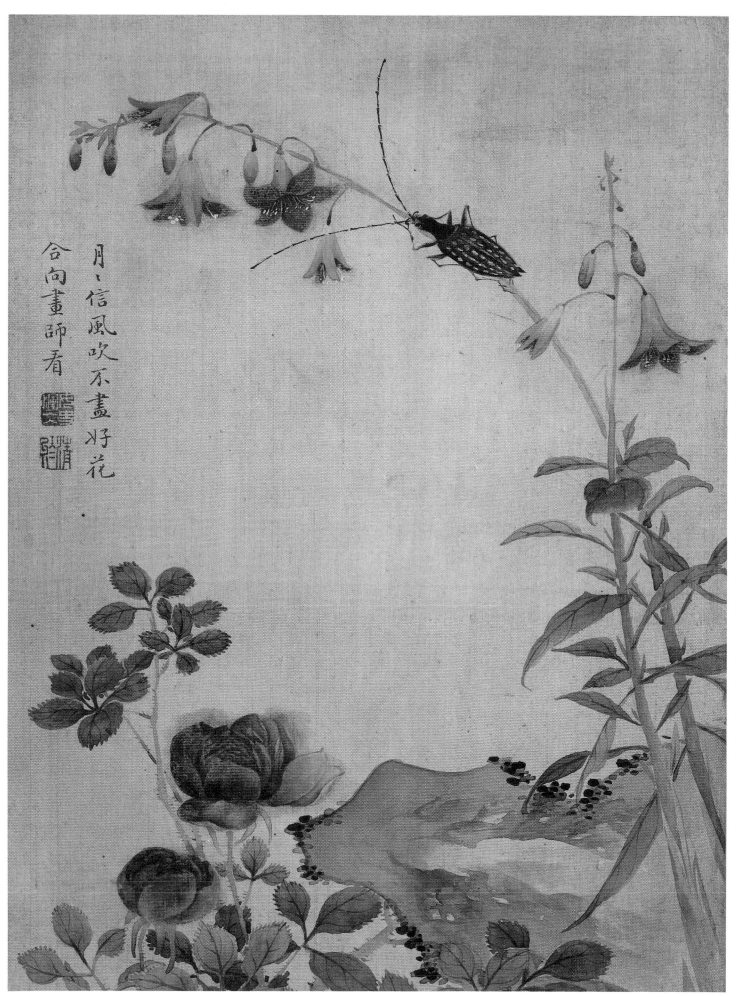

月〻信風吹不畫好花
合向畫師看

40-2 Yun Bing, *Flower and Insect Paintings*

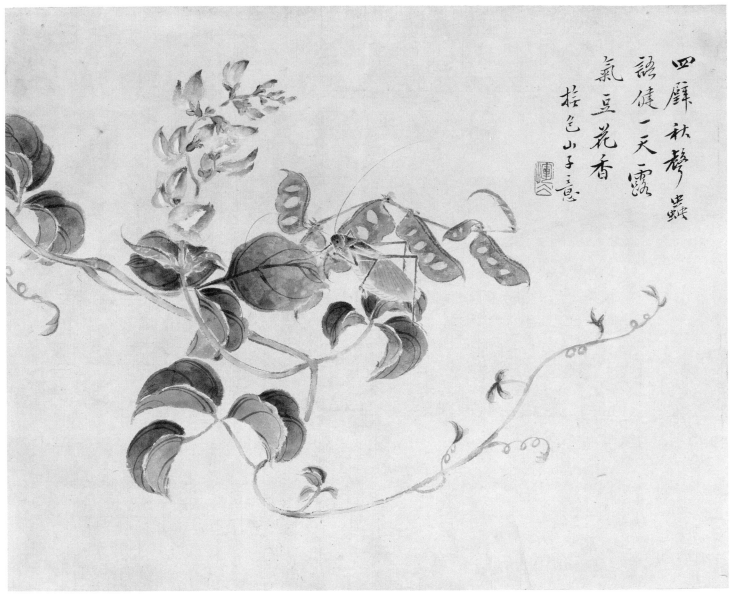

四壁秋聲蟲
語健一天露
氣豆花香
指色山子意
惲〔印〕

41-2 Yun Bing, *Plants and Insects*

10. [Prunus and camellias]
Despite the snow, before spring's coming,
they endure through the cold;
In dark yellow or light pink, they display
their beauty by the riverbank.
Highborn, unimpassioned — the immortal
shares nothing in common with the
vulgar sort:
Now emblazoned in a painting, they are
for the delight of all human eyes.
The lady Yun Bing.

Artist's seals:
Nüshi Yun Bing; Qingyu

This is one of the loveliest extant examples of Yun Bing's work. With an exquisite touch, she combined fine lines and smooth, boneless washes of varied intensity to capture the fugitive colors and shimmering light of transient moments in a southern garden. Each leaf was completed with a brief poem, as was apparently her habit.

1. The poems were translated by Irving Lo, who also provided the notes.
2. It is not clear why this flower is associated with "unhappy fate" (*boming*). It could be because of its white color, the color of mourning in China.

3. Coupled-in-Joy (*Hehuan*), or *albizzia julibrissin*, the mimosa tree, is said to be similar to acacia. Its leaves fold up at night and its blossoms, often hanging down in threads, show white in the upper part and pinkish in the lower part.

4. This is an allusion to the famous story in the *Zhuangzi* in which the Daoist philosopher and the logician Huize one day strolled on the bridge over the River Hao, and the former noted the pleasure enjoyed by the fish swimming about in the water below. Thereupon Huizi demanded, "You are not a fish. How do you know what fish enjoy?" Zhuangzi replied, "You are not me. How do you know that I do not know?"

5. Prince of Western Mansion (*Xifu gongzi*) is the name of one highly-prized variety of *haitang* or crab apple (*Malus Floribunda*), a spring-flowering tree or shrub with an abundance of rose or rose-red flowers.

6. Sixth Month Snow (*Liuyue xue*) is the name of a variety of flower.

7. Embroidered Ball (*xiuqiu*) is the Chinese name for viburnum, also called Snowball (*xueqiu*).

Bibliography: Joseph Vedlich, *The Ten Bamboo Studio* (New York: Crescent Books, n.d.), pp. 104-23.

MW

41

Yun Bing

Plants and Insects
Ink and color on paper
Two album leaves, each 24.2 x 30.5 cm.
Royal Ontario Museum (972.364.7a,b)

Artist's inscriptions: [1]

1. [Dragonflies and flowering legume]
Alighting here and there on water [the
dragonflies] look about restlessly.
Braving the wind with noisy wings,
Hardly daunted by the frail stems and
branches,
They are used to perching on fine fishing
lines.

2. [Grasshopper and snowpea]
The four walls reverberate with the
sound of autumn, as the insects chirp
incessantly.
The air is laden with dew and pea bloom
fragrance.
In imitation of the spirit of Baoshanzi
[Lu Zhi].

Artist's seal:
Yun Bing

With their graceful compositions, fluid brushwork, thin applications of color, and careful detail, these leaves admirably represent the plant-and-insect painting tradition of the Piling [Changzhou] School as revitalized by Yun Shouping. Yun Shouping's twelve-leaf album *Flowers and Plants Sketched from Life* in the National Palace Museum, Taipei, includes a very similar light-color sketch of an insect on pea vines.[2] In his inscriptions for this album Yun Shouping mentioned several artists of the past, and Yun Bing followed the same practice. As the inspiration for her grasshopper and snowpeas she cited the Ming master Lu Zhi (1496-1576). This art-historical reference combines with the poetic inscriptions to impart a scholarly flavor to these small slices of nature.

1. Translations provided by the Royal Ontario Museum.

2. *Gugong shuhua lu* (Taipei, 1965) 6:135-6; the leaf is reproduced in Saehyang P. Chung, "An Introduction to the Changzhou School of Painting — II," *Oriental Art*, n.s. 31:3 (Autumn 1985): 300.

MW

42
Yun Bing
Orchid Fans
Ink and color on paper
Four fans, each 19 x 55 cm.
Chengxun tang Collection

Artist's inscriptions:

1.
Its air is pure, its body chaste, its virtue fragrant, and its conduct upright.
Yun Bing.

2.
Looking at the flowers late at night, I cannot restrain myself;
[I] loudly sing a song, with many cups of wine.
Yun Bing.

3.
Too many fabled musicians[1] deserve our scorn;
Now close to your Orchid Fragrance,[2] I find it lovely.
Do not tell me journeying through Chu has been easy;
I know you desire to be the only Awakened One.[3]
Qingyu Bing sketched.

4.
The lady Qingyu sketched in the Pine Harmony Studio.

Artist's seals:
Yun Bing zhi yin; Lanling nüshi

These leaves display two methods of orchid painting, one with outlines and one without. The direct application of color without outlines, the boneless technique, was a fundamental part of the Yun-family style, and orchids were paint-

ed in this manner by many followers of Yun Shouping (see, for example, cat. nos. 52, 53).

Chinese orchids, which have none of the gaudy flamboyance of the tropical varieties, have long been appreciated by Chinese connoisseurs for their grace and fragrance. H. L. Li explains:

> Indeed, it is their fragrance that is considered the very virtue of the flowers. It is often compared with the association of a true friend or a perfect man, an association that is pleasant and delicate, that permeates one without his being wholly conscious of it.[4]

Raising orchids was a popular pastime among scholars, retired officials, and ladies who had the means and leisure. Yun Bing surely had fine examples at hand to study and sketch.

The second artist's seal on this fan reads "Lanling nüshi" (Lady of Lanling). This name appears together with Yun Bing's signature and seals on a number of recorded and extant works, but questions have been raised about its authenticity because it was used by another eighteenth-century woman of the family,

42
Yun Bing
Orchids
fan no. 4

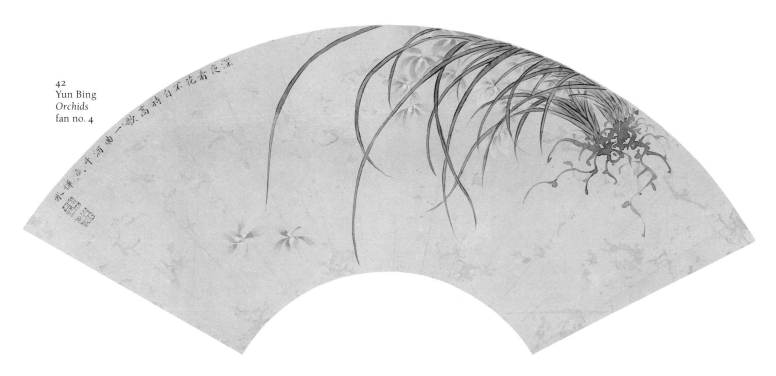

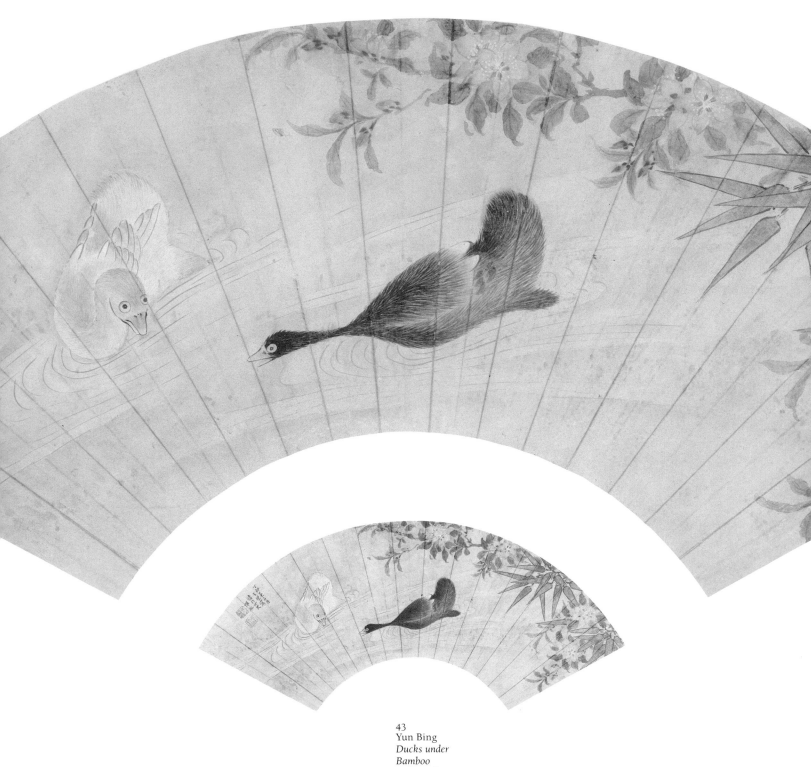

43
Yun Bing
*Ducks under
Bamboo
and Peach
Blossoms*
1747

Yun Huaiying,[5] and does not appear in the early biographies of Yun Bing. However, these sources do not give another *hao* for her, and Lanling was an old place name in the Yun family's native district, so it was a reasonable appellation for any Yun lady.

1. This poem was translated by Irving Lo, who also supplied the notes. The characters rendered "fabled musicians" actually read Xiao Shi. Xiao Shi was an expert flute-player of the Warring States period. Duke Mu of Qin chose him to be the husband and music teacher of his daughter Nongyu. Xiao Shi's music so moved the phoenixes that flocks of them would gather over the terrace where he played. After scores of years, his wife vanished riding a phoenix, and he rode away on the back of a dragon.

2. Orchid Fragrance *(lanxiang)* is customarily used to address someone one admires; hence, the two words are capitalized.

3. The phrase "the Awakened One" always conveys that the person stays "sober" or "enlightened" while the rest of the world is drunk. This is usually said of banishment, referring to the fate of Qu Yuan, exiled by the King of Chu. Perhaps the person being addressed by this poem willingly endured the same kind of fate.

4. H. L. Li, *The Garden Flowers of China* (New York: The Ronald Press Company, 1959), p. 73.

5. Yu, p. 1072.

MW

43
Yun Bing
Ducks under Bamboo and Peach Blossoms, 1747
Ink and color on paper
Fan, 16.3 x 51.7 cm.
Tokyo National Museum

Artist's inscription:
Sketched on the fifteenth day of the third month of [the year] dingmao [1747], the lady Qingyu, Yun Bing.

Artist's seals:
Yun Bing; Qingyu

The subject of this fan may have been taken from the first two lines of a poem composed by the Song-dynasty scholar Su Shi (1036-1101) for a painting by the monk Huichong: "Two or three sprays of peach behind bamboo / When spring warms the river the ducks are the first to know it."[1] Huichong, who was active in the late tenth and early eleventh centuries, specialized in depictions of water birds and quiet river views. Water birds, bamboo, and peach blossoms were common themes in Song-court painting and were rich in literary and popular associations. The peach tree and peach blossoms, for instance, were praised in the *Book of Songs* and admired by the poet Tao Qian (365-427). In Chinese folklore the pink flowers represent happiness and good fortune.

1. *Poetry and Prose of the Tang and Song*, trans. Yang Xianyi and Gladys Yang (Beijing: Panda Books, 1984), p. 246.

Bibliography: *Kaiankyo-rakuji*, the collection of Takashima Kikujiro, comp. Sugimura Yuzo and Takashima Taji (Tokyo: Kyuryudo, 1964), no. 79; Suzuki, JM1-168.

MW

44
Yun Bing
Cut Branches of Summer Flowers and Lychees
Ink and color on gold paper
Fan, 17.6 x 52.4 cm.
Private Collection, Japan

Artist's inscription:
Nanlan nüshi Yun Bing following a Northern Song model.

Artist's seal:
Yun Bing

This fan recalls the tradition of the Northern Song master Xu Chongsi (10th c.), whose boneless manner of painting was so much appreciated by Yun Shouping. Xu Chongsi and his grandfather Xu Xi often treated mundane subjects of this type. Unlike the court masters who produced showy images of the rare birds, exotic blossoms, and fantastic rocks found in the imperial garden parks, they preferred to depict the familiar flowers, fruit, vegetables, plants, grasses, fish, and insects of the southern countryside.

MW

44
Yun Bing
Cut Branches of Summer Flowers and Lychees

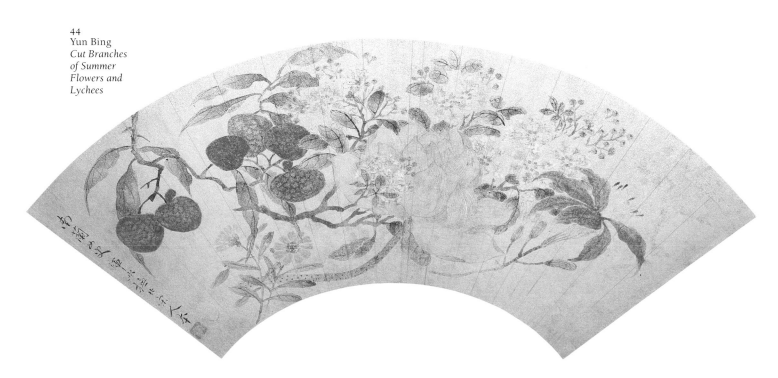

45 Ma Quan, *Flowers and Insects after Song Masters*, 1723, section

45

Ma Quan

First half of the 18th century
Flowers and Insects after Song Masters,
1723
Ink and color on paper
Handscroll, 16.25 x 250 cm.
Private Collection, Honolulu

Artist's inscription:
*Yongzheng [reign period], year in which
the reign name was changed [1723], sixth
month. Jiangxiang Ma Quan, following a
Song model.*

Artist's seal:
Ma Jiangxiang yin

A native of Changshu, Ma Quan (*zi*
Jiangxiang) was a member of another
important family of artists. As with Yun
Bing, there has been some confusion
about her specific relationship to the
male painters of the family, and it can
be traced back to the same source, the
Guochao huazheng xulu. Like Yun Bing,
Ma Quan appears only in the continua-
tion of Zhang Geng's text. There she is
identified as the great-granddaughter of
Ma Mei, the granddaughter of Ma
Yuanyu (1669-1722), the daughter of Ma
Yi, and the wife of an unnamed person
of Changshu. The author's lack of
firsthand knowledge about the family is
evident from the note that follows the
entry for Ma Quan, in which Zhang
Geng is quoted as having said that be-
fore he traveled to Taicang in 1758 he
had often heard of Ma Yuanyu's "draw-
ings from life" but had not seen them.[1]

More reliable are the reports of Feng
Jinbo (18th c.) and Wu Dexuan (1767-
1840) that Ma Quan was Ma Yuanyu's
daughter and Ma Yi's younger sister.[2]
Wu wrote:

Ma Jiangxiang, whose name was Quan, was
a native of Changshu. She was the daugh-
ter of the painter Ma Fuxi [Yuanyu]. Jiang-
xiang was also good at painting. In her late
years her reputation grew, and those who
came from all around offering painting silk
and gold in the hope of obtaining her
paintings became increasingly numerous.
Usually she had several maidservants, all
of whom were ordered to mix pigments.
Many ladies and gentlemen of Qinquan
[Changshu region] sought her instruction.
At that time Yun Bing of Wujin was paint-
ing and was famous for her boneless
method. Jiangxiang [Ma Quan] was known
for her outline-and-color technique. People
of the Jiangnan called them a pair of
incomparables.

Ma Quan was probably born around
1690; her dated works range from the
first to the sixth decade of the eigh-
teenth century. The names of several of
her students have been transmitted, con-
firming Wu's report of her influence on
her contemporaries.[3]

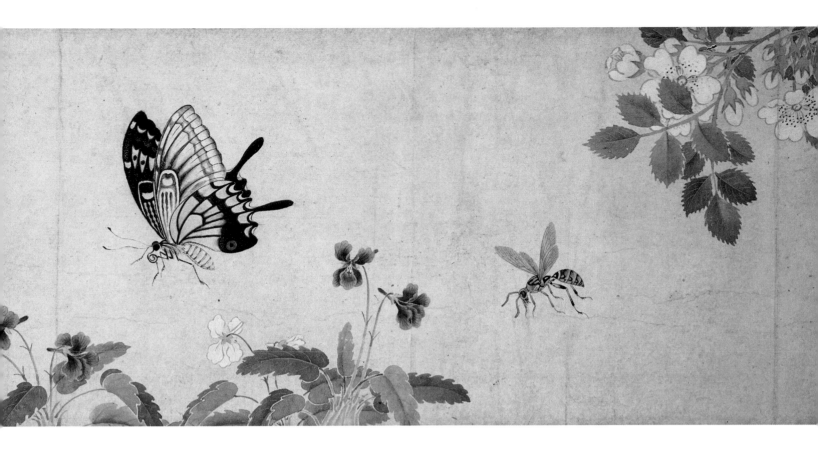

The *Jiangnan tongzhi* (Gazetteer of the Jiangnan Region) tells us something of Ma Quan's married life:

> Gong Chonghe [sic] and his wife Ma Quan were both skilled at calligraphy and painting. Those who sought their works valued them like jade. The family was poor, so the couple went to the capital, where they supported themselves by painting. When her husband died, she returned to their native place, to spin hemp, dip her writing brush, and drink cold tea [endure hardships], living as a faithful widow.[4]

In her late years Ma Quan went blind, and a maidservant named Zhen, whose surname has been lost, painted in her stead.[5] A person named Qian Zhang also served as her ghost painter, presumably to meet the great demand for works with her signature.[6] In addition, Qian E, another Changshu woman, made copies of Ma Quan's birds and flowers that were so good they could be confused for the originals.[7] Obviously Qin Zuyong had good reason to observe that the majority of the works passing under Ma Quan's name in the nineteenth century were fakes.[8] This situation is, of course, discouraging for collectors and scholars, but it is hardly unique to Ma Quan.

Ma Quan specialized in painting flowers, plants, and insects, following the family tradition. Her grandfather Ma Mei was a flower-and-bird painter particularly known for his geese among reeds. Ma Yuanyu, her father and the most famous artist in the family, studied "sketching from life" with Yun Shouping and "discussed the Six Laws" of painting with Jiang Tingxi (1669-1732). Consequently, it is said, his boneless manner of painting became very skillful and was not tied to old ways. As Zhang Geng recorded, Ma Yuanyu also looked to the methods of the Ming masters Lu Zhi and Shen Zhou. Ma Quan's brother Ma Yi studied with Jiang Tingxi and likewise painted in old manners. Father and son both served as ghost painters for Jiang Tingxi.

The tradition inherited by Ma Quan, then, belonged to the eclectic mainstream of eighteenth-century flower painting. It drew on the Ming styles of Suzhou but was more immediately indebted to the work of Yun Shouping. Like Yun Shouping and Yun Bing, Ma Quan observed her subjects closely, favored a light touch and fresh colors, and made frequent reference to the old masters. Often, as in this work, she drew inspiration from the art of the Song dynasty.

It should be noted that in this scroll there is a break in the paper before the artist's inscription. Tseng Yu-ho Ecke suggests that the separation and reattachment of this section may have occurred when the painting was last remounted.

1. Zhang Geng, *Guochao huazheng xulu* (Nagoya book shop edition), *xia*, 14b-15a.

2. Feng Jinbo, *Guochao huashi* (1797; 1831 edition), 17:3b; Wu Dexuan, *Chuyue lou xu wenjian lu*, 1:1a.

3. Zhu Jinlan, Qian Lin, Wu Kangcheng. See Yu, pp. 207, 1432, 297.

4. Cited by Feng Jinbo; her husband's name was Gong Kehe.

5. Yu, p. 645.

6. Ibid., p. 1435.

7. Ibid., p. 1436.

8. Qin Zuyong, *Tongyin lunhua* (Guangzhou, 1864), *fulu*, 2a.

Three collector's seals.

Bibliography: Tseng Yu-ho Ecke, *Wen-jen Hua: Chinese Literati Painting from the Collection of Mr. and Mrs. Mitchell Hutchinson* (Honolulu: Honolulu Academy of Arts, 1988), pp. 58-59.

MW

46

Ma Quan

Chrysanthemums, 1726
Ink and color on paper
Hanging scroll, 107 x 40 cm.
Naprstek Museum of Asian, African
and American Cultures, Prague,
Czechoslovakia

Artist's inscription:
*In the style of Xu Chongsi of the Northern
Song, imitating his main points. Bingwu
[1726], autumn, the ninth month, third
day after the full moon. Sketched by
Jiangxiang nüshi, Ma Quan.*

Artist's seal:
Ma

The Northern Song painter Xu Chongsi
cited in this inscription was a preferred
model of Yun Shouping and his follow-
ers, including the members of the Ma
family. Xu's methods ostensibly inspired
several extant paintings that bear Ma
Quan's name.

MW

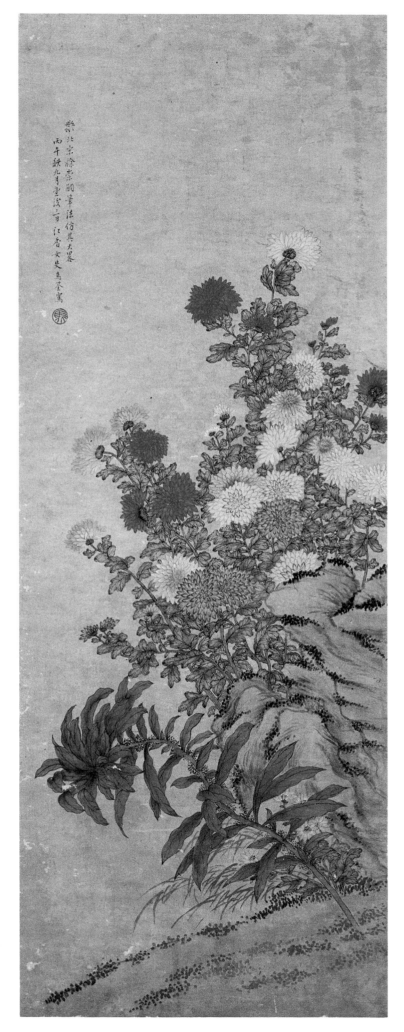

46
Ma Quan
Chrysanthemums
1726

47

Ma Quan

Chrysanthemums and Insects
Ink and color on paper
Hanging scroll, 78.5 x 33 cm.
Urban Council, Hong Kong Museum of
Art (FA 82.32)

Artist's inscription:[1]
A special kind of autumn fragrance:
 whence does it come?
You can be sure its root lies deeper than
 the green moss.
Dabs of dye from the rabbit's hair [of
 my brush] blossom out into patterns of
 frost—
All resembling what was planted by
 Yuanming [Tao Qian] beneath the
 hedge.
All my life I've loved the chrysanthemums
 by the eastern hedge;
But lazy by nature, I also lack even a tiny
 space to plant them.
When inspiration comes, I till the ground
 with my brush and inkstone;
Without constant care of watering, they
 will also blossom forth.
Jiangxiang nüshi, Ma Quan.

Artist's seals:
Ma Quan; Jiangxiang nüshi

Because this scroll has a fairly long
inscription, it might be noted here that
the quality of Ma Quan's calligraphy was
said to "transcend the commonplace."[2]
For discussion of some of the poetic im-
agery and the meaning of the chrysan-
themum in painting, see cat. no. 12.

 1. Translated by Irving Lo.
 2. Qin Zuyong, *Tongyin lunhua* (Guangzhou,
1864), *fulu*, 2a.

Two collector's seals.

 MW

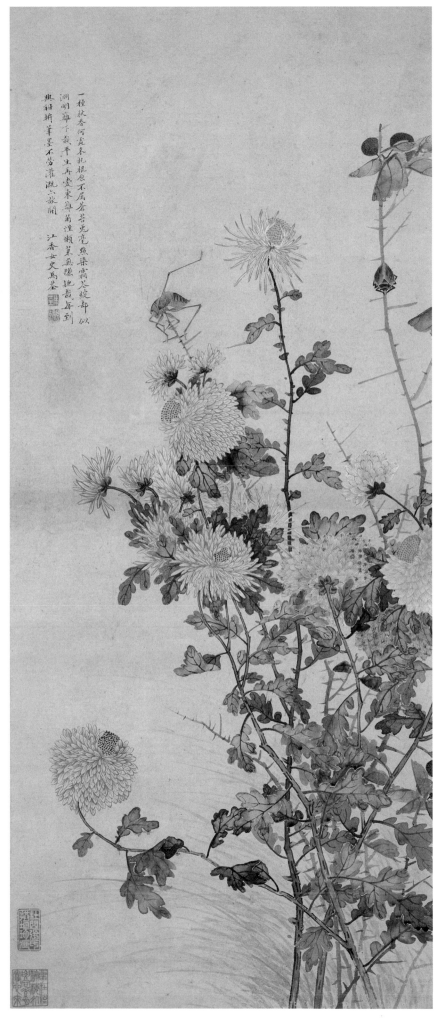

47
Ma Quan
*Chrysanthemums
and Insects*

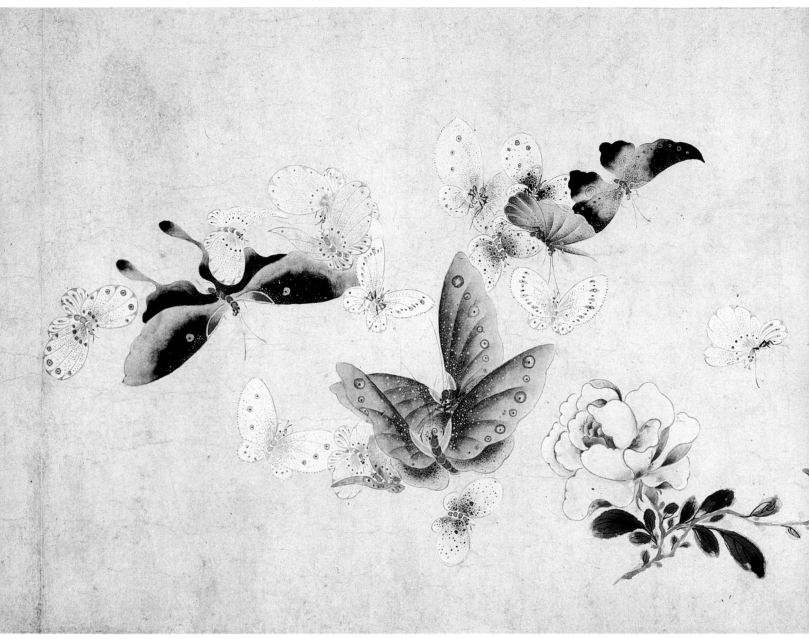

48 Ma Quan, *Flowers and Butterflies*, section

48

Ma Quan

Flowers and Butterflies
Ink and color on paper
Handscroll, 27.9 x 248.9 cm.
A. W. Bahr Collection, The Metropolitan
Museum of Art, Fletcher Fund, 1947
(47.16.116)

Artist's inscription:
Made by Jiangxiang nüshi, Ma Quan.

Artist's seals:
Jiangxiang; Ma Quan

This painting of butterflies, a subject
especially associated with Ma Quan, is
really about fragrance. Drawn by the
scents, the insects cluster around three
sprigs of flowers and a sweet-smelling
citron called Buddha's hand. The subject
also has feminine connotations. Beauti-
ful ladies are sometimes portrayed sur-
rounded by butterflies to suggest that
they possess the aroma and allure of the
flowers. The nineteenth-century album
*Pictures of One Hundred Beauties of the
Past and Present (Gujin baimei tu)* by Wu
Jiayou (d. 1893), for instance, includes
such an image of the famous Tang-
dynasty courtesan Chu Lianxiang, who
was said to have been followed by but-
terflies whenever she ventured outdoors.

Two collector's seals.

Bibliography: Alan Priest, "Insects: The Philoso-
pher and the Butterfly," *Metropolitan Museum of
Art Bulletin*, n.s. 10:6 (February 1952): 172-81;
Alan Priest, *Aspects of Chinese Painting* (New
York, 1954), pp. 2-5; "A World of Flowers,"
Philadelphia Museum Bulletin (May/June 1963):
188; Karen Petersen and J. J. Wilson, *Women Art-
ists: Recognition and Reappraisal from the Early
Middle Ages to the Twentieth Century* (New York:
Harper & Row, 1976), p. 159; Ju-hsi Chou and
Claudia Brown, *The Elegant Brush: Chinese Paint-
ing Under the Qianlong Emperor 1735-1795* (Phoe-
nix: Phoenix Art Museum, 1985), pp. 246-48.

MW

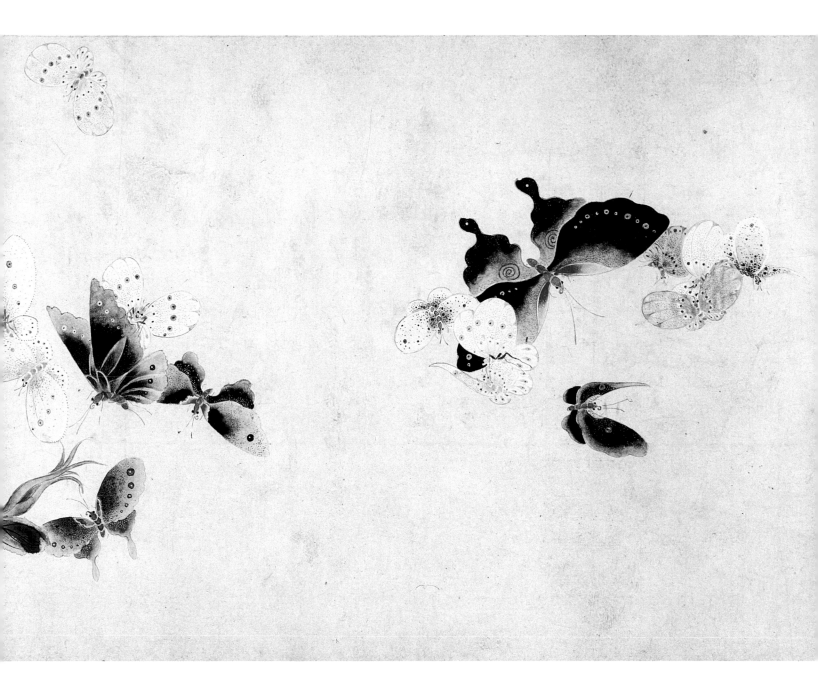

49
Ma Quan
Begonias, Asters, and Butterflies
Ink and color on gold paper
Fan, 16.8 x 51.2 cm.
Chengxun tang Collection

Artist's signature:
Ma Quan

Artist's seals:
[illegible] *shi; Ma Quan yin*

The begonia is a fine example of Ma Quan's delicate use of outlines. As noted above, people of the time paired her with Yun Bing, saying that Yun was known for her boneless method, while Ma was famous for her outline technique. Of course, Ma Quan did not work with this one method exclusively, but used it in combination with direct applications of color.

MW

50
Ma Quan
Flowers and Insects after Ye Xiaoluan
Ink and color on paper
Album of eight leaves, each 21.6 x 30.2 cm.
Tingsong shuwu Collection

Artist's inscription on last leaf:[1]
The album of butterfly paintings by Ye Qiongzhang [Xiaoluan] formerly in my collection was so meticulously and carefully done that, everytime I spread it out to appreciate it more, I found myself fascinated by the deportment of those dancing butterflies. Now, occasionally, I have

found time to copy several leaves, but they look ugly by comparison.[2] Only then did I realize how hard it is to recapture the heights reached by the ancients. Recorded by Jiangxiang Ma Quan.

Artist's seals:
Ma Quan yin; Jiangxiang nüshi

Ye Xiaoluan, whose album inspired Ma Quan, was the daughter of the poets Ye Shaoyuan (1589-1648) and Shen Yixiu (1590-1635).[3] Both were members of illustrious families of Wujiang, Jiangsu. They are said to have been a "well-favored and talented couple," and their marriage in 1605 was a celebrated event in the Suzhou area. Their three eldest daughters, Ye Wanwan (1610-33), Ye Xiaowan (b. 1613), and Ye Xiaoluan (1616-32), were all gifted poets. Until

1625 Ye Xiaoluan lived with her uncle Shen Zizheng and his wife Zhang Qianqian (1594-1627), both of whom were also poets. With such an abundance of models, it is not surprising that Ye Xiaoluan was a child prodigy. She could recite the *Chu ci* at the age of four and went on to excel at poetic composition, the game of *weiqi*, calligraphy, painting, and music. She copied Wang Xianzhi's *Luoshen fu*, painted landscapes, and sketched "falling flowers and butterflies in flight." Dying at seventeen (*sui*), just five days before her wedding, she is also remembered as a tragically short-lived beauty. Her father, Ye Shaoyuan, appreciated the poetic talents displayed by the women of his family, and consequently in the 1630s he edited and published their works and eulogies

about them in a collection called *Wumengtang ji.* He included Ye Xiaoluan's writings and an account of how after her death she became a goddess and appeared at a seance. Later he added a description of a seance held in 1642 in which he learned that his deceased wife and daughters had all become goddesses. Qian Qianyi included fourteen poems by Ye Xiaoluan in his anthology of Ming poetry, three of which are described as posthumous compositions revealed during seances.

As Ma Quan's album suggests, Ye Xiaoluan continued to capture imaginations throughout the Qing period. In the nineteenth century a man named Wang Shoumai acquired an inkstone that had supposedly been hers and published a collection entitled *Yan yuan jilu* with descriptions of her and the inkstone, as well as accounts of seances at which she was said to have appeared. Wu Jiayou in his *Pictures of One Hundred Beauties of the Past and Present,* included an image of Ye Xiaoluan engaged in painting a landscape scroll.[4]

1. Translated by Irving Lo.
2. The text reads *xiaopin,* a common allusion to the well-known story about Xishi, one of the most beautiful women of the world, whose scowl (because of her illness) was thought by the villagers to be becoming until another less beautiful woman tried to imitate her without success.
3. Yu, p. 1214; *Dictionary of Ming Biography,* ed. L. Carrington Goodrich (New York: Columbia University Press, 1976), pp. 1577-79.
4. Wu Jiayou, *Wu Youru huabao quanji* (Shanghai, 1909), *Gujin baimei tu,* 24.

Eleven collector's seals.

M W

51
Fang Wanyi

1732-79
Flowering Plum
Ink and color on paper
Fan, 18.7 x 54 cm.
Private Collection, Honolulu

Artist's inscription:
Painted by the White-lotus Recluse, Fang Wanyi.

Artist's seal:
Fang shi Bailian

The poet, calligrapher, and painter Fang Wanyi (*zi* Yizi; *hao* Bailian jushi) was from Shexian, Anhui province. Her grandfather, Fang Yuanying, served as Guangdong Provincial Administration Commissioner and her father, Fang Baojian, was a National University Student.[1]

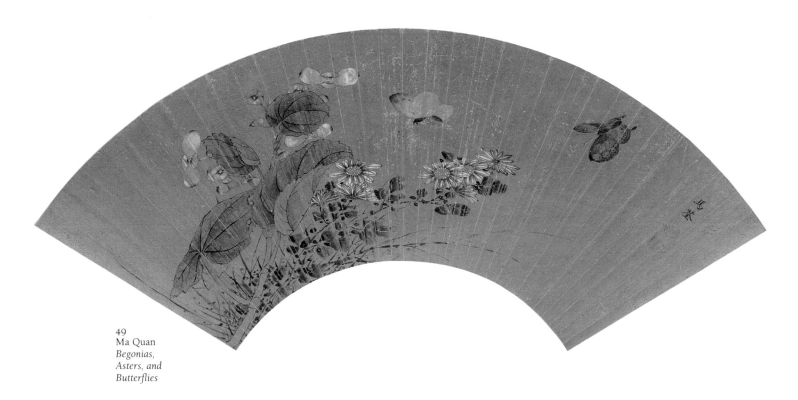

49
Ma Quan
*Begonias,
Asters, and
Butterflies*

50-1 Ma Quan, *Flowers and Insects after Ye Xiaoluan*

50-2

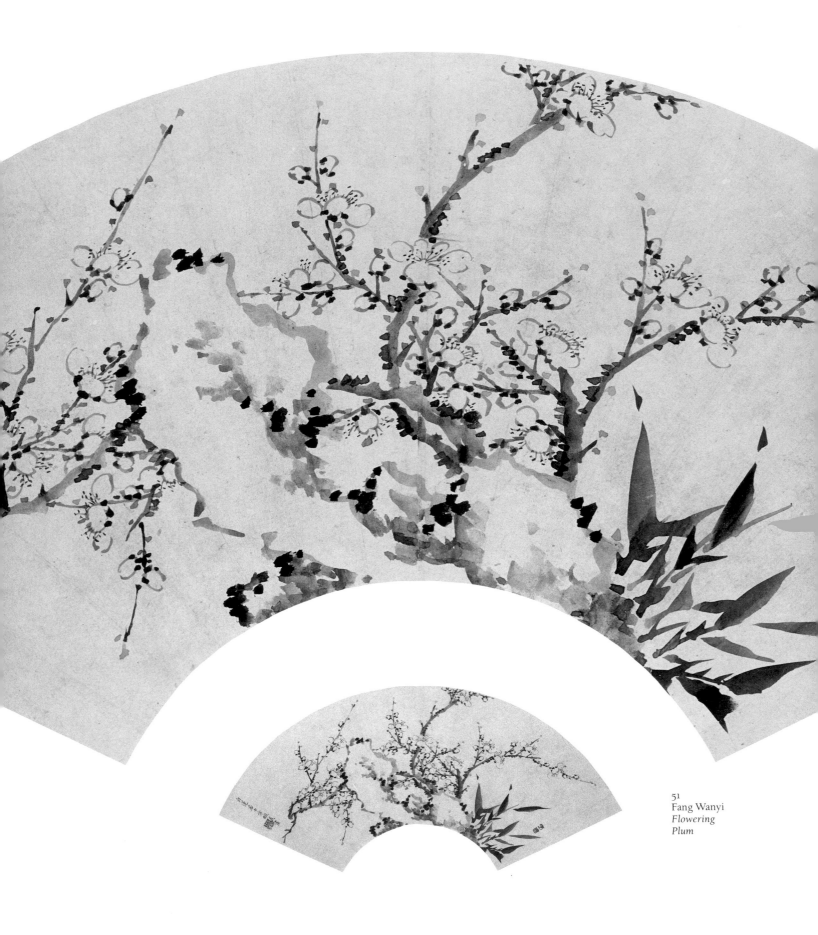

51
Fang Wanyi
*Flowering
Plum*

As a girl she took up the academic traditions of her family and became skilled at "half-regulated" verse. She continued her scholarly pursuits after her marriage and eventually left two volumes of writings.[2] Her literary activities were encouraged by her husband, the poet and painter Luo Pin (1733-99). Luo's ancestral home was also Shexian, but he resided in Yangzhou and was counted among the so-called Eight Eccentric Artists of that city.

Luo Pin was a participant in and beneficiary of the lively culture supported by the wealthy salt merchants of Yangzhou. The talents of many women, including Fang Wanyi, were also fostered in this social environment. Fang received instruction in poetry from her husband's friend Shen Dacheng (1700-71),[3] who was employed as a private scholar by Lu Jianzeng, the Commissioner of the Salt Administration at Yangzhou. Her work was also recognized by such associates of her husband as the bibliophile Wang Qishu (1728-99?), also a native of Shexian; the writer and painter Hang Shijun (1696-1773);[4] the poet and dramatist Jiang Shiquan (1725-85); the figure painter Yu Ji (1738-1823); the painter and connoisseur Song Baochun (1748-?); and the writer and calligrapher Wu Xiqi (1746-1818).[5]

Fang Wanyi called herself the White-lotus Recluse (Bailian jushi), and suggested her special feeling for this flower in a birthday poem:

> The little pavilion is bright, with icy mats and curtains;
> But the scenery by the pond touches my heart the most.
> Muddy sediment does not contaminate the green water;
> The lotus flowers and I share a birthday.[6]

The pure lotus blossom rising out of the mud is, of course, a Buddhist image, and Fang Wanyi was a devout believer in Buddhism. Luo Pin also embraced the religion and styled himself Huazhisi seng, Monk of the Temple of the Flowers; he claimed that he learned from a dream that in a former life he had been abbot of a temple of this name.[7]

The couple also shared their literary and artistic interests. This is evident from the preface that Luo composed for his wife's collected poems. After stressing that she rejected popular romantic literature and never wrote such works, he related that sometimes she would watch him paint winter plum blossoms and bamboo and offer advice. As for her own paintings, he boasted that they possessed meaning that transcended the commonplace.[8] In 1778, a year before

her death, he wrote out Su Shi's "Record of Wen Yuke's Painting the Bent Bamboo of Yundang Valley" and had it mounted with one of her bamboo paintings in a handscroll "for their descendants to treasure."[9] The couple also did joint works. One of Fang's biographers mentions an album on which they collaborated; she contributed a "refined and exquisite" leaf, *Fording the River to Pick Hibiscus Flowers*, and marked it with a seal reading "Wife of Liangfeng [Luo Pin]."[10]

Paintings of flowers and plants, particularly the so-called Four Gentlemen — bamboo, plum blossoms, orchids, and chrysanthemums — were much in demand in eighteenth-century Yangzhou, and many of the leading artists of the city treated them in novel, expressive, and appealing ways. Fang Wanyi specialized in plum blossoms, orchids, bamboo, and rocks. The handscroll mentioned above presents clumps of delicate bamboo on a misty embankment in the tradition of the Yuan-dynasty painter Guan Daosheng (cat. nos. 1, 2). Undoubtedly Fang also had the work of this artist in mind when she painted the handscroll of bamboo now in the Shanghai Museum. Guan's name is frequently invoked in the colophons that follow the painting.[11] At the same time, elements in that scroll, such as the insistent patterns created by the dark, dense leaf clusters, reflect the more immediate influence of Luo Pin and his teacher Jin Nong (1687-1763).

Fang Wanyi also followed her husband's lead in painting plum blossoms. As a recent exhibition elegantly demonstrated, by the eighteenth century the blossoming plum was an old and venerated subject, rich in symbolic, poetic, and art-historical associations.[12] Appearing on gnarled trees early in the new year before other flowers have emerged and when winter weather has yet to depart, plum blossoms have long symbolized renewal and courage. The trees themselves are emblematic of endurance. The white color of the blossoms and their lonely vigil suggest purity, while the brevity of their flowering brings to mind the fleeting nature of beauty. From such associations came two durable literary images: the flowering-plum recluse

and the plum-blossom beauty. Scholarly hermits identified themselves with these lofty flowers by planting plum trees around their retreats and adopting such literary names as "The Plum Blossom Taoist." The plum-blossom beauty was the creation of poets who, in reflecting on the transience of life, likened these delicate, chaste flowers to lovely young women.

A number of the leading Yangzhou masters were devoted to plum-blossom painting, including another native of Shexian, Wang Shishen (1686-c. 1759). Wang Shishen, Jin Nong, Luo Pin, and Fang Wanyi offered individual interpretations of a fundamentally similar plum-painting style. Typically Luo Pin drew ragged branches with broad, moist, gray strokes, accented them with dark lichen dots, and wove them into animated frameworks for a profusion of delicate blossoms, sometimes enriched with color. These elements appear in the fan by Fang Wanyi, but hers is a milder and less idiosyncratic handling of the idiom. Spread gracefully over the fan surface, the flowering branches, rock, and bamboo are enlivened by the artist's light touch and the bits of red color.

Luo Pin and Fang Wanyi passed their enthusiasm for plum-blossom painting on to their children. The first and second sons, Luo Yunshao (or Yuanshao) and Luo Yunzuan (or Yuanzuan), and a daughter, Luo Fangshu, all painted blossoming plums, leading people to speak of the "Luo Family Plum School." Luo Pin and Fang Wanyi added colophons to an album of plum flowers painted by their daughter in 1775.[13]

Fang Wanyi died in Yangzhou on the nineteenth day of the fifth month of 1779 at the age of forty-eight (*sui*). Luo Pin was away at the time, travelling in the north. In Jinan, on the eleventh day of the sixth month, Fang Wanyi appeared to him in a dream, holding one of her own paintings of plum blossoms, but it was only upon his return to the capital in the eighth month that he learned of her death. Grief stricken, he composed a long poem to express his sorrow.[14] Also in tribute, he had a portrait painted of himself holding a white lotus flower.[15] At Luo Pin's request, Weng Fanggang (1733-1818) composed the following lines for her epitaph:

> Myriad scrolls of plum blossoms;
> One of white lotus.
> Her paintings are Chan meditations;
> Her poems belong to the immortals.[16]

1. Chen Jinling, *Luo Liangfeng* (Shanghai: Renmin meishu chuban she, 1981), p. 25.
2. Feng Jinbo, *Guochao huashi* (1797; 1831 edition), 17:12b.
3. Jiang Baoling, *Molin jinhua* (1852), 4:10a.
4. Records concerning Fang Wanyi by both scholars are quoted by Feng Jinbo.

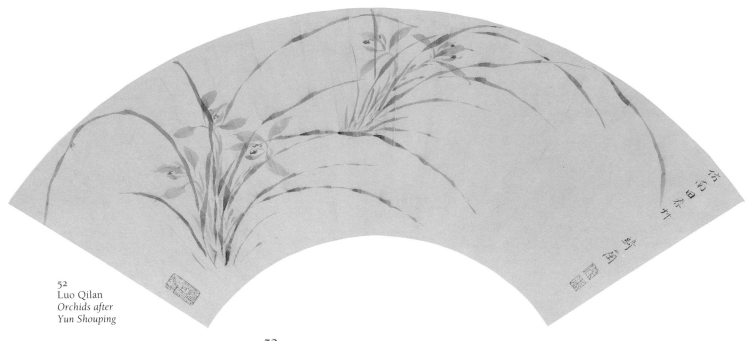

52
Luo Qilan
*Orchids after
Yun Shouping*

52

Luo Qilan

Active 1790s
Orchids after Yun Shouping
Color on paper
Fan, 20.3 x 50.5 cm.
Chengxun tang Collection

Artist's inscription:
*After Nantian's [Yun Shouping] spring
grass [orchids]. Qilan.*

Artist's seals:
Pei; Xiang

Luo Qilan (*zi* Peixiang; *hao* Qiuting) is
said to have been "addicted to books and
fond of chanting poetry" from child-
hood. She was from Juqu, Jiangning
(Nanjing), and married a local man,
Gong Shizhi, who died young.[1] Her con-
temporaries spoke highly of the integrity
of her life as a widow and the care with
which she taught her only child, a
daughter. After her husband's death, she
moved to Dantu (Zhenjiang), where she
enjoyed the artistic and literary society.
Her circle of friends included the painter
Bao Chaixiang, wife of the well-known
Dantu artist Zhang Yin (1761-1829). Luo
presented Bao with a moving poem in
which she contrasted their lives:

Who knows that I envy your good fortune
 and wisdom;
All day in your fine chambers your happy
 affairs overflow.
. .
Alone and away from home, I float and
 drift;
In the mirror I am sad to see my hair has
 grown thin.[2]

In Dantu she also became a follower of
the famous poet and calligrapher Wang
Wenzhi (1730-1802) and one of many
female students of Wang's friend, the
poet and essayist Yuan Mei (1716-98).[3]
Yuan considered Luo very gifted, and

visited her at Dantu early in 1793.[4] From
her studies with these men, it is said, her
poetic style became increasingly skillful.

In 1796 Ding Yicheng painted a por-
trait of Luo Qilan in a landscape, *View-
ing Mt. Ping in Springtime,* (fig. m), for
which she composed a poem.[5] This
handscroll shows her as an introspective
young woman with simple but refined
taste. Wang Wenzhi wrote out the poem
and a record of the event to accompany
the painting. Colophons were also added
by Yuan Mei and Zeng Yu (1759-1830).
Zeng was another important person in
Luo's life. She invited him to inscribe
her painting *Tutoring My Daughter by
the Autumn Lamp.* His poem included
the line "I cannot bear to listen to the
sounds of autumn outside the window."
From this came the name of her study,
the Listening to Autumn Studio (*Tingqiu
xuan*).[6] Zeng also wrote prefatory re-
marks for her volume of poems, *Tingqiu
xuan shiji* (Collected Poems of the Lis-
tening to Autumn Studio), as did Wang
Wenzhi and Yuan Mei.

5. Jiang, Yu, Song, and Wu added inscriptions
to her hanging scroll of azaleas in a pot; see
Zhongguo minghua ji (1909), 2:160.
6. Jiang Baoling, 4:10a-b; also *Qing huajia
shishi,* ed. and comp. Li Junshi, *gui, shang,* 35b-
36a.
7. Jiang Baoling, 4:9b.
8. Feng Jinbo, 17:12b-13a.
9. *Shenzhou daguan* (1912-21), vol. 9.
10. Jiang Baoling, 4:10b.
11. These colophons were written by some
twenty women, after Fang Wanyi's death, at her
son's request. The first, for example, was added
by Cao Zhenxiu (1762-?), a famous woman callig-
rapher and painter of plum blossoms.
12. Maggie Bickford, et al., *Bones of Jade, Soul
of Ice* (New Haven: Yale University Art Gallery,
1985).
13. Yu, pp. 1503, 1505.
14. Chen Jinling, p. 33.
15. Tseng Yu-ho Ecke, *Poems on the Wind*
(Honolulu: Honolulu Academy of Arts, 1982),
p. 143.
16. Chen Jinling, p. 33.

Two collector's seals.

Bibliography: Tseng Yu-ho Ecke, *Poems on the
Wind,* (Honolulu: Honolulu Academy of Arts,
1982), no. 71; Tseng Yu-ho Ecke, *Wen-jen Hua:
Chinese Literati Painting from the Collection of Mr.
and Mrs. Mitchell Hutchinson* (Honolulu: Hon-
olulu Academy of Arts, 1988), p. 68.

MW

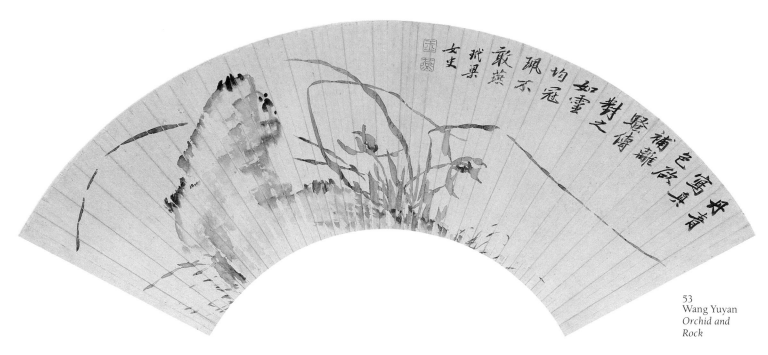

53
Wang Yuyan
*Orchid and
Rock*

and quiet. They possess characteristics that the Yuan painters could not equal. This . . . painting has a special spirit, endowed by heaven, and naturally flows beyond the narrow paths of brush and ink. Only when women imitate it is the lineage proper. Did not the Bodhisattva Guanyin take a female form to expound the [Buddhist] Law?

He went on to note that his granddaughter Wang Yuyan (cat. no. 53) also learned from the plant-and-grass paintings of Wen Shu.[9]

In her middle years Luo Qilan "submerged herself in Chan Buddhism" and apparently did few paintings or poems.[10] The records concerning her artistic activities date to the 1790s, by which time she was a young widow, so we can tentatively conclude that she was born sometime in the 1760s or early 1770s.

1. Jiang Baoling, *Molin jinhua* (1852), 6:16a; Yu, pp. 1441-42.

2. Yuan Mei, *Suiyuan nüdizi shi*, in *Suiyuan quanji* (Shanghai, 1920), 3:3b.

3. Jiang Baoling, 6:16a.

4. Arthur Waley, *Yuan Mei* (London: Allen and Unwin, 1956), pp. 183-84.

5. For the poem, see Luo Qilan, *Tingqiu xuan shiji* (1795), 4:19a.

6. Jiang Baoling, 6:16a.

7. *Zhongguo gudai shuhua mulu* (Beijing, 1985), 2:143, nos. 6075, 6074, 6076, respectively. No. 6076, the picture of a "three-blossom flower," may be the hanging scroll described as "herbaceous peonies" by Shao Songnian, *Guyuan cuilu* (1904), 15: 13b-14a. The painting was a record of a wonderful peony with three flowers on a single branch, for which Wang Wenzhi composed a poem. As noted above, Jiang Baoling (6:16b) mentions a handscroll of the same subject in the style of Yun Shouping, and such a work, with the poem recorded by Shao, appeared in a Sotheby's sale on June 2, 1987. The relationships between these records and paintings have yet to be determined.

8. Jiang Baoling, 6:16b.

9. Wang Wenzhi, *Kuaiyutang tiba* (Shanghai: Guangzhi shuju), 8:14- 15.

10. Jiang Baoling, 6:16b.

While poetry was Luo Qilan's first love, she also enjoyed "sketching from life." The Palace Museum has three of her hanging scrolls: *Plum Blossoms*, dated 1799; *Tree Peony*, dated 1795; and *Three-Blossom Flower.*[7] Occasionally Wang Wenzhi also did ink plum blossoms, and perhaps Luo followed him in painting as well as poetry. A more significant source of inspiration for her art, however, was the work of Yun Shouping. Jiang Baoling reports that she once painted a three-blossom herbaceous peony in his style.[8] She likewise looked to Yun when she painted the fan in the exhibition, but here she used his boneless manner to treat another of her favorite subjects, the orchid.

Luo studied too the work of Wen Shu (cat. nos. 14-16), and one of her paintings in this tradition, a handscroll of plants and grasses, was recorded by Wang Wenzhi:

This was done by Peixiang after Wen Duanrong [Shu]. As for Duanrong's plants and grasses, their origins lie in the Yuan dynasty, but they have a ladylike reserve

53
Wang Yuyan
Late 18th century
Orchid and Rock
Ink and color on paper
Fan, 16.4 x 55.1 cm.
Chengxun tang Collection

Artist's inscription:[1]
*Its true nature depicted in painting,
To make up for gaps in the Li Sao[2]
 biography.
I face it as if it were Lingjun[3]
Whose cap and pendant I dare not treat
 with disdain.
The lady Dailiang.*

Artist's seals:
Yu; Yan

Wang Yuyan (*zi* Dailiang) of Dantu (Zhenjiang) was the granddaughter of the distinguished scholar and poet Wang Wenzhi (1730-1802; see cat. no. 52). She and her husband Wang Yicheng were portrayed together in an unsigned hanging scroll, *Reading in the Private Studio*

One collector's seal.

M W

of Wang Yicheng, now in the collection of the Palace Museum.[4] This double portrait shows two young people seated in a book-filled garden studio, with a scroll open on the table before them. Above the painting her grandfather's friend Bao Zhizhong inscribed a poem that includes the lines "Before the precious mirror stand, myriad scrolls are displayed / Discussing poems and studying paintings, they pass their youth."[5]

On the mounting beside the painting Wang Wenzhi wrote a long poem that tells of his granddaughter's life and reveals the depth of his affection for her. As a child Wang Yuyan served at his side and displayed an enthusiasm for working with ink. Wang Wenzhi was very concerned about her betrothal, but evidently he was quite pleased with the young man chosen. He points out that his grandson-in-law's family had collected art for generations, and so he was naturally "addicted to" books and paintings.[6]

The intellectual compatibility of the couple was, of course, only one aspect of their match. As in all traditional arranged marriages, social and financial factors weighed heavily. Some of these have been discussed in a recent study by Lin Xiaoping.[7] Lin observes that Wang Wenzhi was never a wealthy man and had only a brief official career before retiring to earn his living through teaching. Wang Yicheng's economic background was probably quite different. His ancestry is difficult to investigate, but references in Wang Wenzhi's poetry indicate that his family lived in Yangzhou and were among the wealthy families who moved there from Anhui. Lin thinks that their money probably came from trade, rather than office holding. A rich, art-loving, salt merchant family of the same surname is mentioned in the *Yangzhou huafang lu* as having moved from Anhui to Yangzhou. The sons of this household were good at poetry and painting. If this was Wang Yicheng's background, then he brought money to the marriage; Wang Yuyan, in turn, brought the prestige of her scholarly heritage.

In his poem for *Reading in the Private Studio of Wang Yicheng*, Wang Wenzhi draws attention to his granddaughter's work as a painter. He states that she first sketched the *hui* orchids of the Xiang River and then gradually progressed to other flowers as well as grasses and insects. She received instruction from Pan Gongshou (1741-94), a famous Dantu master known for his depictions of landscapes, plants and flowers, Buddhist subjects, and beautiful women. According to other sources, Wang Yuyan also painted female figures.[8]

Pan Gongshou was Wang Wenzhi's good friend, and Wang frequently inscribed his paintings. One of these, a hanging scroll in the Palace Museum, is a portrait of Wang Yuyan seated at a garden table sketching orchids (fig. n).[9] Wang's inscription identifying Pan as the artist is dated 1790. Wang Yuyan could not have been very old in this year, but she is shown as a serious, mature individual. With her brush raised over the inkstone and a half-finished painting under her left hand, she seems to have stopped work only for a moment. This presentation was a clear tribute to her personality and achievements. The artist did not cast her in the old role of "beauty," but employed instead a formula developed to represent scholarly gentlemen: a reasonably well-characterized individual sits in a manicured garden, with objects for scholarly diversion at hand.

As a scholar-painter Wang Yuyan looked for models in the art of the past.

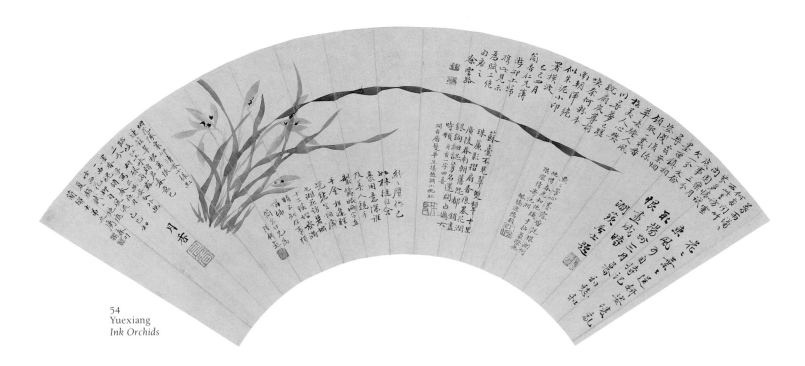

54
Yuexiang
Ink Orchids

In one instance, at her grandfather's command, she copied a Yuan-dynasty painting of sweet osmanthus, hibiscus, and white-headed birds to present to an elderly female relative on the occasion of her birthday.[10] Like Luo Qilan (cat. no. 52), Wang Yuyan was particularly inspired by the work of the late-Ming painter Wen Shu (cat. nos. 14-16), and presumably she and Luo were both influenced in this regard by the opinions of Wang Wenzhi, who wrote about one of Wen's handscrolls:

> Wen Duanrong's [Shu] plants and grasses are unlike those of the masters; they havetheir own style and flavor. One look and you know they are from the brush of a woman. [They are something that] not even an old master thoroughly versed in the principles of painting can achieve. My granddaughter Dailiang enjoys studying them, but she is only partially successful.[11]

The family's interest in Wen Shu is further reflected in a copy of a portrait of her by Wang Guichan, Wang Yuyan's younger sister. This painting also has a long inscription by Wang Wenzhi.[12]

Luo Qilan and Wang Yuyan certainly knew one another. According to one anecdote, when Luo saw a painting of Wang Yicheng done by Ding Yicheng in 1796, she found it unsatisfactory because Wang was shown seated without his wife.[13] Moreover, the orchid fans by Luo and Wang in the exhibition suggest an artistic relationship. Working in color, without outlines, both artists drew the attentuated leaves with fluctuating strokes and introduced elements of awkwardness and playfulness into their sweeping movements. Wang Yuyan twisted two leaves into a frame for a single flower in the middle of her composition and used another to underscore her poetic inscription. The color is in keeping with the report that she often painted orchids in a grass green.[14]

1. Translated by Irving Lo, who also provided the next two notes.
2. *Li sao*, the longest narrative poem of ancient China, found in *Chu ci* (*The Songs of the South*), whose putative author is Qu Yuan (4th-3rd c. BC), is generally regarded as an autobiographical, allegorical poem about the fate of the poet. The poem abounds in references to the flora and fauna of the Yangzi region, including the orchid, a symbol of integrity and purity.
3. Lingjun, mentioned in line 4 of *Li sao*, appears as the courtesy-name of the poet (translated by David Hawkes as "Divine Balance.")
4. Reproduced in Lin Xiaoping, "Wang Wenzhi yu *Wang Yicheng mizhai dushu tu*," *Dangdai meishu jia* (Sichuan Fine Arts Institute, Spring 1985), pp. 48-52.
5. Ibid., p. 48.
6. Ibid.
7. Ibid, pp. 49-50.
8. Yu, p. 69.
9. Lin Xiaoping finds the style of this work close to that of *Reading in the Private Studio of Wang Yicheng* and suggests that the latter may also be by Pan, or perhaps by one of his followers.
10. Shao Songnian, *Guyuan cuilu* (1903), 15:13a-b.
11. Wang Wenzhi, *Kuaiyu tang tiba* (Shanghai: Guangzhi shuju), 7:9-10.
12. *Yilin yuekan* (1930), no. 9, p. 2.
13. Lin Xiaoping, p. 51.
14. Yu, p. 69.

M W

54
Yuexiang

c. 1800
Ink Orchids
Ink on paper
Fan, 16.8 x 51 cm.
Chengxun tang Collection

Artist's inscription:
Yuexiang.

Artist's seal:
Yuexiang

A courtesan living in Yangzhou, Yuexiang studied painting with the Hangzhou poet, painter, and calligrapher Chen Hongshou (1768-1822). Yuexiang was noted for her ink orchids and once painted some with another Yangzhou courtesan, Moxiang. The well-known poet Chen Wenshu (1771-1843) wrote a poem for this work.[1]

Yuexiang's orchids, a traditional subject for courtesans, are indeed done in the style of her mentor. She shares with

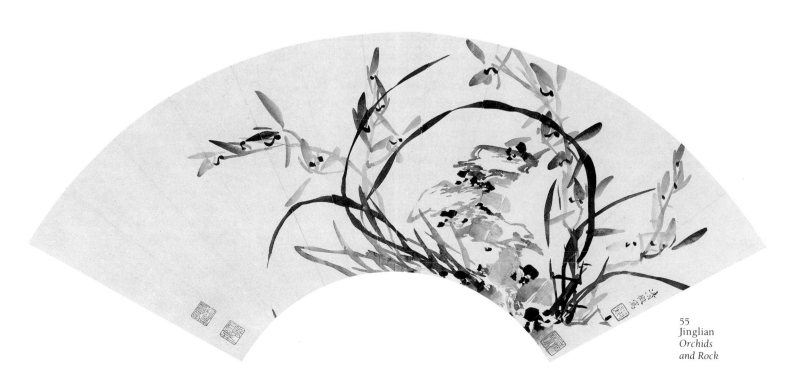

55
Jinglian
*Orchids
and Rock*

143

60
Liang Ruozhu
Butterflies

60
Liang Ruozhu
Active late 18th-early 19th century
Butterflies
Ink and colors on paper
Hanging scroll, 220 x 48 cm.
Wing Yuen Collection

Artist's inscription:
Made by Liang Ruozhu of Nanhai.

Artist's seals:
Ruo; Zhu

Liang Ruozhu (*hao* Jinjiang nüshi) was
a member of a large family of painters
from Nanhai, Guangdong. A painting by
her dated to 1796 in the Art Gallery,
Chinese University of Hong Kong, helps
to frame her active period from the late
eighteenth century to the early nine-
teenth century.[1] When she was young,
her father, Liang Yunqi, tutored her in
the art of painting, and she was known
for her skill in painting butterflies. She
would capture rare species of butterflies
and use the dried, pressed specimens for
copying to obtain true likenesses. Later
she also became known for her painting
of insects, shellfish, and birds. Liang
Ruozhu lived with her father in Guang-
zhou, and there was not one day that
passed without her admirers coming
with money to beg for her paintings.
Peng Renjie, a widower and the magis-
trate of Panyu, was one of those admir-
ers. After seeing her painting, he was so
overcome that he went directly to ask
for her hand in marriage, dispensing
with the matchmaker. After their mar-
riage, Peng was assigned to an official
post in northern China, and Liang
Ruozhu spent the rest of her life there. [2]

This hanging scroll of butterflies is a
fine example of Liang Ruozhu's meticu-
lous work. Utilizing the boneless paint-
ing method and coloring schemes of Yun
Shouping, Liang Ruozhu exercised a
high degree of control over the painted
elements. By clever placement of the
motifs, she set up a vivacious rhythm
across the picture surface.

1. This painting is catalogued in *Guangdong
shuhualu* (Hong Kong: The Art Gallery of the
Chinese University of Hong Kong, 1981), no. 244,
p. 120.
2. Liang Ruozhu's biography is included in
Shunde xianzhi, 29:16a; Wang Zhaoyong, *Lingnan
huazhenglüe* (Hong Kong, 1972), 12:3-4; Yu, pp.
908-9. See also Xie Wenyong, *Guangdong hua-
renlu* (Guangzhou, 1985), p. 189.

One collector's seal.

Bibliography: *Guangdong shuhualu* (Hong Kong:
The Art Gallery of the Chinese University of
Hong Kong, 1981), no. 244, p. 120; *Kwangtung
Painting* (Hong Kong: City Museum and Art Gal-
lery, 1973), p. 87.

CC

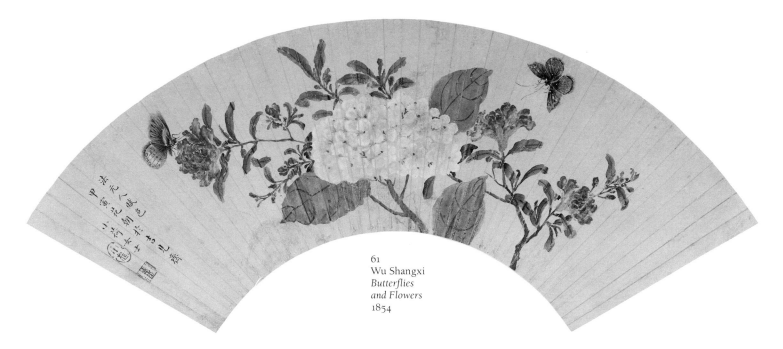

61
Wu Shangxi
*Butterflies
and Flowers*
1854

61

Wu Shangxi

Active mid-19th century
Butterflies and Flowers, 1854
Ink and colors on paper
Fan, 16.5 x 53.5 cm.
Chengxun tang Collection

Artist's inscription:
Color application in the method of the Yuan masters. [Painted] at Jijianzhai [Studio of Auspicious Views] on the birthday of the hundred flowers [huazhao, twelfth day of the second month] in the jiayin year [1854], the lady Xiaohe.

Artist's seals:
Xiaohe; Ye Wu Luqing

Wu Shangxi (*zi* Luqing, Xiaohe; *hao* Xiaohe nüshi) was the daughter of the famous Guangdong collector Wu Rongguang (1773-1843), a native of Nanhai. She had access to his fine collection of paintings and traveled with him extensively during the early part of his distinguished official career. Later she married Ye Yingqi, the son of another important Guangdong collector, Ye Menglong (1775-1832). Ye Yingqi's official career also enabled Wu Shangxi to travel to many parts of China. In a seal she carved for herself she claimed "to have traveled ten thousand miles on official tours following my father and accompanying my husband."

Her father indulged her with affection and attention. As a youth she was allowed to copy paintings by old masters. In flower-and-bird painting, she mastered the techniques of *shuanggou* (double outline) and *zhongcai* (repeated application of pigment) in the manner of Huang Quan (903-968). She also received some informal instruction from the Jiangsu flower-and-bird painter Song Guangbao, who was the teacher of Ju Chao (1811-65) and Ju Lian (1828-91). Her painting was known for its charming colors.

Wu Shangxi was also accomplished in poetry. Her literary works were collected in the *Xieyunlou ci* (Poetry from the Pavilion of Rhyme Writing). Her talents enabled her to announce proudly, "My life is not meant to be overshadowed by men." Indeed, Wu's fate removed her from the class of melancholy painters, male and female, that one normally encounters.[1]

In the centralized composition of this fan Wu employed the boneless method of painting, applying color in a charming fashion, with subtle nuances, particularly on the petals of the white blossoms. Despite the inscription, little in the painting can be connected to the works of the Yuan masters Wu was supposedly imitating. In essence, it is a candid statement that scarcely takes the folding fan format into consideration.

The second seal noted above incorporates her husband's family name, indicating that this painting was done after her marriage.

1. Wu Shangxi's biography is recorded in Wang Zhaoyong, *Lingnan huazhenglüe* (Hong Kong, 1972) 12:4; Yu, p. 287; Xie Wenyong, *Guangdong huarenlu* (Guangzhou, 1985), p. 85.

62

Wu Shangxi

Immortals' Feast of Gouling
Ink and colors on silk
Handscroll, 18 x 237 cm.
Art Gallery, The Chinese University of Hong Kong (82.92)

Artist's inscription:
The Immortals' Feast of Gouling after a work by Nantian caoyi [Yun Shouping] for presentation to the old master Ligu as an elegant pastime. Luqing, Wu Xiaohe.

Artist's seals:
Luqing; Wu Xiaohe yin

Wu Shangxi gave the title *Immortals' Feast of Gouling* to this scroll of fruits and vegetables. *Gouling*, also known as *Goushishan*, is a mountain situated to the south of Yenshi prefecture in Henan. It was sanctified by a legend of a prince of the Jin dynasty (266-420), who became an immortal as he rose from the peak of Gouling, riding on a white crane, and bade farewell to his earthbound companions.

Fruits and vegetables appeared in Chinese painting at an early date. The cabbage, portrayed alone for its simplicity and earthy quality, appears in many Song-dynasty paintings. An early example of a grandiose presentation of an array of vegetables in a horizontal scroll format is the painting by Muqi (c. 1225-

CC

理谷老翁清玩　縹嶺傈餐　　
祿御吳峅荷　擬南田草衣本　
　　　　　　即呈

62 Wu Shangxi, *Immortals' Feast of Gouling*, section

70) in the collection of the Palace Museum in Beijing. It would be reasonable to assume that this type of presentation appeared just a little later than the "hundred flowers" presented in the same manner. From the Song dynasty on, examples of scroll paintings of "hundred vegetables" and "hundred flowers" by many major masters of flower painting have survived, including works by Shen Zhou, Chen Chun, Xu Wei, Shitao, Yun Shouping, and the Yangzhou masters.

This composition is unlike those in which the floral or vegetable motifs extend beyond the upper and lower borders of the picture, implying expansive space. The parade of vegetables is carefully confined to the middle section of the handscroll. While the vegetables relate to one another in a visually compact sequence, there are intermittent breaks to provide visual relief. Overlapping elements fall into neat groups. As soon as the scroll is unrolled, the composition picks up a steady tempo, and it ends as dramatically as it starts. With the fruits and vegetables placed on a neutral ground, the visual tension is sustained in a steady progression. Wu Shangxi

consciously and successfully animated each of her subjects.

Using a combination of *shuanggou* and *mogu* techniques, together with a vivid color scheme, Wu Shangxi has orchestrated a vegetarian feast palatable to the most discriminating immortals.

This scroll bears a colophon by the Guangdong painter Zhang Guchu (1890-1968) which gives an account of the painting:

> For generations Zhu Ligu's family has lived in Gaodijie in Suiheng. He excelled in connoisseurship and had a large collection. He was friendly with Huang Yunchao, Ye Yungu (Ye Menglong), Xie Lansheng (1759-1831) and Wu Hewu (Wu Rongguang). Lansheng and Hewu used to authenticate and inscribe paintings by famous masters in Zhu's collection. Therefore paintings that had been in his collection can be traced. This scroll of the Immortals' Feast of Gouling was painted by Hewu's daughter, Madam Xiaohe, for Ligu. Madam Xiaohe had received some instruction from Song Outang (Song Guangbao) on the method of painting and coloring. The fragrance of her rouge and the glow of her powder survive in her paintings for generations, and are earnestly treasured and protected. Written on a spring morning in the year *jihai* [1959] as instructed by [Li] Rongsen. Inscribed by Shenzhai Zhang Hong.[1]

The placement of the seals at the beginning and the end of the scroll suggest that the paper has been trimmed at both ends.

1. *Wenwuguan jixun* (Hong Kong: The Art Gallery, Chinese University of Hong Kong), *juan* 3, 4:9.

Two collector's seals.

63
Wu Shangxi
Peony after Yun Shouping
Ink and colors on paper
Fan, 17 x 52.5 cm.
Chengxun tang Collection

Artist's inscription:
Emulating the color application of Ouxiangguan [Yun Shouping]. Painted by the lady Xiaohe, Wu Luqing.

Artist's seals:
Xiaohe nüshi; Wu shi shuhua

Painted on sized gold-flecked paper, the boneless flowers appear light and delicate and seem transparent. Unlike the other two paintings by Wu Shangxi in the exhibition, which have frontal and central presentations, the arrangement of the floral motif in this painting accords with the format of the folding fan. The curve of the long stem, which extends from the lower left corner of the fan, echoes the upper and lower edges of the fan itself. In this regard, the painting is compositionally akin to the works of Yun Shouping.

CC

CC

64

Yu Ling
Mid-19th century
Three Drunken Men
Ink and colors on paper
Hanging scroll, 95.1 x 47.6 cm.
Leal Senado/Luis de Camoes Museum,
Macau (A111)

Artist's inscription:
Painted by the lady Jingxiang, Yu Ling.

Artist's seal:
Jingxiang

Yu Ling (*zi* Jingxiang) was active during the Daoguang period (1821-50). She was the concubine of the famous Guangdong painter Su Liupeng (c. 1814-60). Noted for her figure paintings with intricate details, she was also capable of executing works of immense size. She and the concubine of Liang Xianting were lauded by contemporary poets as the "beautiful ink grinders" who kept company with their professional-painter husbands:

> The two lofty scholars, clad in plain cloth all their lives, never complained of the poverty they had to suffer. Who would ever realize that it was because the companions who held the inkstones beside their painting desks were as beautiful as flowers?[1]

On a painting of a drunken immortal done for Liang Xianting (in the collec-tion of the Art Gallery of the Chinese University of Hong Kong), Liang commented that Yu Ling was well versed in the figure style of the Ming master Tang Yin. Although Yu Ling may have acquired a lot of her painting skill from Su Liupeng, some said that Yu Ling's use of the brush and ink was superior to his.[2] She was, in any case, able to command a position as an independent artist.

The painting in the exhibition depicts men drinking. Famous drinking personalities in Chinese history include Liu Ling, one of the Seven Sages of the Bamboo Grove of the Jin dynasty (266-420), and the Tang poet Li Bai (701-762), who, according to legend, while intoxicated, tried to catch the moon reflected in the water and drowned. A drunken personality popular in Shiwan pottery figures is Bi Zhuo, also of the Jin dynasty, a high official who stole wine from a neighbor.[3] Liu Ling is often depicted as a thin man, Li Bai in official attire, and Bi Zhuo as a fat person. There is, however, no iconographic evidence to identify the three figures in Yu Ling's scroll, so this could be just a common drinking scene.

Apparently, drinking men was also a favorite subject of Su Liupeng. There are two paintings of a similar subject by Su in the collection of the Luis de Camoes Museum. Both are horizontal scrolls; one is dated 1838,[4] and the other was done in 1854.[5] The earlier painting shows two drinking friends and a young attendant and is accompanied by an inscription of the "The Drinking Song" by Li Bai. However, there is no distinguishing feature to identify the drinking friends. The later painting, *Three Drunk-en Men*, is a finger painting showing a scholar in a tall hat, a monk, and an old man. It can be deduced that this group is composed of the three famous Song-dynasty literati: Su Shi (1037-1101) in his tall hat, the monk Foyin (act. c. 1183), and the calligrapher and poet Huang Tingjian (1045-1105).

The wine jar with the keyfret band, wide belly, and ladle in Yu Ling's scroll is the same as the one in Su's 1854 painting, and it is likely that his work served as her model. Yu Ling, however, used a simpler descriptive method in the drapery and facial features of her men, and her figures placed in a zigzag diagonal arrangement, one with his back turned, create a more dynamic group than the figures in Su Liupeng's paintings, which either frontally or partially face the viewer.

1. Wang Zhaoyong, *Lingnan huazhenglüe* (Hong Kong, 1972), 12:8; Yu, p. 265; Xie Wenyong, *Guangdong huarenlu* (Guangzhou, 1985), p. 56.

2. *Guangdong shuhua lu* (Hong Kong: The Art Gallery, Chinese University of Hong Kong, 1973), nos. 483, 484.

3. *History, Lore and Legend* (Hong Kong: Hong Kong Museum of Art, 1968), pp. 184, 517.

4. *Kwangtung Painting* (Hong Kong: Hong Kong City Museum and Art Gallery, 1974), p. 190.

5. Helen Chan, *A Catalogue of Chinese Paintings in the Luis de Camoes Museum* (Macau, 1975), pl. 27.

CC

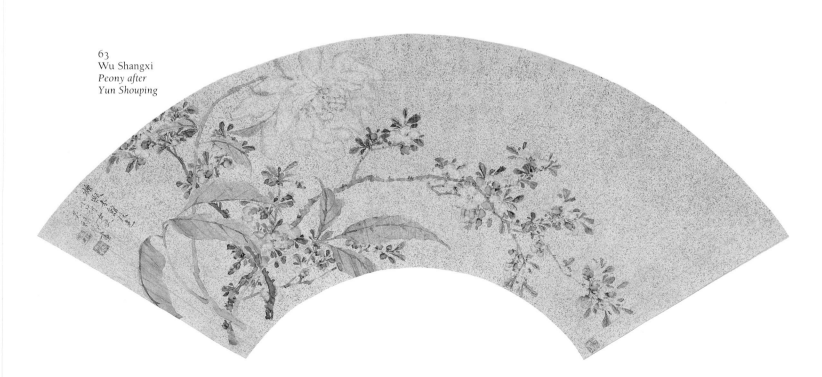

63
Wu Shangxi
*Peony after
Yun Shouping*

posed at this springtime gathering of poets became a calligraphic masterpiece.

The Rens present an original and much less formal depiction of the geese story. Wang is given one of the Ren's stock facial types — a ski-jump nose in a concave face; a rounded, jutting jaw; and an elongated skull. Paunchy and slightly hunched, he grandly peers from a safe height at the fowl barely visible below the stone-slab bridge. Meanwhile, his excited servant can hardly contain his curiosity. As often happens in paintings by the Rens and others in nineteenth-century Shanghai, the objects of attention are often treated in a whimsical fashion. Here the geese are partially hidden behind the trees and the stone slabs. Another characteristic of the art of the Rens is the placement of tall trees to one side of the composition.

1. Yang Yi, *Haishang molin* (1920; reprint Taipei: Wenshiji, 1975), 1st supplement, no. 640; Zhang Mingke, *Hansong ge tanyi suolu* (Shanghai: Wenming, 1936), 6:11b; Yu, p. 186; Gong Chanxing, *Ren Bonian yanjiu* (Tianjin: Renmin meishu, 1962), pp. 2, 18.

EJL

78
Ren Xia
Cat on a Rock Beneath Banana Palms, 1904
Ink and color on paper
Hanging scroll, 102.5 x 55.4 cm.
Harold Wong Collection

Artist's inscription:
Done in Shanghai by Ren Xia, Yuhua, of Shanyin, in the fourth month of the jiachen *year of the Guangxu reign* [1904].

Artist's seal:
Yuhua

The distinctly expressive face of this black-tailed cat seated on a rock is typical of the individualized treatment accorded animals by nineteenth-century Shanghai painters. The Four Rens in particular delighted in picturing surly pheasants, quizzical ducks, or angry birds. One of Ren Bonian's animal depictions shows a rather defensive-looking black-tailed cat seated on a rock below wisteria.[1]

1. Reproduced in Ho Kung-shang, *Haishang huapai, Masters of the Shanghai School* (Taipei: Art Book Co., 1985), pl. 38.

EJL

77
Ren Xia
*Wang Xizhi
Watching Geese*
1896
(detail at left)

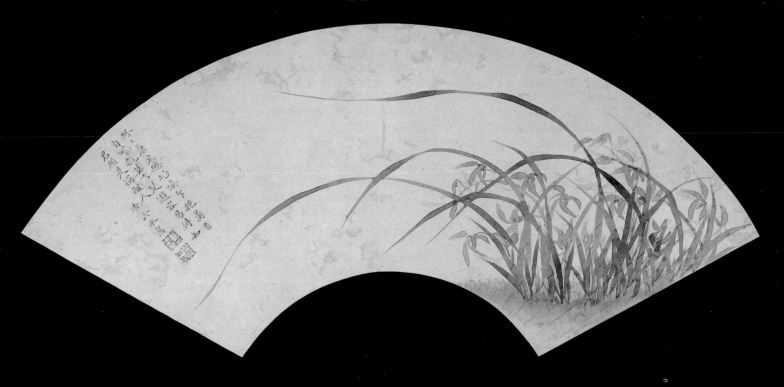

scroll? Lan-ch'ien-shan-guan Collection. Suzuki S 4-015.

____ Outline bamboo and rock. Hanging scroll. N. P. Wong Collection, Hong Kong. Suzuki S 10-008.

____ Landscape. Hanging scroll. Private collection, Hong Kong.

____ Rock and bamboo. Handscroll. Kyoto National Museum. Suzuki JM 11-045.

____ Orchids. Album leaf or hanging scroll. Kunizō Agata Collection. Suzuki JP 8-010.

____ Bamboo and rocks. Handscroll. Ogawa Collection, Kyoto. Cahill, p. 295.

____ Bamboo and rock. Album leaf. National Museum, Stockholm. Suzuki E 20-78.

____ A bamboo grove in mist. Handscroll. Yale University Art Gallery. *2

____ Landscapes with bamboo. 12 leaf album. Freer Gallery (11.501a-1). Cahill, p. 295.

____ Bamboo growing by a garden rock. Seattle Art Museum. Cahill, p. 295.

____ Bamboo and rock. C. C. Wang Collection, New York. Cahill, p. 295.

____ Bamboo. Handscroll. Formerly Frank Caro, New York. Cahill, p. 295.

____ Early snow at Wujiang. Hanging scroll. Zhongguo minghua 27.

____ A man in an open pavilion on a river shore among bamboo. Double album leaf. Zhongguo ming hua 2.

____ Three figures in boat near wooded shore. With Zhao Mengfu. Handscroll. Toso 139.

____ Orchid and rocks. Hanging scroll. Shina nanga taisei suppl. 4:5.

Huang Guolan. Early 19th c.

1827 Garden of the Chin family. Hanging scroll. Art Gallery, The Chinese University of Hong Kong. Guangdong shuhua lu 299.

____ Landscape. Ju Ping An Guan Collection. Guangdong mingjia 48.

Huang Yuanjie. Mid-17th c.

1639 Landscape. Hanging scroll. Zhongguo minghua 15:2.

1651 Landscape. Handscroll. Tianjin I, 48. *fig. d.

1656 Landscape. Hanging scroll. Shanghai Museum. Zhongguo mulu III, 1-2374.

____ Landscape. Fan. Palace Museum, Beijing. Zhongguo mulu II, 1-3603.

____ Landscape. Fan. Palace Museum, Beijing. Zhongguo mulu & Zhongguo tumu II, 1-3604.

Jiang Jixi. Late 17th-mid 18th c.

1693 Peonies. Fan. Chengxun tang Collection, Hong Kong. *38

____ Flowers and fruit. 12 leaf album. Head Store of China Antique Store. Zhongguo mulu I, 9-134.

Jiang Shu. 18th c.

1727 Lingzhi and Bamboo. 6 leaf album. Shanghai Museum. Zhongguo mulu III, 1-3843.

____ Flowers. Album. Palace Museum, Beijing.

Jin Liying. 1772-1807.

1800 Copy of a portrait of Li Qingzhao. Hanging scroll. Palace Museum, Beijing. Zhongguo mulu II, 1-6269.

1801 Birds and plum blossoms under the moon. Hanging scroll. Shanghai Museum. Zhongguo mulu III, 1-4361.

1806 Birds and willow. Hanging scroll. Shanghai Museum. Zhongguo mulu III, 1-4362.

____ Plum blossoms in a vase, teapot and bowl of sprouts. Bomei ji.

____ Portrait of Luzhu. Hanging scroll. Zhongguo lidai renwu, p. 193.

____ Hibiscus, after a Yuan master. Hanging scroll. Contag and Wang, p. 203.

Jin Yue. 17th c.

1675 *Wuduan tu*. With Cai Han. Nanjing Museum. Yu Jianhua, *Zhongguo meishujia renming cidian* (Shanghai: Renmin meishu chuban she 1981), p. 554.

(1691 Rock and *lingzhi*. By a concubine of Mao Xiang, probably Jin Yue. Hanging scroll. Private collection.) *35

____ Landscape in the style of Mi Fei. Hanging scroll. Jean-Pierre Dubosc, *Great Chinese Painters of the Ming and Ch'ing Dynasties* (New York: Wildenstein & Co., 1949), no. 75.

____ Birds, chrysanthemums and flowering tree. With Cai Han. Hanging scroll. Shanghai Museum.

____ Birds and flowers, fish and insects. 10 leaf album. Shanghai Museum. Zhongguo mulu III, 1-2602.

____ Birds and flowers. Hanging scroll. Shanghai Museum. Zhongguo mulu III, 1-2603.

____ Autumn flowers and butterflies. With Cai Han. Hanging scroll. Shanghai Museum. Zhongguo mulu III, 1-2604.

____ Autumn smartweed and butterflies. With Cai Han. Hanging scroll. Shanghai Museum. Zhongguo mulu III, 1-2605.

____ Autumn flowers and bird. With Cai Han. Hanging scroll. Shanghai Museum. Zhongguo mulu III, 1-2606.

____ Cat watching a butterfly. With Cai Han. Hanging scroll. British Museum. Shina nanga shusei I, 8:8; Shenzhou guoguang ji 18; Suzuki E 15-142.

____ The hundred flowers. Handscroll. Occidental College Library, Special Collections Department. *34

____ Birds and flowers. Hanging scroll. Zhongguo minghua 15:4.

____ Autumn flowers and butterflies. With Cai Han. Hanging scroll. Gems I, 55.

Jinglian. First half of the 19th c.

____ Orchid, bamboo and stone. Hanging scroll. Zhongguo minghua 15:9.

____ Orchids and rock. Fan. Chengxun tang Collection, Hong Kong. *55

Ju Qing. 19th c.

1859 Flowers. Hanging scroll. Art Gallery, The Chinese University of Hong Kong. Guangdong shuhua lu 673.

1863 Roses. Folding fan. Lei Collection. Guangdong mingjia 51.

____ Spring flowers in full bloom. Fan. Ju Ping An Guan Collection. Guangdong mingjia 51.

____ Peony. Fan, mounted with a fan by Ju Chao

in a hanging scroll. Art Gallery, The Chinese University of Hong Kong. Guangdong shuhua lu 676. *67

____ Two beautiful ladies: lady with willow, lady with fan. 2 album leaves. Art Gallery, The Chinese University of Hong Kong. Guangdong shuhua lu 674, 675. *69

____ Butterflies and peonies. Hanging scroll. Leal Senado/Museu Luis de Camoes, Macau (A42). *68

Kong Suying. Qing dynasty.
____ Landscape. Album. Palace Museum, Beijing.

Li Jue. 19th c.
1869 Landscape. Fan. Private collection, Hong Kong.

Li Yin. 1616-85.
1633 Wild geese among reeds. Nanju 18.
1634 Flowers and birds. Handscroll. Shanghai Museum. Zhongguo mulu III, 1-2543.
1642 Flowers and birds. Handscroll. Palace Museum, Beijing. Zhongguo mulu II, 1-3724.
1648 Flowers and birds. Hanging scroll. Contag and Wang, p. 151.
1649 Pine and eagle. Hanging scroll. Palace Museum, Beijing. Zhongguo mulu II, 1-3725.
1649 Flowers of the four seasons. Handscroll. Private collection, Honolulu. *24
1654 Rock, bird, and pear blossoms. Fan. Mr. & Mrs. J. P. Dubosc Collection. *26
1659 Pine and eagle. Hanging scroll. Palace Museum, Beijing. Zhongguo mulu & Zhongguo tumu II, 1-3726.
1660 Birds and flowers. 4 panels. Shanghai Museum. Zhongguo mulu III, 1-2544.
1665 Chrysanthemums, rock, and calling bird. Hanging scroll. *Yiyuan duoying* 35 (April, 1987), p. 31.
1668 Eagle on pine branch. Hanging scroll. Private collection, Japan.
1668 Two birds on a branch of blossoming plum. Hanging scroll. Yūji Eda Collection. Suzuki JP 14-075.
1669 Hibiscus and mandarin Ducks. Hanging scroll. Shanghai Museum. Zhongguo mulu III, 1-2545.
1670 Hibiscus and mandarin ducks. Hanging scroll. Shanghai Museum. Zhongguo mulu III, 1-2546.
1670 Flowers and birds. Handscroll. Palace Museum, Beijing. Zhongguo mulu II, 1-3727.
1670 Eagle on a pine branch. Hanging scroll. Private collection, Japan.
1671 Magpie on willow. Hanging scroll. Palace Museum, Beijing. Zhongguo mulu II, 1-3628.
1672 Pine and eagle. Hanging scroll. Palace Museum, Beijing Zhongguo mulu II, 1-3729.
1673 Mynah and pomegranate. Hanging scroll. Palace Museum, Beijing. Zhongguo mulu II, 1-3730.
1673 Swallows and peonies. Hanging scroll. Private collection, Japan. *27
1675 Birds on plum branches. Fan. Christie's, June 29, 1984, no. 789.
1677 Hibiscus and water birds. Hanging scroll.

Shanghai Museum. Zhongguo mulu III, 1-2547.
1678 Lotus and egret. Hanging scroll. Shanghai Museum. Zhongguo mulu III, 1-2548.
1678 Flowers and birds. Screen, 12 sections. Palace Museum, Beijing. Zhongguo mulu II, 1-3731.
1679 Egret (?) in water under flowers and grasses. Hanging scroll. Private collection, Japan.
1680 Two birds on branches. Hanging scroll. Taitsu Hashimoto Collection. Suzuki JP 30-117.
1681 Lotus and mandarin ducks. Nanjing Museum. Nanjing 1:91.
1682 Birds and flowers. Handscroll. Shanghai Museum. Zhongguo mulu III, 1-2549.
____ Lotus flowers. Hanging scroll. Palace Museum, Beijing. Zhongguo mulu II, 1-3732.
____ Lotus flowers and mandarin ducks. Hanging scroll. Palace Museum, Beijing. Zhongguo mulu & Zhongguo tumu II, 1-3733.
____ Flowers. Fan. Palace Museum, Beijing. Zhongguo mulu & Zhongguo tumu II, 1-3734.
____ Camellia. Shanghai Museum. Zhongguo mulu III, 1-2550.
____ Peonies. Hanging scroll. Private collection, Japan.
____ Yellow hibiscus. Fan. Chengxun tang Collection, Hong Kong. *25
____ Mandarin ducks and flowers. Private collection, Oakland.
____ Squirrel. Fan. Christie's, N.Y., June 23, 24, 28, 1982.
____ Autumn lotus & crab. Fan. Christie's, June 29, 1984, no. 789.

Liang Ruozhu. Late 18th–early 19th c.
1796 Cat watching butterflies. Hanging scroll. Chinese University of Hong Kong. Guangdong shuhua lu 244.
____ Butterflies. Hanging scroll. Private collection, Los Angeles.
____ Butterflies. Hanging scroll. Wing Yuen Collection. *60

Liao Yunjin. Late 18th–early 19th c.
1801 Flowers and butterflies. Fan. Palace Museum, Beijing. Zhongguo mulu & Zhongguo tumu II, 1-6256.
____ Flowers and birds. 10 leaf album. Shanghai Museum. Zhongguo mulu III, 1-4242.
____ Lotus and egret. Hanging scroll. Shanghai Museum. Zhongguo mulu III, 1-4243.
____ Flowers and butterflies. 2 album leaves. Zhongguo minghua 15:11.

Lin Xue. First half of the 17th c.
1620 Landscape. Fan. Mr. & Mrs. J.P. Dubosc Collection. *18
1621 Landscape. Hanging scroll. Shanghai Museum.
1621 Landscape. Hanging scroll. Shanghai Museum. Zhongguo mulu III, 1-1714.
1621 A slender plum tree in bloom, two small bamboo. Private collection, Paris. Sirén VII, p. 210.
1627 Landscape. Album. Yilin. Yu Jianhua, ed., *Zhongguo meishujia renming cidian* (Shanghai: Renmin meishu chubanshe, 1980), p. 523.

1642 Landscape. Fan. Chengxun tang Collection, Hong Kong. *19

_____ Guanyin over the waves. Hanging scroll. Lichao minghua Guanyin.

_____ Wild geese and marsh. Hanging scroll. Freer Gallery (19.180). Suzuki A 21-175. *fig. f.

_____ Landscape after Huang Gongwang. Fan. Museum für Ostasiastische Kunst, Cologne. *20

Liu Shi. 1618-64.

_____ Willows on a moonlit embankment. Handscroll. Palace Museum, Beijing. Zhongguo mulu I, 1-4044; Tianjin I, 46-47. *fig. g

_____ Bird on a branch of blossoming magnolia. Album leaf. Shenzhou guoguang ji 5.

_____ Ladies on a terrace, after Li Gonglin. Hanging scroll. Sogen 356.

_____ Landscapes with figures. 8 leaf album. Mr. & Mrs. J. P. Dubosc Collection. *23

Lu Danrong. Qing dynasty.

_____ Portrait of Lady Han, mother of Yuan Tingtao (1764-1810). Hanging scroll. Ming Qing renwu xiaoxiang 52.

Lu Yuansu. 18th c.

_____ Red orchids. Album. Contag and Wang, p. 464.

Luo Fangshu. 18th c.

_____ Plum blossoms. 6 leaf album. Shanghai Museum. Zhongguo mulu III, 1-4358.

_____ Plum blossoms. Album. Contag and Wang, p. 492-93.

Luo Guifen. Late 19th c.

_____ Flowers and butterfly. Fan. Museum of Fine Arts, Boston. *59

Luo Qilan. Late 18th c.

1795 Peonies. Hanging scroll. Palace Museum, Beijing. Zhongguo mulu II, 1-6074.

1799 Plum blossoms. Hanging scroll. Palace Museum, Beijing. Zhongguo mulu II, 1-6075.

1800 Landscape, orchids and bamboo. Album leaf. Palace Museum, Beijing. Zhongguo mulu I, 1-137.

_____ Three-blossom flower. Hanging scroll. Palace Museum, Beijing. Zhongguo mulu II, 1-6076.

_____ Orchids, after Yun Shouping. Fan. Chengxun tang Collection, Hong Kong. *52

_____ Three-blossom peony. Handscroll. Sotheby's, June 2, 1987, no. 95.

Ma Quan. 18th c.

1706 Fragrance of the vegetables of the four seasons. Handscroll. Contag and Wang, p. 254.

1711 Flowers in a vase. Hanging scroll. Shenzhou guoguang ji 12.

1714 Two birds on a branch of wisteria. Hanging scroll. Taitsu Hashimoto Collection. Hashimoto 115; Suzuki JP 30-124.

1714 Flowers of the four seasons. Handscroll. Shanghai Museum. Zhongguo mulu III, 1-3835.

1714 Flowers. Art Gallery of Greater Victoria.

1723 Grasses, insects, flowers and plants. Fan. Palace Museum, Beijing. Zhongguo mulu & Zhongguo tumu II, 1-5568.

1723 Flowers and insects, after Song masters. Handscroll. Private collection, Honolulu. *45

1724 Bird on a branch watching fish below. Hanging scroll. Zhang Yunzhong Collection. Suzuki JP 7-034.

1726 Chrysanthemums [after Xu Chongsi]. Hanging scroll. Náprstek Museum of Asian, African and American Cultures, Prague (A 1.771). *46

1726 Lotus flowers, after Yun Shouping. Hanging scroll. Chugoku 8.

1731 Flowers on a river bank. Hanging scroll. Private collection, Japan. Suzuki JP 12-123; Shincho 88.

1734 Fifth day of the fifth month. Hanging scroll. Shanghai Museum. Zhongguo mulu III, 1-3836.

1736 Peonies and peach blossoms. Hanging scroll. Nanjing Museum. Nanjing 2:117.

1739 Flowers and birds. Handscroll. Palace Museum, Beijing. Zhongguo mulu II, 1-5569.

1742 Flowers and insects, after a Song fan. Hanging scroll. Private collection, Honolulu. Christie's, June 29, 1984, no. 840.

1744 Peach blossoms and swallows. Hanging scroll. Zhou Huaimin Collection. Yiyuan duoying 23:48.

1747 Flowers and birds. Hanging scroll. Contag and Wang, p. 676.

1753 Lotus, after Xu Chongsi. Hanging scroll. Private collection, Hanford, California.

1755 Cypress, wisteria and parrot. Hanging scroll. Shanghai Museum.

1758 Chrysanthemums and insects, after Yun Shouping. Hanging scroll. Private collection, Virginia.

1762 Two kittens on a garden rock amid huge peonies. Hanging scroll. Seiichi Honde Collection, Kyoto National Museum. Suzuki JP 60-001.

1762 A pine forest. Hanging scroll. Shenzhou guoguang ji 6.

_____ Flowers. Album. Head Store of China Antique Store. Zhongguo mulu I, 9-148.

_____ Flowers and birds. Album leaf. Beijing Branch of the Import and Export Company of Arts and Crafts. Zhongguo mulu I, 10-080.

_____ Wicker basket of flowers. Fan. In an album of fans by women painters. National Palace Museum, Taipei.

_____ Chrysanthemums and insects. Hanging scroll. Urban Council, Hong Kong Museum of Art. *47

_____ Begonias, asters and butterflies. Fan. Chengxun tang Collection, Hong Kong. *49

_____ Flowers and insects, after Ye Xiaoluan. 8 leaf album. Tingsong Shuwu collection, Hong Kong. *50

_____ Two birds in a landscape with pine, rocks and flowers, after Xu Chongsi. Hanging scroll. Shigeki Kaizuka Collection. Suzuki JP 42-027.

_____ Lotus and flowers. Hanging scroll. Nelson Gallery, Kansas City. Suzuki A 28-73.

_____ Flowers and butterflies. Handscroll. The Metropolitan Museum of Art (47.16.116). *48

_____ Rock, poppies and birds. Hanging scroll. Asian Art Museum of San Francisco.

_____ Plum blossoms. Hanging scroll. Contag and Wang, p.254.

_____ 5th of the 5th lunar month scene. Hanging scroll. Contag and Wang, p. 254.

_____ Butterfly and flowers. Fan mounted as a hanging scroll. Formerly Sumitomo collection. Sotheby's, December 18, 1980, no. 33.

_____ Flowers and insects. Hanging scroll. Sotheby's, January 25-26, 1978, no. 184.

_____ Eagle in a pine tree. Mingren shuhua 4.

_____ A cat catching a butterfly by a rockery with blossoming plants. Signed. Compagnie de la Chine, Paris. Sirén VII, p. 383.

_____ The three beauties of the sixth month: lotus, gardenia and cymbidium. Sirén VII, p.383.

_____ Hundred cranes along the shore with blossoming trees. Handscroll. O. Kamiki, Japan. Sirén VII, p.383.

Ma Shiban. Born 1777.
_____ Fishing by snowy banks. Handscroll. Suzhou 93-94.

Ma Shouzhen. 1548-1604.
1563 Orchid, bamboo and rock. Hanging scroll. Private collection. *4

1566 Colored fungus, orchids, bamboo and rocks. Handscroll. CEMAC Ltd. Collection. *8

1572 Bamboo, rock and outline orchid. Handscroll. Harold Wong Collection, Hong Kong.

1572 Orchid and rock. Hanging scroll. The Metropolitan Museum of Art (1982.1.7). *5

1573 Orchids and rocks. Hanging scroll. Christies, Dec. 11, 1987, no. 4.

1575 Orchids. Hanging scroll. Princeton University (L68.85).

1576 Boating by a cliff. Mounted together with her portrait. Handscroll. Tokyo National Museum. *6

1576 Orchids and rock. Handscroll. Mounted together with handscroll of colored orchids dated 1566. CEMAC Ltd. Collection.

1589 Orchid and bamboo. Fan. Shanghai. Shanmian hua 30.

1590 Orchids and rocks. Fan. Shanghai Museum.

1592 Colored orchids. Hanging scroll. Kurokawa Institute of Ancient Cultures. *7

1596 Orchids, bamboo and stone. Fan. Yuji Eda collection, Tokyo. Suzuki JP 14-187-12.

1599 Orchid. Album leaf. Xu Bozhai collection. Yiyuan duoying 31, p. 8.

1599 Orchid, bamboo and rock. Hanging scroll. Anonymous loan, The Art Museum, Princeton University. Suzuki A 18-046. John Hay, _Kernels of Energy, Bones of Earth_ (New York, 1985), p. 116.

1600 Orchids and Rock. Fan. Manpukuji Temple. Suzuki JT 178-011-13.

1601 Flowers. Handscroll. Shanghai Museum.

1601 Rock, bamboo and orchids. Fan. Private collection, Hong Kong.

1603 Bamboo, orchid and rock. Hanging scroll. Private collection, Japan.

1603 Orchid. Hanging scroll. Private collection, Vancouver, B.C.

1604 Orchids, bamboo, _lingzhi_ and rocks. Handscroll. Palace Museum, Beijing. Zhongguo mulu II, 1-2086.

1604 Two kinds of orchids. Handscroll. Mounted together with work signed Xue Susu (Xue Wu). Shanghai Museum. Zhongguo mulu III, 1-1263.

1604 Colored fungus, orchids, bamboo and rocks. Handscroll. Indianapolis Museum of Art (60.25). *9

1604 Orchids and bamboo by a rockery. Shina nanga taikan 6.

1604 Orchids and plants. Handscroll. Rong Geng, comp. _Fulu shuhua lu_ (Catalogue of the collection of Chen Handi; 1936), 3.

1605(!) Orchids and bamboo, after Zhao Mengjian. Hanging scroll. Shenzhou daguan 9.

1612(!) Orchids and bamboo. Handscroll. Bunjin gasen 2:5.

_____ Copy of Guan Daosheng's "Three Friends." Hanging scroll. Palace Museum, Beijing. Zhongguo mulu II, 1-2087.

_____ Orchids and rock(s). Fan. Palace Museum, Beijing. Zhongguo mulu & Zhongguo tumu II, 1-2088.

_____ Orchids, in outline technique. Handscroll. National Palace Museum, Taipei. Gugong shuhua lu 8:46.

_____ Orchid and rock. Outline technique. Album leaf. National Palace Museum, Taipei.

_____ Ink orchids. Fan. In album of fans by women painters. National Palace Museum, Taipei.

_____ Bamboo, orchids and rock. Handscroll. Private collection, Hong Kong.

_____ Landscapes and orchids. 6 album leaves. Private collection, London.

_____ Lotus in late summer. Hanging scroll. National Museum, Stockholm. Sirén VI 325b; Suzuki E 20-013.

_____ Orchids and bamboo. Album leaf. Freer (11.163r).

_____ _Lingzhi_, orchids and bamboo. Album leaf. Shenzhou guoguang ji 11.

_____ Orchids, bamboo and rocks. Fan. Shanmian hua 30.

_____ Orchids, bamboo by a stone. Hanging scroll. Zhongguo minghua 15:8.

_____ Orchid and bamboo. Hanging scroll. Zhongguo minghua 9:5.

_____ Orchid and bamboo. Zhongguo minghua ji 2:60.

_____ Flowers and butterflies. Fan. Gugong zhoukan 21:106.

_____ Orchid and bamboo. Gugong zhoukan 14:302.

_____ Narcissi. Handscroll. Toso 211.

Mao Yuyuan.. 17th c.
1651 Orchids and flowers. Fan. Chengxun tang Collection, Hong Kong. *28

Mao Zhou. Qing dynasty.
_____ Flowers and butterflies. Fan. Palace Museum, Beijing.

_____ Peonies. 12 leaf album. Beijing Antique Store. Zhongguo mulu I & Zhongguo tulu I, 12-334.

_____ Chrysanthemums. Hanging scroll. Sotheby's, March 16, 17, 1984, no. 36.

Miao Jiahui. 19th c.
1902 Lotus and insects. Fan. Dr. S. Y. Yip Collection, Hong Kong. *74

Wen Xin. Qing dynasty.

____ Landscape. Hanging scroll. Chinese University of Hong Kong. Guangdong shuhua lu 290.

Wu Guichen. 19th c.

1830 Peony flowers after Yun Shouping. Sirén VII, p.446.

____ Flowers. Fan. Palace Museum, Beijing.

____ Flowers. Hanging scroll. Shanghai Museum. Zhongguo mulu III, 1-4283.

____ A plum tree after Zhao Mengjian. Bomei ji.

____ Flowers and rock. Hanging scroll. Sotheby's, June 13, 1984.

Wu Shangxi. 19th century.

1854 Butterflies and flowers. Fan. Chengxun tang Collection, Hong Kong. *61

____ Flower. Fan. *Baiyuntang* (Huang Junbi Collection, Taipei) II, 141.

____ Immortals' Feast of Gouling (fruit and vegetables). Handscroll. Art Gallery, The Chinese University of Hong Kong. *62

____ Peony, after Yun Shouping. Fan. Chengxun tang Collection, Hong Kong. *63

Wu Shujuan. 1853-1930.

1880 Silkworms and peonies. Fan. Jindai zhongguo huaji 59.

1904 Mountain hermitage. Jinbainian 37.

1909 Two female immortals. Hanging scroll. The Metropolitan Museum of Art, Robert H. Ellsworth collection (P071.01). *80

1920 Bamboo and stone. Shina nanga taisei 2:123.

1923 Landscape. Kindai chugoku kaiga 78.

1925 Ten flowers of spring. 20th Century 43. A collaborative work by 10 artists, including Wu Shujuan.

____ Peacock, pheasants and birds. Fan. Jindai zhongguo huaji 59.

____ Landscape. Yilin 17.8.

____ Landscape. *Guotai meishuguan xuanji* (Taipei, 1977-80) 1:24.

____ Landscape. *Meizhan tekan* (The Fine Arts Exhibition of 1929; Shanghai) 2:89.

____ Landscape. Hanging scroll. Osaka Municipal Museum.

____ Fence and chrysanthemums. Shina nanga taisei 2:211.

____ Chrysanthemums. Shina nanga taisei 2:211.

____ Ducks and willows. Kindai chugoku kaiga 79.

____ Landscape: mountain cottage, after Lan Ying. Jinbainian 37.

____ Landscapes. Four fans mounted as a two hanging scrolls. The Denver Art Museum. 20th Century 44, 45.

____ Flowers. Hanging scroll. Private collection, Hong Kong.

Wu Xiao. 18th c.

1720 Birds and Flowers. Hanging scroll. Palace Museum, Beijing Zhongguo mulu II, 1-5288.

____ Flowers and Insects. Handscroll. Shanghai Museum. Zhongguo mulu III, 1-2811.

Wu Xiushu. 19th century.

____ Flowers. Album, joint work with husband Tao Guan and daughter Tao Fu. One leaf dated 1834. Sotheby's, December 8, 1987, no. 123.

Wu Yingzhen. 18th c.

1720 Lotus. Hanging scroll. Palace Museum, Beijing. Zhongguo mulu & Zhongguo tumu II, 1-5647; *Gugong bowu yuan huaniao*, 80.

Xiangfan.

____ Bamboo, after Guan Daosheng. Fan. Chengxun tang Collection, Hong Kong. *58

Xiang Jianzhang. 19th century.

1822 Plum blossoms and bamboo. Fan. Chengxun tang Collection, Hong Kong. *56

Xing Cijing. 16-17th centuries.

____ Plum. Hanging scroll. Shanghai Museum. Zhongguo mulu III, 1-1452.

____ Guanyin. Hanging scroll. National Palace Museum. *fig. b.

____ The thirty-second manifestation of Guanyin. National Palace Museum. Women Artists, fig. VIII, 18.

Xu Can. 17th c.

____ Guanyin crossing the sea. Hanging scroll. *fig. c.

Xue Susu (Wu). active 1565-1635.

1598 Orchids and bamboo. Handscroll. Palace Museum, Beijing. Zhongguo mulu & Zhongguo tumu II, 1-2412.

1598 Orchids. Hanging scroll. Shanghai Museum. Zhongguo mulu III, 1-1545.

1599 Bamboo and rock. Fan. Shanghai Museum. Shanmian hua 52.

1601 Outlined ink (wild) orchids. Handscroll. The Honolulu Academy of the Arts. *10

1615 Flowers. Handscroll. Asian Art Museum of San Francisco, The Avery Brundage Collection. *11

1633 Chrysanthemums and bamboo. Fan. The Honolulu Academy of Arts. *12

1633 Plum and narcissus. Hanging scroll. Shanghai Museum. Zhongguo mulu III, 1-1546.

1637 Flowers. Album. Contag and Wang, p. 477.

____ Traveler(s) on a river bridge. Fan. Palace Museum, Beijing. Zhongguo mulu and Zhongguo tumu II, 1-2413.

____ Girl playing a flute (self-portrait ?). Nanjing 1:90.

____ Narcissus. Fan. Shanghai Museum.

____ Orchids. Handscroll. Mounted together with work of Ma Shouzhen (1604). Shanghai Museum. Zhongguo mulu III, 1-1263.

____ Cicada on leaf. Fan. Chengxun tang Collection, Hong Kong. *13

Yao Shu. 17th c.

____ Album. Contag and Wang, p. 204.

Ying Chuan. 18th–early 19th c.

1797 Orchids. Album leaves. Yale University Art Gallery.

Yu Hui. Qing dynasty.

1862? Landscape. Fan. Art of Chinese Fan Painting 3.

Yu Ling. Mid-19th c.

____ Three drunken men. Hanging scroll. Leal Senado/Museu Luis de Camoes, Macau. *64

____ An elegant gathering. Fan. Leal Senado/Museu Luis de Camoes, Macau. *65

_____ Figures. 2 album leaves. Art Gallery, Chinese University of Hong Kong. Guangdong shuhua lu 483.

_____ Fisherman's pleasure, after Lu Zhi. Leaf mounted on a hanging scroll with works of two other artists. Art Gallery, Chinese University of Hong Kong. Guangdong shuhua lu 484.

Yuexiang. c. 1800.

_____ Ink orchids with colophons. Fan. Chengxun tang Collection, Hong Kong. *54

Yun Bing. 18th century.

1730 Lilies and butterflies. Fan. Walters Art Gallery, Baltimore. Christie's, June 3, 1987, no. 48.

1735 Flowers. 10 leaf album. Sotheby's, Dec. 7, 1983, no. 25.

1746 Hollyhocks. Fan. Private Collection, Hong Kong.

1747 Ducks under bamboo and peach blossoms. Fan. Tokyo National Museum. *43

1770 Snowball flowers, pink blossoms and birds. Hanging scroll. Private collection, Kyoto.

1775 Flowers. 3 album leaves. Private collection, Hong Kong.

1786 Butterflies and flowers. Hanging scroll. Li Yuanfu, _Piling huazheng lu_ (Changzhou, 1933).

_____ Red lotus. Hanging scroll. Palace Museum, Beijing.

_____ Flowers. 10 leaf album. Shanghai Museum. Zhongguo mulu III, 1-3525.

_____ Mynah in the spring wind. Hanging scroll. Shanghai Museum. Zhongguo mulu III, 1-3524.

_____ Chrysanthemums. Hanging scroll. Head Store of China Antique Store. Zhongguo mulu I, 9-143.

_____ Orchid and rock. Set of four fans. Chengxun tang Collection, Hong Kong. *42

_____ Peonies and rocks. Hanging scroll. E. Lu collection. Suzuki S 6-016.

_____ Cut branches of summer flowers and lychees. Fan. Private Collection, Japan. *44

_____ Flower and insect paintings. 10 leaf album. Musee Guimet, Paris. *40

_____ Plants and insects. Two album leaves. Royal Ontario Museum (972.364.7a-b). *41

_____ Chrysanthemums by a rock. Hanging scroll. Ching Yüan Chai Collection? Sirén VII, p. 461.

_____ Twelve flowers of the year. 12 leaf album. Asian Art Museum of San Francisco, The Avery Brundage Collection (65 D49). *39

_____ Peonies. Hanging scroll. Allen Art Museum, Oberlin College.

_____ Peonies and rocks. Hanging scroll. Private collection, Stanford, California.

_____ Butterflies among autumn flowers. Hanging scroll. Christie's, December 11, 1987, no. 103.

_____ Cranes and peonies. Hamburg Exhibition, 1949-50. Sirén VII, p. 461.

_____ Peonies and rock. Hanging scroll. Sogen 2:357.

_____ One hundred flowers. Handscroll. Zhongguo minghua 15:l; 16:17; 17:15.

_____ Basket of chrysanthemums. Fan. Shanmian daguan 4.

Zhao Zhao. 17th century.

_____ Album after old masters. Private collection, Shanghai.

Zhou Hu (Zhou Shuhu). 17th century.

1654 Flowers and insects. With Zhou Xi. Fan. _Mingren shanji_ 10.

_____ Flowers and fruits. With her father Zhou Rongqi and sister Zhou Xi. 4 panels. Palace Museum, Beijing. Zhongguo mulu II, 1-4130.

_____ Dandelion and insects. With Zhou Xi. Hanging scroll. Nanjing Museum. Nanjing 1:133.

Zhou Xi (Zhou Shuxi). 17th century.

1653 Bird on a pomegranate branch. Hanging scroll. National Palace Museum, Taipei. Gugong shuhua lu 8:101.

1654 Hibiscus and insects. With Zhou Hu. Fan. _Mingren shanji_ 10.

1663 White bird on a plum. Fan. Museum of Fine Arts, Boston (1977.7511). *31

1663 Washing the elephant. Hanging scroll. Palace Museum, Beijing. Zhongguo mulu II, 1-4353.

1670 Luohan paintings. Set of 10 hanging scrolls. National Palace Museum, Taipei. Gugong shuhua lu 8:101; Gugong zhoukan 21, nos. 86-90.

1639 (or 1699) Bird and camellias. Hanging scroll. Nanjing Museum. Nanjing 1:132.

_____ Dandelion and insects. With sister Zhou Hu. Hanging scroll. Nanjing Museum. Nanjing 1:133.

_____ Birds, plum blossoms and camellias. Hanging scroll. Nanjing Museum.

_____ Eight-armed Guanyin. Hanging scroll. Lichao minghua Guanyin.

_____ Flowers and fruits. With father Zhou Rongqi and sister Zhou Hu. 4 panels. Palace Museum, Beijing. Zhongguo mulu II, 1-4130.

Zhu Meiyao. 19th c.

_____ Landscapes. 3 album leaves. Art Gallery, The Chinese University of Hong Kong. *66

Zhu Ying.

_____ Solitary boatman on a river. Fan. Shanmian daguan 4.

Zuo Xihui. 19th c.

1821 Lady under trees. Hanging scroll. Museum of Chinese History, Beijing. Zhongguo mulu I, 2-72.

Select Bibliography

Abbreviations used in the text:

Birrell: Anne Birrell, trans. *New Songs from a Jade Terrace: An Anthology of Early Chinese Love Poetry* (London: Allen & Unwin, 1982)

ECCP: Arthur W. Hummel ed., *Eminent Chinese of The Ch'ing Period (1644-1912)* (Taipei: Ch'eng Wen, 1975).

Levy: Howard Levy, *A Feast of Mist and Flowers: The Gay Quarters of Nanking at the end of the Ming* [translation of Yü Huai, *Diverse Records of Wooden Bridge*] (Yokohama: 1966)

Minghua lu: Xu Qin, *Minghua lu, Huashi congshu* edition (Shanghai: Renmin meishu chubanshe, 1963)

Nozaki: Nozaki Nobuchika, *Zhongguo jixiang tu'an* (Taipei: Guting shuwu, 1979)

Sirén CP: Osvald Sirén, *Chinese Painting, Leading Masters and Principles*, 7 vols. (London: Lund Humphries, 1956-58)

Suzuki: *Chūgoku kaigai sōgō zuroku* [*Comprehensive Illustrated Catalog of Chinese Paintings*], 5 vols. Compiled by Suzuki Kei. (Tokyo: University of Tokyo Press, 1982)

WSSS: Jiang Shaoshu, *Wusheng shishi, Huashi congshu* edition (see *Minghua lu*)

YTHS: Tang Souyu, *Yutai huashi, Huashi congshu* edition (see *Minghua lu*)

Yu: Yu Jianhua, *Zhongguo meishujia renming cidian* (Shanghai: Renmin meishu chubanshe, 1981)

Ayscough, Florence. *Chinese Women: Yesterday and Today*. Boston: Houghton Mifflin Company, 1937

Barnhart, Richard M. *Peach Blossom Spring: Gardens and Flowers in Chinese Paintings*. New York: The Metropolitan Museum of Art, 1983.

Bartholomew, Terese Tse. "Botanical Puns in Chinese Art from the Collection of the Asian Art Museum of San Francisco." *Orientations* 16, no. 9 (September 1985): 18-34.

Bickford, Maggie. *Bones of Jade, Soul of Ice: The Flowering Plum in Chinese Art*. New Haven: Yale University Art Gallery, 1985.

Broude, Norma and Mary D. Garrard, eds. *Feminism and Art History: Questioning the Litany*. New York: Harper & Row, 1982.

Carl, Katherine. *With the Empress Dowager of China*. London: Eveleigh Nash, 1906.

Ch'en Pao-chen. "Kuan Tao-sheng and the National Palace Museum 'Bamboo Rock'." *Gugong jikan* (*National Palace Museum Quarterly*) 11, no. 4 (Summer 1977): 51-84 (English summary: 39).

Chiang Chao-shen. "The Identity of Yang Mei-tzu and the Paintings of Ma Yüan." *National Palace Museum Bulletin* 2, no. 2 (May 1967): 1-14; no. 3 (July 1967): 9-14.

Chung, Saehyang P. "An Introduction to the Changzhou School of Painting." *Oriental Art*, n.s. 31, no. 2 (Summer 1985): 146-160; no. 3 (Autumn 1985): 293-308.

(Ecke) Tseng Yu-ho. "Hsüeh Wu and her orchids in the collection of the Honolulu Academy of the Arts." *Arts Asiatiques* 2, no. 3 (1955): 197-208.

Ecke, Tseng Yu-ho. *Wen-jen Hua: Chinese Literati Painting from the Collection of Mr. and Mrs. Mitchell Hutchinson*. Honolulu: Honolulu Academy of Arts, 1988.

Fister, Patricia. *Japanese Women Artists 1600-1900*. Lawrence, Kansas: Spencer Museum of Art, 1988.

Gerstlacher, Anna and Ruth Keen, Wolfgang Kubin, Margit Miosga, and Jenny Schon, eds. *Woman and Literature in China*. Bochum: Studienverlag Brockmeyer, 1985.

Hackney, Louise. "Chinese Women Painters." *International Studio* 78 (October 1923): 74-77.

Harris, Ann Sutherland and Linda Nochlin. *Women Artists: 1550-1950*. Los Angeles: Los Angeles County Museum of Art, 1976.

Keswick, Maggie. *The Chinese Garden*. New York: Rizzoli, 1978.

Lai, Tien-chang. *Noble Fragrance: Chinese Flowers and Trees*. Hong Kong: Swindon, 1977.

Li, Hui-lin. *Chinese Flower Arrangement*. Philadelphia: Hedera House, 1956.

Li, Hui-lin. *The Garden Flowers of China. Chronica Botanica: An International Biological and Agricultural Series*, no. 19. New York: The Ronald Press, 1959.

Lin Yutang. "Feminist Thought in Ancient China." *T'ien Hsia Monthly* 1, no. 2 (September 1935): 134-45.

Lo, Irving Yucheng and William Schultz eds. *Waiting for the Unicorn: Poems and Lyrics of China's Last Dynasty, 1644-1911*. Bloomington: Indiana University Press, 1986.

Mao Xiang. *Yingmei an yiyu*. Translated by Pan Tze-yen (Z. Q. Parker) as *The Reminiscences of Tung Hsiao-wan*. Shanghai: The Commercial Press, Ltd., 1931.

Nochlin, Linda. "Why Have There Been No Great Women Artists?" *Art News* 64 (1971): 22-39, 67-71.

O'Hara, Albert R. *The Position of Women in Early China*. Taipei: Mei Ya Publications, Inc., 1971.

Parker, Rozsika and Griselda Pollock. *Old Mistresses: Women, Art and Ideology*. New York: Pantheon Books, 1981.

Petersen, Karen and J.J. Wilson. *Women Artists: Recognition and Reappraisal from the Early Middle Ages to the Twentieth Century*. New York: New York University Press, 1976. (Appendix: Lori Hagman, "Ladies of the Jade Studio: Women Artists in China").

Rexroth, Kenneth and Ling Chung. *The Orchid Boat: Women Poets of China*. New York: The Seabury Press, 1972.

Ropp, Paul S. *Dissent in Early Modern China: "Ju-lin wai-shih" and Ch'ing Social Criticism*. Ann Arbor: University of Michigan Press, 1981.

Ropp, Paul S. "The Seeds of Change: Reflections on the Condition of Women in the Early and Mid Ch'ing," *Signs: Journal of Women in Culture in Society* 2, no. 1 (Autumn 1976): 5-23.

Swann, Nancy Lee. *Pan Chao: Foremost Woman Scholar in China*. American Historical Association, 1932. Reprint. New York: Russell and Russell, 1968.

Warner, Marina. *The Dragon Empress: Life and Times of Tz'u-hsi, 1835-1908, Empress Dowager of China*. New York: Macmillan, 1972.

Wolf, Margery and Roxane Witke, eds. *Women in Chinese Society*. Stanford: Stanford University Press, 1975.

Xu Bangda (Hsu Pang-ta). "Women Painters' Works in the Palace Museum." *Chinese Literature* no. 7 (1959): 165-67.

Index and List of Chinese and Japanese Terms

Chronology

Dynasties and Later Reigns of China

Shang *16th c.–1045 BC*

Zhou *1045–256 BC*
 Western *1045–771 BC*
 Eastern *770–222 BC*
 Spring and Autumn *770–481 BC*
 Warring States *480–222 BC*

Qin *221–206 BC*

Han *206 BC–220 AD*
 Western *206 BC–9 AD*
 Eastern *25–220*

Three Kingdoms *220–265*

Western Jin *265–317*

Southern Dynasties *317–589*

Northern Dynasties *386–581*

Sui *581–618*

Tang *618–906*

Five Dynasties *907–960*

Song *960–1279*
 Northern *960–1127*
 Southern *1127–1279*

Jin *1115–1234*

Yuan *1279–1368*

Ming *1368–1644*

Hongwu *1368–*	Hongzhi *1488–*
Jianwen *1399–*	Zhengde *1506–*
Yongle *1403–*	Jiajing *1522–*
Hongxi *1425–*	Longqing *1567–*
Xuande *1426–*	Wanli *1573–*
Zhengtong *1436–*	Taichang *1620–*
Jingtai *1450–*	Tianqi *1621–*
Tianshun *1457–*	Chongzhen *1628–*
Chenghua *1465–*	

Qing *1644–1911*

Shunzhi *1644–*	Daoguang *1821–*
Kangxi *1662–*	Xianfeng *1851–*
Yongzheng *1723–*	Tongzhi *1862–*
Qianlong *1736–*	Guangxu *1875–*
Jiaqing *1796–*	Xuantong *1909–*

Artists Represented in the Exhibition

Ailian, Lady *Late 19th century*
Cai Han *1647–86*
Chai Jingyi *17th century*
Chai Zhenyi *17th century*
Chen Shu *1660–1736*
Chen Yi *17th century*
Cixi, Empress Dowager *1835–1908*
Dong Bai *1625–51*
Fang Wanyi *1732–79*
Fu Derong *Late 17th century*
Gu (Xu) Mei *1619–64*
Guan Daosheng *1262–1319*
Jiang Jixi *17th–18th century*
Jin Yue *17th century*
Jinglian *Early 19th century*
Ju Qing *19th century*
Li Yin *1616–85*
Liang Ruozhu *18th–19th century*
Lin Xue *Early 17th century*
Liu Shi *1618–64*
Luo Guifen *Late 19th century*
Luo Qilan *Late 18th century*
Ma Quan *Early 18th century*
Ma Shouzhen *1548–1604*
Mao Xiang's Concubine *17th century*
Mao Yuyuan *Middle 17th century*
Miao Jiahui *19th–20th century*
Qian Juying *Middle 19th century*
Qiu, Miss *Middle 16th century*
Ren Xia *1876–1920*
Su Chenjie *16th or 17th century*
Wang Yuyan *Late 18th century*
Wen Shu *1595–1634*
Wu Shangxi *Middle 19th century*
Wu Shujuan *1853–1930*
Xiang Jianzhang *Early 19th century*
Xiangfan *19th century (?)*
Xue Susu *16th–17th century*
Yu Ling *Middle 19th century*
Yuexiang *18th–19th century*
Yun Bing *18th century*
Zhou Xi *Late 17th century*
Zhu Meiyao *19th century*

Photographic Appendix

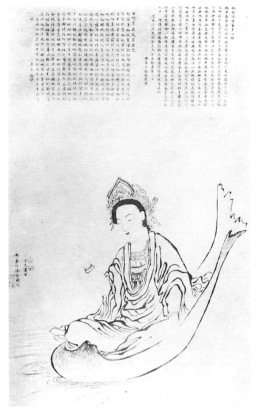

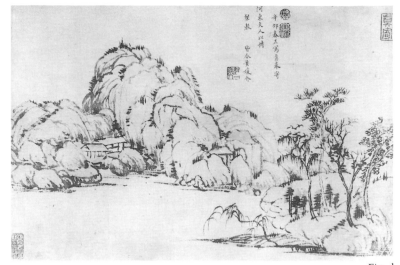

Fig. d

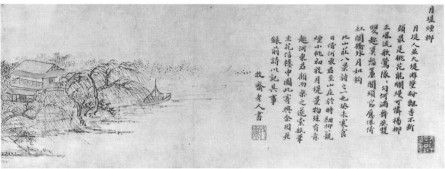

Fig. g

Fig. c

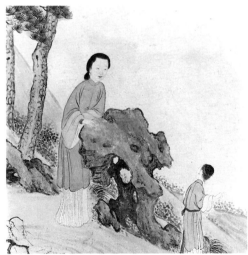

Fig. k

Fig. m

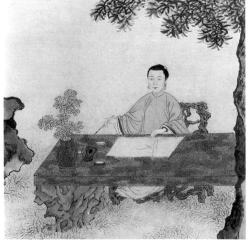

Figure c. Xu Can, Qing dynasty, *Guanyin Crossing the Sea.* Palace Museum, Beijing.

Figure d. Huang Yuanjie, active mid-17th century, *Landscape,* 1651. Palace Museum, Beijing.

Figure g. Liu Shi, 1618-64, *Willows on a Moonlit Embankment.* Palace Museum, Beijing.

Figure k. Chen Shu, 1660-1736, *Sketches from Life,* 1713. Collection of the National Palace Museum, Taiwan, Republic of China.

Figure m. Ding Yicheng, 18th century, *[Luo Qilan] Viewing Mt. Ping in Springtime.* Palace Museum, Beijing. (detail)

Figure n. Pan Gongshou, 1741-94, *Wang Yuyan Sketching Orchids.* Palace Museum, Beijing. (detail)

Fig. n

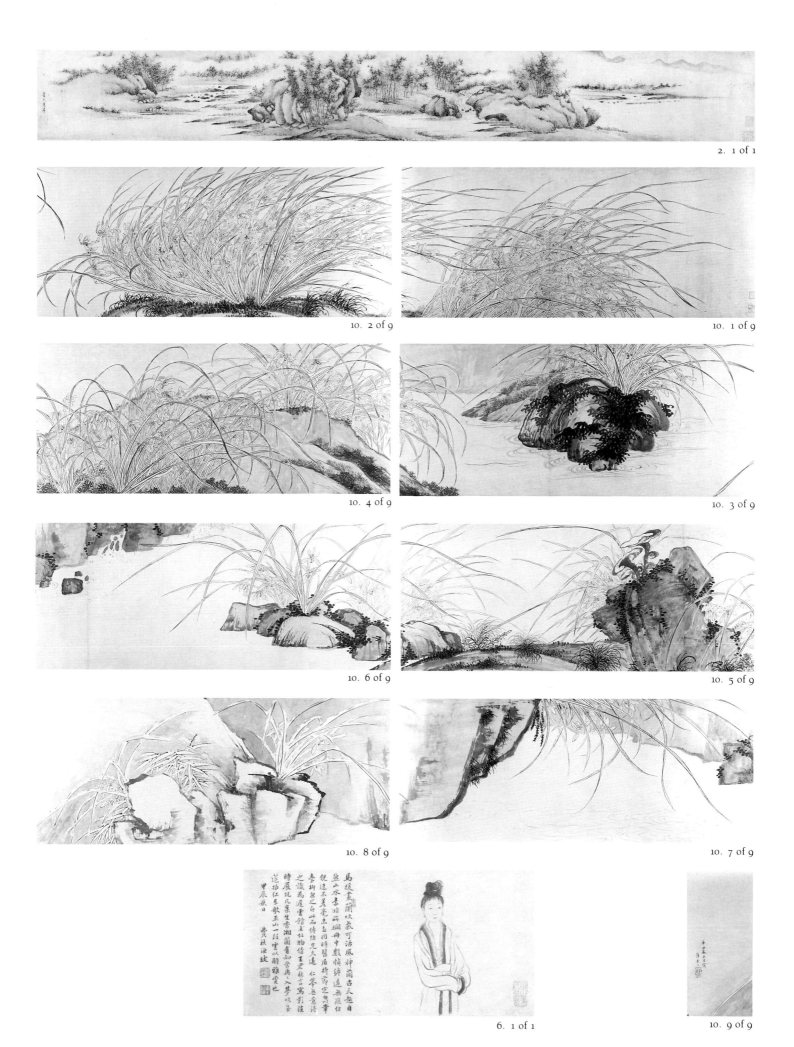

2. 1 of 1

10. 2 of 9

10. 1 of 9

10. 4 of 9

10. 3 of 9

10. 6 of 9

10. 5 of 9

10. 8 of 9

10. 7 of 9

6. 1 of 1

10. 9 of 9

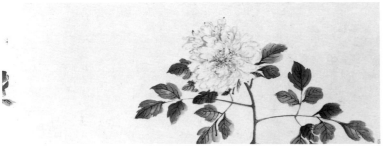

11. 1 of 8

11. 2 of 8

11. 3 of 8

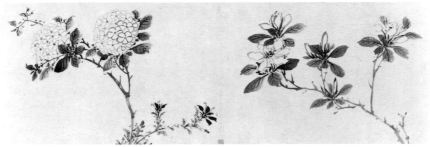

11. 4 of 8

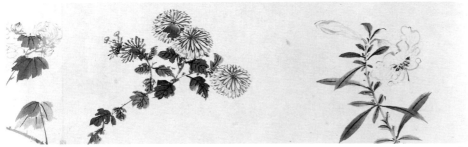

11. 5 of 8

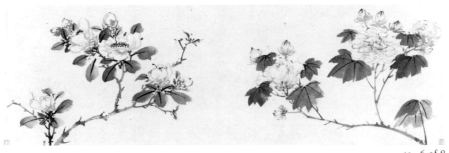

11. 6 of 8

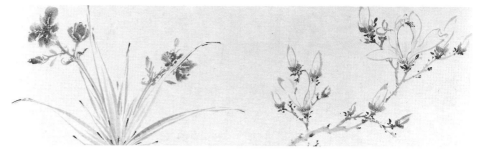

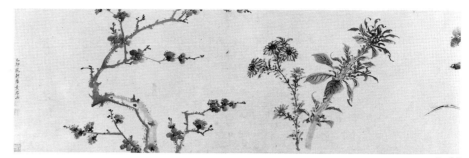

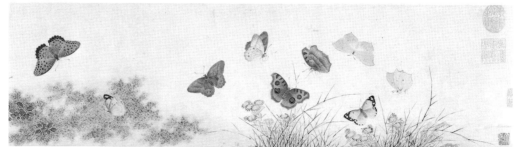

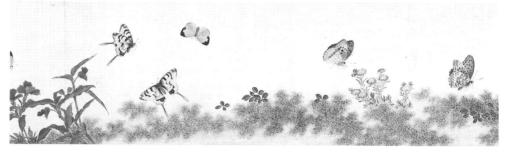

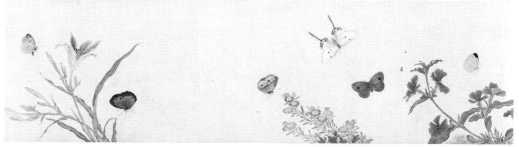

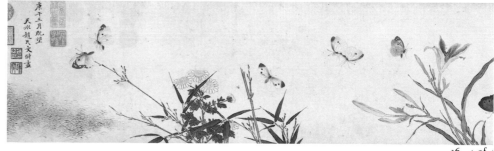

21. 1 of 3

21. 3 of 3

23. 1 of 8

24. 1 of 8

23. 2 of 8

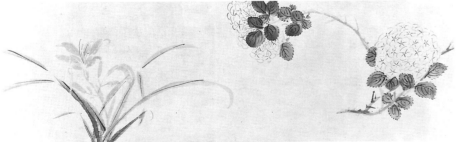

24. 2 of 8

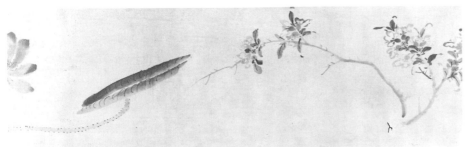

24. 3 of 8

24. 4 of 8

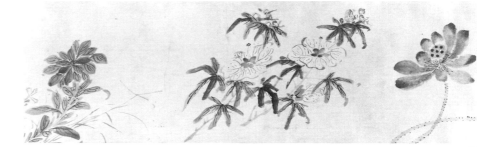

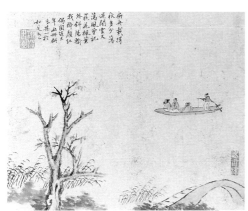

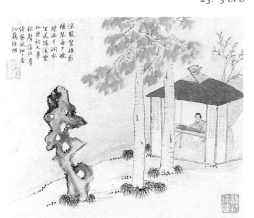

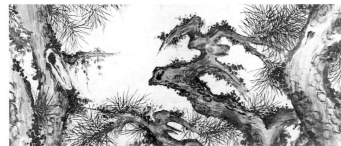

33. 2 of 4

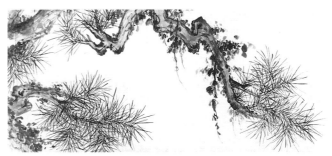

33. 1 of 4

33. 4 of 4

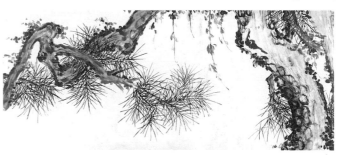

33. 3 of 4

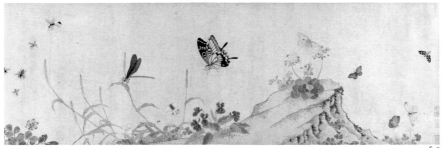

30. 1 of 6

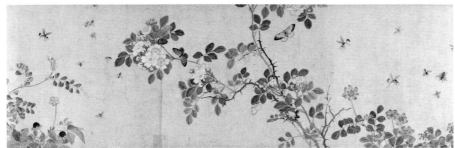

30. 2 of 6

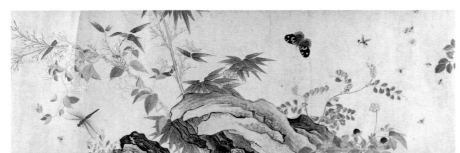

30. 3 of 6

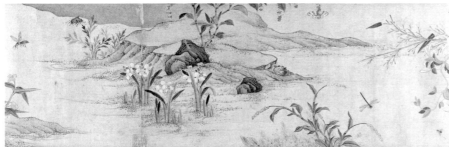

30. 4 of 6

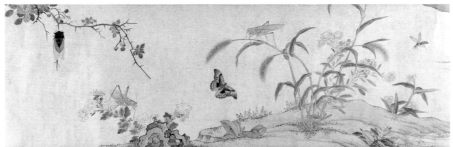

30. 5 of 6

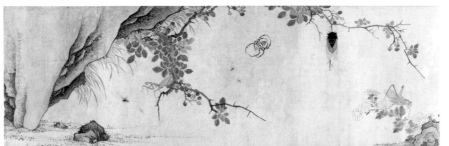

30. 6 of 6

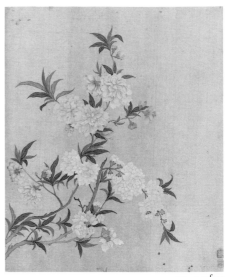

39. 1 of 12

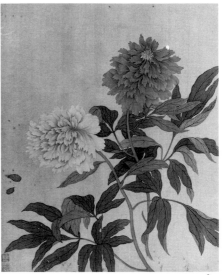

39. 2 of 12

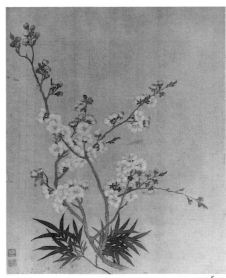

39. 3 of 12

218

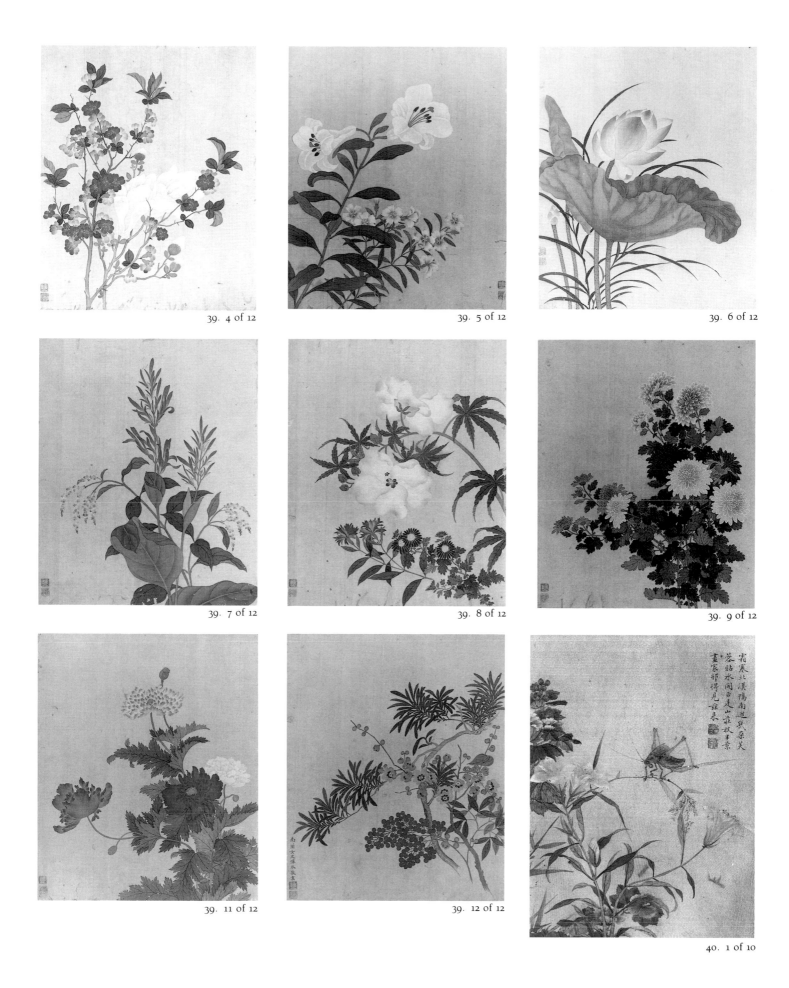

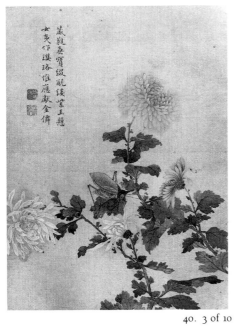

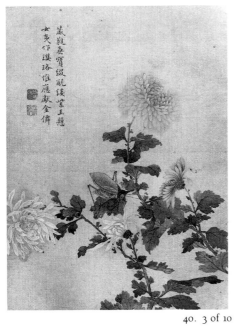
40. 3 of 10

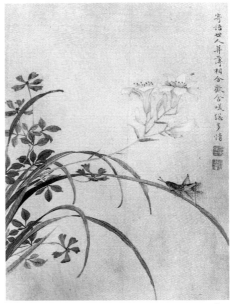
40. 4 of 10

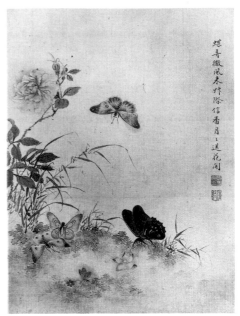
40. 5 of 10

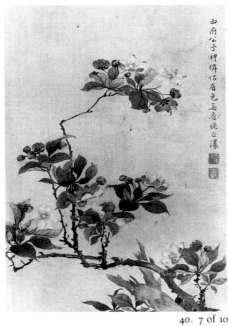
40. 7 of 10

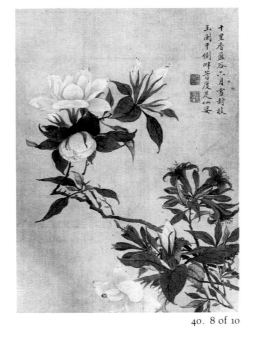
40. 8 of 10

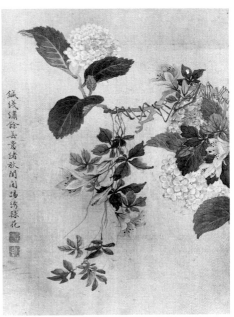
40. 9 of 10

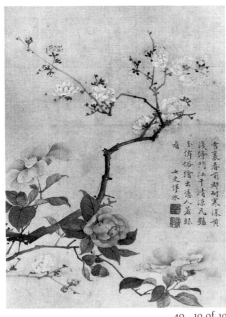
40. 10 of 10

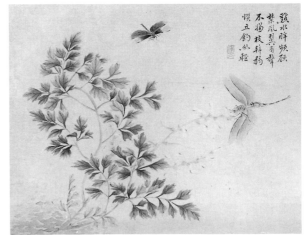
41. 1 of 2

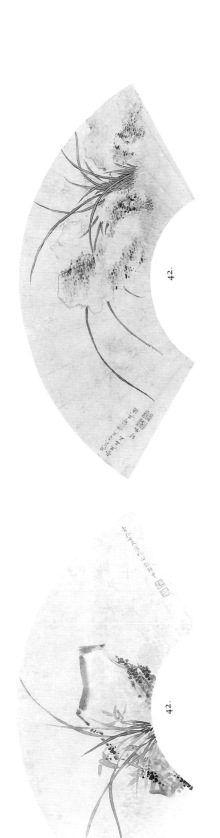

42.

42.

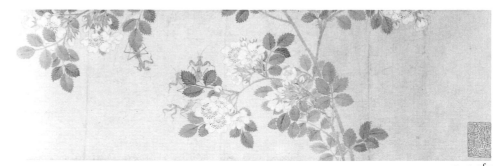

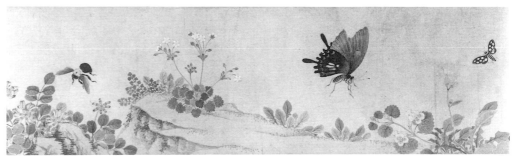

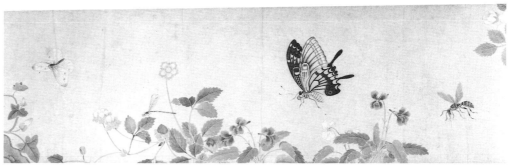

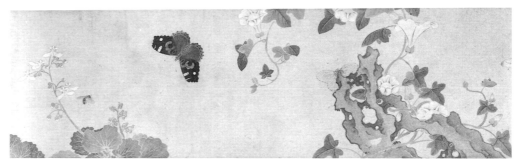

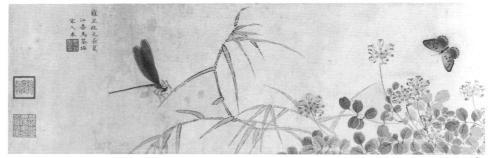

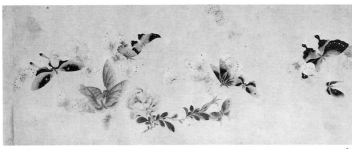

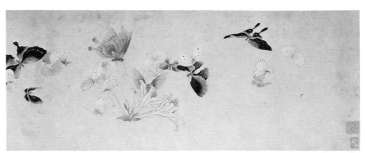

48. 2 of 4 48. 1 of 4

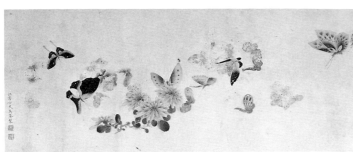

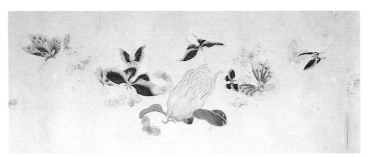

48. 4 of 4 48. 3 of 4

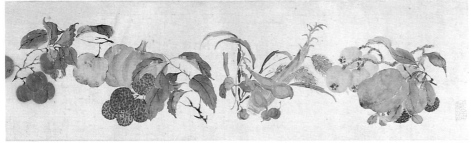

62. 1 of 4

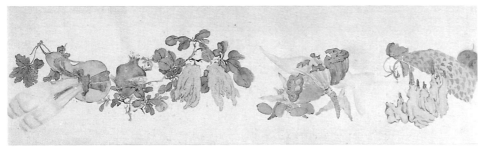

62. 2 of 4

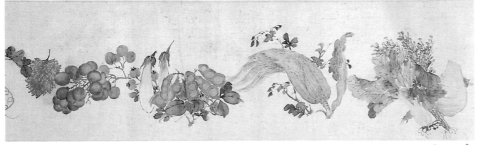

62. 3 of 4

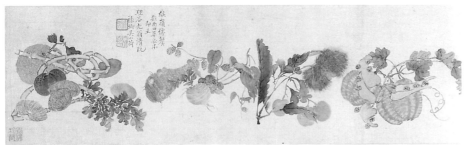

62. 4 of 4

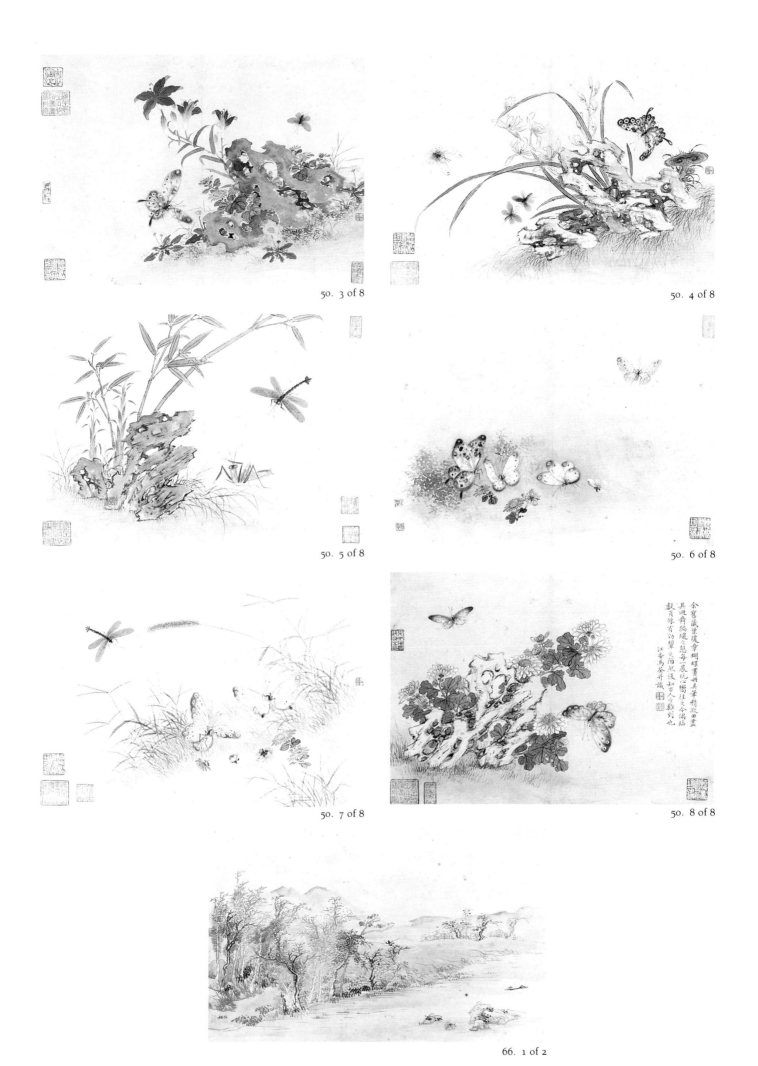

50. 3 of 8

50. 4 of 8

50. 5 of 8

50. 6 of 8

50. 7 of 8

50. 8 of 8

66. 1 of 2

玉臺縱覽展品目錄　　蔡杏莉編

管道昇（1262—1319）
　　字仲姬，一字瑤姬，吳興（今浙江吳興）人，趙孟頫妻。延祐四年（1317）封魏國夫人。工墨竹梅蘭，山水，佛像。

1. （傳）竹圖卷，1309
　　鑑藏印章：容光（郭照，1827—95）
　　題　　跋：（傳）管道杲

2. （傳）煙雲叢竹圖卷
　　題　　首：綠篠媚漣漪，昌碩
　　作者款識：管氏道昇。
　　作者印章：仲姬
　　鑑藏印章：吳昌石，庭蓉珍藏，藹達思默墨悟珍藏印，趙（僞印），瘦仙鑒藏，潁川珍賞，潤州戴氏倍萬樓鑑眞，魏氏珍藏，顧子嘉珍藏印（吳昌碩，1844—1927；魏庭蓉，二十世紀；趙孟頫，1254—1322；金望喬，清朝；戴植，十九世紀上半葉；顧子嘉，二十世紀）
　　題　　跋：顧瑛（1310—69），盛著（十四世紀），葉德輝（1917），王震（1918），沈定一（1918），沈儀彬（1920），張昭漢（1920），譚澤闓（1920）

仇氏（活躍於十六世紀下半葉）
　　號杜陵內史，江蘇太倉人。仇英女，得父法，精人物，亦工山水。

3. 觀音像冊頁
　　作者款識：吳門仇氏寫。
　　鑑藏印章：家於隴西鳳道之間，項李氏珍藏，桃花園裏人家
　　題　　跋：屠隆（1542—1605）

馬守眞（1548—1604）
　　字元兒，玄玄子，湘蘭，號月嬌，一署馬湘。金陵（今南京）妓，居秦淮。工書，善蘭竹。

4. 竹石幽蘭圖軸，1563
　　作者款識：雖與小草伍，幽芬出谷中。
　　　　　　　素心拖君子，時可拂清風。
　　　　　　　癸亥穀雨寫於秦淮水榭。

玄玄子湘蘭馬守眞。
　　作者印章：馬湘蘭印
　　鑑藏印章：曹氏幹濟藏眞，沈氏兼之珍玩，會稽沈氏君度所藏經籍金石書畫之印

5. 蘭石圖軸，1572
　　作者款識：翠影拂湘江，清芬瀉幽谷。
　　　　　　　壬申清和寫於秦淮小閣。湘蘭子玄玄馬守眞。
　　作者印章：湘蘭，月嬌
　　鑑藏印章：[]安鑑賞，兪艮之印
　　題　　跋：王穉登（1535—1612），薛明益（十六世紀），褚德彝（1939）

6. 秦淮水榭圖卷，1576
　　作者款識：萬曆丙子春二月畫于秦淮水榭，湘蘭女史馬守眞。
　　作者印章：守眞，馬湘蘭印，守眞玄玄子
　　鑑藏印章：定靜堂藏書印，東山席氏珍藏，志超鑑藏，志超墨緣，小（？）父心藏，定靜堂收藏印，小婕過目，酒祓清愁花消英氣，志超（朱梧，十九世紀；朱子庚，十九世紀）
　　題　　跋：費秋漁（1844），王穉登（1535—1612），兪岳（1846），朱子庚（十九世紀），顧文彬（1847），程庭鷺（1847），魏謙升（1852），楊錦雯（十九世紀中葉），張左鉞（1852），定山，姚石如（1897），彭醇士（(1897)

7. 蘭圖軸，1592
　　作者款識：萬曆壬辰長夏坐秦淮水榭，畫呈百穀社兄正，湘蘭女弟馬守眞。
　　作者印章：馬，月嬌，守眞
　　鑑藏印章：拍翻紅豆，草閣

8. 設色靈芝蘭竹圖卷，1566
　　題　　首：九畹芷蘭
　　作者款識：丙寅夏日爲滇陽契兄，湘蘭馬守眞。
　　作者印章：湘蘭，守眞玄玄子，湘蘭女史，九畹中人
　　鑑藏印章：神品，崑畬，海山僊館珍藏書畫印，延齡之印，健庵，曾藏潘健蠡處，延齡季子，[]霞主人書畫之印記，健菴平生眞賞，潘氏健

盦珍藏書畫印，雨谷之子，臨溟
張氏珍藏（潘延齡，十九世紀中
葉）

　　題　　跋：裴景福（1865－1937），陸以謙
　　　　　　　（1785），董彬（1785），張燕
　　　　　　　昌（1785），王文治（1730－
　　　　　　　1802），奚岡（1746－1803），
　　　　　　　胡璧城（1799）

9. 設色靈芝蘭竹圖卷，1604
　　作者款識：萬曆甲辰秋月坐於秦淮水榭，湘
　　　　　　　蘭女史馬守眞。
　　作者印章：馬湘蘭印，守眞，湘蘭女史，九
　　　　　　　畹中人
　　鑑藏印章：芷林曾觀，德畬審定（梁章鉅，
　　　　　　　1775－1849；潘仕成，1832進士）

薛素素，即薛五（約活躍於1565－1635）
　　其名衆說紛紜，字素卿，潤卿，素素，或小
　　字潤娘，行五，或名雪素。吳（今江蘇蘇州）
　　人，一作嘉興人，明萬曆（1573－1620）浙
　　江嘉興妓。善黃庭小楷，工山水，蘭竹，花
　　卉，草蟲，兼擅白描大士，中年長齋繡佛。

10. 雙鈎蘭圖卷，1601
　　作者款識：辛丑春正月寫，薛素素。
　　作者印章：薛[]
　　鑑藏印章：正闇審定，正闇收藏，[]

11. 墨花卉卷，1615
　　題　　首：彤管有煒，范允臨
　　作者款識：乙卯花朝，薛素君畫。
　　作者印章：薛，第五之名
　　鑑藏印章：伯奮，伯奮珍賞，古歈程氏珍藏
　　　　　　　，程琦印信，程可庵書畫記（程
　　　　　　　琦，二十世紀）
　　題　　跋：范允臨（1558－1641）

12. 竹菊圖扇面，1633
　　作者款識：
　　　　　枝霜後約輕黃，籬落微開淡夕陽。
　　　　　何事南山重對酒，隱居吾已足餱糧。
　　　　　薛氏素君寫并題，時癸酉夏日。
　　作者印章：女校書，薛素君

13. 靑蟬浮葉圖扇面
　　作者款識：素素寫。
　　作者印章：素卿畫印

文俶（1595－1634）
　　字端容，款署寒山蘭閨畫史，長洲（今江蘇

蘇州）人。徵明（1470－1559）其高祖父也
，適寒山趙均。工花蟲蝶石。

14. 錦花園石圖扇面，1627
　　作者款識：丁卯夏五月，文俶。
　　作者印章：端容，文俶

15. 萱蝶圖軸，1627
　　作者款識：丁卯夏日天水趙氏文俶寫。
　　作者印章：趙文俶印，端容，文俶之印，文
　　　　　　　端容氏，蘭閨
　　鑑藏印章：朱靖侯家珍藏，律本長壽，新安
　　　　　　　[]舊存賞心眞跡，漢光閣主顧洛
　　　　　　　阜鑑藏中國古代書畫之章

16. 戲蝶圖卷，1630
　　作者款識：庚午三月旣望，天水趙氏文俶畫。
　　作者印章：文端容，趙文俶印，端容
　　鑑藏印章：乾隆御覽之寶，嘉慶御覽之寶，
　　　　　　　石渠寶笈，海堂書屋，三希堂精
　　　　　　　鑑璽，宜子孫，乾隆鑑賞，宣統
　　　　　　　御覽之寶，瀏陽李鴻球字韻淸鑒
　　　　　　　藏（淸內府藏；李鴻球，二十世
　　　　　　　紀）
　　題　　跋：長公

陳懿（十七世紀）
　　字德美，號古吳女史，生平不詳。

17. 設色蘭竹園石圖軸，1635
　　作者款識：崇禎乙亥仲秋古吳女史陳懿寫。
　　作者印章：古吳女史，陳懿媛氏

林雪，即林天素（活躍於十七世紀上半葉）
　　閩（福建）人，西湖妓。工書畫，臨古畫，
　　嘗亂眞。

18. 山水圖扇面，1620
　　作者款識：庚申冬月爲平倩兄作，林雪。
　　作者印章：林雪
　　鑑藏印章：藥[]長平生眞賞

19. 山水圖扇面，1642
　　作者款識：壬午春正月寫，林雪。
　　作者印章：林雪，天素
　　題　　跋：金娘（雪鷺館，甲寅年）

20. 仿黃公望山水圖扇面
　　作者款識：林雪倣子久筆法。
　　作者印章：天素

顧媚，即徐眉（1619—64）

字眉生，一字眉莊，號橫波，又號智珠，亦號梅生。其名眾說紛紜，或謂顧眉，本姓徐，或本姓顧，適龔鼎孳爲妾後，改姓徐。上元（今南京）人，名妓。嫁龔後，號善材君，入清封夫人。工畫蘭。

21. 蘭石圖卷，1644
作者款識：長至日眉畫于莫愁居。
作者印章：白門眉子
鑑藏印章：鈖州舊史馮氏小羅浮草堂珍藏，鍾仁階家珍藏，鍾仁階謝荷香，鈖州鍾氏，仁階心賞（馮敏昌，1747—1807；鍾仁階，二十世紀）
題　　跋：龔鼎孳（1644），黃易（1792），翁方綱（1793），吳錫麒（1746—1818），余集（1738—1823），小香（1792或1852），津生［］（1799或1859），汪兆鏞（1937，1933），吳道鎔（1934），桂坫（二十世紀初），張學華（1938），陳洵（1938），謝蒙（1939），溫廷敬（二十世紀），鄧爾疋（1947）

董白（1625—51）

字小宛，號青蓮女史，金陵（今南京）人，如皋冒襄姬。歸冒後，居水繪園豔月樓，通詩善畫。及卒，冒襄作影梅庵憶語悼之。

22. 仿王冕梅花圖扇面
作者款識：傚王元章法，未識似否，董白畫。
作者印章：小宛，青蓮
鑑藏印章：扶風淥吟天，叔蘋珍賞
題　　跋：叔萍

柳是，即柳隱（1618—64）

本姓楊，名愛兒，又名因，亦名隱。字如是，號影憐，又號蕪蘼君，江蘇吳江人。盛澤歸家院妓，徐佛弟子，晚歸錢謙益稱河東君。工白描花卉，山水竹石。

23. 山水人物圖册
作者款識：
(一)爲得風騷趣，柴門迥不開。
人從塵外見，詩向靜中來。
消息須微悟，推敲別有才。
吟成誰解愛，幽徑長莓苔。
古蘇詞長先生爲余作西泠探［］長卷，

余臨古八幀以報之。我聞居士柳如是。
(二)攪雲一徑澹風漪，翠篠蕭蕭冷硯池。
便仿朱書僉片瓦，官私不許怒蛙知。
愛掬溪泉浣硯塵，溪花俱暈墨痕春。
可知眞硯何曾損，七客於中認主賓。
仿文氏畫法，［］溪滌硯并題。
(三)扁舟載得秋多少，蕩過閒雲又蕩風。
曾記荻花楓葉外，斜陽輸我醉顏紅。
偶閱趙大年畫册，戲臨其一於如是庵。
(四)雨過空亭聽亂流，無人漁釣鑑湖秋。
晚風夕照開水洗，［］月依［］上白頭。
(五)涼散碧梧影，橫琴每夕暉。
靜涵千澗水，坐送隔溪雲。
仙樂鈞天夢，秋聲落雁篁。
綺寮風細細，香沁藕絲裙。
(六)棗花簾額暝烟低，清絕疏寮見舊題。
滿徑苔［］人迹少，仙禽［］過竹枝西。
(七)葉葉濃愁寸寸陰，碧雲天末澹疏吟。
年時憶聽同峯雨，人與芭蕉一樣心。
仿宋人設色法并題。
(八)一重空翠一重煙，樓閣三層小洞天。
才子最宜花眷屬，仙人分結月嬋娟。
那無俊語酬春色，如此聞根亦破禪。
譜要替修香要［］，東風還要出大千。
［］［］［］寓花叢裏，聽吹簫，圖［］撫其意。
作者印章：柳隱書畫
鑑藏印章：［］庵［］玉，故將軍，幷蘋父，九壺生，［］系餘生，部特，行素學齋長物，吳中蔣氏珍藏，韻濤珍賞，賜書樓，雲翁
題　　跋：無偶居士

李因（1616—85）

字今是，又字今生，號是菴，又號龕山逸史，海昌女史。錢塘（今杭州）人，海寧葛徵奇（1645卒）妾。得陳淳（1483—1544）法，多用水墨，工蘆雁。

24. 四季花卉卷，1649
作者款識：己丑孟秋寫於留燕堂，錢塘李因。
作者印章：李因之印，今氏生
鑑藏印章：君實（黃君實，二十世紀）
題　　跋：黃君實

25. 秋葵圖扇面
作者款識：是菴。
作者印章：李因，是菴

26. 粉墨梨花圖扇面，1654

作者款識：甲午春日爲沖甫詞兄寫，女史李
　　　　　因。
作者印章：雲臥

27．飛燕牡丹圖軸，1673
　　作者款識：癸丑冬日海昌女史李因畫
　　作者印章：李因之印，今氏生

茅玉媛（活躍於十七世紀中葉）
　　字小素，錢塘（今杭州）人。九仍女，適同
　　邑許世翌。幼承母梁孟昭教，工山水。

28．蘭卉圖扇面，1651
　　作者款識：辛卯秋日寫，小素氏。
　　作者印章：玉媛，小素
　　鑑藏印章：柿葉山房秘玩之章，研香閣棣如
　　　　　　　珍賞之印（王文治，1730－1802）

蘇陳潔（十六世紀末或十七世紀中葉）
　　字太素，江蘇常熟陸虞在妻。工花鳥，能詩。

29．綠雲弄媚圖扇面，1591或1651
　　作者款識：
　　　　　綠雲一片綴輕紅，弄媚爭妍八月中。
　　　　　疑是阿環微醉後，沉香亭畔臥秋風。
　　　　　辛卯初夏寫幷題，蘇陳潔。
　　作者印章：蘇陳潔印，太素，大雅
　　鑑藏印章：竹景研齋，潞河李韻湖藏，秋
　　　　　　　[][]
　　題　　跋：文英，雲麓運，東園循，常曜

柴貞儀，柴靜儀姊妹（十七世紀）
　　貞儀，字如光，錢塘（今杭州）人。世堯長
　　女，黃介眉妻，與妹靜儀幷擅詩名。工花鳥
　　草蟲。靜儀，字季嫻，一作季畹，世堯次女
　　，沈鏐妻，工梅竹。

30．花卉草蟲圖卷
　　作者款識：杭郡女子柴貞儀靜儀合摹於凝香
　　　　　室。
　　作者印章：貞靜合同
　　鑑藏印章：子彰清玩，[][]山人（半印），
　　　　　　　老漁，青芷山房寶藏，[]存[][]
　　　　　　　玉庵，[][]彰[][]印，[][]（半
　　　　　　　印），董氏[][]

周禧，即周淑禧（活躍於十七世紀下半葉）
　　自號江上女史，江蘇江陰人。榮起（1600－
　　86）次女，適同邑諸生，與姊淑祜皆善畫。
　　工花鳥，大士像。

31．白鳥梅枝圖扇面，1663
　　作者款識：癸卯暮秋江上女子周禧製。
　　作者印章：淑禧之印

傅德容（活躍於十七世紀下半葉）
　　吳郡（今江蘇蘇州）人。康熙（1662－1722）
　　間此地婦人能畫者多，德容乃翹楚之一。工
　　人物。

32．歸隴西圖扇面
　　作者款識：歸隴西傅德容筆。
　　作者印章：德容，[][]
　　鑑藏印章：[][]嚴子，平生賞此

蔡含（1647－86）
　　字女蘿，吳縣（今江蘇蘇州）人。如皋冒襄
　　（1611－93）姬，與金玥時稱冒氏兩畫史。
　　工山水，人物，花草，禽魚。善臨摹，喬松
　　，墨鳳尤奇。

33．仿夏昶橫松卷，1676
　　作者印章（？）：書中有女畫中有詩，雉皋冒
　　　　　　　　氏水繪庵蘭閨雙畫史
　　鑑藏印章：雉皋冒巢民平生眞賞，煙雲供養
　　　　　　　，名賢[]樂琴書圖畫代去雜欲，
　　　　　　　水繪菴老人，雉皋古巢民冒襄辟
　　　　　　　彊氏圖書印記，金香室心賞（冒
　　　　　　　襄，1611－93）
　　題　　跋：冒襄（1676），蔡金臺（1910）

金玥（十七世紀）
　　字曉珠，號圓玉，江蘇崑山人，如皋冒襄姬
　　。山水得高克恭氣韻，工花鳥，善水墨。

34．百花圖卷
　　作者款識：染香閣女史金玥寫。
　　作者印章：金玥
　　鑑藏印章：水繪菴老人，辟彊，宋季子玩，
　　　　　　　銕某眞賞，吉林宋季子古歡室收
　　　　　　　藏金石圖書之印，銕某，宋小濂
　　　　　　　（冒襄，1611－93；宋小濂）
　　題　　跋：冒襄，宋小濂

冒襄姬人（十七世紀下半葉，金玥？）
35．芝秀圖軸，1691
　　鑑藏印章：巢民命姬人倣古，巢民辟彊，如
　　　　　　　南山之壽（冒襄，1611－93）
　　題　　跋：冒襄（1691）

陳書（1660－1736）

字南樓，號上元弟子，或復庵，晚號南樓老人。秀水（今浙江嘉興）人，適海鹽錢綸光。善花鳥草蟲，用筆類陳淳（1483－1544），善佛像。

36. 白鸚鵡圖軸，1721
作者款識：辛丑仲冬南樓老人陳書。
作者印章：女史，陳書

37. 花蝶圖扇面，1735
作者款識：乙卯初秋日南樓七十有六老人陳書寫於萬松閣中。
作者印章：陳，書

蔣季錫（活躍於十七世紀末至十八世紀初）

字蘋南，江蘇常熟人。廷錫（1669－1732）妹，華亭王圖煒妻。花鳥得馬氏法。

38. 牡丹圖扇面，1693
作者款識：癸酉秋仲寫，應湘蘭大姊雅屬，妹蔣季錫畫。
作者印章：季，錫

惲冰（十八世紀）

字清於，號浩如，一號蘭陵女史，亦署南蘭女子。武進（今江蘇常州）人，惲珠（1771－1833）族姑，故為壽平（1633－90）曾孫女一說較為合理。善花果，得家法。

39. 十二月花卉圖册
作者款識：南蘭女史惲冰敬畫。
作者印章：（各頁）惲冰，清於

40. 花葉草蟲圖册
作者款識：
(一)霜寒北漠鴨南迴，幾朵芙蓉貼水開。
正是山莊秋半景，畫家那得見茲來。
(二)月月信風吹不盡，好花合向畫師看。
(三)葳蕤垂寶綬，覼縷紫玉懸。
女夷作瓔珞，惟應獻金僊。
(四)寄語世人，莫薄相合歡，含笑總多情。
(五)蝶弄微風來草際，信番月月送花開。
(六)點水萍絲亂，牽風荇帶長。
落紅吹不定，幽趣在濠梁。
(七)西府公子神儔侶，有色無香睡正濃。
(八)十里香盈谷，六月雪封枝。
玉蘭干側畔，等度是仙姿。
(九)鐵綫繡餘無意緒，秋閨閒踢繡球花。
(十)雪裡春前都耐寒，深黃淺絳鬥江千。

清涼凡豔分儕俗，繪出憑人著眼看。
女史惲冰。
作者印章：女史惲冰，清於

41. 草蟲圖册
作者款識：
(一)點水眸頻顧，禁風翼有聲。
不嫌枝幹弱，慣立釣絲輕。
(二)四壁秋聲蟲語健，一天露氣豆花香。
撫包山子意。
作者印章：惲冰

42. 蘭花圖扇面
作者款識：
(一)其氣清，其體靜，其德馨，其品正，惲冰。
(二)深夜看花不自持，高歌一曲酒千巵，惲冰。
(三)紛紛蕭史總堪嗔，乍把蘭香自可親。
莫言楚遊容易得，知君願是獨醒人。
清於冰寫。
(四)清於女史寫於松韻軒中。
作者印章：惲冰之印，蘭陵女史

43. 雙家鴨圖扇面，1747
作者款識：丁卯春三月之望寫，清於女史惲冰。
作者印章：惲冰，清於

44. 荔枝花卉圖扇面
作者款識：南蘭女史惲冰撫北宋人本。
作者印章：惲冰

馬荃（活躍於十八世紀上半葉）

字江香，江蘇常熟人。元馭（1669－1722）女，逸妹，龔克和妻。工花卉，得家法。

45. 仿宋人花蟲圖卷，1723
作者款識：雍正改元長夏，江香馬荃撫宋人本。
作者印章：馬江香印
鑑藏印章：古潤州戴培之收藏書畫私印，翰墨軒，戴芝農鑑賞章，賀清生（戴植，十九世紀上半葉）

46. 菊花圖軸，1726
作者款識：擬北宋徐崇嗣筆法仿其大略，丙午秋九月望後三日，江香女史馬荃寫。
作者印章：馬

47. 菊花蚱蜢圖軸
　　作者款識：
　　　　　一種秋香何處來，托根原不屬蒼苔。
　　　　　兔毫點染霜苞綻，卻似淵明籬下栽。
　　　　　平生再愛東籬菊，性嬾兼無隙地栽。
　　　　　每到興酣拼筆墨，不勞灌溉亦放開。
　　　　　江香女史，馬荃。
　　作者印章：馬荃，江香女史
　　鑑藏印章：杜曲張氏拱垣珍藏，留在仙山瀛
　　　　　　　海外興同素月賞心來

48. 花蝶圖卷
　　作者款識：江香女史馬荃製。
　　作者印章：江香，馬荃
　　鑑藏印章：藹然如坐春風，元[]齋珍賞

49. 花蝶圖扇面
　　作者款識：馬荃。
　　作者印章：[]史，馬荃印

50. 臨葉小鸞蝴蝶册
　　作者款識：余舊藏葉瓊章蝴蝶畫册，其筆精
　　　　　　　微曲盡，其迴舞蹁躚之態，每一
　　　　　　　展玩，心嚮往之，今偶臨數頁，
　　　　　　　殊有效顰之陋，然後知古人之難
　　　　　　　到也，江香馬荃并識。
　　作者印章：馬荃印，江香女史
　　鑑藏印章：聽松書屋珍藏，吳中陶[]收藏之
　　　　　　　印，聽松書屋，曙東心賞，曙東
　　　　　　　私釦，蘇州陶[]書畫金石收藏之
　　　　　　　印，懷滄書屋，識在析思，滄憶
　　　　　　　客，[][][][][]東風，陶[]（招
　　　　　　　曙東，二十世紀）

方畹儀（1732－79）
　　字儀子，號白蓮居士。安徽歙縣人，羅聘
　　（1733－99）妻。善畫梅蘭竹菊。

51. 梅竹石圖扇面
　　作者款識：白蓮居士，方畹儀畫。
　　作者印章：方氏白蓮
　　鑑藏印章：子，貢（？）

駱綺蘭（活躍於十八世紀下半葉）
　　字佩香，號秋亭，上元（今南京）人。江寧
　　諸生龔世治妻，早寡。少耽吟詠，袁枚
　　（1716－98），王文治（1730－1802）詩弟
　　子。工花卉寫生，喜畫蘭。

52. 春蘭圖扇面

　　作者款識：仿南田春草，綺蘭。
　　作者印章：佩，香
　　鑑藏印章：李均湖讀畫記

王玉燕（活躍於十八世紀下半葉）
　　字玟梁，江蘇丹徒（今鎮江）人。文治孫女
　　，適汪詣成。能詩，善畫蘭與仕女。

53. 蘭石圖扇面
　　作者款識：丹青寫眞色，欲補離騷傳。
　　　　　　　對之如靈均，冠珮不敢燕。
　　　　　　　玟梁女史。
　　作者印章：玉，燕

月香（活躍於十九世紀上半葉）
　　佚其姓氏，爲揚州名姝。受書法於陳鴻壽
　　（1768－1822），工墨蘭。

54. 墨蘭圖扇面
　　作者款識：月香。
　　作者印章：月香
　　題　　跋：顧廣圻（1776－1835），楓橋漁
　　　　　　　隱，徐雲路（1809），鬢華生，
　　　　　　　張鏐（十八世紀末十九世紀初）
　　　　　　　，春畦（1809）

淨蓮（活躍於十九世紀上半葉）
　　女道士，姓王，字韻香，號清微道人，玉井
　　道人，二泉，江蘇無錫人。中年皈依，爲福
　　慧雙修庵住持。善畫，工蘭竹。

55. 蘭石圖扇面
　　作者款識：清微寫。
　　作者印章：韻香
　　鑑藏印章：惜芳，慧吾珍藏，天景樓（莫華
　　　　　　　釧，二十世紀）

項絪章（活躍於十九世紀上半葉）
　　一名絪，字屛山，號絪卿，錢塘（今杭州）
　　人。賦隸女，許乃普（1787－1866）繼室。
　　善畫花卉。

56. 梅竹圖扇面，1822
　　作者款識：壬午中夏錢唐女士項絪寫于翰墨
　　　　　　　和鳴舘。
　　作者印章：絪印

錢聚瀛（活躍於十九世紀中葉）
　　字斐仲，號餐朝，別號雨花女史，秀水（今

229

浙江嘉興）人。昌齡（1771-1827）女，德
清戚士元妻。工畫花卉，有陳書風。

57. 梅花圖扇面，1861
作者款識：海珊先生清屬，辛酉秋日寫於筍
溪客舍，秀水女史錢斐仲。
作者印章：斐仲
題　　跋：吳雲（1811-83）

纕范，生平不詳
58. 竹圖扇面
作者款識：管夫人清心勁節圖幷臨贈陳夫人
教正，女弟纕范。
作者印章：纕范

駱桂芬（活躍於十九世紀下半葉）
59. 花蝶圖團扇
作者印章：駱桂芬
背面題跋：邵鄮（十九世紀）

梁若珠（活躍於十八世紀末至十九世紀初）
廣東順德人。幼工畫蜨，稍長，以蟲介翎毛
得名。番禺令彭人傑慕其名，聘爲繼室。

60. 粉蝶圖軸
作者款識：南海梁若珠製。
作者印章：若，珠
鑑藏印章：子珪（？）過目

吳尙熹（活躍於十九世紀中葉）
字祿卿，一字小荷，廣東南海人。榮光
（1773-1843）女，適同邑葉應祺。善設色
花卉。

61. 蝶花圖扇面，1854
作者款識：法元人賦色，甲寅花朝於吉見齋
，小荷女士。
作者印章：小荷，葉吳祿卿

62. 緱嶺僊餐卷
作者款識：緱嶺僊餐，擬南田草衣木，即呈
理谷老翁清玩，祿卿吳小荷。
作者印章：祿卿，吳小荷印
鑑藏印章：如玉如金（？），寄樓珍藏
題　　跋：張虹（1899）

63. 仿惲壽平牡丹花卉圖扇面
作者款識：撫甌香館設色，小荷女史，吳祿
卿畫。
作者印章：小荷女史，吳氏書畫

余菱（活躍於十九世紀中葉）
字鏡香，順德蘇六朋妾。工人物，能作巨幅。

64. 三醉翁圖軸
作者款識：鏡香女史余菱畫。
作者印章：鏡香

65. 雅集圖扇面
作者款識：鏡香女史。
作者印章：鏡香，女史
鑑藏印章：[][]

朱美瑤（活躍於十九世紀）
字伯姬，南海（今廣州）人。次琦（1807-
81）女。工山水，書法秀逸。

66. 山水圖册頁
作者款識：（一）伯姬製。
（二）伯姬。
作者印章：（一）信清河朱氏伯姬女史畫
（二）伯姬

居慶（活躍於十九世紀）
字玉徵，番禺（今廣州）人。巢（早於1828
-99）長女，適廣西于氏。工花卉，仿惲壽
平，並傳家學。

67. 牡丹圖團扇
作者款識：衡齋先生大人雅鑒，
禺山女史居慶。
作者印章：玉徵書畫
鑑藏印章：又文藏品

68. 藍地牡丹蝴蝶圖軸
作者款識：寫呈瑞貞姊倩雅鑑，
玉徵女士居慶。
作者印章：[][]

69. 仕女圖册頁
作者印章：（一）居慶，玉徵
（二）禺山女史居氏玉軒
鑑藏印章：（一）又文藏品
（二）又文藏品

慈禧太后（1835-1908）
那拉氏，文宗之妃，垂簾聽政。學繪花卉，
挑能書畫之婦人入內供奉，爲之代筆。

70. 鴻疇錫壽圖軸，1897
作者款識：光緒丁酉仲春中浣御筆。
作者印章：慈禧皇太后之寶，大雅齋，澂心

正性，清風承景，永壽樂悵

題　　跋：陸寶忠（十九世紀末二十世紀初）

71. 瑤階福壽圖軸，1904

作者款識：瑤階福壽，光緒甲辰小易上浣御
筆。

作者印章：慈禧皇太后之寶，大雅齋，致中
和，日有萬喜

72. 梅竹圖軸，1906

作者款識：光緒丙午季春下浣御筆。

作者印章：慈禧皇太后之寶，大雅齋，天地
一家春，澂心正性，肇揚清芬

題　　跋：陳伯陶（十九世紀末二十世紀初）

73. 試繪花卉圖卷

作者款識：秋海棠紫萼；蓼，螳螂，菊之一
種。

作者印章：御賞，慈禧皇太后御筆之寶，知
樂仁壽，欽賜功名，（?）車公瑩
園嫡系圖記

繆嘉蕙（活躍於十九世紀末二十世紀初）

字素筠，昆明人。適同邑陳氏，早寡，以彈
琴賣畫爲生。工翎毛花卉，小楷佳。經督撫
薦爲慈禧太后代筆，人稱繆姑太。

74. 荷塘蜻蜓圖扇面，1902

作者款識：壬寅夏四月化（畫）于都門雪竹
軒南窗下，滇南女士繆素筠寫。

作者印章：嘉惠

鑑藏印章：曾經振甫收藏

75. 牡丹花束圖軸

作者款識：誥封夫人羅伯母伍太夫人八旬開
一大壽，素筠女史繆嘉蕙敬繪謹
祝。

作者印章：素筠

鑑藏印章：龍山陳氏梓嘉珍藏典籍書畫金石
之章，[][][]

愛蓮女史（活躍於十九世紀末）

生平不詳

76. 洛神圖團扇，1893

作者款識：翩若驚鴻，癸巳夏午月仿雲龍
山人筆法，愛蓮女史。

作者印章：漫漶不清

任霞（1876—1920）

字雨華，山陰（今浙江紹興）人。頤（1840
—96）女，吳興吳少卿妻，居滬上。人物花
卉，得父傳。

77. 王羲之觀鵝圖軸，1896

作者款識：光緒丙申仲冬之吉，山陰任雨華
寫於滬城書齋。

作者印章：雨華

78. 貓石芭蕉圖軸，1904

作者款識：光緒甲辰四月山陰任霞雨華寫於
海上。

作者印章：雨華

79. 浣沙圖軸

鑑藏印章：海昌呂氏所得銘心神品，青無盡
齋鑒藏書畫記（呂萬，1885—?）

題　　跋：呂萬（1941），吳湖帆（1941）
，吳東邁（1941）

吳淑娟（1853—1930）

晚號杏芬老人，安徽歙縣人。父鴻勳。工花
鳥，山水，幼秉家學。適同邑唐光照，作畫
尤勤。

80. 鹿鶴仙姑圖軸，1909

作者款識：宣統元年己酉秋七月，仿新羅山
人筆意，吳杏芬寫於義廬之西廂。

作者印章：義廬

鑑藏印章：水磨山莊，安思遠藏